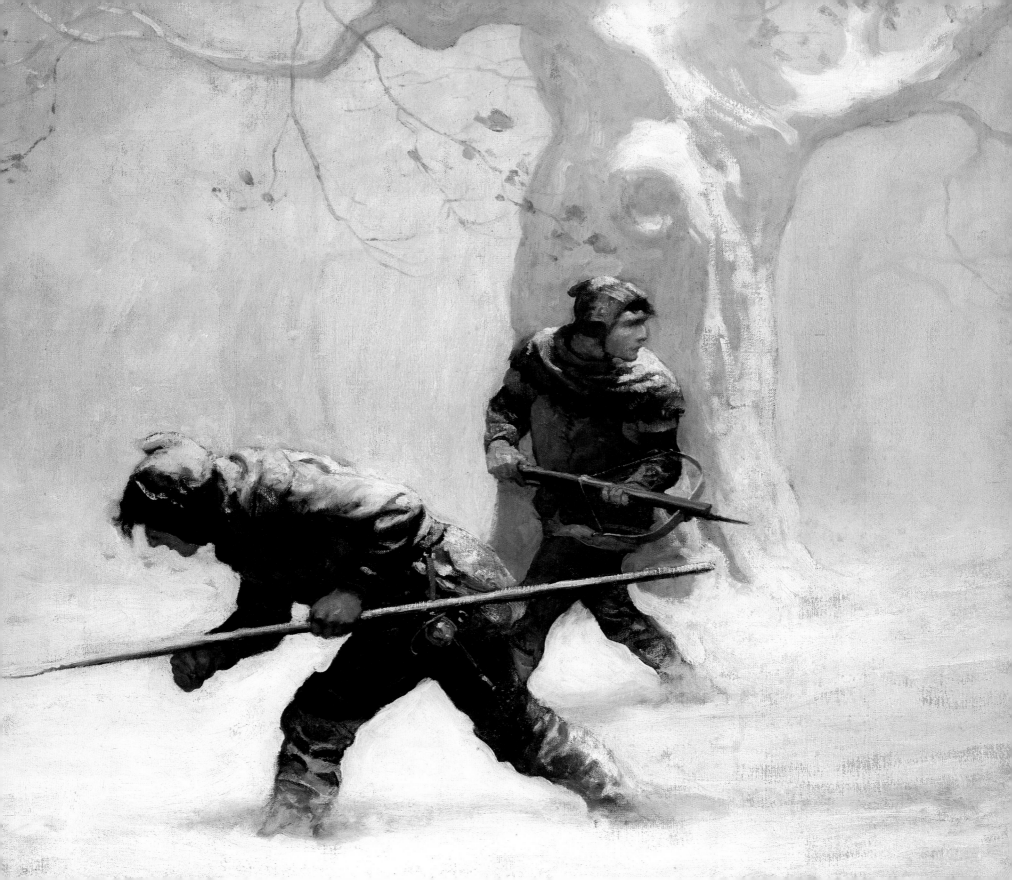

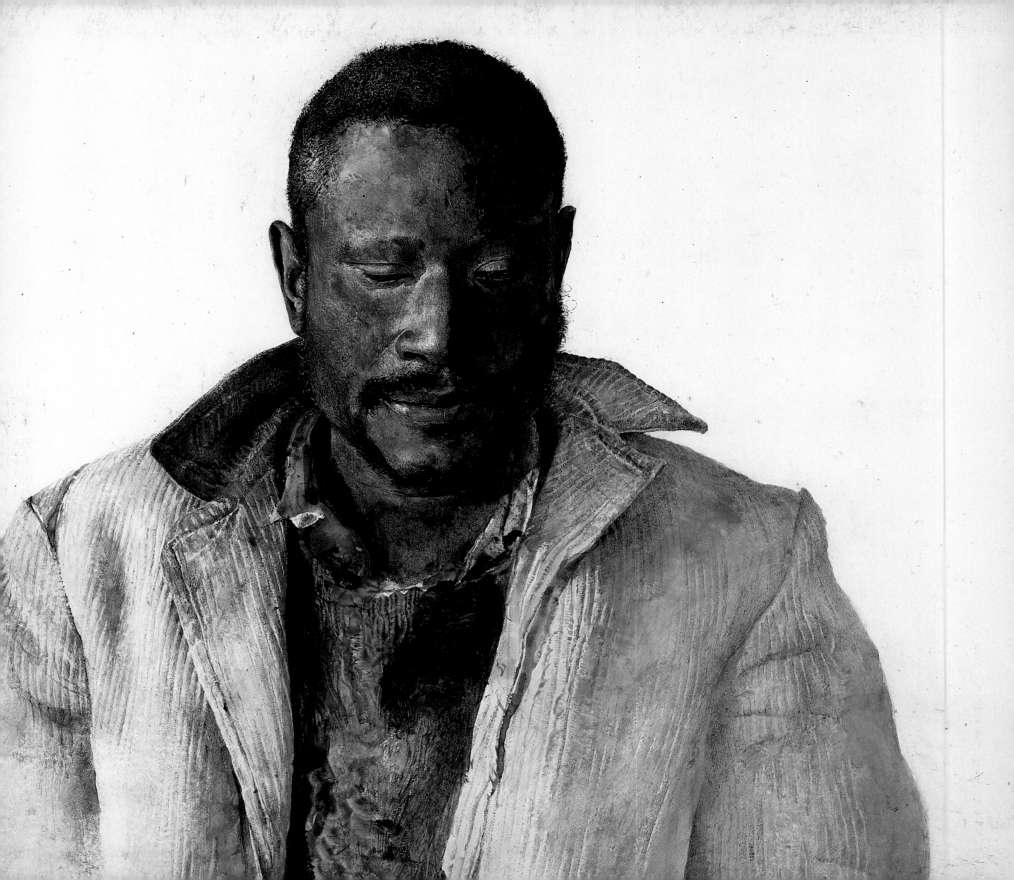

An American Vision
Three Generations of Wyeth Art

N. C. WYETH *ANDREW WYETH* *JAMES WYETH*

Essays by

JAMES H. DUFF ANDREW WYETH THOMAS HOVING LINCOLN KIRSTEIN

Published in association with the Brandywine River Museum

A New York Graphic Society Book · Little, Brown and Company · Boston

This book was published in connection
with the exhibition organized
by the Brandywine River Museum and shown at:

Academy of the Arts of the USSR,
 Leningrad, March 11–April 12, 1987;

Academy of the Arts of the USSR, Moscow,
 April 24–May 31, 1987;

Corcoran Gallery of Art, Washington, D.C.,
 July 4–August 30, 1987;

Dallas Museum of Art, Dallas, Texas,
 September 29–November 29, 1987;

Terra Museum of American Art, Chicago, Illinois,
 December 13, 1987–February 14, 1988;

Setagaya Art Museum, Tokyo, Japan,
 March 10–April 21, 1988;

Palazzo Reale, Milan, Italy, May 17–June 20, 1988;

Fitzwilliam Museum, Cambridge, England,
 July 12–August 29, 1988;

Brandywine River Museum, Chadds Ford, Pennsylvania,
 September 17–November 22, 1988.

The exhibition was made possible by AT&T.

This exhibition is supported by an indemnity
from the Federal Council
on the Arts and the Humanities.

In captions for color illustrations,
numbers in parentheses refer to Checklist designation.

Captions for illustrations on opening pages

page i: N. C. WYETH "And Lawless, keeping half a step in front of his companion . . ." (detail) 1916 (29)

page ii: ANDREW WYETH "The Drifter" (detail) 1964 (50)

page iii: JAMES WYETH "Portait of Lady" (detail) 1968 (85)

title page: ANDREW WYETH "The Corner" (detail) 1953 (42)

New York Graphic Society books are published by
Little, Brown and Company, Inc.

Published simultaneously in Canada by
Little, Brown and Company (Canada) Limited

PRINTED IN SWITZERLAND

Library of Congress Cataloging-in-Publication Data
An American vision.
 "A New York Graphic Society book."
 Published in association with the Brandywine River
Museum to accompany an international exhibition
organized by it.
 Bibliography: p.
 Includes index.
 1. Wyeth family— Exhibitions. 2. Realism in art—
United States— Exhibitions. I. Wyeth, N. C. (Newell
Convers), 1882–1945. II. Wyeth, Andrew, 1917–
III. Wyeth, Jamie, 1946– . IV. Duff, James H.,
1943– . V. Brandywine River Museum.
ND237.W94A4 1987 759.14'074 86-21357
ISBN 0-8212-1652-X
ISBN 0-8212-1656-2 (pbk.)

Sponsor's Statement

For nearly half a century, AT&T has been committed to enhancing the quality of life in communities across the United States through its association with the arts. With its sponsorship of "An American Vision: Three Generations of Wyeth Art," AT&T globalizes that commitment.

The paintings and drawings of N. C. Wyeth, Andrew Wyeth, and James Wyeth capture the enduring values of American life even as they chronicle a century of change. Now, for the first time, a comprehensive presentation of the Wyeths' unique view of American lives, history, and beliefs will be shared not only with the people of the United States, but also with those of the Soviet Union, Japan, Italy, and the United Kingdom.

AT&T is especially gratified that "An American Vision: Three Generations of Wyeth Art" will be the first exhibition of American art to travel to the Soviet Union as part of the General Exchanges Agreement signed at Geneva in 1985 and is proud of its part in this historic undertaking.

With the international tour of "An American Vision," we have an opportunity to showcase some of America's great art while making an important investment in international understanding. For a company that has been bringing people together for more than a hundred years, it is a particularly satisfying investment.

JAMES E. OLSON
Chairman of the Board and Chief Executive Officer
AT&T

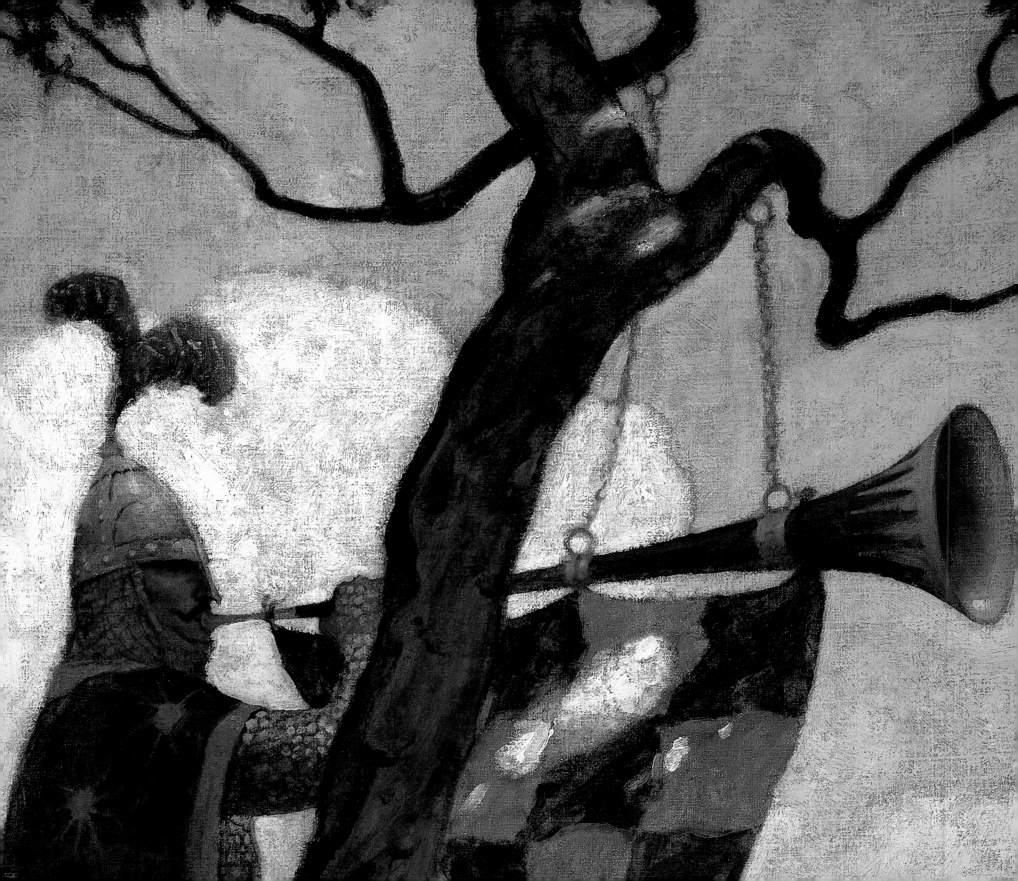

Contents

N. C. WYETH *"It hung upon a thorn, and there he blew three deadly notes" (detail) 1917* (33)

Preface

We are delighted to present "An American Vision: Three Generations of Wyeth Art," the first major international exhibition to examine the art of N. C., Andrew, and James Wyeth, and the first to focus on the enduring traditions that have shaped one of America's foremost artistic families. The Wyeths deserve their fame for many reasons, not the least of which is the unusual circumstance of artists of three successive generations each achieving broad and well-deserved recognition in his own right; seldom does such artistic talent occur within a single family. We are now accorded the rare opportunity to study their techniques and the themes of their paintings and to examine continuities and changes among the art of father, son, and grandson over nearly a century.

In recent years a spate of exhibitions has traced various parts of these three careers, but none has traced interconnections among the three generations in great detail. As a result, they have also been unable to slake the thirst for more information about the Wyeths. The essays in this book are by individuals who have long been acquainted with the Wyeth tradition. Each of the authors may be described as someone who has had the opportunity to study that art and the artist and to discuss them with the man himself. Andrew Wyeth, the youngest son of N. C. Wyeth, studied solely with his father and early in his career worked closely with him. He has previously discussed his own career, but never before has he publicly analyzed his father's life in depth. His essay here results from lengthy discussions with James H. Duff during June 1986. Thomas Hoving, former director of the Metropolitan Museum of Art, had known Andrew Wyeth for several years before he assembled an exhibition for the Metropolitan in 1976 entitled "Two Worlds of Andrew Wyeth: Kuerners and Olsons" and worked closely with the

artist to create a valuable catalogue that explores Andrew's thoughts and artistic process. In the years since then, the two men have remained in close personal contact. Lincoln Kirstein has been a close friend of all three artists and has observed their development. He has known James Wyeth since before the artist painted his portrait in 1967; they have been friends since, and Kirstein has actively followed James's career. The insights that each of these authors brings to his essay broaden our perspective of this outstanding family of artists. Together with the essentially historical overview provided by James H. Duff, they present a composite picture of the Wyeth tradition, one that delineates the men and their work in the context of the twentieth century. In these four essays are traced the traditions and innovations that make the Wyeths' art so fine and so compelling.

Each of the Wyeths is capable of working in a variety of media, and their images contain both surface statement and underlying complexity. Viewers are left to choose the level at which to read each picture. Those who delve deeply, whether into an individual painting or into the entire oeuvre of each artist, will discover an amazing breadth. They will also discover that all three men share one important talent: the ability to intimate qualities that symbolize enduring aspects of human nature and to accomplish this complex task through careful depiction of seemingly simple elements of the human condition.

Disturbed by their simple, often spare, images or unable to move beyond the surface content, some critics have dismissed the Wyeths' art out of hand, claiming that the three men's works are only narrative in nature, that their techniques simply rehash nineteenth-century methods, and that individually or collectively they show little growth or development. In the past, such judgments came all too easily to critics whose view of appropriate contemporary art was nonobjective. In more recent years art historians and a perceptive, excited public have taken a fresh look at one or another of the Wyeths and been fascinated by the technical ability and the underlying vision of American life and art. It is this vision so well rendered that we now proudly present.

This exhibition has been organized by the Brandywine River Museum, but without the commitment and considerable involvement of mem-

bers of the Wyeth family, an exhibition of this scope would be impossible. We thank them for their enthusiasm and many unique contributions to this joint endeavor.

We also express gratitude to AT&T, which— in keeping with its reputation for support of the arts— has generously underwritten costs of assembling this extraordinary international exhibition. No project this complex could be accomplished without such aid and without such faith in the process as our sponsor has shown.

We thank our respective governments for their assistance in bringing these paintings to the people of three continents, and finally, but most earnestly, we thank the lenders to this exhibition who agreed to part for a lengthy period with cherished works of art.

BORIS S. UGAROV, *President*
Academy of the Arts of the USSR, Leningrad and Moscow

MICHAEL BOTWINICK, *Director*
Corcoran Gallery of Art, Washington, D.C.

HARRY S. PARKER III, *Director*
Dallas Museum of Art, Dallas

MICHAEL H. SANDEN, *Director*
Terra Museum of American Art, Chicago

SEIJI OSHIMA, *Director*
Setagaya Art Museum, Tokyo

LUIGI DADDA, *Head*
Department of Culture, City of Milan

MICHAEL JAFFÉ, *Director*
Fitzwilliam Museum, Cambridge

JAMES H. DUFF, *Director*
Brandywine River Museum, Chadds Ford

Acknowledgments

Our deepest thanks go to Mrs. Ronald Reagan, the Honorary Chairman of "An American Vision: Three Generations of Wyeth Art," whose enthusiasm and support have helped ensure that this notable American artistic legacy would be seen throughout the world.

The artists' contribution to this undertaking has been extraordinary. Andrew and James Wyeth are very frequently asked to make commitments to exhibitions of their work, but it is not often possible for them to do so. The volume of those requests is prohibitive, and the humility with which they view their work also inhibits participation. Each is more likely to support an exhibition of the other's work than of his own. Thus, this exhibition and the publication of this book are rare and happy circumstances made possible by their desire to celebrate each other and N. C. Wyeth. We celebrate them. And we honor the essential, thoughtful contributions of their wives, Betsy Wyeth and Phyllis Wyeth. We thank them all for sharing their American vision with an eager audience stretching around the world.

The exhibition became a reality because of the generous corporate sponsorship of AT&T. Special gratitude is extended to James L. Brunson, Vice-President of AT&T, whose initial interest brought the sponsor and the exhibition together; to R. Z. Manna, Corporate Advertising Manager, for his constant personal concern, which greatly facilitated this endeavor; and to Jacquelyn R. Byrne, A. Brian Savin, and Judith Finore for their expertise.

It is unusual for a museum the size of the Brandywine River Museum to undertake a project as large and complex as this exhibition and the publication of this companion volume. It could not have been done without the immediate and wholehearted commitment of George A. Weymouth, Chairman of the Board of Trustees of the Brandywine Conservancy. His personal belief in the importance of the art this exhibition represents never wavers in its intensity. His fellow trustees of the Museum's parent organization were equally supportive and understood the significance of this undertaking, which reflects much of the purpose of their institution. All departments of the Brandywine Conservancy were affected by this project and gave it special consideration. Jean A. Gilmore, Museum Registrar, oversaw so much, from insurance to couriers, that the list of her personal accomplishments would be as great as our gratitude for her patience and skill. Marylou Ashooh Lazos, Anne F. Neilsen, and Deborah S. Seymour were her very able assistants. No exhibition has had a more competent conservator than Timothy Jayne to serve it, and the excellence of Peter Ralston's photography for this publication speaks for itself. Frances Norton, Executive Secretary; Mary Bassett, Librarian; and John Sheppard, Director of Public Relations, must represent many others for whom limited space is the only obstacle to published gratitude.

At museums in five countries, this exhibition has been received eagerly by colleagues who brought considerable professional expertise to its installation and presentation. In Leningrad and Moscow, at the Academy of the Arts of the USSR, Boris S. Ugarov, President, showed great enthusiasm and was assisted by Ekaterina V. Grishina, Director of the academy's museum in Leningrad, and by Vera Nikolaeva, Chief of the Foreign Department, and Zhenia Kucherova at the Academy in Moscow. Michael Botwinick, Director of the Corcoran Gallery of Art, signifi-

cantly aided both domestic and international arrangements. His capable and helpful staff includes William B. Bodine, Jr., Assistant Director for Curatorial Affairs. Harry S. Parker III, Director of the Dallas Museum of Art, made an early commitment to the exhibition, and his keen interest has been reflected in the work of his staff: Steven Nash, Deputy Director/Chief Curator; Rick Stewart, Chairman, American Painting and Decorative Arts; and Anna McFarland, Associate Curator for Exhibitions. In Chicago, the Honorable Daniel J. Terra, Ambassador-at-Large for Cultural Affairs for the United States of America, is founder and Chairman of the Terra Museum of American Art. His enthusiasm and the diligence of Michael H. Sanden, Director, have made it possible for "An American Vision" to appear at the new Terra Museum of American Art on North Michigan Avenue. Seiji Oshima, Director of the Setagaya Art Museum in Tokyo, has had a special, personal interest in the art of the Wyeth family and greeted this exhibition with much warmth. Junichi Shioda, Curator, has provided essential assistance in Tokyo. Luigi Dadda, Head, and Ludina Barzini, former Head of the Department of Culture of the City of Milan, made possible the exhibition's appearance in Italy. Vittorio Del Vecchio, Special Assistant to the Head, and Giuseppe Chieppa, Chief Manager of the Cultural Branch, deserve mention for their eager support. Anna Sansuini, Curator of the Exhibits Office for the Department of Culture, has provided professional care for the exhibition at the Palazzo Reale. Professor Michael Jaffé, director of the Fitzwilliam Museum in Cambridge, England, has guided the exhibition to a land that inspired many of N. C. Wyeth's illustrations. He has been assisted by David E. Scrase, Keeper of Paintings, Drawings, and Prints; Jane A. Monroe, Assistant Keeper of Paintings, Drawings, and Prints; and Frances Hazlehurst.

Arrangements to share this exhibition with the people of the Union of Soviet Socialist Republics, Japan, Italy, and England were greatly facilitated by the United States Information Agency and the personal interest of Charles Z. Wick, Director. In addition to his commitment, the experienced and capable staff at the USIA, including the Office of the Coordinator of the President's U.S.–Soviet Exchange Initiative, was always available to aid the exhibition's progress. Special mention goes to John Coppola and Susan Flynt Stirn of the Arts America program, whose proficiency and constant attention maintained communications and informed the inexperienced. Their diligent colleagues in American embassies and consulates deserve similar gratitude: Raymond E. Benson, Anton N. Kasanof, and Mark A. Taplin in Moscow; Lyndon K. (Mort) Allin in Leningrad; Warren Obluck and Fusako Ishibashi in Tokyo; John M. Keller, Douglas Wertman, and Chiara Grioni in Milan; and Anne Collins in London. Their knowledge and judgment made preparations far more efficient than could otherwise have been possible.

Mabel H. Brandon, President of Rogers & Cowan, in Washington, D.C., has been involved in this project from its earliest stages, contributing her enormously valuable talent, experience, and insight. She has been ably assisted by Pamela Johnson, Senior Vice-President of the firm, and by Elizabeth A. C. Weil, former Vice-President. Gratitude is extended to the Federal Council on the Arts and the Humanities for the Indemnity granted, and to Alice Martin Whelihan, Indemnity Administrator at the National Endowment for the Arts. Everyone involved with the exhibition is deeply grateful to the many generous lenders who made it possible; they are listed elsewhere in this publication, but they cannot be rewarded enough. Among the many individuals who provided special help to keep aspects of the exhibition on schedule are Wendell Fenton and Michael M. Ledyard, whose legal expertise and good humor were much appreciated; R. Frederick Woolworth, President of Coe Kerr Gallery, New York; Frank Fowler, Lookout Mountain, Tennessee; Robert Lescher of Lescher and Lescher Literary Agency, New York; and Sally Duff, my wife. No Museum could have a more understanding publisher than New York Graphic Society Books, where Janet Swan Bush, Executive Editor, and Betty Childs, Senior Editor, reacted with informed consideration to the special nature of the undertaking represented in this book.

JAMES H. DUFF
Director
Brandywine River Museum

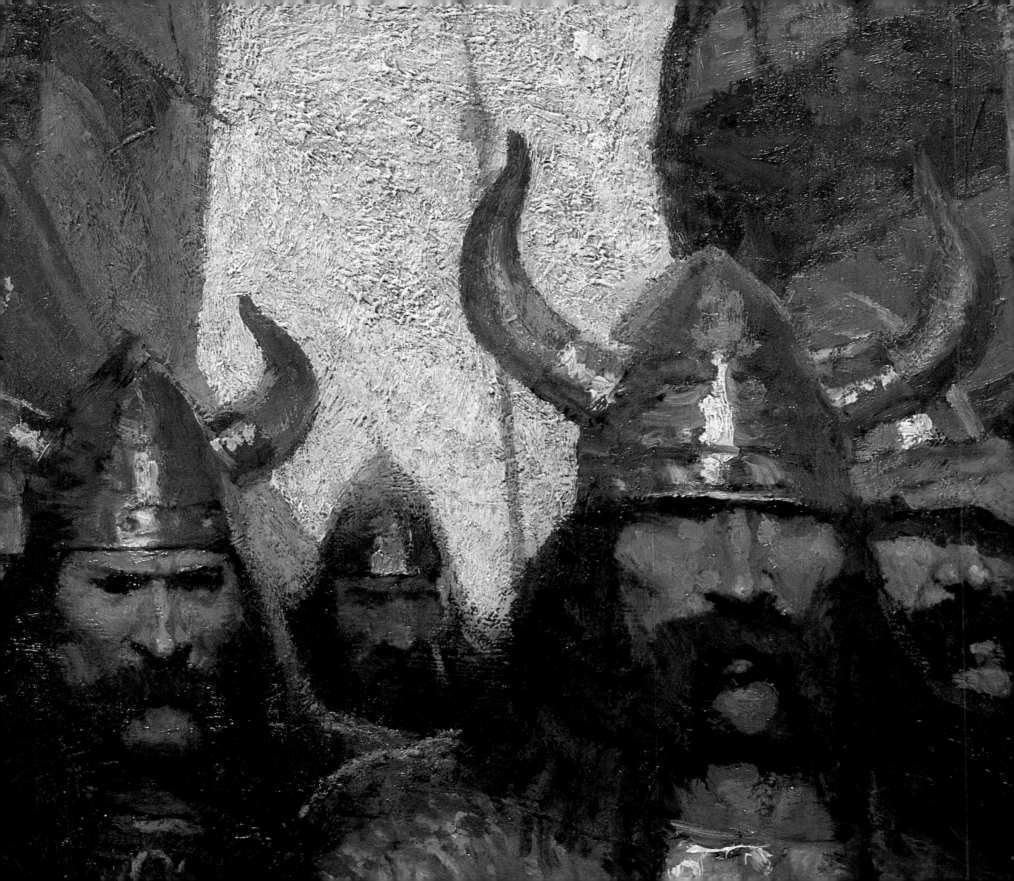

An American Vision

JAMES H. DUFF

JAMES H. DUFF

An American Vision

And lonely as it is, that loneliness
Will be more lonely ere it will be less,
A blanker whiteness of benighted snow,
With no expression— nothing to express.

They cannot scare me with their empty spaces
Between stars— on stars void of human races.
I have it in me so much nearer home
To scare myself with my own desert places.

　　　　　　　　　　　　　　　　　— *Robert Frost*

I

For three generations, members of the Wyeth family have created works of art that have captured the imagination and admiration of a broad public. To much of that public it may seem easy to understand these compelling images, and to know the artists whose lives are reflected in them— just as it seems easy to define the "American spirit," or to describe the features of the areas of the northeastern United States that they paint.

Thus, for most admirers of the art of the Wyeth family, N. C. Wyeth is "the great illustrator," the man with as much gusto as the swash-bucklers he painted. Andrew is "the painter of old barns," and many an admirer has said (without any attempt at humor) that if only Andrew could see a certain broken gate or window, he would surely paint it. James Wyeth, we hear, paints attractive animals in cute poses and bucolic settings. As for their techniques, N. C. Wyeth is constantly acclaimed for accuracy of historical detail, Andrew for the detail itself, and James for the lushness of his paint. The voluminous reproductions of their work— along with newspaper and magazine articles — reinforce the notion that these artists depict easily recognized things in a manner easily understood, that the artists themselves are easily understood. Only a cursory look at their work could produce such a response; there is a need to look again, more intently.

It cannot be obvious to casual observers that such diverse elements as immigrant life in Massachusetts, Emily Dickinson's poetry, Thoreau's declarations, King Vidor's film *The Big Parade,* and contemporary

events in American national life have been significant factors in the development of the art of N. C. Wyeth, his son, and his grandson. But such complex aspects of American culture have indeed provided motivation for their work and prompted the intensely romantic spirit that pervades it.

That spirit is a vital thread traceable through the fabric of the family and binds these men. The romance is not primarily of nineteenth-century character. It is not necessarily based in conventionally beautiful settings, and it is certainly not found in mundane circumstances. Rather, it is profoundly expressed through art that reflects the humor, the drama, and the darker events that have been part of these artists' personal experience. It is informed by the farmer's practical knowledge as well as by the history of warfare, but it displays its particular character by uncovering and embracing fascinating and beautiful things most often unobserved— or at least untreated— by others.

To discover their unique visions, to see what is distinctive in any work by any one of these artists, we need to look at the traditions they share, at the life of their family and the influences upon it. Such an examination reveals elements of adventure and romance that could easily support imaginative endeavor.

To understand the art, then, a portion of the history of American immigration is a proper study. That study begins with Nicholas Wyeth, who came from England to Cambridge, Massachusetts, in 1645. A stonemason who contracted to build one of the earliest structures at Harvard College, his son attended that school. Later Wyeths died in the Deerfield Massacre, in the French and Indian War, and then at Lexington, where a surprisingly large number of them fought the British in that early Revolutionary battle. Wyeths were among the young agitators at the Boston Tea Party, Wyeths were privateers during the War of 1812, and immediate ancestors of N. C. Wyeth fought and died in the American Civil War. Members of the family shipped ice from Cambridge to the Caribbean, and many of them remained and prospered in New England. Others helped open the Oregon Trail and became farmers and merchants in many parts of the continent.[1] Thus, growing up in that family has meant growing up with American traditions and with a sense of the strength of traditions, both national and familial.

During the wave of immigration in the mid-nineteenth century, another settler who came to Cambridge, Massachusetts, would be an extremely important contributor to the Wyeths' heritage. John Denys Zirngiebel arrived there to become director of the Harvard Botanical Gardens after first immigrating to New Orleans from Switzerland in 1855. His new position and the financial security it offered enabled him to bring his wife to Cambridge. The family they established there spoke French and consistently honored their French-Swiss traditions. When one of their three children, Henriette, married a local man, Andrew Newell Wyeth II, she passed these traditions on to their son, Newell Convers.

This emotional inheritance that passed from grandmother to mother to son was recognized and prized by N. C. Wyeth. In his twenties, he wrote about it to his friend Sidney M. Chase:

My grandmother was born in the mountains of Switzerland. When twenty-three years of age she tore herself from all her people and the quiet romantic little dairy home to follow my grandfather to America. Dropped into the heart of Cambridge, Mass., among strange people, unable even to speak a word of their tongue, she lived for three years. Then it was, in 1867, that my grandfather purchased a lonesome bit of land in the outskirts of Needham and on the Charles River, and here my dear old grandmother almost pined her heart away for her home and people in the Swiss mountains. During this pitiful condition of mind she gave birth to her only daughter— my mother.

Here, prenatal influence asserted itself. Her longing soul became my mother's inheritance. I can read it in her every letter, in her eyes and her voice. It has always impressed me profoundly, and I in turn have inherited that strange love for things remote, things delicately perfumed with that sadness that is so exquisitely beautiful.

. . . I only dare hope that I can commune these feelings to you in my work— sometime.[2]

The letter says much about the artist's character, as well as his mother's

and grandmother's. In a letter to his mother of about the same time, N.C. wrote of his own sense of melancholy: ". . . for some reason or another *anything* that I appreciate keenly and profoundly is always sad to the point of being tragic. Whether it is a lone tree on a hillside bathed in the fading light of the afternoon sun, or the broad stretch of a green meadow shining and sparkling after a shower . . . it is all so sad, because it is all so beautiful— so hopeless."[3] Thus, the hope that he described to Chase may well be considered the major goal in his career; his painting was often an intense effort to give emotional impact and drama to life's quietest moments, as well as to its most vigorous.

N.C.'s mother provided a strong intellectual as well as emotional heritage. "My mother as a little girl sat on the knees of Longfellow many, many times. His daughters were friends of ours for years," he wrote much later. "Henry David Thoreau was a personal acquaintance of my grandfather's and family talk about him was commonplace. . . ." And he told about cherished keepsakes, things that belonged to Oliver Wendell Holmes, Asa Gray, William Lloyd Garrison, and others: "But how we reverenced those names, and how our mother did cultivate in us a reverence and regard for life and the people about us. . . ."[4]

Andrew and Henriette Wyeth had also moved from Cambridge to Needham, in order to be close to the Zirngiebels. N.C. was born there on October 22, 1882, and grew up with three younger brothers. His youth in then-rural Needham, along the Charles River, reinforced his emotional bent. He was always aware of the countryside, and elements of family life reinforced the sense of romance and love of nature that was so much a part of his maternal heritage. In the same letter in which he spoke of Longfellow and Thoreau, he also remarked, "Our relaxations were vigorous out-of-door sports and much time was spent hunting, fishing, sailing, etc. In some undefinable way our parents made us feel the romance of *every day* living. . . ."

His notable passion for land, even for soil itself, for farming and farmers, was certainly nourished from his earliest days, and his intimate knowledge of rural life was gained through daily activity. In an often quoted letter, he said:

My brothers and I were brought up on a farm, and from the time I could walk I was conscripted into doing every conceivable chore that there was to do about the place. This early training gave me a vivid appreciation of the part the body plays in action.

Now, when I paint a figure on horseback, a man plowing or a woman buffeted by the wind, I have an acute sense of the muscle strain, the feel of the hickory handle, or the protective bend of head and squint of eye that each pose involved.[5]

It was not a brag. His ability to depict a body in action convincingly and subtly without the use of models testifies to his sure knowledge of such forms. He must have been an astute observer from the beginning, and it is likely that this was another inheritance from his mother.

It was she who encouraged his art, over the objections of his father, who viewed with alarm the young man's lack of attention to school and his inclination toward art.[6] His mother took up her son's cause, secured a professional opinion of his drawing ability, and arranged to send him to the Mechanic Arts School in Boston for an education in drafting. He was graduated from this school in 1899, but he was not interested in drafting as a profession. Through a loan from his now more supportive father, he attended the Massachusetts Normal Arts School, where he was encouraged to pursue illustration as a career. He next studied at the Eric Pape School of Art in Boston, then at Annisquam, Massachusetts, with George L. Noyes in 1901. By 1902, he was studying illustration with Charles W. Reed.

Perhaps the most important decision in his life was made that year, when three Massachusetts friends— Sidney M. Chase, Clifford W. Ashley, and Henry Peck— who had been accepted at the Howard Pyle School of Art in Wilmington, Delaware, and Chadds Ford, Pennsylvania, encouraged Wyeth to join them.

When N. C. Wyeth presented himself to Pyle in Wilmington in 1902, Americans were enjoying the full bloom of what is often proclaimed the "golden age" of American illustration. Pyle was famous as one of this country's finest illustrators and widely recognized as the most impor-

Howard Pyle, 1902 N. C. Wyeth, 1916

tant American teacher of that art. His methods, interests, and personality were ideal for Wyeth; to a large extent they appear to parallel impulses and interests in the younger man. His influence on N. C. Wyeth and Wyeth's progeny was so immediate, dramatic, and long-lasting that Pyle's own career must be examined carefully in order to understand the work of his student, as well as the art of Andrew Wyeth, and of James Wyeth three generations later.

II

The early experiences of Howard Pyle and N. C. Wyeth had many vital elements in common: British ancestry, early ability in drawing, a mother who supported his art, a merchant family, and a love of the countryside. These similarities make it easy to understand why the younger artist was immediately drawn to Pyle. While Pyle's fame as a teacher and illustrator was certainly the major factor bringing N. C. Wyeth to Wilmington and Chadds Ford, it was his personality that captivated N.C., whose attitude quickly passed from the attentiveness of the protégé to devotion.

By the time Wyeth arrived in the Brandywine Valley, Howard Pyle had done most of his life's work and established new standards for illustration. Indeed, his influence, while it may have waxed and waned, has been felt by successive generations of illustrators and has lasted to the present day. The title often associated with him, "father of modern American illustration," is deserved.

Born in Wilmington in 1853, Pyle grew up in a time when illustrated periodicals like *Harper's Weekly* and *Frank Leslie's Illustrated Newspaper* were becoming regular fare in American households. Both of these journals were found in his parents' home, along with British children's magazines, *Punch*, and *The Illustrated London News*.[7] Thus, as a young man with an eye for art, he became aware that pen and ink and wash drawings could convey excitement. The noted illustrator Felix O.C. Darley lived and worked nearby, and his presence in the community must have made the world of commercial illustration appear very accessible. He also became deeply familiar with the graphic work of Dürer and Cranach, and studied the work of the Pre-Raphaelites (who

became significant influences on his style of illustration), and developed an interest in the paintings of one European impressionist only, Giovanni Segantini.

The impact of contemporary illustration on American culture increased with each succeeding decade from Pyle's youth into the twentieth century. Illustrations helped create an enormous audience anticipating each new issue of the popular periodicals, an audience regularly seeking the work of certain illustrators. Advances in printing technology brought increasingly well reproduced art into homes. Eventually, and long before Pyle's career ended, such advances brought color into the major publications, making it both possible and necessary for N. C. Wyeth and Pyle's other students to work frequently in color and to develop techniques in which color was a major concern.

But when Howard Pyle went to study in Philadelphia at about age sixteen, art education was grounded in black-and-white images. It was black-and-white work that he would later present to the art editors at *Scribner's Monthly* and *Harper's New Monthly* magazines. He moved to New York City, where Mary Mapes Dodge, editor of the very popular *St. Nicholas*, the children's magazine, was among those encouraging him to take up a career in illustration. Pyle's first major publication appeared in *Harper's Weekly* in 1878. Working at *Harper's*, he became friends with such established illustrators as Charles Stanley Reinhart, Edwin Austin Abbey, A. B. Frost, and Thomas Nast. Their work helped formulate his ideas, as did the American artists he met while studying composition at the Art Students League in 1878: William Merritt Chase, J. Alden Weir, George Inness, Frederick S. Church, and Rufus Zogbaum.

Through contact with such men and frequent visits to museums and exhibitions, he gained a deeper knowledge and pride in American art that would be expressed in his insistence to his students that artists in this country need not look to European models, that an indigenous art was capable of great vitality and quality. Elements in Pyle's work had European antecedents, but, writes his biographer Henry Pitz, "Europe's bland disregard of American art irked him. He was gearing for a redoubtable and expressive native art that would stun Europe by its vigor. He

thought he saw the beginnings of it in American illustration. . . ."[8] Later in his career, Pyle developed friendships with artists who continually reinforced his feeling for American art and culture, among them Daniel Chester French, George de Forest Brush, Augustus Saint-Gaudens, Gari Melchers, Kenyon Cox, and Frederic Remington. Their work affected Pyle and is often clearly reflected in the work of his students.

Pyle's rapidly growing ability brought him increasing commissions. When he returned to Wilmington in 1879 at age twenty-six, he was assured of continued recognition. He married in 1881, settled there, and remained there for the rest of his life.

In the 1880s, Pyle both wrote and illustrated children's books that became extremely popular; many of them, such as *The Merry Adventures of Robin Hood*, are still in print. Their illustrations demonstrate the remarkable flexibility of his pen and ink technique. He was master of the medium, showing on one hand an extremely decorative style and on the other a fine, linear style. Such works as the frontispiece for *The Wonder Clock* (1888; page 8) reveal both his study of European pen and ink and his own romantic streak.

This romantic streak is clearly present in the oil paintings on board and canvas and in the wash drawings that he began to produce in the 1890s, showing great competence from the beginning. He indulged his sense of romance with fantasies compelling to children (and to himself), at the same time as he illustrated a great many episodes from American history for adult publications. He prided himself on the accurate detail of his historical illustrations. Whether or not the subjects were fictional, his depictions were based on careful observation and research. The Revolutionary War soldiers in fine paintings such as "The Nation Makers" (1903; page 8), as well as his many depictions of pirates, show thorough historical accuracy. He collected costumes and provided backgrounds based on research in his own library of books on such subjects as English dress and armor.

"But the bred-in-the-bone romantic was tantalized by a secondary craving for realism— he wanted to write like William Dean Howells," Pitz tells us. He conveyed this concern for realism to his students and insisted upon correct perspective and detail in their work. Thus, the romance inherent in his principal subjects— stories of the Middle Ages, piracy, the American colonial period, and warfare— was joined with accurate representation to produce illustrations with credible drama. Such work was constantly before his students as an example.

In 1894, Pyle began teaching a course in illustration at Drexel Institute of Art, Science and Industry in Philadelphia, in which he placed special emphasis on design for drama and grisaille techniques. The course was more satisfying to the institute and its students than to Pyle, who wanted smaller classes and more intense concentration on illustration. While commuting regularly to Drexel, he began a summer school in the village of Chadds Ford on the Brandywine River north of Wilmington. The school was actually on the site of the Revolutionary War Battle of Brandywine; Pyle's students lived in houses that Washington and Lafayette had used during the battle. An inspiring sense of American history was in the air, and the rural landscape surrounding the milling and farming village provided beautiful subjects. Finally breaking away from Drexel in 1900, Pyle built studios in Wilmington and founded his own school of art, with emphasis on producing working illustrators. But he continued the summer classes in Chadds Ford and attracted a student group of the ability and number he desired.

Being a student under Pyle was an exhilarating experience, according to the testimony of many of those students. Aside from sessions in the studio, there were picnics, excursions, and impromptu dramas organized with Pyle's props and costumes. The teacher was "Master" at both Drexel and the new school. And he had apparent mastery at selecting applicants; many of the more than one hundred he trained would be among America's most important illustrators. Henry Pitz writes:

Pyle developed an uncanny instinct for judging student potential. Over the years he made only a few unfulfilled judgments. The quality called talent *was only one gift he looked for. He looked deeply for character, purpose, general intelligence, ambition, imagination, and health. He read the submitted drawings, not for skill, finish, or surface display but for an inner purpose, for imagination and a hint of individuality.*[9]

HOWARD PYLE
"The Nation Makers," 1903
Oil on canvas, 40¼ x 26 inches (102.2 x 66 cm)
Collection of the Brandywine River Museum.
Purchased through a grant
from the Mabel Pew Myrin Trust

HOWARD PYLE
Frontispiece for *The Wonder Clock*, 1888
Pen and ink on paper, 9¼ x 6½ inches
(23.5 x 16.5 cm)
Collection of the Brandywine River Museum.
Museum Volunteers Purchase Fund, 1976

HOWARD PYLE
"The Sixth Sketch" ("The Mermaid Tavern"), c. 1893
Pen and ink on paper, 7 x 9½ inches (17.8 x 24 cm)
Illustration for "A Set of Sketches" by Howard Pyle,
Century Magazine, December 1893.
Collection of the Brandywine River Museum.
Museum Volunteers Purchase Fund, 1976

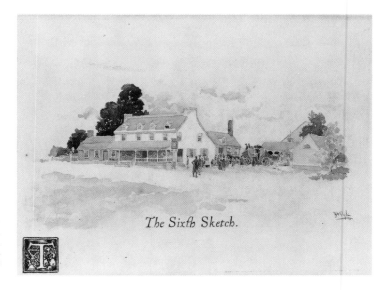

The Sixth Sketch.

Pyle himself wrote, ". . . in general my opinion is that pictures are creations of the imagination and not of technical facility, and that which art students most need is the cultivation of their imagination and its direction into practical and useful channels of creation."[10]

He told his students that they must be artists first, and then illustrators, but aside from the composition, drawing, and painting techniques he taught, he constantly emphasized drama and emotional content, which he believed had to arise from the artist's personal concern for a subject. Composition could strengthen drama, but only if personal commitment and knowledge accompanied it. For that reason, he urged his students to paint what they knew or could come to know well. Following this precept, Harvey Dunn, who came from a homesteader's sod hut on the South Dakota prairie, made the plains people, the cowboy, the American Indian his frequent subjects. Frank Schoonover visited Hudson Bay to gain experience for illustrating such books as Jack London's *White Fang*. Many of Pyle's women students, like Jessie Willcox Smith and Elizabeth Shippen Green, became known for work depicting women, children, and family life. He often acquired appropriate commissions for his students while they were still studying with him.

Pyle died in Florence, Italy, in 1911 (much impressed, it must be said, by Italian art when he at last saw it). In the final, very busy years of his life, Pyle served for a time as art editor of *McClure's Magazine*, completed a number of murals for major public buildings, and published hundreds of illustrations. He left behind an enormous body of work, much of which is now in public collections, and he created a legacy through his art and teaching that has continued to affect American culture. No doubt as fresh and broader views of American art make for more positive attitudes toward illustration, Howard Pyle's stature as an artist will be increasingly recognized.

III

Years afterward, N. C. Wyeth recalled his first meeting with his teacher in Pyle's Wilmington studio in 1902:

The soft top-light from the glass roof high above us poured down like a magical and illuminated mist over his magnificent head . . . the entire countenance became majestically severe, forceful, unrelenting. The recollection of the masks of Beethoven, Washington, Goethe, Keats, passed in swift succession before my vision, and in a sudden grasp of the truth I realized that the artist's face before me was actually a living compromise [sic] of the men of history and romance which he had so magically and dramatically perpetuated on canvas.[11]

The quotation says at least as much about Wyeth as about Howard Pyle. It contains references to historical figures important to Wyeth throughout his career, and it points to his romanticism and his search for magical elements in both reality and fiction.

He progressed rapidly under Pyle's tutelage. After only a few months of study with him, N.C. saw his first published illustration, a bucking bronco and rider, appear on the cover of the *Saturday Evening Post* in February 1903. It was a major accomplishment for so new a student to have his work published, not just *in*, but *on the cover of* one of the most widely circulated magazines in the country. The work he produced was already greatly advanced in technique from the art he had presented for acceptance at the school. This extraordinary progress testifies to both Pyle's success as a teacher and Wyeth's native ability.

Through his student years, while working on basic disciplines and looking to Pyle for guidance and criticism, Wyeth began to think of himself as a western illustrator. The American West was a magical world for the young man. Like most of his generation, he was raised on the work of artists such as Frederic Remington and felt personally familiar with cowboys and cattle drives. He would soon gain a reputation among publishers for depictions of the Wild West. By mid-1903 he was telling his mother about this interest— and something more: "I know that I will paint something that will tell someday. Just give me time. I've fully decided what I will do. Not altogether Western life, but true, solid American subjects— nothing foreign about them."[12] In 1904 the *Saturday Evening Post* commissioned him to illustrate a western story, and at this point Pyle's precept regarding the artist's need for direct knowledge of his subject became a serious issue: N.C. prepared to travel west.

Pyle urged him to go, and Joseph Chapin, art editor at *Scribner's,* arranged transportation with the expectation that Wyeth would produce work for publication. He left in September of 1904 for what became a remarkable series of adventures, heading directly for Denver. In his letters home he wrote with enthusiasm about nearly every observation. What he saw kept him "in a frenzy of excited expectation."[13] In Colorado he found things as he had anticipated: "I am gratified," he soon wrote, "to think that my conceptions of the West were about right. In fact I feel perfectly at home here."[14]

He worked on a ranch in a cattle roundup, where his early training with horses served him well. During this "wildest and most strenuous three weeks of my life"—he worked 300 head of cattle on the first day alone— he lived with the "punchers," took photographs, and made diary entries and observations that served him the rest of his career. When he returned to Denver, he rented a studio and began a series of paintings, including "Roping Horses in the Corral," based on his experiences at Hashknife Ranch. These four paintings, his first in full color, were exhibited at a Denver gallery. He said then, "The color in the West is magnificent and cannot be touched with paint and brush."[15] But he certainly tried his best to touch it, and the palette he developed for the purpose was used for a wide variety of subjects for the next two decades.

He had planned to visit Indian reservations, so from Denver he went to Arizona. There he made some photographs of Navajos, but because they disliked cameras, he concentrated on sketches. He made many drawings of them, including some of the finest he ever produced. His study was interrupted by an unplanned adventure when his money was stolen from a safe in a government post in New Mexico and Wyeth joined in an unsuccessful hunt for the thieves. Without funds, he found necessary work as a mail carrier on horseback, riding 150 miles every three days between one small town in New Mexico and another in Arizona.

He then returned to eastern civilization, but with some longing: "How I hated to leave those Indians," he wrote to his mother, "and how I shall miss the many long silent evenings spent with them in their 'hogans,' seated around a flaming pile of crackling pinon listening to the low

N.C. in cowboy gear, 1904

Photograph made by N.C. on his western trip, 1904

N.C. in chaps, Denver, c. 1904

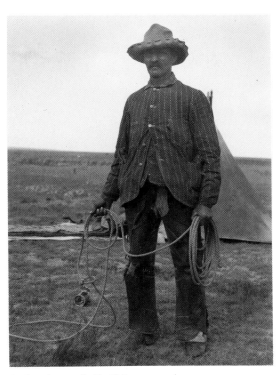

Cowboy photographed by N.C., 1904

Photograph made by N.C. on his western trip, 1904

Indian photographed by N.C., 1904

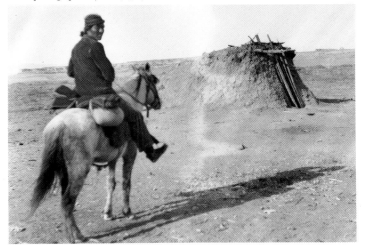

plaintive moan of the wind as it swirled down the canyon. The life is wonderful, strange— the fascination of it clutches me like some unseen animal— it seems to whisper, 'Come back, you belong here, this is your real home.' "[16]

He did go back, in 1906, when the *Outing Magazine* sponsored the second trip, this time to the Rocky Mountains of Grand County, Colorado. He went to collect specific information on mining, but became a fireman stoking the engine of a work train in the snowy and freezing mountains. The illustration "From an upper snow plat-form . . ." (page 14) is clearly based on this experience. On this second trip, as on the first, he collected costumes and artifacts that would provide details for illustrations he would do years afterward. In his collection were Mackinaw coats, cowboy costumes and accessories, and much Indian material, from beadwork to saddles and silver belts. He was almost completely caught up in western subjects for several years, and publications such as *Scribner's, Harper's, McClure's,* and *Outing* constantly sent him commissions related to western stories. He illus-trated for the best-known writers of western fiction and himself wrote and illustrated two fascinating articles for *Scribner's Magazine* based on personal experiences in the West.[17] (These are worth reading for his keen observations coupled with a sense of humor and an understanding of ironic elements in life.) Many well-known western books were pub-lished with Wyeth illustrations (even as late as the 1930s), among them works by Francis Parkman and Edna Ferber. *An Autobiography of Buffalo Bill* contains a particularly dramatic Wyeth work, "Fight on the Plains" (page 15), which contains a self-portrait showing the artist as Indian fighter behind a barricade of dead mules.

An interest in Native Americans, among other things, prompted Wyeth and a fellow student, Harvey Dunn, to travel to Washington in 1905 for Theodore Roosevelt's inaugural parade, in which Indians, scouts, and cowpunchers appeared. The two left Wilmington outfitted with their own western costumes, and, as he wrote home, they found the cowboys "extremely cordial and learning that we were from New Mexico and South Dakota immediately dispatched orders to save two 'mounts' for us. The result was that Dunn and I were *in* the 'Inaugural Parade' and

were enthusiastically cheered by the million-and-a-half people."[18] The sense of adventure and especially the sense of humor in this affair exemplify the gusto with which N. C. Wyeth sought special experiences throughout his life.

For him, the West was a great romance and a great teacher. It sharpened his vision and his abilities. It impressed him with the effects of light in nature, a lesson vital to future work. It was the source of some of his best and best-known work. But as he had written to his mother in 1903, it was not the only subject that compelled his attention. In 1910, he told a newspaper reporter, "My ardor for the West has slowly, but with increasing impetus, been dwindling, until my desires to go there to paint its people are already lukewarm. The West appealed to me as it would to a boy, a sort of external effervescence of spirit seemed to be all that substantiated my work."[19]

He had been engaged with other subjects from the beginning, and also with work other than illustration. With other Pyle students, he had painted rural landscapes and buildings near the Brandywine River, and his early sentiment for the farmland and woodlands of the Northeast increasingly asserted itself. Because he wanted change, the subjects of his commissions altered: "I am trying to instill into the minds of the magazine editors that I want subjects that are *local*, subjects that I can paint honestly and conscientiously . . . ," he wrote in 1908.[20] And he was by that time enough in demand to gain, to some extent, commis-sions he found appropriate.

The Native American, particularly the eastern woodland Indian, was a most appropriate topic for his frame of mind at this time and became a frequent subject. The Indian represented a natural way of life, man confronting nature directly. The theme appealed to him as Thoreau appealed to and drew on his fascination with wilderness. Wyeth's Indians are often shown in solitude, in seemingly unmoving contempla-tion of nature around them and integrated with their environment. Of course, his sympathetic depiction of the eastern Indian arises to a large degree from his direct experience with the western Indian, and in the quiet country of the Brandywine Valley, Wyeth was able to make the

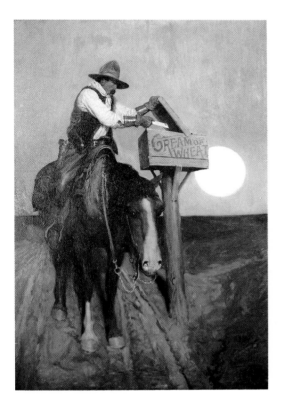

N.C. painting at Chadds Ford, c. 1908

N.C. in his studio before his painting
"From an upper snow platform . . . ," 1906

N. C. WYETH
"Rural Delivery"
("Where the Mail Goes Cream of Wheat Goes"), 1906
Painting for advertisement
Oil on canvas, 44¼ x 37⅞ inches (112.3 x 96.2 cm)
The Minneapolis Institute of Arts

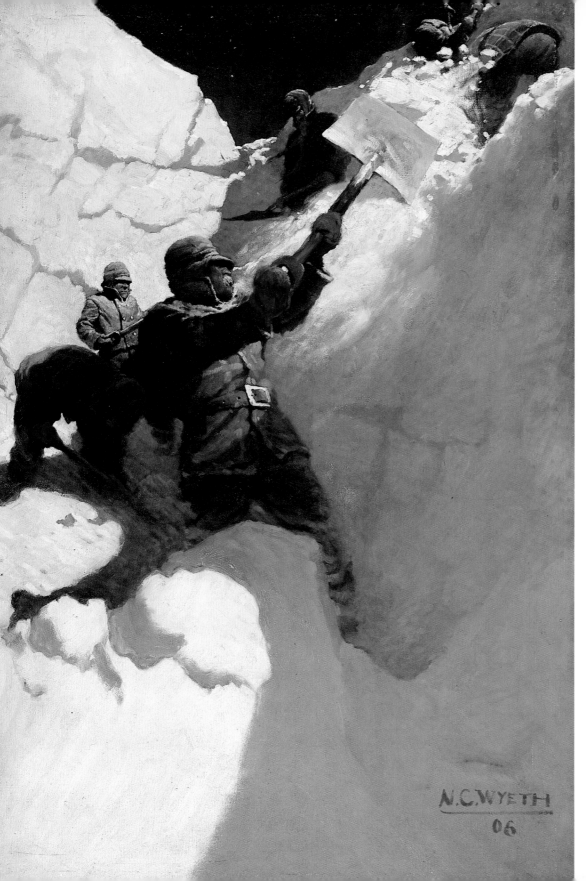

N. C. WYETH
"From an upper snow platform . . ."
("Attack of the Snow Shovels") 1906 (1)

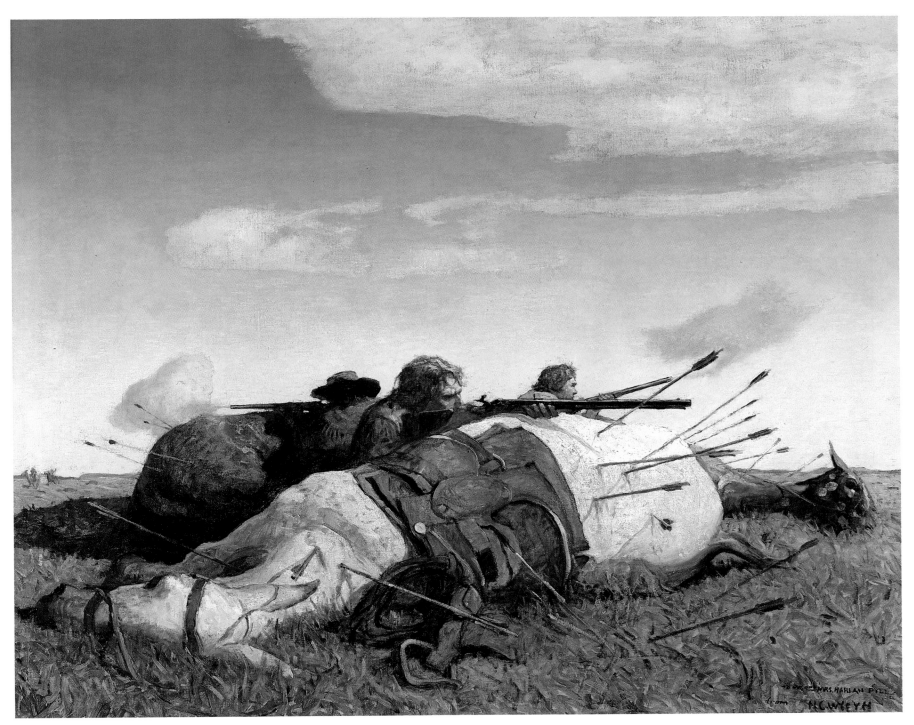

N. C. WYETH *"A shower of arrows rained . . ."* (*"Fight on the Plains"*) *1916* (31)

anthropological transfer quite easily. Following earlier successful Indian work, he painted four images that were offered by *Outing Magazine* in 1907 as a portfolio of reproductions. This group included "In the Crystal Depths" (page 17), a painting that demonstrates his understanding of the subject, as well as his technical ability, dramatic design, and fine use of light and shadow. The Indian and his canoe are painted with much detail, while the carefully arranged background is broadly brushed and thinly painted. The musculature and posture of the Indian testify to the artist's understanding of the human form. The woodland Indian was the subject of many more paintings (including his first set of murals painted in 1911 for the Hotel Utica in Utica, New York), which in themselves prove Wyeth's mastery of Pyle's lessons, and through comparison with his western work of the same period make a point essential to understanding Wyeth's art: he was capable of painting in a wide variety of styles and constantly experimented with variant techniques.

The sympathy with which he depicted the eastern Indian seems also to have resulted from "that strange love for things remote, things delicately perfumed with that sadness that is so exquisitely beautiful" that he defined as his inheritance. Once introduced to the Brandywine countryside, Wyeth sought pastoral experiences with an earnestness derived in large measure from nostalgia for the life of his youth in Needham. He found Wilmington, and most cities, unattractive and uncomfortable. In 1906 he traveled to Bushkill, Pennsylvania, with Frank Schoonover, and was fascinated by the wildness and wildlife of the place. He was captivated by the notion that a virgin forest existed there and sought out this kind of drama in nature. But within a few months he was describing his excitement over nature more subdued:

I've driven out to Chadds a number of evenings this past 10 days, and it has aroused my feeling to such a point as to make me feel exceedingly homesick— the country strikes home— it is a homelike country! sympathetic and so pastoral . . . Bushkill is fine! but it hasn't the barnyards, the waving grain, the great fields of corn— it hasn't the great piles of corn in the fall with scattered pumpkins and little piles of golden ears— it hasn't the neat white farm buildings and cattle. . . .[21]

And the things he named as dear are precisely the things he painted. His attachment to this farming landscape ran deep: "I feel so moved sometimes toward nature that I could almost throw myself face down into a ploughed furrow— *ploughed* furrow understand! I love it so," he wrote to his mother.[22]

To Sidney Chase he announced from Chadds Ford in 1907:

Never have I appreciated nature as I have in this place— I have enthused over Colorado's mountains and Arizona's deserts. I have been profoundly impressed by the great canyons with their torrents and falls and I have watched hair-raising struggles between men and horses midst wonderfully picturesque surroundings, but never have I felt the real story of nature as I have this summer. . . . And this is a country full of "restraints." Everything lies in its subtleties, everything is so gentle and simple, so unaffected.[23]

That summer he painted a group of farm scenes for a *Scribner's Magazine* story published in August 1908.[24] These highly successful illustrations increased his appetite for commissions related to his abiding interests. Pyle praised these paintings as the best work done by any of his students. One painting for the group, known today as "Mowing" (page 19), was never published as an illustration, but is often thought to be among his finest.

Indeed, "Mowing" may well serve as an emblem of Wyeth's deepest concern, his desire to paint scenes that demonstrate the affinity of man for the land (or sea) on which he lives and goes about his business. In "Mowing," a girl stands beside a young man who has taken a break from scything. She holds a pitcher while he drinks. Another mower labors on the hillside. The heat and dampness of the day are conveyed in fine atmospheric effects. The figures impart a sense of their place in the world and their relationship to each other. Wyeth wants us to see that people living close to the land have an understanding of forces affecting them.

A basic tension was developing in him: he wanted to paint more on that land, out-of-doors, but illustration seldom provided the opportunity to

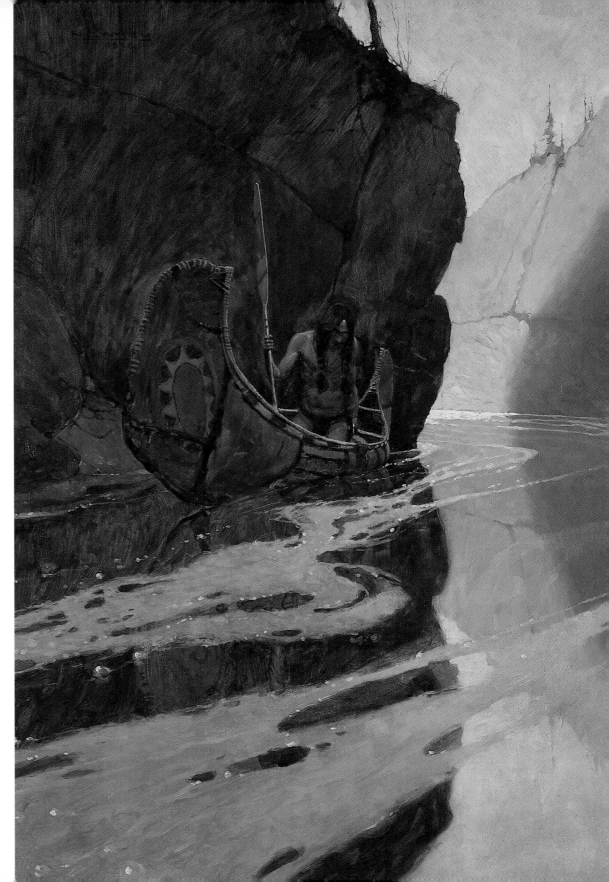

N. C. WYETH *"In the Crystal Depths"* 1906 (3)

do so, and he was now straining to break away from it. The man who had once written of his efforts to woo a publisher, ". . . I will fondle the puppet of fate scandalously,"[25] was now far from sure illustration was the path to satisfaction. As early as 1905 he had talked with Pyle about his desire and had remarked that Pyle did not give students enough outdoor assignments, that they needed more landscape work to develop appropriate techniques and backgrounds for illustration. He told Chase that the students had "missed the great underlying impulses of *nature.*"[26] Although he had left Pyle's formal training by 1906, he wrote to his mother in 1907 about increasingly frequent differences with his former teacher and his profession of illustration:

It has been absolutely *evident to me the past six months of the useless-ness of clinging to illustration and hoping to make* great *art. "It is a stepping stone to painting," so says Mr. Pyle — but I am convinced that it is a stepping stone backwards as well, which will in time leave you in that most unsatisfactory position of "a good illustrator, but he has* done *his best work."*

Now I'll tell you why. To begin with, an illustration must be made practical, not only in its dramatic statement, but it must be a thing that will adapt itself to the engravers' and printers' limitations. This fact alone kills *that underlying inspiration to create thought. Instead of expressing that inner feeling you express the outward thought or imitation of that feeling, because a feeling is told by subtleties and an engraver cannot handle such delicate matter.*[27]

A few years later he remarked about commercialism:

To come in contact with men who talk money, who want to buy me by piecemeal, and in searching for the best get the worst, because they push and prod, they are disrespectful. They consider you a cog in their clattering machinery, and they drop a dirty check into your bearings that you will run the faster.[28]

And so it went throughout life; until his death, he continued to make it clear in letters and other commentaries that illustration was not his ultimate goal, that despite the pleasure derived from a particular illustration or series, he wanted to give up his profession. Yet though he had been painting landscapes since at least 1903, he never made the complete commitment to painting. Early on, he may have felt a strong need for the monetary rewards of illustration in order to demonstrate to his father the wisdom of his investment in art training. The elder Wyeth had remained unconvinced for years that a decent living could be generated through art. If N.C. left illustration, no income could be predicted, let alone assured. His father's concerns might prove well-founded.

Another and somewhat related reason why he continued in illustration was his marriage to Carolyn Bockius of Wilmington on April 16, 1906, and the growth of their family. The couple moved to Chadds Ford, and over a period of time his attachment to that community grew ever stronger. Commissions came constantly, the pace of work was ex-tremely fast, and his fame was growing throughout the country. As his family grew to include five children, his excellent income was a certain comfort, and he knew that no pure painter of his day could match that income. He often said that he needed money to support the family and to provide good schooling, and that, if he could save enough, he would give up illustration. By 1914 he accused himself of having "*bitched* myself with the accursed *success* in *skin*-deep pictures and illustrations!"[29]

However, throughout his life he continued to paint landscapes, and for a number of years in mid-career he painted still lifes of surprising diver-sity. He also painted very fine portraits of family members, close friends, and himself. In all of this work, as in his illustrations, his style changed frequently as he experimented with numerous and varied techniques. The styles in which this consummate technician worked and the influences upon his stylistic changes are well worth examination.

Among early inspirations was George Inness, whom he greatly admired. He wrote about the tonalists Henry Ward Ranger and J. Francis Murphy, whose reputed "quietism" appealed to him. Their preimpressionist tendencies warmed his eventual interest in impressionism, but most important to him must have been their subject matter: isolated wood-lands and meadows of the kind he loved, the sort of territory he sought

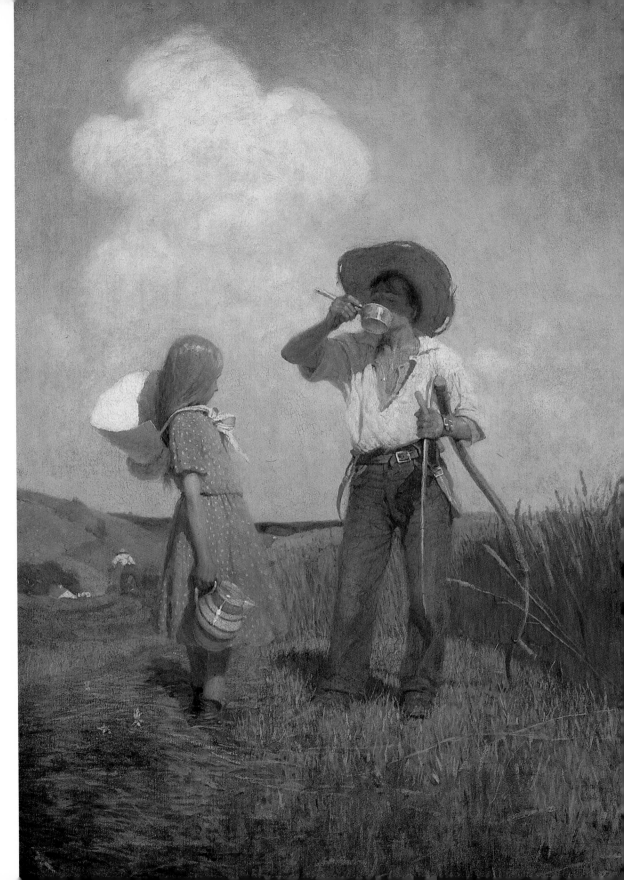

N. C. WYETH *"Mowing"* 1907 (4)

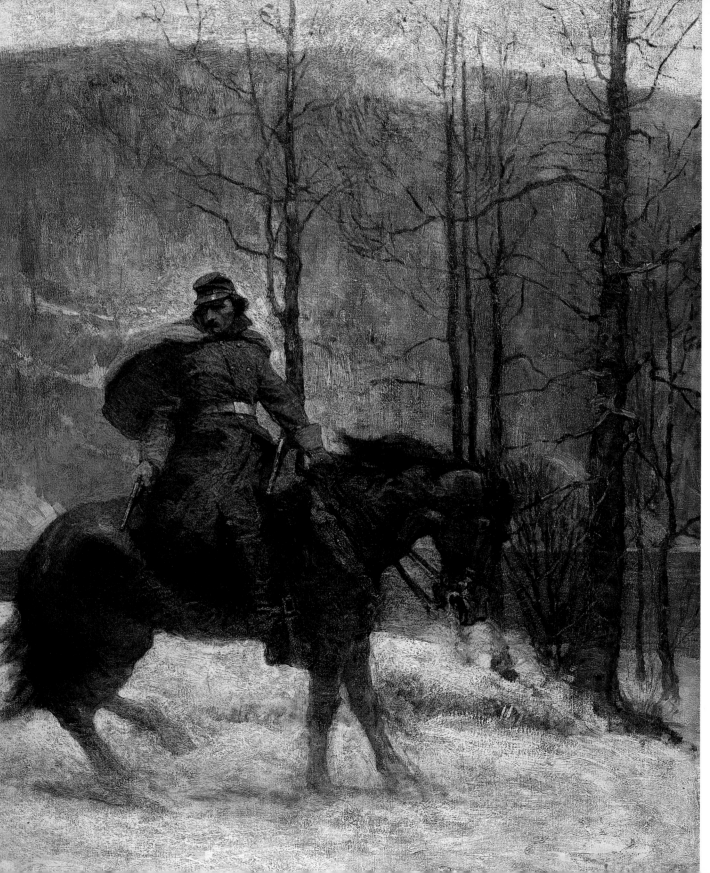

N. C. WYETH *"The Vedette"* *1910* (8)

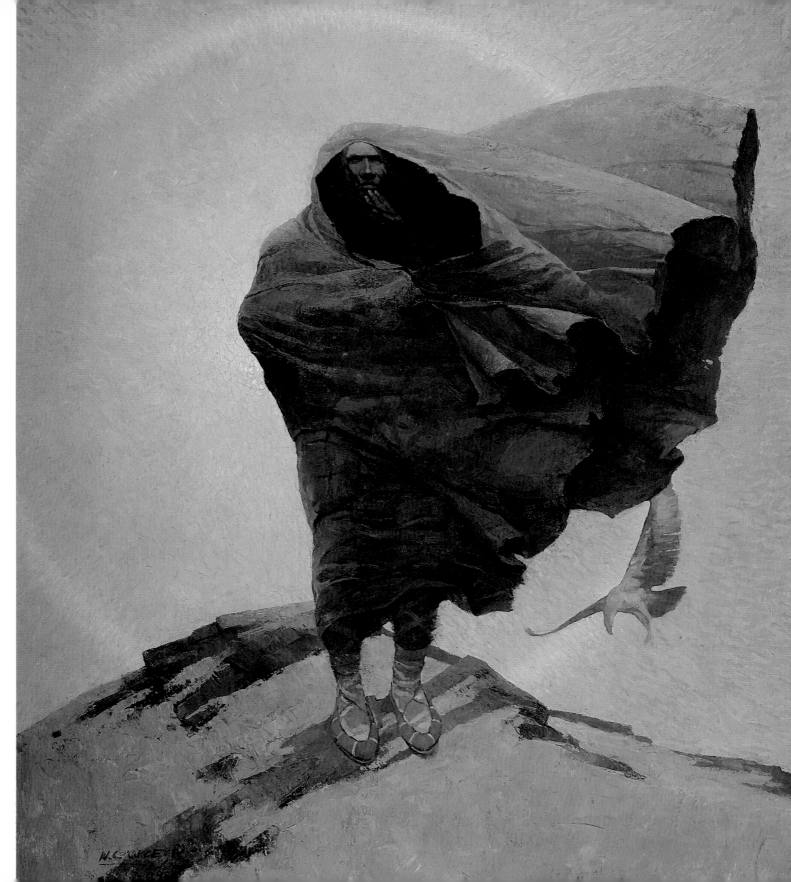

N. C. WYETH *"Winter"* 1909 (6)

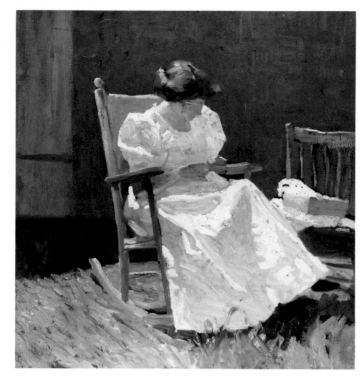

N. C. WYETH
"Mrs. N. C. Wyeth in a Rocking Chair," 1908
Oil on canvas, 26 x 24 inches (66 x 61 cm)
Private Collection

GIOVANNI SEGANTINI (1858–1899)
"Springtime in the Alps"
Oil on canvas, 47 x 90½ inches (119.3 x 229.8 cm)
The Fine Arts Museums of San Francisco.
Jacob Stern Family Loan Collection

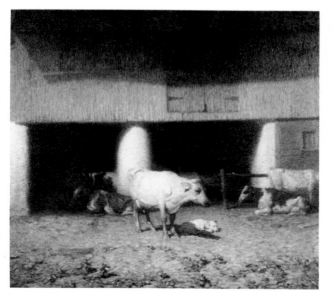

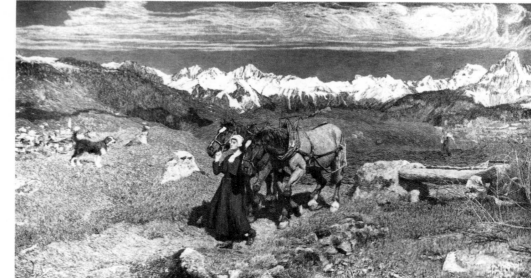

N. C. WYETH
"Newborn Calf," 1917
Oil on canvas, 41¾ x 46 inches (106 x 116.8 cm)
Private Collection

in solitary moments. He found their styles perfectly adapted to their subject matter, and to his own; their contemplative approach to nature and lyricism he also espoused, and the romance and melancholy he found in nature seemed embodied in their work as well. Their success and popularity must also have given him confidence in a poetic approach to his subject matter. The effect these painters had on Wyeth can perhaps best be seen in his skies and misty atmospheres, in his muted tones, in rather thick layering of paint, and in glazing, all of which became common in his landscapes and illustrations by 1907. Such features are apparent in several western illustrations about 1908 and in some of his 1911 illustrations for *Treasure Island.* He made increasing use of light and shade, and while the specific techniques of the tonalists gradually disappeared from his work over approximately two decades, he never forgot that subtleties of light and shadow could produce dramatic effects.

Other influences rapidly assaulted him in his first decade of continuous work. While he constantly talked and wrote about Rembrandt, Constable, and Millet, there were living artists he came to know who immediately impressed him, often through the impact of their personalities as much as through their art. He saw Gari Melchers's work in Philadelphia in 1907 and thought it "wonderful" and challenging, and soon he came to know Melchers personally. He was close to William V. Cahill, another former Pyle student who had an especially strong influence and often shared with Wyeth his views about landscape painting.[30] Wyeth called William Paxton, whom he met on a visit to Massachusetts in 1913, "an inspiring friend," and he remarked that he would have liked to study with the Boston painters Edmund Tarbell and Frank Benson. He also admired impressionists Childe Hassam, John Twachtman, and J. Alden Weir.

Such influences naturally led Wyeth to try impressionist techniques. By 1909, he began to produce work that may be called impressionist because it shows more concern with pure color than with tone, and indeed, because it reflects the style of some well-known impressionists. Of course, in 1909 there was nothing radical about adopting such methods, and Wyeth made no grand announcements about a change of

style. But his letters show a growing interest in the precise techniques of American impressionist painters. The impasto and coloration in much of Wyeth's work for nearly two decades seem to owe much to Hassam, and perhaps to Weir. Certainly he owed much to Segantini, the Italian impressionist who had interested Pyle. Segantini applied brilliant color full strength in heavy brush strokes, building his paintings in an extremely painstaking manner.[31] In trying such techniques, Wyeth said, "I have heightened the brilliancy of my pictures 50%."[32] He was also thrilled by the subject matter and particularly by the moods of Segantini's work. Andrew Wyeth believes that his father's natural exuberance often made detail unimportant to him and that impressionism was "a natural direction for him to go."[33] Both the broad slash of paint and the heavy impasto are responses to his enthusiasm.

A number of American impressionists he came to know well have been collectively labeled "the New Hope Group." He was bound to feel an affinity, if for no other reasons than that they stressed plein-air work and usually painted rural Pennsylvania countryside. For a time he exchanged visits with them almost regularly, especially with Daniel Garber, whom he liked very much, and who, it may be argued, had some effect on his art. (Garber had also done illustration and they shared publishers.)

As for many other Americans, the 1913 Armory Show in New York was a major experience for Wyeth. While he did not care for much of the radical art exhibited, the event appears to have affected the design and coloration of his work, making him bolder about both. It also must have helped prepare him for other influences. About this time, he became acquainted with the well-known critic Christian Brinton, a champion of contemporary art, who lived only a few miles north of Chadds Ford. For the rest of his life, Brinton was a frequent visitor to the Wyeth house. He was of major importance to Wyeth because he urged the artist to eschew illustration and look to other painting. Wyeth was especially susceptible to the scholarly Brinton, who compounded his dissatisfaction by showing him European publications with superior reproductions. Exactly what Brinton showed Wyeth over several decades is not known, but it included Russian modernist paintings, of which Brinton amassed a

N. C. WYETH *"Ben Gunn"* 1911 (11)

N. C. WYETH *"The Black Spot"* *1911* (12)

N. C. WYETH
"The Siege of the Round-House" 1913 (25)

N. C. WYETH
"On the Island of Earraid" 1913 (24)

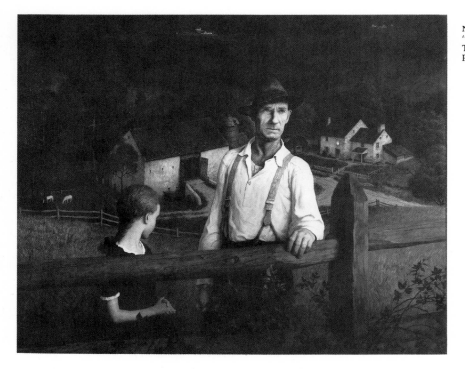

N. C. WYETH
"Nightfall," 1945
Tempera on panel, 39 x 31 inches (99 x 78.7 cm)
Private Collection

N. C. WYETH
"Island Funeral," 1939
Tempera on panel, 47½ x 55¼ inches (120.7 x 140.3 cm)
The Hotel du Pont Collection of American Art

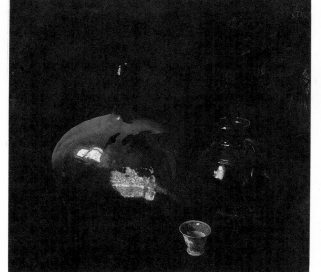

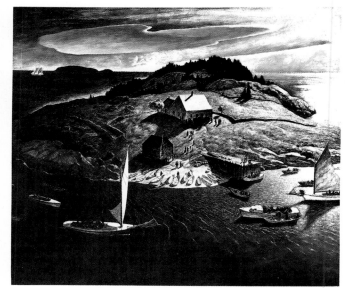

N. C. WYETH
"Dusty Bottle," 1924
Oil on canvas, 37 x 39⅞ inches (94 x 101.3 cm)
Collection of the Brandywine River Museum.
Gift of Mary M.R. Phelps

large personal collection. He aroused Wyeth's interest in modernism and prompted him to travel to see more of such work.

In the 1930s Wyeth's work began to change greatly, and it was during this decade that he most clearly showed his interest in postimpressionism and modernism. He had on occasion used thin paint surfaces, but in the 1930s his oil became extremely thin in response to these new influences. By the late 1930s, his son-in-law and former student, Peter Hurd, was experimenting in New Mexico with the egg tempera medium. With great enthusiasm, Hurd brought his tempera techniques to Chadds Ford. After a time, Wyeth welcomed this new way of working, and the thin paint of his recent work made it easy for him to utilize tempera. He had begun to use panels for oil paintings, and, of course, panels were essential to the tempera technique. Late landscapes such as "Island Funeral" and "Nightfall" were painted in tempera. Many of these late works seem to show his awareness of American regionalism of the same period, the works of Thomas Hart Benton, John Steuart Curry, Grant Wood, and others. The designs show some similarities to Benton, and occasional panoramic perspectives recall Wood. Aside from his illustrations (which were still painted in oil), such temperas were the work of his last six or seven years.

Wyeth reflected his study of other artists directly in his own work. Occasionally he based illustrations on images from George de Forest Brush, Rufus Zogbaum, or Pyle, although N.C. gave his own twist to such rare borrowings. Among the easel paintings there are portraits that clearly reflect Sorolla's bravura technique, landscapes that owe their impasto to Segantini, and still lifes that show obvious postimpressionist influences. He moved through rather distinct periods: most of the work, including illustrations, would reflect an interest in one particular style, and then he would move on quickly to another style, changing the elements of his technique as necessary. His diversity, and his success in all the styles he used, is extraordinary. But he did not alter his work to accommodate trends; he knew what he did not like. He found that "modern art critics and their supine followers *like* the flat and the shallow. They like it as they like soft drinks and factory-made bread." He believed that "depth of style can only spring from a deepening of our emotional life."[34]

Through all the stylistic developments, his finest works were his illustrations. From the beginning, they were executed on a large scale that is surprising to those who know his work only through reproductions. As a group they are stronger paintings than his other work and demonstrate the techniques he employed most successfully. The illustrations were not used for experimentation, and in the early years his keen interest in landscape benefited them. In the first two decades, at least, he put his greatest efforts into illustration and concentrated his imaginative powers in giving unique form to the various worlds for which he is best known. While the action and characters depicted in these illustrations are based on his reading of texts, the details of both background and foreground are derived from personal experience. In "Old Pew" (page 102), for example— one of the most famous images in American illustration— the Admiral Benbow Inn behind the dramatic figure is based on his own home in Needham. The landscapes, woodlands, and buildings of Needham, Chadds Ford, and, much later, the Maine coast provided elements for illustrations.

N.C.'s most important commission came from Charles Scribner's Sons for the 1911 edition of Robert Louis Stevenson's *Treasure Island* (pages 24, 25, 98, 100, 101, 102, 103, 105). The seventeen paintings he produced for this classic are often viewed as his finest group for a single publication. Indeed, while working on them, he remarked on the "feeling of real encouragement at the turn my work has taken just at the moment when one would expect the spirit of practicality and commercialism to prevail."[35] These are extremely painterly works. The designs, details, sense of scale, use of light and shadow, brushwork, and figures in motion all show him at his most masterful. Certainly, it is the quality of these memorable images, like "Old Pew," that has kept this edition of the popular adventure story in print for decades, published around the world, and reissued as recently as 1981 with new color plates made from the original paintings. Seen alone on a museum wall, these works are enormously dramatic. In the context of the novel, they may compete with Stevenson's narrative for attention, yet make ideal illustrations because they are excellent foils to that text.

Two years later, in 1913, Scribner's published Stevenson's *Kidnapped*

with Wyeth's illustrations. The artist said that in this series, in works such as "The Wreck of the 'Covenant,' " "The Siege of the Round-House," "On the Island of Earraid" (pages 99, 26, 27), and the very fine "The Torrent in the Valley of Glencoe" (page 107), he wanted to improve on the work he did for *Treasure Island.* In any case, the paintings are among Wyeth's best. The color and brushwork are very similar to those used for the 1911 series, although later he seems to have consciously altered his style from book to book, so that almost every series appears unique in its technical aspects and even in its mood. Those familiar with N.C.'s career can often associate a painting they have not seen before with a specific book.

The enormous success of the collaboration with Scribner's led to a great many commissions. From 1911 through 1939, Wyeth's name appeared on the title pages of many popular novels and classics read by generations of Americans, ranging from several more works by Stevenson to *The Last of the Mohicans* by James Fenimore Cooper (1919) to Marjorie Kinnan Rawlings's *The Yearling* (1939), a varied group for which he provided hundreds of images.[36] Some of his most beautiful work illustrated Mary Johnston's Civil War novels *The Long Roll* and *Cease Firing,* and he once called "The Vedette" (page 20), from the former, his best painting. He also illustrated anthologies, magazine articles, and short stories, and sometimes did dust jackets or covers. Occasionally he did book illustrations in pen and ink.

Scribner's was a major source of commissions, but he worked for many other publishers and was offered more work than he could accept. He was able to choose his texts and to demand good prices. Indeed, he built his house and studio in Chadds Ford with the proceeds from *Treasure Island.* Both house and studio were precisely what he wanted in living and working spaces, and as his family grew, he built additions. A large addition to the studio allowed him to stretch canvas for murals as much as fifteen feet high and thirty feet long.

The murals make a fascinating separate study within his career. From 1911 and the Indian murals for the Utica Hotel until his death in 1945, he worked in large format on a wide variety of subjects. William Price, architect of the Traymore Hotel in Atlantic City, New Jersey, asked him to do a series for the hotel's Submarine Grille. These murals, from 1915, depicted mermaids and fantastic sea creatures and were intended to make patrons feel they were under the sea. He did historical murals for public buildings and private concerns in many American cities, among them five murals showing explorers of the New World for what was then the National Geographic Society headquarters in Washington, D.C. For a number of years before his death he was busy with his most extensive series, those devoted to the Pilgrim experience at Plymouth. They were commissioned by the Metropolitan Life Insurance Company for their headquarters in New York City and can be seen there.[37]

Along with the book and magazine illustrations and the murals, he did poster work and advertisements for corporations ranging from the American Telephone and Telegraph Company to Coca-Cola. (Many Americans will remember his work for Cream of Wheat, especially the image of the mail carrier on horseback in "Where the Mail Goes Cream of Wheat Goes"; page 13.)

During all of this production, he never ceased making easel paintings: landscapes to which he always wanted to devote more time; still lifes, almost always of oversize objects, that seem to be rehearsals of various techniques; and portraits of family members and friends. He also found time for a full social schedule. He frequently traveled to see exhibitions or on business, vacationed with his family, and spent as much time as possible with other artists, writers as well as painters. Throughout the 1920s and 1930s, the Wyeth house on its hill overlooking the village of Chadds Ford and the Brandywine River was the scene of frequent visits by well-known literary people, among them the F. Scott Fitzgeralds, Joseph Hergesheimer, and Paul Horgan. He built a tennis court for such company and enjoyed those times with them.

By the early 1930s he had completed renovation of an old captain's house that looks to sea from a beautiful neck of land in Port Clyde, Maine. There he spent summers with his entire family, becoming increasingly familiar with the Maine coast and the customs of people whose lives depend on the sea. His landscapes and seascapes from later years demonstrate this familiarity.

N. C. WYETH *"They fought with him on foot more than three hours . . ."* 1917 (34)

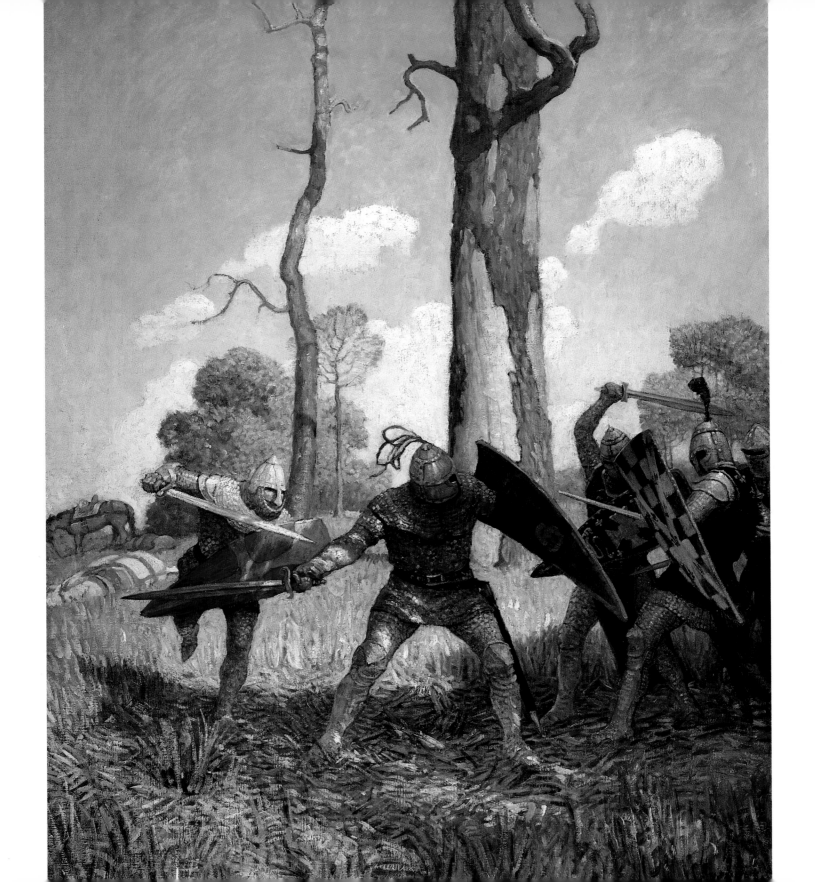

N. C. Wyeth, c. 1940–1945
Photograph by William E. Phelps

N. C. Wyeth, c. 1940–1945

Andrew and N.C. on Cannibal Shore, Maine, c. 1936

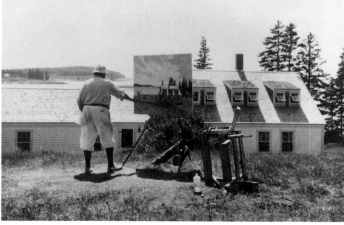

N.C. Wyeth painting at "Eight Bells," his summer home at Port Clyde, Maine, 1936
Photograph by William E. Phelps

For many years, he had resisted the strong urgings of Christian Brinton, his New Hope friends, and others to find a dealer and exhibit his work. He had always said his work was not ready for exposure in galleries or museums. But from 1930 through 1943, he participated in contemporary exhibitions at the Corcoran Gallery of Art, and his work appeared at the Toledo Museum of Art, at the Baltimore Museum of Art, and in the Carnegie Institute's exhibitions of American art in the 1940s. In December of 1939 he finally had a one-man exhibition, showing his Maine paintings at Macbeth Gallery in New York. He was elected to the National Academy in 1941 and appeared in its annual exhibitions from 1940 on.

How could he have had time in his career of forty-three years to do so much? It is not generally known that he produced thousands of works of art, most of considerable complexity, so the question becomes critical. The answer appears too simple: he was an extremely rapid painter and proud of that speed. A very successful still life from 1924, "Dusty Bottle" (page 28), for example, is a typically large canvas whose central feature is a bottle covered with gray dust and reflecting bright light; in the upper right corner he scratched in wet paint his initials and the notation "3 HRS."

What is more difficult to understand than the amount of work he produced or the speed with which he produced it is the technical achievement, the enormous variation in style from painting to painting, from year to year, indeed, from day to day. His styles sometimes seem as varied as his subjects. He valued technique highly and painted on canvases and panels far larger than any publisher would have required. The scale reflects the large physical stature of the man and his energy.

Even so, he always cherished the most minute things in his path, his country life, his American inheritance and sense of romance. It is all there in his paintings, in the subjects he chose to illustrate, in the art that is so distinctly his. It is clearly reflected in his work, as are the influences of a lifetime: the painters noted here; writers and poets he often mentioned, including Thoreau (whom he painted), Keats, Tolstoy, Dickinson, Whitman, and Frost; and composers such as Bach,

Beethoven, Sibelius, Stravinsky, and Berg. He was nourished by the poetry and music he loved.

His sudden accidental death in 1945 had a profound effect on his family. That event, as well as his art, did much to shape the artists of the next two generations of Wyeths in Chadds Ford.

IV

N. C. and Carolyn Wyeth had five talented children. Henriette, the eldest, is a well-known painter of portraits and still lifes. She paints in New Mexico and for decades did so beside her husband, Peter Hurd, who had come to Chadds Ford to study with her father. Carolyn, the second child, is a painter whose bold, distinctive work dwells on objects and places with strong relationships to her family. Nathaniel, the next born, became an extremely talented engineer whose inventions have affected contemporary life throughout the world. Ann, who married her father's student John W. McCoy, showed from youth fine musical ability and is a composer. Andrew was the last born.

To each of his children N. C. Wyeth was extremely attentive, and he provided them with all possible opportunities to pursue their interests. He also provided them with a remarkable and unforgettable example of vibrant energy, disciplined ability, and love of life. The family read together, played in forest and stream, took frequent walks, and celebrated their closeness to nature. Pageantry and costumes from the illustrator's collection made Christmas (with N.C. as Santa Claus) and Halloween memorable. There were always fireworks on the Fourth of July. N.C. brought romance and adventure to life for his children.

When his youngest child was born on Thoreau's one hundredth birthday, July 12, 1917, N. C. Wyeth found the coincidence exciting and meaningful. His devotion to Thoreau and nature was to affect his approach to Andrew's development. Father and son had in common some of the most important elements that shaped their art: a love for details of the rural landscape, a sense of romance, a strongly felt heritage, admiration for certain other artists and writers, innate artistic ability,

and deep concern with technique. N. C. Wyeth has been an enormous influence on Andrew in many ways.

Yet Andrew Wyeth treats his subjects very differently. Even his media are not those N.C. regularly used. Except in his early work, the younger artist has had nothing to do with illustration and has striven to reflect in unique images the land and people he has known— to do what his father wanted to do with his own private painting: to develop a distinctly American response to the subjects in which his life has been immersed. In 1943, the father wrote about the son: "He is carrying now, in such full stride forward, the fundamental study and discipline I *should* have followed."[38]

Andrew's opportunities came early; his talent was visible from a very young age. As a boy, he drew constantly and delighted his father with his developing ability and imagination. Once, as a young teenager, he built a miniature theater and made cut-out figures to perform for him on strings. The play presented to his parents was adapted from *The White Company* by Arthur Conan Doyle, a book his father had illustrated. Andrew prepared the dialogue and played a Bach record as background. At the end of that evening's entertainment, N.C. announced that his son would begin regular work in the studio. There followed the only art lessons Andrew has had.

"It was tough for me to have to buckle down and just draw casts," he recalls, but his father insisted that he pursue the fundamentals of drawing before beginning to paint.[39] He made studies of basic shapes in charcoal and for years did pen and ink work. When Andrew was at last asked to choose his own subject, he selected an old flintlock. About the following years of his father's teaching he says, "I dictated what I wanted to do. I had no intent except to put down what I felt and saw in front of me. He helped me *simplify* things. He rarely talked about technique." But N.C. did criticize, much in the fashion of Howard Pyle, if less formally. That is, he made very brief but effective comments, letting the student work out his own solutions.

Andrew spent an extraordinary amount of time with his father and developed a personal relationship for which the word *close* is not

N.C. as Little John, c. 1904

Andrew and friends in Robin Hood costumes, c. 1930

Andrew in Civil War costume, c. 1936

James in crusader costume, c. 1955. Photograph by Betsy Wyeth

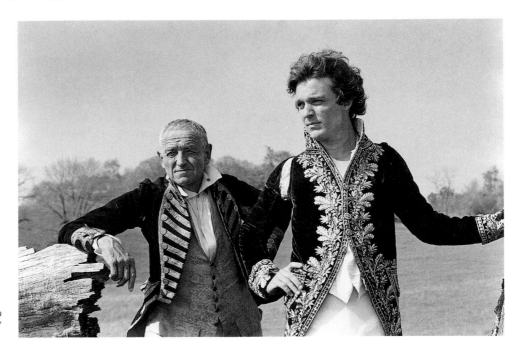

Andrew and James in uniforms, 1979
Photograph © Susan Gray

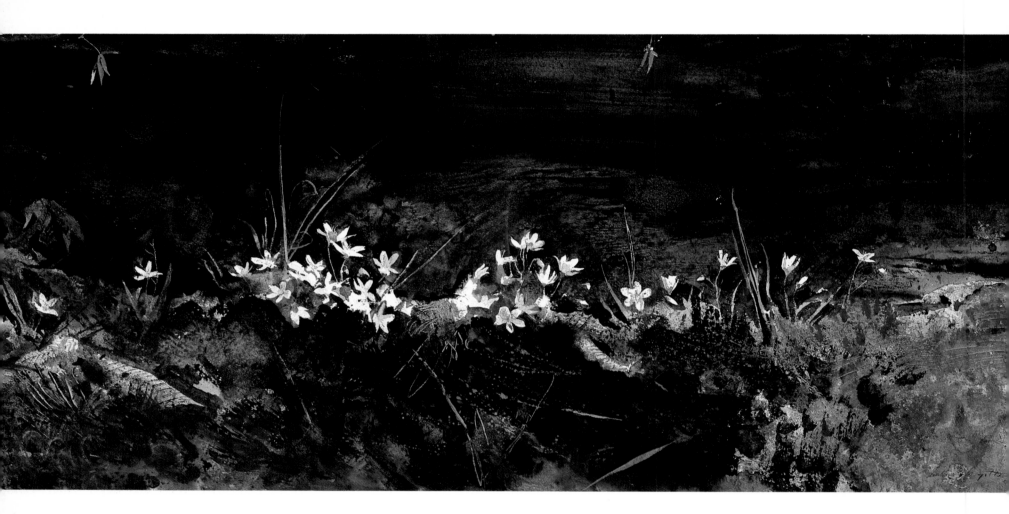

ANDREW WYETH *"May Day"* *1960* (46)

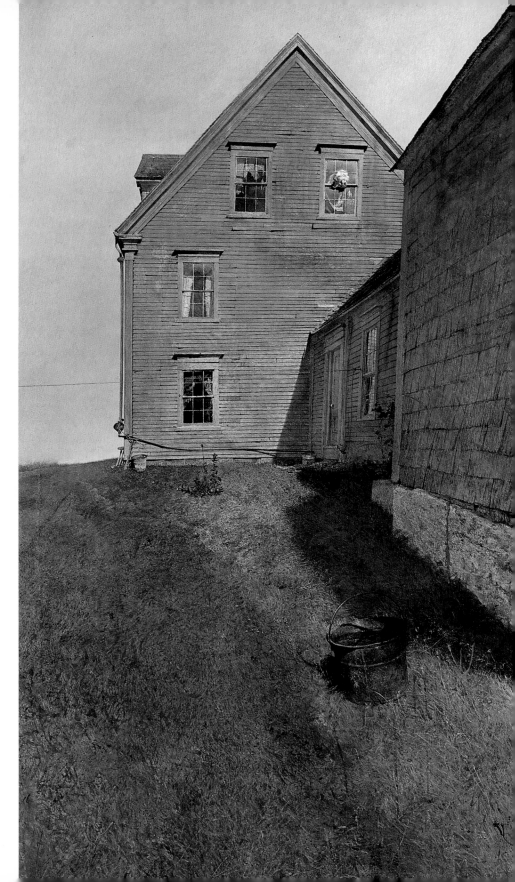

ANDREW WYETH *"Weather Side"* 1965 (52)

adequate. He was able to do so partly because he was not a healthy child. Because of illness, he was tutored and spent much of each day at home with his family or wandering alone through the Chadds Ford countryside. He had few young friends; his father was his greatest interest and closest companion.

Andrew Wyeth's draftsmanship has always been distinguished by its control, its sureness of line and fineness of detail, but also by a simplicity that refuses unnecessary flourish or detail. He brought this particular talent to watercolor work while still a student. His father supported him in this direction also; it is little known that N. C. Wyeth was a fine watercolorist, although he seldom worked in the medium. Even in the early watercolors, Andrew confidently exercised his precision of line, as well as the freedom of washes he had studied in other artists. His father also had him work for a time in oil, "but," he says simply, "that didn't work." Andrew Wyeth has never been comfortable with turpentine and canvas.

He became very comfortable, however, with the egg tempera medium that his brother-in-law Peter Hurd had introduced into the Chadds Ford studio in the late 1930s. Andrew wrote out Hurd's instructions for working with tempera, made his own gesso panels, and for a while applied the combination of ground mineral pigments, egg yolk, and distilled water with watercolor brushes as if he were simply working in watercolor on panel. Finally, he asked himself why he should go to so much trouble to achieve an effect like watercolor. He and Hurd visited the Philadelphia Museum of Art to examine early tempera paintings and to learn more about the medium. Eventually, by observation and experimentation, he developed desired effects through layering and cross-hatching tempera in a variety of ways. According to Wyeth, his study of Pyle's pen and ink technique (among other studies) aided this development. It took him about two years to begin to understand tempera, to see that it held possibilities that could make it a primary medium. He says, "I wanted something heavier than watercolor, a pure medium. I wanted something I could chew on for months at a time and pour myself into." Tempera became that thing, although it was the early 1940s before he produced major work with it.

Andrew Wyeth knows art history well. He is a constant student who can quote Delacroix's words or remember details of Renaissance paintings. He is extremely familiar with American art, from Copley to Franz Kline. Through the years of informal and formal study with his father, and occasionally beside other students such as Hurd and John McCoy, he was exposed to and influenced by many of the artists N.C. admired. Pyle, of course, and Constable were carefully studied. Millet and Segantini, he says, were strong early influences on his technique. His respect for Dürer and Homer is intense and absolute. What such artists painted and their responses to their subject matter were just as important as their techniques. However, about his sympathetic response to those subjects, Wyeth says, "I never wanted to copy other people's work, but they made me want to find the truth in nature they were expressing and to find my own."

Some of those truths were to be found in literature and music as well, and to these arts his father's introductions were also keys. Like N.C., he read Whitman and Thoreau. He has always valued Frost for his subject matter, his structure, and his "dryness," feeling a sympathy on many levels between his own art and Frost's. (Betsy Wyeth says of her husband, "His life *is* 'The Road Not Taken.' ") In music he has turned to Bach and Sibelius especially. His father loved films, and from an early age Andrew Wyeth has been a collector and careful observer of movies of many types. He views favorite films again and again, remembering the details of sets and particular action on them.

But such shared staples of life have evoked in Andrew Wyeth artistic responses far different from those of N.C. Even in early colorful and joyful watercolors this is apparent: Andrew avoids obvious drama and shows an economy of detail. He has stated what he must have come to believe early in his career, that "the great danger of the Pyle school is picture-making." This approach did not always win his father's understanding or approval. He recalls an instance:

I did a picture of a friend of mine in Maine walking across a field in the late fall towards a distant pine. It's a very clear fall morning, and he's striding through the grasses. They're pressed down where he's walking,

leaving a trail behind him. I was very pleased with it because it had an authority in the feeling of his striding with blond hair but only the back of his head showing. I showed it to my father. He said, "Andy, you've got to put a gun in that man's hand and you ought to have a dog going beside him." Well, I realized he missed the point of the picture, which was the silence of one of those fall mornings in Maine I'd seen so many times. Exactly the kind of thing my father loved, but he wanted a little drama in it. He said, "You'll never sell it."

But his work did sell. In 1936 he exhibited thirty watercolors at the Art Alliance in Philadelphia and the following year had a one-man show at Macbeth Gallery in New York. It sold out during the first day. In the next year came two watercolor shows in New York and Boston, along with an exhibition at the Currier Gallery of Art in Manchester, New Hampshire. His career had clearly begun; by his twentieth year he had established a firm reputation based on his distinct qualities, his extraordinary virtuosity with watercolor, and his unique responses to the Pennsylvania countryside and the Maine coast.

His palette is more limited than his father's, showing his preference for the tones of earth and cloudy days. His is a sparser world, where man does not fully embrace nature but must content himself with being user and observer. It is a world in which nature, however beautiful, can threaten discomfort and danger. This is the world of Andrew Wyeth that many viewers miss in claiming him as a recorder and defender of the picturesque and the quaint. This starker and very personal vision is distinctly a twentieth-century perspective. Surely it is affected by Wyeth's sense of isolation while growing up. Another possible origin has been suggested by Wanda Corn:

Andrew Wyeth belongs to the generation that grew up between the world wars. Born in 1917, his baby years were colored by reminiscences of the horrors and heroism of the First World War. He was a teenager during the great Depression. Just as he reached adulthood and maturity, the whole world was swept into another tragic war.

This bare chronology suggests that his was a generation brought up on the milk of harsh human realities. To be developing as an artist in the

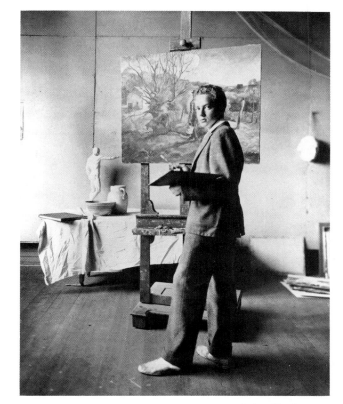

Andrew Wyeth, c. 1935

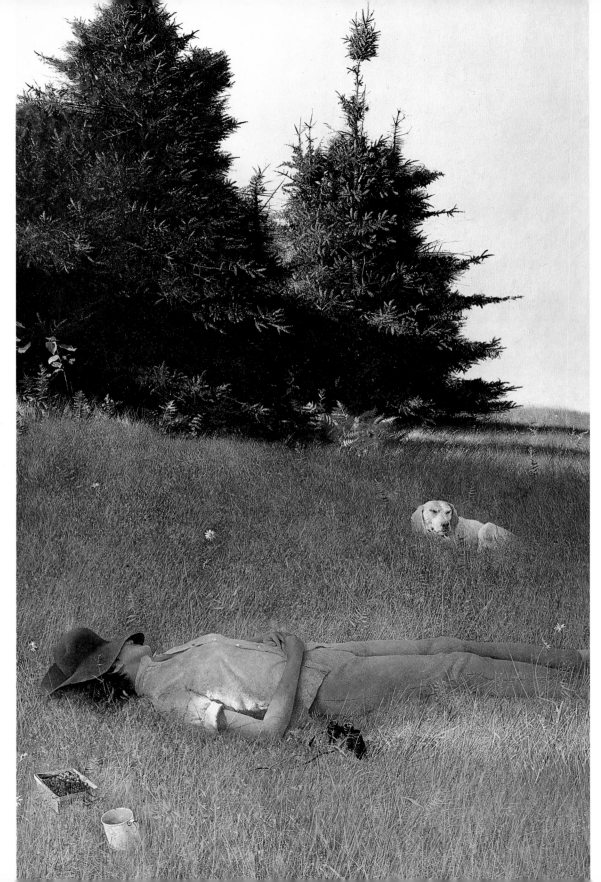

ANDREW WYETH *"Distant Thunder"* *1961* (48)

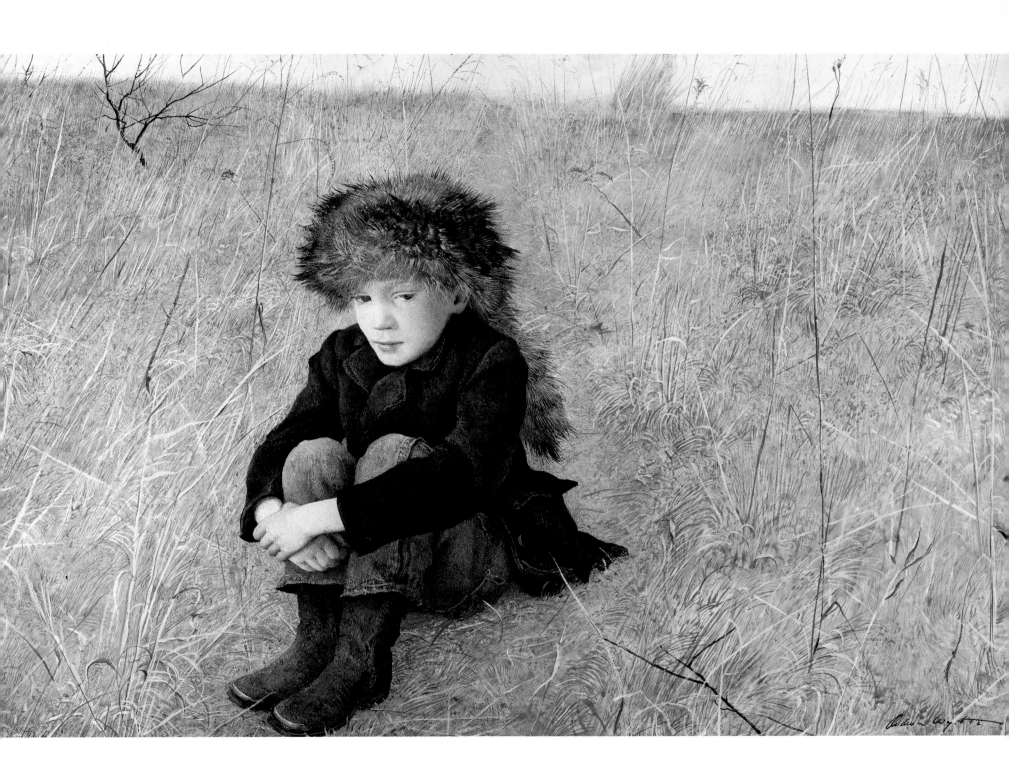

ANDREW WYETH *"Faraway"* 1952 (41)

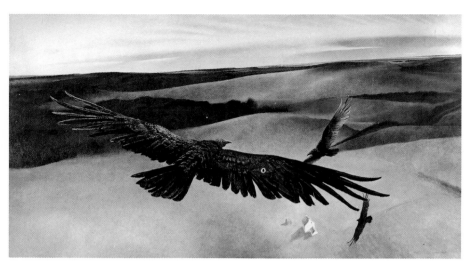

ANDREW WYETH
"Soaring," 1950
Tempera on panel, 48 x 87 inches (121.9 x 221 cm)
Shelburne Museum, Shelburne, Vermont

ANDREW WYETH
"Winter 1946"
Tempera on panel, 31⅛ x 48 inches (79.7 x 121.9 cm)
The North Carolina Museum of Art, Raleigh

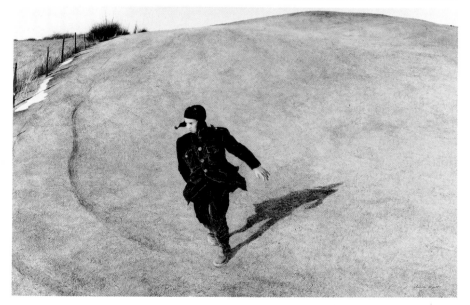

late 1930's and early 1940's meant coming of age in a time of bleakness. Things often seemed out of control; the future was terrifyingly uncertain; and the demonic side of man increasingly reigned around the world.[40]

Bleakness increasingly characterizes his painted world through the early 1940s. It is a beautiful world, surely, but often one in which man and his inventions must abide indifferent nature. Such a perspective is incompatible with the needs of commercial illustration. Wyeth made illustrations in one form or another from the age of twelve, and had accepted occasional commissions from magazine and book publishers in the early part of his career. Now it had become important to render subjects without the constraints of obvious narrative and to dwell entirely on self-generated concepts. In 1943 he abruptly ceased illustrating.

Shortly thereafter, in 1945, he confronted the sudden death of his father. The loss was as enormously significant to him as their close relationship had been. This was the major turning point in his life, an emotional event to be confronted through his art. It greatly changed his art. Now Andrew Wyeth needed "to prove that what he had started in me was not in vain— to do something serious and not play around with it, doing caricatures of nature."[41] As his father's memory dominated his thoughts, Andrew found him embodied in features of the country, and he painted those features as symbols of his father. His palette became far less colorful. The dark-toned tempera, "Winter 1946," is a direct response to his grief, and indeed, it evokes a sense of loss. In it a solitary boy runs down a hill, a hill he viewed as the embodiment of his father. A very personal iconography began to develop from this time, an iconography of hills, paths, windows, doorways — the details and shapes with which Andrew Wyeth has built his pictures and endowed them with meaning.

Many writers have called "commonplace" these things that are so important to the artist, but to him they are unique objects, and specific knowledge of them informs his art, directly and indirectly. Throughout his life he has walked the hills around Chadds Ford and the coast of the peninsulas of Port Clyde and Thomaston, Maine, observing everything

with an eye— and ear, because sounds also stimulate him— that (as his friends say) misses nothing. He has studied the history of those places so that he knows how the contemporary scene came to be; he knows what lies under the landscape, the bones of the houses, and the heritage of the people. He knows about the plants and cattle of Pennsylvania, the military and naval history of Pennsylvania and Maine. He knows all the history, but he does not paint history. Rather, he paints its remnants, the vestiges that affect the present. His eye and ear and the serious student in him were encouraged by his father. N.C. had believed that "a man can only paint that which he knows even more than intimately, he has got to know it spiritually. And to do that he has got to live around it, in it and be a part of it."[42]

Daily walks have always been part of Andrew Wyeth's artistic process; this solitary walker reflects his heritage. The walks have brought him together with the things he paints. To hear that he is fascinated with the minute is not surprising, but the way he approaches subjects can be. He says, "I love to lie on my stomach and study a flower or a dry grass. For 'May Day' [page 36], I was lying on my belly and I got ticks all over me, but I wanted the feeling of those spring things breaking. I wanted to be a part of it."

His walks took him to the Kuerner farm in Chadds Ford. He says, "As I grew up, my first memories were about World War I. And then I found this German soldier, a machine gunner, right here on a Chadds Ford farm. I was fascinated." The farm and its family reminded him of much in his own heritage, and he painted it for decades. It became one of the major places in the limited world the artist has prescribed for himself. The hill that represented his father in "Winter 1946" is a dominant shape on the Kuerner farm. (This now immensely symbolic hill appears in dozens of well-known works, among them "Spring Fed," "Wolf Moon," and "Spring"; pages 134, 53, 45.) Karl Kuerner even became something of a stand-in for his father. Thus, one must ask if Karl in the thawing snow of the surrealistic 1978 "Spring" is dead or being reborn under the waxing moon, and if this final painting of him is not the summary statement of the artist's experience at the Kuerners'. The startling portrait of Karl and Anna, "The Kuerners" (page 127), is

Andrew Wyeth's view of the long relationship of this immigrant couple. Because of his knowledge of Karl's military past, images from the artist's favorite film, Vidor's *The Big Parade*, have much influenced his paintings of the Kuerners. It appears that the forests of that film became the trees on the farm, and the shadows on its sets were transferred to the farmhouse.

He has deeply valued the opportunity to move among the Kuerners night and day as an observer. Wyeth has often said that he wants to melt into the walls of a place, to see without being seen so that he can see everything, to paint without self-consciousness on any side. Friends who are his subjects accept his seeming ubiquity, his comings and goings without need for knock or acknowledgment.

In Maine one summer, before she and Andrew were married in 1940, Betsy James took Wyeth to visit the Olsons. The artist's fascination with Christina Olson, her brother Alvaro, and their farm was immediate and endured for more than twenty years of summers in Maine as a parallel to the Kuerner experience. He has said, "The Olsons and Christina really were, to me, symbols of New England and Maine and ancient Maine, witchcraft, all sorts of things like that. That's what really got me into the Olsons' environment. I just couldn't stay away from there."[43] "Christina's World" (page 46), his most famous image, was painted there in 1948. The crippled woman strains to reach her house, which, through unusual perspective, is made to seem almost beyond reach. Like many of his paintings, this one grew out of an incident he observed. Other incidents at that farm by the sea inspired a large number of paintings that through more than two decades produced a rich record of these people and their lives. The endlessly fascinating portrait of their house, "Weather Side" (page 37), is an essential part of that record. It is not an architectural rendering, although nearly every detail is there, but an image of a decaying house that reflects the family that built it and persevered within it. No architect would have fashioned that perspective, and the building seems held on the panel only by the extraordinary and unlikely device of a taut clothesline.

Not long after his father's death, Wyeth fell ill with a serious lung

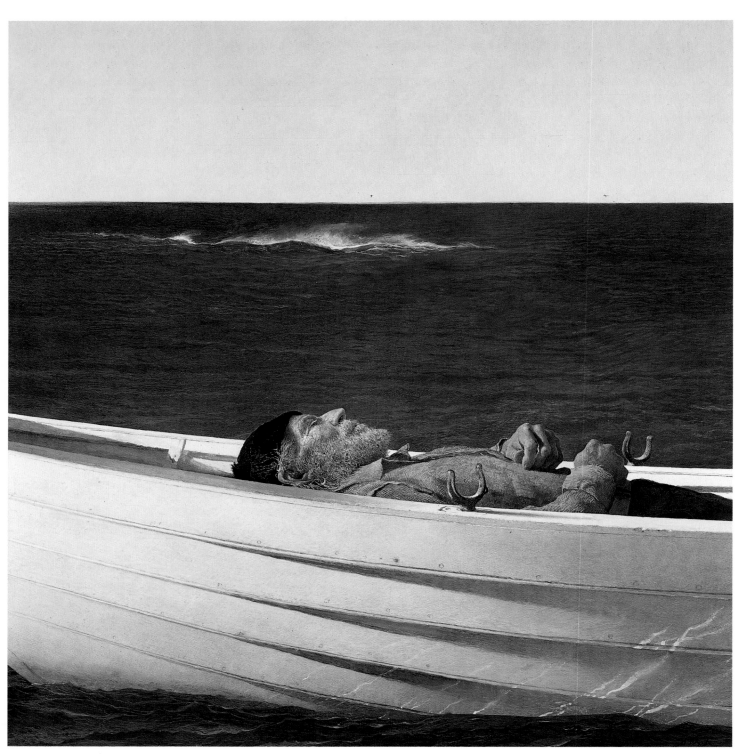

ANDREW WYETH
"Adrift" 1982 (68)

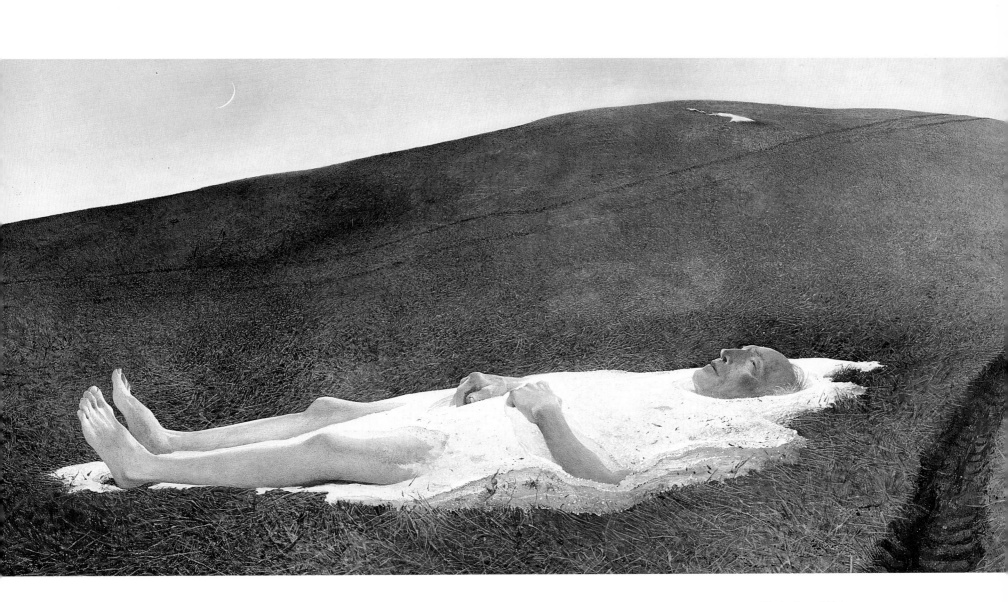

ANDREW WYETH *"Spring"* 1978 (62)

condition that required surgery and a prolonged recovery. This period
had profound importance for his art. It is not too far-fetched to character-
ize Andrew Wyeth as a "survivor" of that difficult time. The experience
altered his outlook and may explain why he has sought out other
survivors, such as Christina Olson, and chosen to paint almost exclu-
sively those who have endured a harsh existence through difficult
perseverance. These are strong (Wyeth would say "tough") people, alone
but not obviously lonely, who understand and take pride in their own
worth, abilities, and limitations. His self-portrait "Trodden Weed" (page
124) was intended to represent his survival of that serious illness and to
reflect on the repeatedly discovered fragility of life. The boots he wears
were Howard Pyle's boots, which he owns, and he had actually walked
more than one difficult mile in them to arrive at "Trodden Weed." Once
again, it is the Kuerners' hill over which he takes those shoes.

As his approach changed after his father's death, Wyeth began to tighten
his watercolor technique. The result was the drybrush method he used
for many well-known works, in which watercolor is applied with a
brush squeezed almost dry of moisture. It allows cross-hatching and
building textures as with tempera, but Wyeth varies the technique by
moving between dry and wet on the same piece of paper, achieving a
variety of complementary thick and thin surfaces. Once accused of
improperly using a medium designed to be thinly applied, he replied,
"It's not the medium that's thin, it's the people who use it." One of the
earliest notable successes with drybrush is "Faraway" (page 41), a 1952
portrait of his young son Jamie in a raccoon hat. Perhaps his finest work
in the medium is "Lovers" (page 141), where variant techniques appear;
in places he has even torn the paper to produce whites with textures that
catch the light in darkly painted areas. Andrew Wyeth has stretched the
watercolor medium, using it in entirely new and definitely bold ways.
He has said that he will try anything to get results.

Wyeth's world has encompassed a great many people and places in
Pennsylvania and Maine. The dwindling community of blacks he has
known well in Chadds Ford has provided compelling images such as
"The Drifter," "Garret Room," "Barracoon," and "Rag Bag" (pages 144,
142, 143, 153). The essence of that rural region is revealed in beautiful

Ralph Cline "The Patriot," Christina Olson, and Andrew Wyeth

ANDREW WYETH
"Christina's World," 1948
Tempera on gesso panel, 32¼ x 47¾ inches (81.9 x 121.3 cm)
Collection, The Museum of Modern Art, New York.

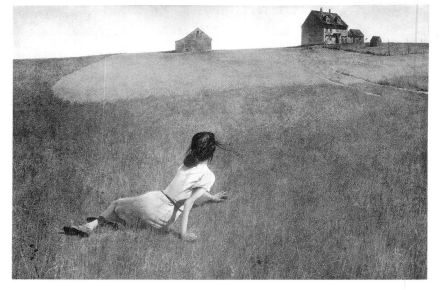

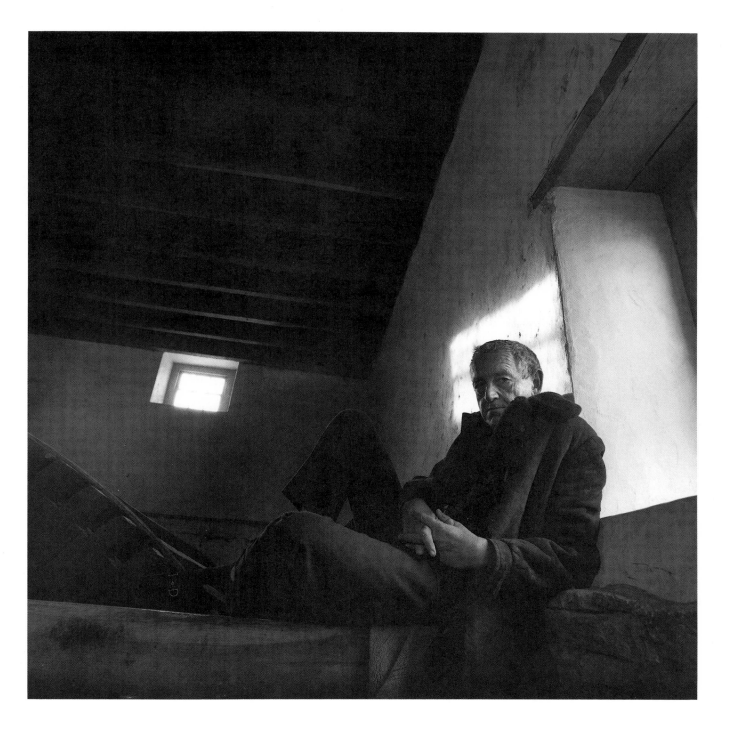

Andrew Wyeth in Brinton's Mill,
Chadds Ford, c. 1970
Photograph by Arnold Newman
Courtesy © Arnold Newman

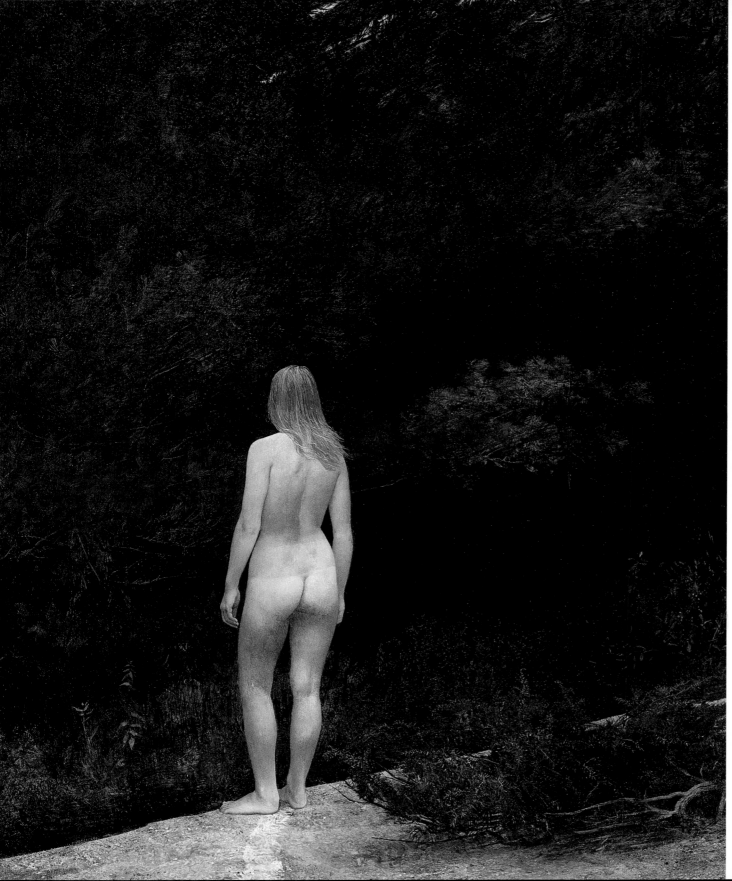

ANDREW WYETH *"Indian Summer"* 1970 (55)

48

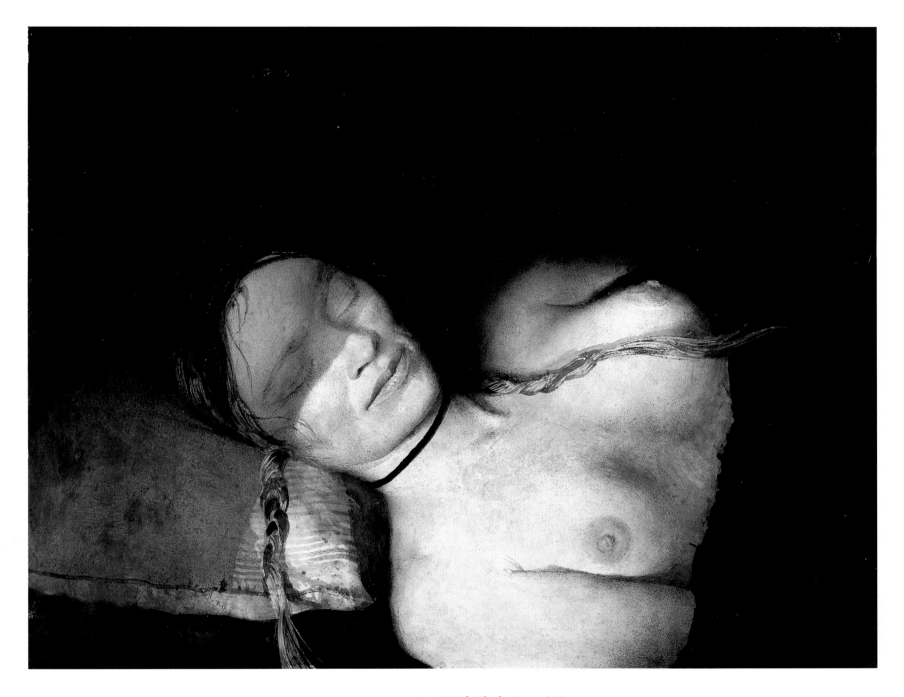

ANDREW WYETH *"Night Shadow"* 1979 (64)

Andrew and Saco at Chadds Ford, 1965

Andrew Wyeth
sketching
at Barnegat Light,
New Jersey, 1979
Photograph
by Richard Carr

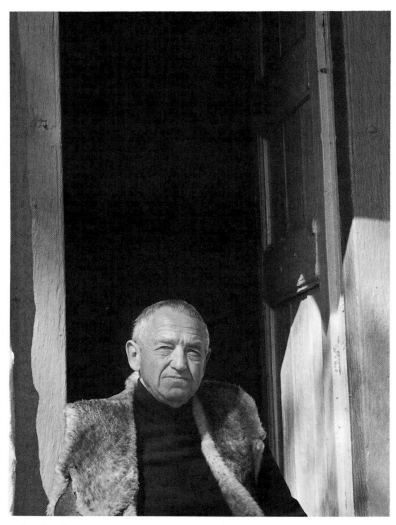

Andrew Wyeth, 1985
Photograph © Peter Ralston, 1985

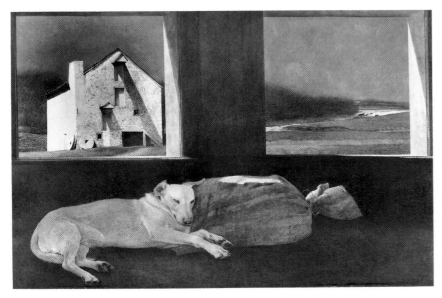

ANDREW WYETH
"Night Sleeper," 1979
Tempera on panel, 48 x 72 inches (121.9 x 182.9 cm)
Private Collection

and technically difficult achievements such as the famous image of isolation, the tempera "Roasted Chestnuts" (page 128), and the enormous and remarkable watercolor "Big Top" (page 131). That country is also mirrored in paintings of his own home. In 1958, the Wyeths purchased— and Betsy Wyeth restored— a group of eighteenth-century mill buildings that had long drawn Andrew's attention, a house, mill, and granary. "Night Sleeper" contains a formal portrait of this mill, which has appeared often in his work.

From Maine have come similarly important works, and there, too, Betsy Wyeth has played a key role. She has made quintessentially Maine buildings and their contents part of the artist's daily life there and has restored and made a home at the lighthouse at Southern Island, where Andrew has often painted. In Chadds Ford he has pursued the characteristic solid hills and stone buildings that seem to represent his father's strength as well as his mother's Pennsylvania German heritage; in Maine he looks to the strong light, the frame houses, and the equally ancient traditions of New England, the other side of the Wyeths' American experience. The human fabrications he finds posed on the Maine landscape appear less substantial, like the fog he paints so well. His summertime world is as beautiful as the watercolor "Spruce Grove" (page 125), but like winter in Chadds Ford, it demands recognition that nature has another side. "Distant Thunder" (page 40), the well-known tempera of his wife, offers escape into temporary peace and plenty, but it suggests that other side explicitly.

Wyeth's work has always attracted attention. From his first exhibition, he has been followed by curators, collectors, and dealers. One-man museum exhibitions and gallery shows have appeared throughout the United States and abroad.[44] Art historians have discussed and honored his extraordinary technique, penetrating insight, and unique perspectives. The permanent importance to American art of this regional painter has become clear, but just as clear in all this activity is the universal appeal that makes his regional implications appear secondary to his broader view of the human condition.

Many recent works will enlarge on such considerations. Andrew Wyeth

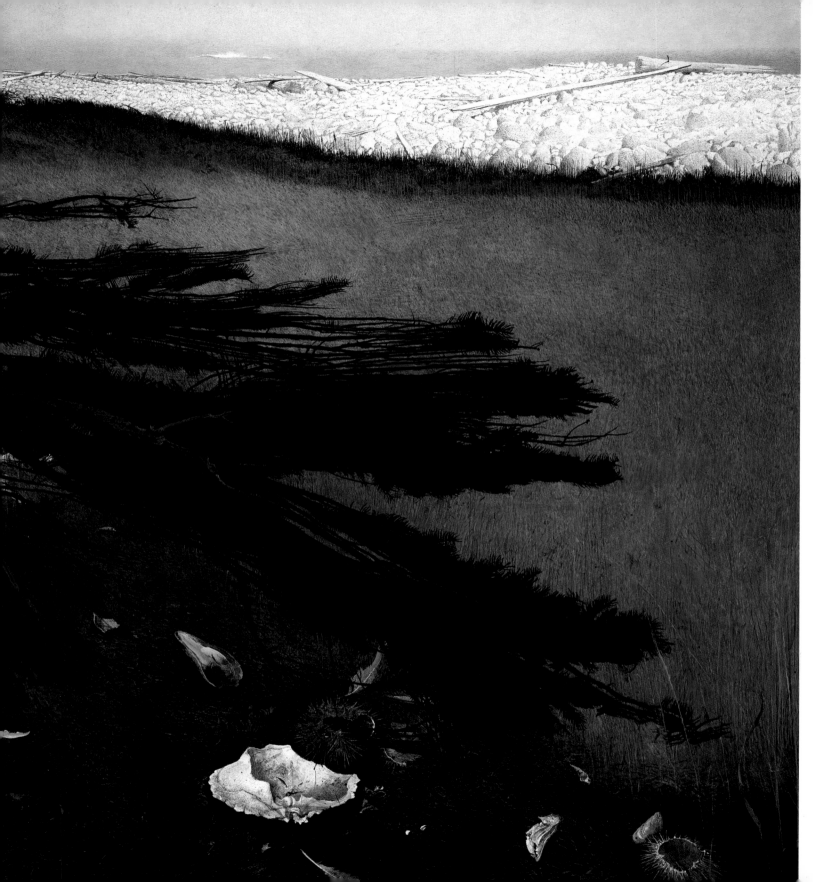

ANDREW WYETH
"Ravens Grove" 1985 (74)

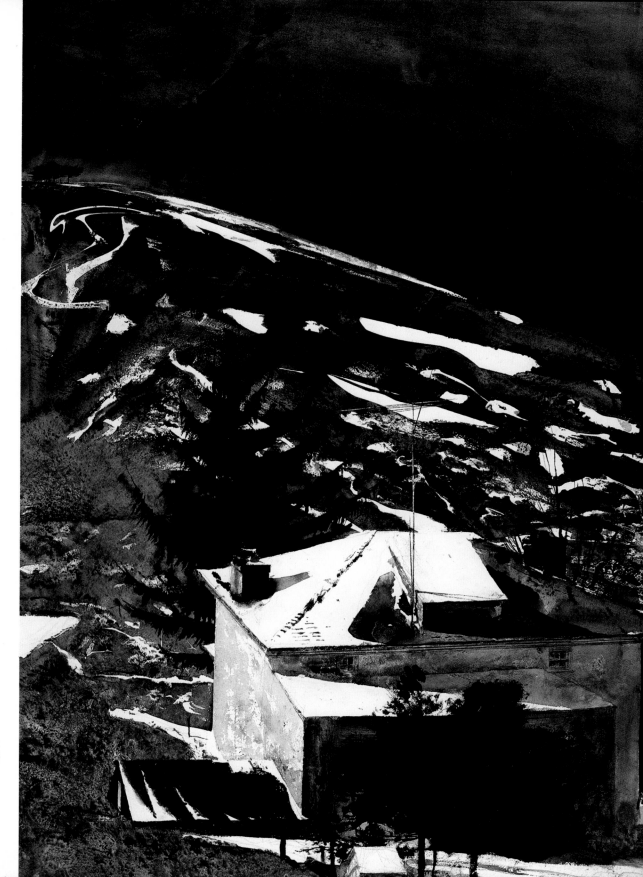

ANDREW WYETH
"Wolf Moon" 1975 (60)

53

James, Betsy, and Andrew Wyeth before Andrew's painting "Faraway"

Andrew and Betsy Wyeth, 1982
Photograph by Charles Isaacs

James Wyeth sketching, 1979
©Richard Farrell Photography, Monhegan Island, Maine

works constantly and constantly surprises his admirers by rarely repeating a perspective, by offering new subjects, and by steadily refining his techniques. In the late 1960s and early 1970s, he produced his first nudes, paintings of a young Finnish girl from Maine, Siri Erickson, who was tied into his experience with Christina Olson. The thought-provoking "Indian Summer" (page 48) is one of those paintings. And only recently he has revealed a large body of work, a unified collection that occupied him for more than a decade and is associated with the German elements in Chadds Ford. Some of his most beautiful paintings appear in this one group, technically fascinating works such as "Lovers" and "Night Shadow" (pages 141, 49). This group is unique because it contains so many images of one person, the model known as Helga.

For Andrew Wyeth, the thousands of images he has produced are part of a tight web of related experiences. The works are connected precisely because he has sought circumstances that lead from one to another. A sudden observation, an unexpected event in familiar territory appears related to a moment in his past and sparks the new work of art. He paints only subjects with which he is deeply involved, and to a large degree this explains his self-imposed geographical limitations. He cannot intimately know what is over the next hill and thus will not paint it. He has consciously developed a unique world that is solely his. A thread he has spun with great deliberation ties together Karl Kuerner, Christina Olson, Betsy Wyeth, and many others, ties together the places they inhabit, ties them to *his* vision of human existence. He makes art about man's place in the world. He is a humanist. Contrary to much contemporary art that removes man from consideration, his art puts man at the center, even when man is not in the picture.

How he does that is perhaps the most interesting study of all. To paint a brilliant portrait capturing such a distinctive character as the proud old soldier in "The Patriot" (page 146) is one obvious way. Another is the use of his particular iconography: paths and tire marks represent an outer world (and the artist) passing by (as in "Spring"; page 45); windows offer tantalizing views, but remind us that those pleasant visions are beyond our reach (as in "Spring Fed"; page 134); the whites of snow, wave, shell, and stone evoke death (as in "Adrift" or "Ravens Grove";

pages 44, 52). The melancholy we sometimes feel in his work certainly comes from these features. He describes himself as a romantic and says, "My father was a melancholy man, and I inherited that from him." Like his father, he very skillfully uses intense light to direct our attention. As Agnes Mongan writes, "It is this acutely observed and recorded angle of light that gives the sense of an exact moment of vibrating time."[45]

Our attention is further directed when he focuses with great detail on certain features and allows the remainder of a picture to resolve itself into mere suggestions of background elements. Very importantly, he seldom shows us precisely what sits before him. He is a representational artist, not a strict realist. He never paints an element twice with identical details. Often, as his preliminary drawings prove, he eliminates much detail in order to clarify forms. He says, "The shape comes first for me, then I fill in objects."

The strong patterns of "Wolf Moon" (page 53) make an enjoyable abstraction, even when the painting is seen upside down. And through dramatic forms, "Night Sleeper" (page 51) invites us into multiple worlds, a variety of Wyeth haunts. Houses and windows, hills and streams resolve themselves into identifiable shapes, compatible and harmonious, or incompatible and disturbing— as the artist chooses. Those shapes are his abstraction, the forms with which he builds a complex image. This very contemporary artist says, "Catching the essence of a landscape without making it into a picture is the *most* important thing to me."

V

The tradition continues. It is extraordinary that the talent with pencil, pen, and brush vested in N. C. and Andrew Wyeth should appear in the third generation. Andrew's son, James, has inherited that ability in full measure. Childhood drawings by father and son are strikingly similar and appear equally competent. The resemblances only begin there. A look at James Wyeth's life and work to date finds him firmly in the family tradition, but it reveals strengths that are uniquely his.

James has had a remarkable career, and although he is barely forty years

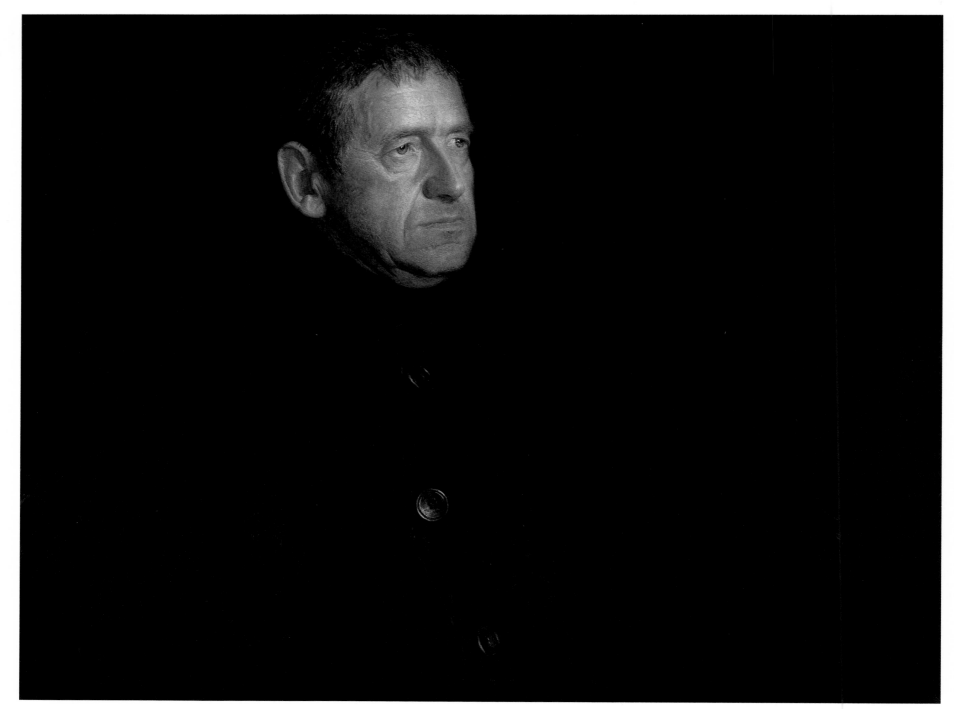

JAMES WYETH *"Portrait of Andrew Wyeth"* *1969* (86)

old, most of his life has been spent painting. Exhibitions of his work in museums and galleries have attracted enormous attention. His family name coupled with his own famous images make him news in the popular press as well as in the art world.

Yet his art and artistic process have always been intensely private. Like his father and grandfather, he is extremely personable, but also like them, his outward personality provides little immediate insight into his work. For him, too, art has meant constant, solitary work. And, as with them, the work began early.

He was born in Chadds Ford in 1946. His brother, Nicholas, now an art dealer, was the only other child, born nearly three years earlier. James, called "Jamie" from the beginning, was committed to art studies by age twelve through his own inclination and his parents' strong feeling that an obviously uncommon talent should be given the best opportunity for development. He attended public school for only six years, after which he was privately tutored in order that he could spend most of his day drawing. Dual schooling was fashioned for him much as it had been for Andrew, although in James's case it was not because of illness. The father's example proved valuable: the son's talent developed quickly.

An important difference, however, between the training of father and son is that James Wyeth never studied with his father in the manner that Andrew had with N.C. Rather, in 1958 he was sent for formal studies with his father's sister Carolyn in her studio within N.C.'s studio building. Carolyn Wyeth had learned her father's lessons well; like him, she emphasized the fundamentals of drawing; all her students had to work in charcoal, rendering basic shapes repeatedly until she was satisfied. About his two years of training with Carolyn, James has said, "She was very restrictive. It wasn't interesting, but it was important."[46] He saw Carolyn's own intense works in oil, as well as those of N.C. and other family members, about the studio and in the Wyeth houses, and, of course, he constantly saw his father's paintings at home. He saw Pyle's work in family and other collections, was exposed to the family's art books, went to exhibitions, and met the collectors and art historians in the family circle. He always wanted to paint.

James says that he became interested in oil because of the way Carolyn squeezed it onto her palette. "I could eat it. Tempera never looked particularly edible. You have to love a medium to work in it. I love the feel and smell of oil." And so oil, rather than his father's medium, tempera, became his primary interest.

He went at it on his own, turning to aunt and father for help and criticism as necessary, building his own technique. Because oil was his grandfather's medium, it is often assumed that James looked to N.C.'s technique to evolve his methods. He admires his grandfather intensely as a "masterful technician," but he says it is "the strength" of N.C.'s paintings and "his sense of total personal involvement with and intuitive grasp of his subjects" that James wants most to emulate. For oil technique, he looked first to Carolyn and then to Howard Pyle. Pyle has constantly fascinated him. The illustrator's compositions, the scale of his figures, his handling of oil (and ink), and the intensity of his imagination all delight James. Even now, he says he "loves the work sincerely" and frequently goes out of his way to look again and again at Pyle's work in museums and private collections. Pyle's influence has not waned through the Wyeth generations.

With watercolor, however, his father was an important source of advice from the beginning. Like Andrew, James has produced more work in watercolor than in opaque media. He began very early; "it was a natural thing to do, fooling around with color," he says. His early watercolors often remind us of his father's technique, although James's results are usually more colorful. His greens are often very bright, and there are strong blues and even striking oranges. James paints all four seasons in Pennsylvania.

By 1963, at seventeen, he could paint a portrait such as "Shorty" (page 163), which showed a perception far beyond what might be expected of anyone his age. He found Shorty in Chadds Ford, a man who lived in a simple hut and for twenty years had spoken only to a local storekeeper. Wyeth has conveyed much of that silent railroad worker's character in his portrait. The juxtaposition of the unshaven sitter and the elegant wing chair that envelops him is startling.

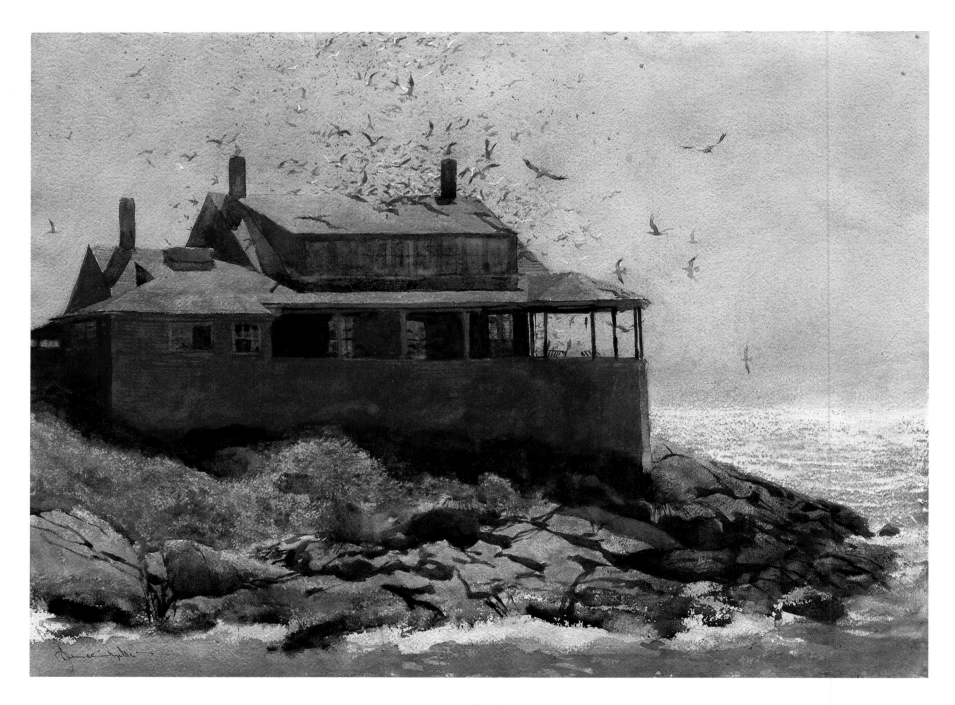

JAMES WYETH *"The Red House"* 1972 (92)

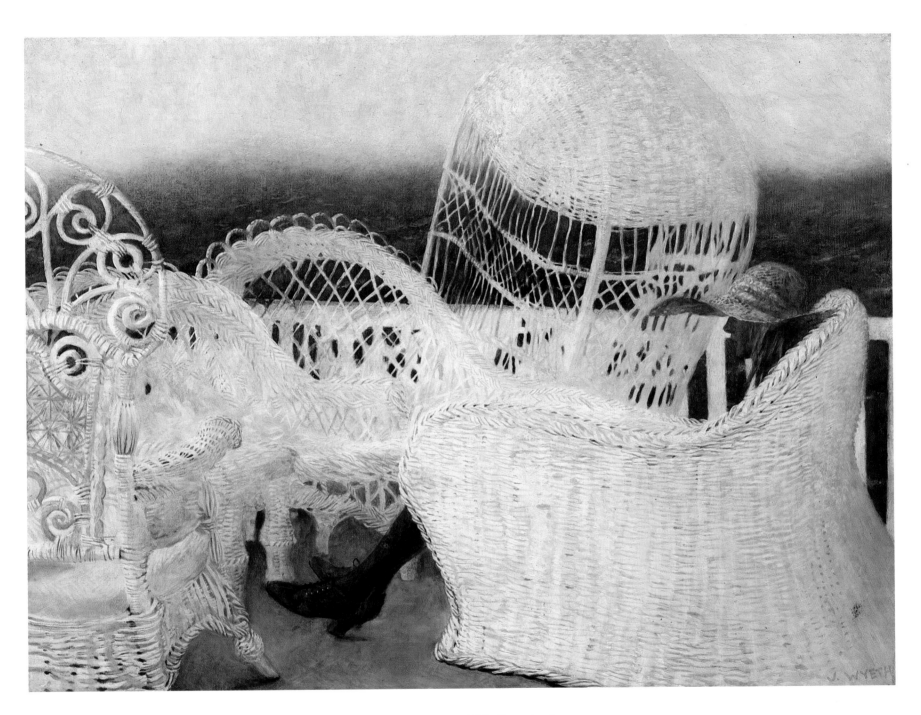

JAMES WYETH *"Wicker"* 1979 (103)

Indeed, such a contrast prefigures a major element in James Wyeth's art: consciously or unconsciously he often makes surprising juxtapositions. Sometimes they are humorous; sometimes they are seriously provocative. In fact, the humor can lead to disturbing thoughts of implied threats to the subjects, to the artist, or to the viewer. "All great humor has that side to it," he says. These humorous relationships suggest a keen sense of irony that the artist has used to illuminate his world.

Recognizing his need for a greater knowledge of the human form in order to paint it, James lived in New York for some months in 1965 in order to study anatomy in a hospital morgue. The city provided him a classical education, both artistically and socially. New York has been an important place to him ever since, and he has painted some of its most interesting citizens.

His involvement in the public events of his times is visible in one of his most famous images, "Draft Age" (page 164). This oil on canvas painted in 1965 is his personal commentary on the era of the Vietnam War. For a portrait, James says that he often spends 200 hours or more, observing and drawing, as well as painting. For "Draft Age" some of those hours must certainly have been spent considering the implications of the subject, the young rebel (the model was a friend who might well be described that way) who flouts the values of society but who might be called upon to fight, perhaps against his will, to preserve those values. This painting provokes strong reactions that depend on each viewer's experience with individuals like the sitter. Whatever else he conveys, this young man in the black leather jacket clearly conveys pride, as do nearly all of James Wyeth's sitters. The artist mastered his subject, both the portrait and the painting's larger implications. He had also mastered the medium; "Draft Age" is an extraordinary technical achievement for a nineteen-year-old painter.

James Wyeth is widely considered a major portraitist, and he has earned the distinction. He has never painted for mere likeness, although his representation of sitters is remarkable. He has always portrayed dimensions of personality in portraits, qualities for which he chose his subjects, telling something about them that they might not reveal them-selves. Like "Shorty" and "Draft Age," other portraits from early in his career demonstrate this ability: "Jeffrey" (1966; page 165), "Lincoln Kirstein" (1967), "John F. Kennedy" (1967), and "Andrew Wyeth" (1969).

His "Portrait of Lincoln Kirstein" (page 167) was his first major painting of a well-known American. He had known Kirstein all his life as a friend of the Wyeth family, and he asked him to pose— although the challenge "mortified" him. The portrait, painted in New York, took hundreds of hours. Also in 1967, he finished one of his most famous images, the posthumous "Portrait of John F. Kennedy" (page 166). He had become acquainted with members of the Kennedy family who asked him to do the work. Both Robert and Edward Kennedy posed for him, and he studied photographs of the late president. The final work shows Kennedy in an unguarded pose characterized by unexpected eyes— this is a pensive president we did not know. In all of his portraits, James Wyeth concentrates on eyes to suggest character. His portrait of his father (page 56) shows a serious Andrew Wyeth, eyes determined and concentrated. It is not a public pose. For those who know the elder artist well, this painting is an important record.

Two portraits that have had much public attention are of other artists, Andy Warhol (pages 67, 173) and Rudolf Nureyev (page 66). They are artists of very different qualities, but Wyeth feels strong personal relationships with both. His depiction of pop artist Warhol is again an unexpected view, almost as if Warhol had been caught off guard without his public persona. Nureyev is an intense and strong image, even when seen in the preliminary mixed-media studies for the finished oil portrait. The painter says that Nureyev, with whom he has spent much time, "continues to fascinate me like no other subject." Wyeth likens him to an animal, and his portrait conveys that animal quality coupled with the physical strength that supports it. "Automaton" (page 172) is based on a detail of a relatively small eighteenth-century French clockwork toy he delights in; he rendered the face accurately, but made it appear in human scale because it reminds him of Nureyev in stage makeup.

"Pumpkinhead" (page 171) is James Wyeth's self-portrait. Much has been written in the popular press about this work, which is so unlike the

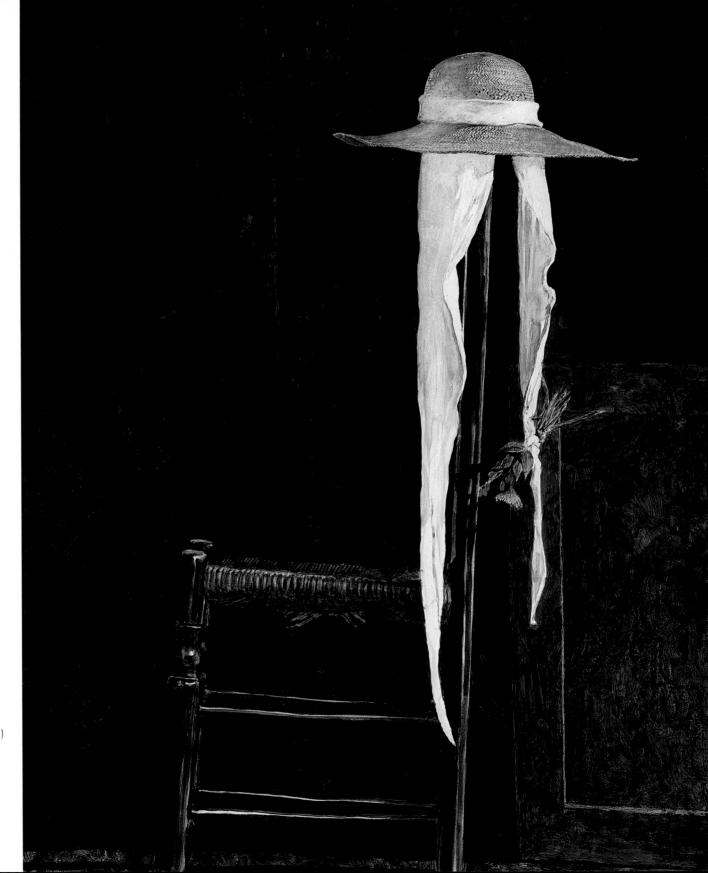

JAMES WYETH *"Wolfbane"* 1984 (113)

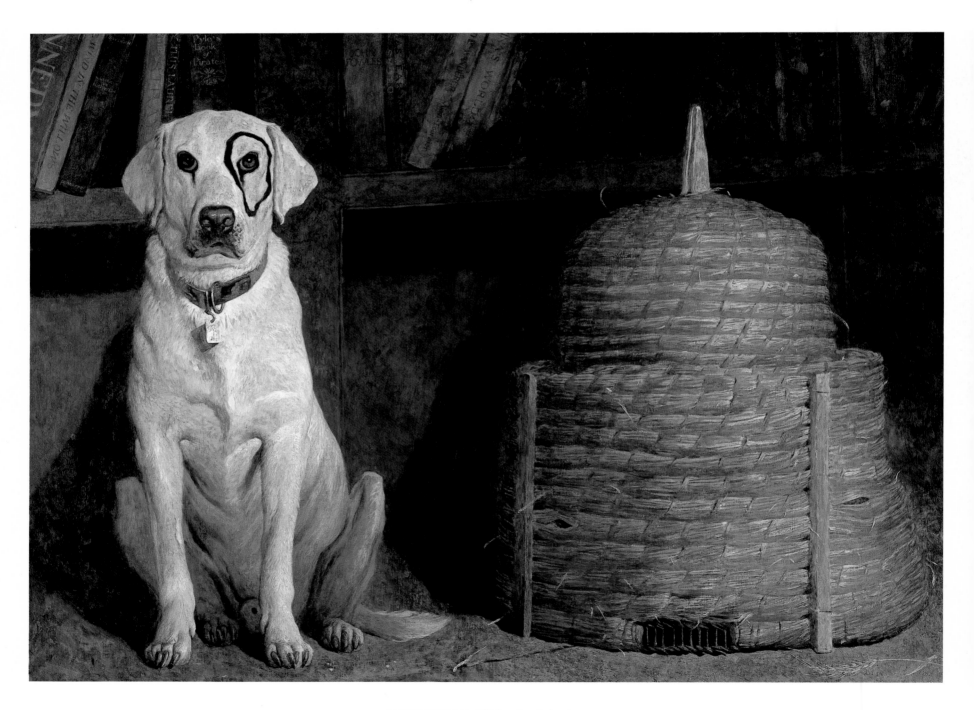

JAMES WYETH *"Kleberg"* 1984 (111)

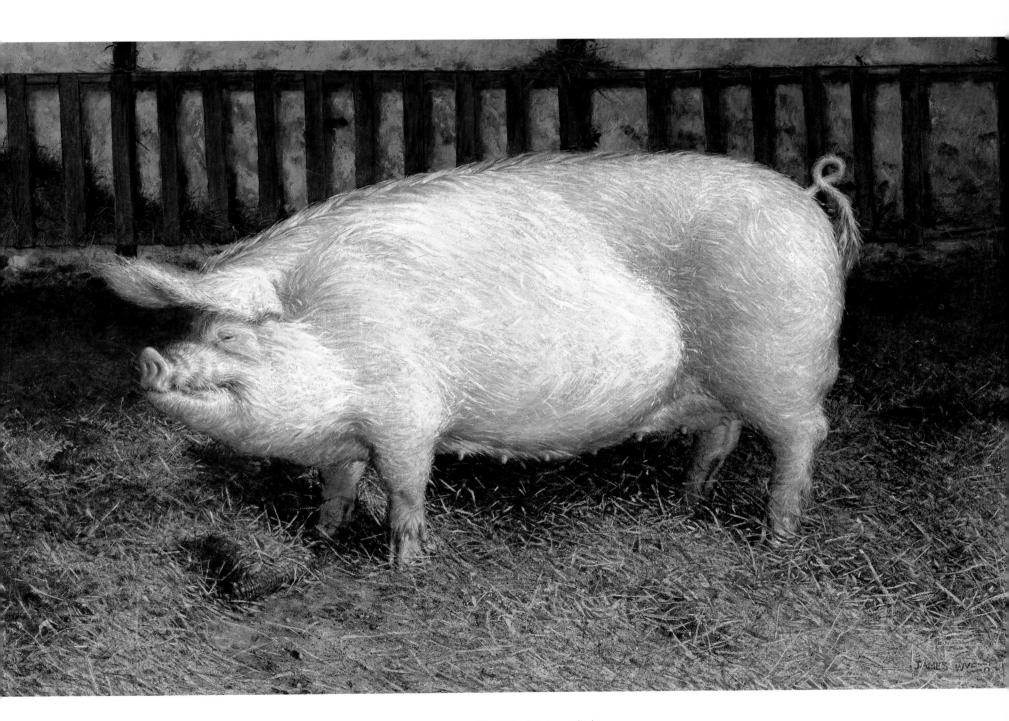

JAMES WYETH *"Portrait of Pig"* 1970 (87)

self-portraits of his grandfather and father. But here is the younger artist as he wants to be, that is, unseen but all-observing. (He is certainly like his father in this regard.) He describes the expression on his pumpkin's face as a sneer.

In 1968 the artist married one of his sitters, Phyllis Mills. She has posed for paintings ever since, appearing in such works as "And Then into the Deep Gorge," "Whale," and "Wicker" (pages 169, 168, 59). "Wolfbane" (page 61), showing only her hat on a chair, is very much a portrait. Phyllis Wyeth was crippled in an automobile accident and now moves with great effort and the help of crutches, but she is strong in every respect. Her husband says, "She is so incredibly determined. And there's something elusive. I'm constantly discovering new qualities, and that's what I love about her. Nothing is more *un*interesting than completely knowing somebody, being totally at ease. I've never been *totally* at ease with Phyllis in my life."[47] It is the depth of such personality and the challenge in it that brings James Wyeth to his subjects.

James Wyeth before his "Portrait of John F. Kennedy," 1968

The Wyeths live on a working farm along the Brandywine River, and thus the artist has at his doorstep the countryside that inspired his grandfather and with which his father is so intensely familiar. James has always wandered that landscape, and none of its details escapes him. He has used both woods and meadows— the natural landscape— for subjects. But more often he has used the farm, its buildings and animals. Animals have been subjects as important to him as people. Pigs, chickens, sheep, cattle, geese, and other animals have posed for paintings that must be called portraits because of their careful portrayal of individuals. In Maine, where he now owns the house on Monhegan Island built by Rockwell Kent, he finds the animals of the islands a particular interest. The sheep and gulls have especially captured his attention and repeatedly become his subjects.

Among his animal images, "Portrait of Pig" (page 63) is certainly the best known. It may well stand as an emblem of the others. This is surely the archetypal sow, shown in great detail, nearly life size, and in her element. But at the same time, this is an individual, a careful portrait based on as much study as any of the artist's human portraits. "I get as

James painting murals for Air Guard dance, c. 1969

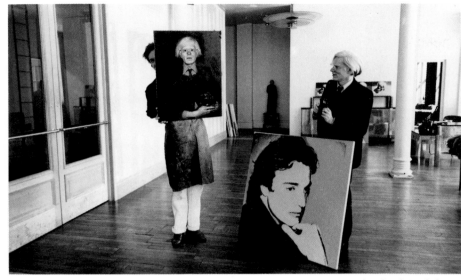

James Wyeth and Andy Warhol, 1976
Photograph by Stanley Tretick

James Wyeth, Lincoln Kirstein, and Andy Warhol, 1976
Photograph by Stanley Tretick

James and Phyllis Wyeth with Rudolf Nureyev, 1975
Photograph by Robin Platzer, Images

James at work on the portrait of Rudolf Nureyev, 1977

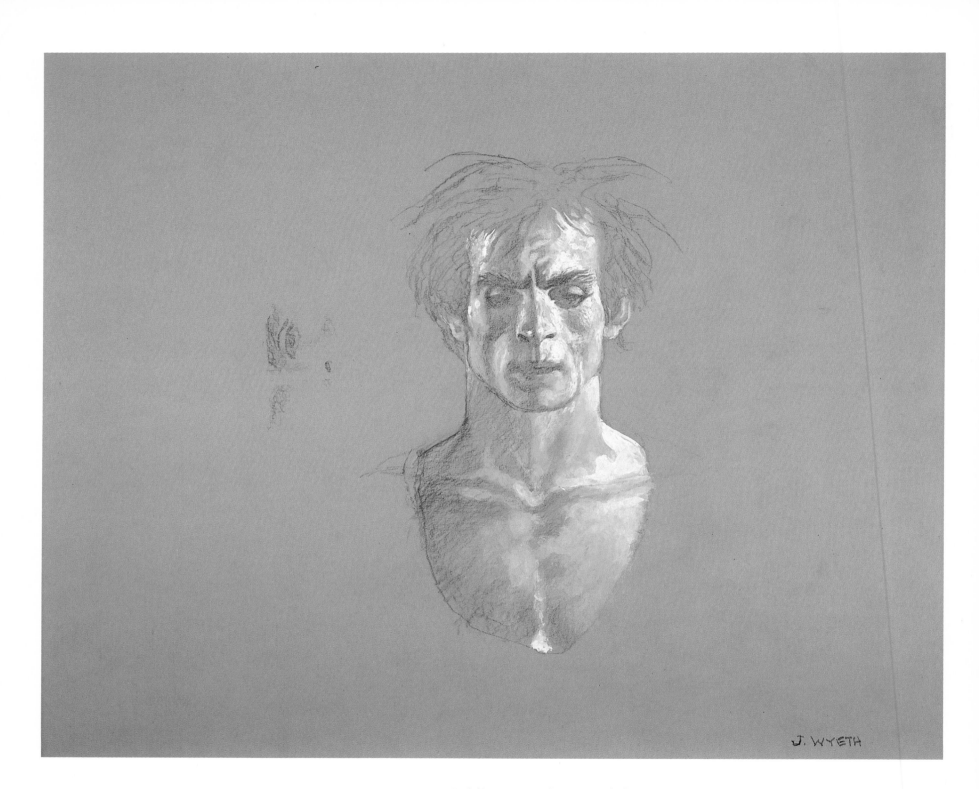

JAMES WYETH *"Rudolf Nureyev, Study #10"* 1977 (99)

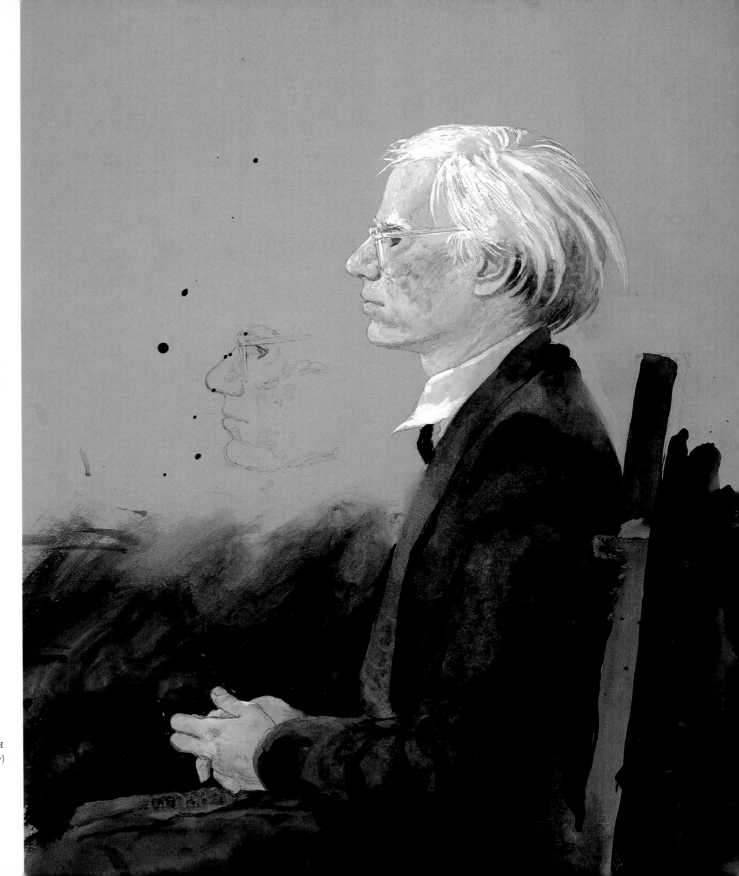

JAMES WYETH
"Andy Warhol Facing Left" 1976 (97)

involved with a sheep as I do with a president of the United States," he says. The pride often visible in the people he paints is also a strong feature in his animals. And in them we see as much character, as much personality, perhaps, as it is possible to see in any animal that must be frozen in two dimensions and in time.

Animals fascinate James— especially their eyes— and they are a constant and vital aspect of his life and his art. He has no illusions about them, and he spares us none of the brutality that is part of them. The "Island Geese" (page 188) devour smaller sea creatures, and death is a constant. They may be beautiful and they may be fun at times, but they demand serious consideration, and all this is in the painting. In "Angus" (page 187), cattle are shown held at bay, beautiful in their own way, and dangerous; they are in motion, and their motion demands caution. James Wyeth's world is no more pleasant and secure than his father's, and in the son's art the threat is often more overt. He once told a critic, "I love the country, but not the pretty fields so much. There are horrors there, and I love those. This morning, a calf was caught in the barbed wire. It was ugly, but it was wonderful. . . . Well, what I like about piggies is that they can be very difficult. They can attack. Those eyes aren't sweet. I want to be aware of that."[48]

Like his father and grandfather, he has painted almost exclusively in Pennsylvania and Maine and has found no limitation in self-imposed circumscription. "Bale" (page 177) is representative of the many works in oil and watercolor that come from the Chadds Ford countryside. It shows Wyeth's concern with abstraction and with the process of painting. But at the same time we find here another portrait, a precise rendering of a hay bale that defines the thing for us.

He shows the same multiple concerns in his Maine paintings. In his many paintings of the houses of Monhegan, for example, the buildings as shapes become the major elements of abstract compositions. At the same time, each house— and he has painted nearly every house on the island— is portrayed as an individual building. "The Red House" (page 58) stands precariously, empty, with gulls like scavengers, suggesting as much as any of his paintings the natural forces arrayed against human

habitation. In "Sea of Storms" (page 180) the towing bit from a wrecked ship lies out of place on the shore and bespeaks devastation in the sea. Although Wyeth cherishes and enjoys the most enticing and beautiful objects on the landscape, they are seen and painted without illusions as to their possible fates.

Paintings such as "Bale," "Pig," and "Islander" (page 182) show that love of paint that Wyeth felt from an early age. The three-dimensional surface of the paint and the brushwork with which it is applied duplicate as much as possible the actual surfaces of his subjects. His bale has the texture of hay; his sheep's curly coat is very thick impasto. He is intrigued by the complexity of objects and enjoys the technical challenges painting elaborate subjects presents. His many paintings depicting wicker furniture attest to this; the difficulties of painting woven white on white are too severe not to require real devotion to technique.

The love of such challenges has in recent years led him to experiment with a mixed-media technique he now uses often. It is seen here in "10W30," "Wolfbane," "Dragonflies" (pages 190, 61, 189), and other works. He considers it essentially watercolor, but adds other media for a variety of effects learned through trial and error. On very heavy paper, he uses watercolor pigments, charcoal, india ink, and acrylic varnish. The charcoal mingles with the color and can change it in various ways. The varnish is combined with other ingredients and is also used on the surface for special effects. From work to work, he changes the way he mixes these media and obviously delights in the various qualities he achieves through experimentation. He says (and it sounds like Wyeths before him), "No medium should be limited."

James Wyeth has often sought to develop his painting by studying other artists' work. The influences are many; the results are his own. Like his father, he considers Winslow Homer a great American artist, but for James, Thomas Eakins is preeminent. He finds Homer, Eakins, and Degas, as well as Pyle and his grandfather, particularly important because of their deep sympathy for their subjects; and when he discusses them it is apparent that nothing is more important to him than that involvement between artist and subject. He also values their under-

James and friends, c. 1974. Photograph by Scott Heiser

JAMES WYETH
"The Rookery," 1977
Oil on canvas,
31 x 43 inches
(78.7 x 109.2 cm)
Private Collection

James and Kleberg, 1984. Photograph © Susan Gray

James and Dozer in studio, 1985. Photograph © Susan Gray

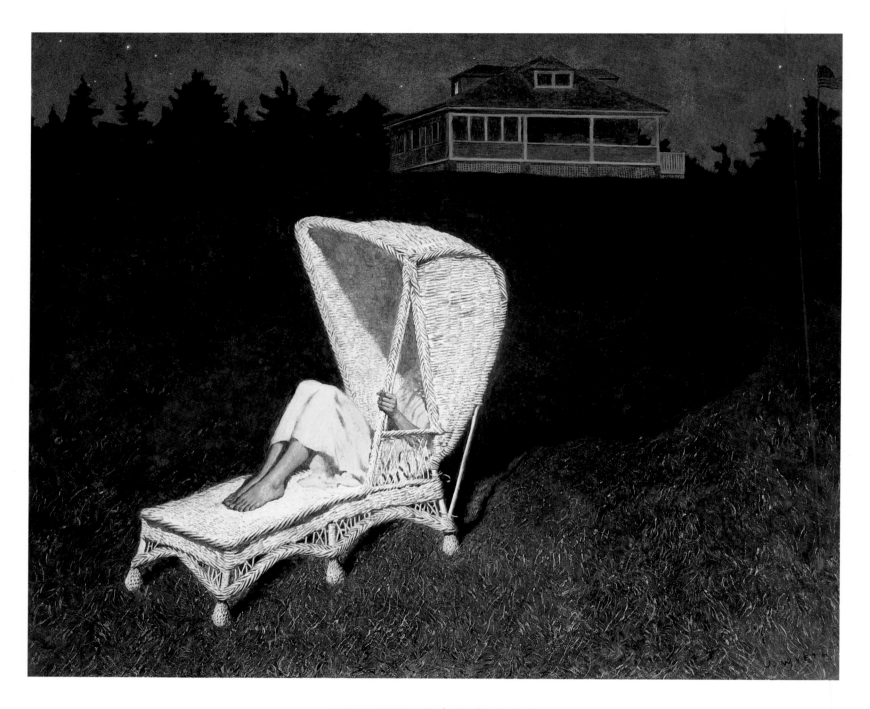

JAMES WYETH *"Night Wind"* 1983 (109)

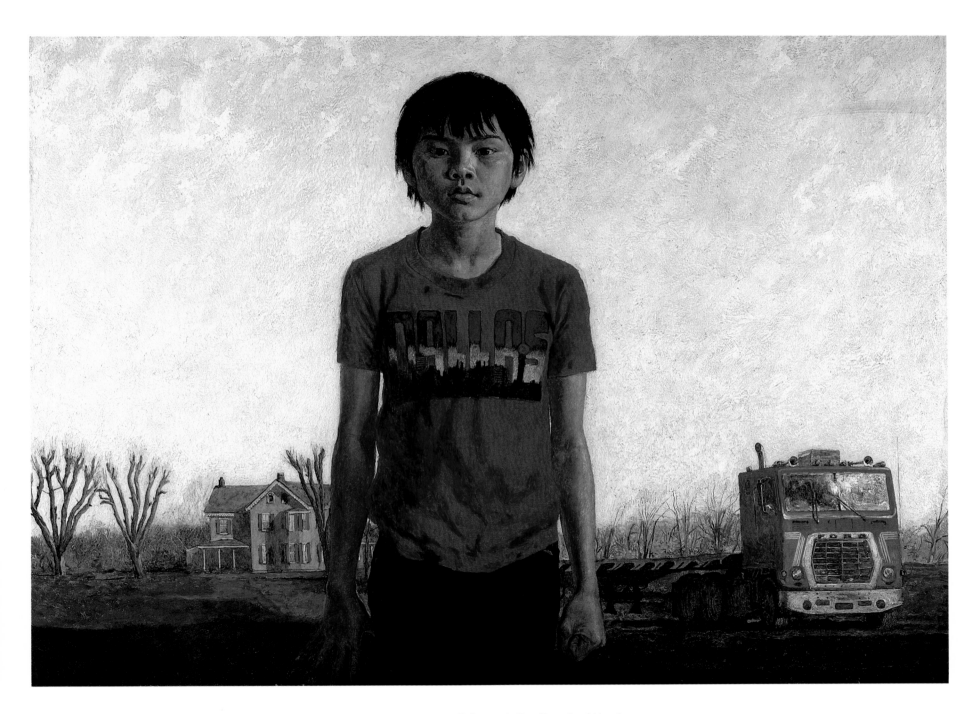

JAMES WYETH *"Kalounna in Frog Town"* 1986 (117)

Betsy Wyeth and James Wyeth on Southern Island, Maine, 1979
Photograph © Susan Gray

JAMES WYETH
Christmas card, 1971
Pen and ink on paper, 4 x 5¾ inches (10.1 x 14.6 cm)
Private Collection

James Wyeth and scale, 1986
Photograph © Susan Gray

standing of anatomy, their sense of scale, and their placement of figures in compositions. Degas's "*Le Viol* (Interior)" is a key work in his thinking, and he has spent much time poring over that artist's work. James is no less a student of art history than any other Wyeth. His interests can be predictable or surprising: he shares his family's adoration of Rembrandt, but he believes that the greatest of all paintings is Botticelli's "Primavera."

Many of James's paintings show influences of earlier artists not in precise technique, but in tones and the relationships among tones. The careful handling of tones seen in "Draft Age" has developed in the two decades since. Subtle shifts, usually from a very low key, are a major feature of his art and present much of the difficulty he creates for himself in each painting. In "Sea Star" (page 176) the camouflaged subject is a fascinating challenge successfully met. By establishing a low key and keeping color shifts very subtle, he can startle us with major features rendered in altogether different tones. Thus he captures our attention with the drama of color in works such as "Night Wind" (page 70) and the more recent "Kalounna in Frog Town" (page 71).

At various times in his career, he has worked very seriously and successfully in other media. Pen and ink frequently attracts him; he used it to illustrate a book by his mother, *The Stray* (1979), a fanciful romance based on people and places along the Brandywine. The book contains dozens of delightful drawings that demonstrate his imaginative ability as well as his fine draftsmanship. He grew up surrounded by illustrated books and recalls that E. H. Shepard's illustrations for *The Wind in the Willows* were especially important to him. Of course, he was very familiar with the drawings of his father and grandfather, and Pyle was a strong influence on his draftsmanship. Such associations were again important when he succumbed to another fascination and began making prints. For several years he worked regularly at etching and produced a number of works in the medium. He still wears his apron from those days, but says of printmaking, "I've done it. Painting spoils you because it's a solitary discipline. With painting you don't have to have people working with you."

James Wyeth is a solitary painter. His paintings emphasize aspects of human experience that dominate many of his father's and his grandfather's works: isolation, endurance, nature, and a profound but not sentimental sense of melancholy. He sounds like Andrew Wyeth when he says of Monhegan, "Fall, you know, that's the great time. There's a wonderful sort of melancholy. Nobody's here. Houses are closed up, sheets are pulled over furniture. I love it."[49]

Through all of the familial similarities and the persistence of traditions, we cannot forget that James Wyeth is his own man. The ways he focuses on subjects are distinctly his own, as are his techniques. We are lured by the sensuous qualities of his art, even by his sense of humor, but, once caught, we must deal with his very serious side. We are allowed to see the beauty in nature, but we are not allowed the solace of belief that beauty transcends any human predicament. If the "Deep Gorge" of James Wyeth's painting stands for known and unknown threats to which nature and living expose us, then it is an excellent metaphor for much of his art: he has plunged into that gorge and recorded its deceptively beautiful views. In it are found many perspectives of his contemporary art.

VI

The content of truly fine art defies literal interpretation. N. C. Wyeth's most compelling illustrations move us to a level of contemplation beyond their relationship to text; we find our own environment illuminated by them. Andrew Wyeth's reflections — literally on life and death — often go beyond our experience and enlarge our understanding. James Wyeth's treatment of subjects forces us to consider alternatives to established points of view. Through a shared, distinct, and honored heritage— and through aesthetic qualities based on great ability— these artists have set aside complacent thought and loose methods. Their art is extremely disciplined, and from within the conditions and limits it sets for itself comes a cogent, American vision of man in his world.

Notes

1. Mrs. Andrew Wyeth has provided much information based on her research on the Wyeth family's history.

2. Betsy James Wyeth, editor, *The Wyeths: The Letters of N. C. Wyeth, 1901–1945.* Boston: Gambit, 1971, pp. 236–37.

3. Ibid., p. 282.

4. The quotations in this paragraph and the next are from a letter from N. C. Wyeth to Katherine Williams Watson published in her book, *Once Upon a Time: Children's Stories Retold for Broadcasting.* New York: The H. W. Wilson Co., 1942, pp. 262–63.

5. *Letters*, p. 6.

6. Information concerning N. C. Wyeth's early years is contained in Betsy James Wyeth's introductory chapter to the artist's letters.

7. For information on Howard Pyle's personal history, any reader will be indebted to Henry Pitz, whose two most important books related to the subject are *The Brandywine Tradition*, Boston: Houghton Mifflin, 1969; and *Howard Pyle: Writer, Illustrator, Founder of the Brandywine School*, New York: Clarkson Potter, 1975.

8. Pitz, *Howard Pyle*, p. 57.

9. Ibid., p. 145.

10. Ibid., p. 149, quoted by Pitz.

11. N. C. Wyeth is quoted by Pitz in *The Brandywine Tradition*, pp. 127–28.

12. *Letters*, p. 41. Throughout his life, and especially in his early years, N. C. Wyeth wrote regularly to his mother and often to other family members and friends.

13. Ibid., p. 94.

14. Ibid., p. 95.

15. Ibid., p. 112.

16. Ibid., pp. 121–22.

17. These narratives are "A Day with the Round-Up," *Scribner's Magazine*, March 1906, and "A Sheep-Herder of the South-West," *Scribner's Magazine*, January 1909. They are reprinted in *N. C. Wyeth* by Douglas Allen and Douglas Allen, Jr., New York: Crown, 1972, pp. 38–42 and pp. 45–51, respectively.

18. *Letters*, p. 131.

19. *The Star*, Wilmington, Delaware, January 23, 1910, quoted in Allen and Allen, Jr., *N. C. Wyeth*, p. 53.

20. *Letters*, p. 269.

21. Ibid., p. 205.

22. Ibid.

23. Ibid., p. 213.

24. "Back to the Farm," by Martha Gilbert Dickenson Bianchi, *Scribner's Magazine*, August 1908.

25. *Letters*, p. 78.

26. Ibid., p. 217.

27. Ibid., p. 211.

28. Ibid., p. 340.

29. Ibid., p. 458.

30. Conversation; Andrew Wyeth to J. H. Duff, June 1981.

31. Wyeth wrote of his hope to travel to Europe to see more of Segantini's paintings. Visiting with the critic Christian Brinton, Gari Melchers, and J. Alden Weir in 1916, he found that they also thought Segantini's methods important.

32. *Letters*, p. 525.

33. Conversation; Andrew Wyeth to J. H. Duff, June 1981.

34. Ibid., pp. 834 and 835.

35. Ibid., p. 385.

36. The long list includes *The Black Arrow* by Robert Louis Stevenson (1916), *The Mysterious Stranger* by Mark Twain (1916), *The Boy's King Arthur* edited by Sidney Lanier (1917), *Robin Hood* by Paul Creswick (1917), *The Mysterious Island* by Jules Verne (1918), *Westward Ho!* by Charles Kingsley (1920), *Robinson Crusoe* by Daniel Defoe (1920), *The Scottish Chiefs* by Jane Porter (1921), *Rip Van Winkle* by Washington Irving (1921), *David Balfour* by Stevenson (1924), *The*

Andrew, c. 1927

Deerslayer by James Fenimore Cooper (1925), *The Oregon Trail* by Francis Parkman (1925), and *Michael Strogoff* by Jules Verne (1927).

37. Among the other murals he did were two Civil War subjects for the walls of the Missouri State Capitol in 1920. For the Federal Reserve Bank of Boston he painted Abraham Lincoln at work, and for the First National Bank of Boston he did a series on shipping and commerce. He painted the Dutch exploration of the Hudson River for the Hotel Roosevelt and a romantic view of the Founding Fathers titled "An Apotheosis of Franklin" for the Franklin Savings Bank, both in New York City. Other murals were for the First Mechanics National Bank of Trenton, New Jersey, Washington Cathedral, and the Wilmington Savings Fund Society in Delaware.

38. Ibid., p. 820.

39. Conversations; Andrew Wyeth to J. H. Duff, June 1986. Information and quotations following come from these conversations.

40. Wanda M. Corn, editor, *The Art of Andrew Wyeth*. Greenwich, Connecticut: New York Graphic Society, 1973, p. 99.

41. Richard Meryman, "Andrew Wyeth: An Interview," *Life*, May 14, 1965, pp. 93–116, 121.

42. *Letters*, p. 205.

43. Thomas Hoving, *Two Worlds of Andrew Wyeth: Kuerners and Olsons*. Boston: Houghton Mifflin, 1978, p. 146.

44. Museum exhibitions have been held at the Albright-Knox Gallery, the Fogg Art Museum, the Pierpont Morgan Library, the Corcoran Gallery of Art, the Pennsylvania Academy of the Fine Arts, the Baltimore Museum of Art, the Whitney Museum of American Art, the Art Institute of Chicago, the Fine Arts Museums of San Francisco, the Metropolitan Museum of Art, at museums of modern art in Tokyo and Kyoto, Japan, and at the Royal Academy in London.

45. Fogg Art Museum, *Andrew Wyeth: Dry Brush and Pencil Drawings* (exhibition catalogue), 1963. Essay by Agnes Mongan, no page number given.

46. Conversations; James Wyeth to J. H. Duff, June 1986. Information and quotations following come from these conversations.

47. Quoted in *People*, February 9, 1981, p. 116. Untitled article by Richard Meryman.

48. Quoted in *Philadelphia Magazine*, September 1980, p. 171. "Jamie's World" by Marshall Ledger.

49. Quoted in *The Christian Science Monitor*, November 3, 1981, p. B2. "Jamie Wyeth: The Artist Is a Lonely Hunter" by Maggie Lewis.

Overleaf: N. C. WYETH "*Old Pew*" (detail) 1911 (17)

N. C. Wyeth

ANDREW WYETH

N. C. Wyeth

My father was a very robust, powerfully built man. Muscular. But strangely enough, his hands were very delicate. They weren't big. A lot of people like to think, since he was a great big man, that he ate enormous amounts of food. But he was a very delicate eater. He gave the impression of great power, physical power which was very obvious. One of the stories around Chadds Ford was about a milk train he would meet and how he would help the farmers lift their cans, these enormous ten-gallon cans— one in each hand— up onto the platform beside the tracks. That gives an idea of his physical strength.

But he had other sides to him also. He was a man who admired many arts, literary, dramatic, musical. From being hardly a reader at all in his youth, he had become a constant reader. He had a remarkable talent for writing. My mother's mother got him reading Thoreau. He also read Tolstoy. And he loved Robert Frost. He thought Keats was terrific. He loved Emily Dickinson. He was interested in drama. He went to see, and talked about it many, many times, *Mourning Becomes Electra*. He loved music. It was emotional. That's where we kids certainly learned about it. On Sundays after dinner we'd lie on the floor and listen to it. He loved Rembrandt. He admired George de Forest Brush and mentioned him often to me. He was a complex man in many ways.

I grew up and became mature under him. He had a marvelous way of never talking down to a young person. And I spent a lot of time with my father— much more than the rest of the children did. When I was a child I'd go out into the back room of the studio where he kept his drawings and paintings and many reproductions. Often I'd drag them out, wipe the dust off, and ask him about them. He told me so many things about these pictures that I got a pretty thorough knowledge of what he had done. I also spent hours in his studio going through his books of medieval armor, and his historical books, and trying on costumes that he stored in his big chests. The costumes fascinated me. I was able to spend the time because I wasn't going to public school, I was being tutored at home. While all the rest were being shipped off to be educated, I was being educated by my father in a very direct way; I feel very lucky.

As an illustrator, my father's life revolved around children; yet he was a very severe father and did not pamper us in any way. He loved our imagination and it excited him, so our Christmases and Easters and Valentine's Days— all those occasions— meant a great deal. And although he was a born illustrator for children, his works elevated the level of illustration. I think this is the thing that bothered the social or literary people about my father's illustrations. I remember someone said to me— probably Philip Hofer— "You know, your father's illustrations are really paintings. They jump out of the pages and in a certain way ruin the looks of the book. They don't fit. Now when you see the originals and discover the size of them— and then you think of Rackham, whose images are all tiny (*they're* illustrations!)— you realize that your father painted on the barn-door scale." Pa lifted illustration into something it had never been before. He set himself apart. He transformed the nature of illustration.

Pa believed his artistic talents and literary interests were the contribution of his mother's Swiss-French heritage. He was doing watercolors by the age of twelve, working with a local woman, Cora Livingston, who lived down the street in Needham. When he was about to turn twenty,

he traveled to Wilmington with hopes of being accepted as a student by Howard Pyle.

Illustration was already in my father's soul; he had his thoughts already in mind. All he really needed was the technical training. It's astounding how quickly he learned to paint under Pyle. I mean, it was a year and a half, and he just tore through the training and was off. Pyle taught him the essence of drama. The style was pretty much my father's, so only a few pictures show the strong influence of Pyle. (In fact Pyle only touched one of my father's pictures: "The Hunter." He touched up the feathers on the goose and sensed that Pa didn't like him doing it.)

After learning Pyle's technique of drama, theatrical drama, Pa added the moods from his home in Needham and worked from his imagination. His talent, his technical ability, his painterliness exploded. The difference between what my father was doing in Massachusetts — as fine as it was — and what he did only a few months later in Wilmington is so extraordinary that you look for a reason why. I think Pyle was a magnificent teacher. My father thought so, too. He often recalled Pyle saying so many things that his students were incapable of understanding at their age. For one class a student did a picture of a meeting house. It showed the Quakers sitting and thinking, heads bowed, as they do before some of them stand up and speak. Pa recalled, "Pyle looked at it and remarked, 'Well, that's a very good graphic picture of what takes place in a Quaker meeting. But, listen, in my experience at Quaker meetings— and I went to many of them as a child and many of them bored me — the thing that I remember the most, which to me is the essence, is looking out the window and seeing a horse tethered at his carriage, his head moving up and down, and a sultry, misty landscape beyond.' That idea conveyed more of the quietness of the meeting house than did the picture of all those people sitting around. And," my father continued, "that's where Pyle was a master. But none of us understood it at the time." Pa even doubted that some of them ever understood it. Pyle was subtle.

Soon after beginning work with Pyle my father received commissions for magazine illustrations. Within a few years he was a full-time illustra-

tor. Some of his earliest commercial illustrations were of the West. Those of the Indians are extraordinary. "In the Crystal Depths" (page 17) is certainly one of those — a lovely, quiet picture. The reflection, the sudsy water below the falls, allow me to imagine where the canoe is drifting. It has the feeling of Howard Pyle in its glazing. Then, of course, I love the one of the three Indians sitting up on the top of the bluff ["Nothing would escape . . ."; page 93], which my father considered the finest Indian picture he ever did. He once said, "That's the true character of an Indian as I knew it." And that picture is not overly dramatic. Indians were never dramatic, you know. Indians in Pa's experience just stood solemnly with very little expression. You see pictures of Indians in dramatic poses, but that's a lot of crap! Pa knew the Navajos; he lived with them. His paintings are remarkable, outstanding. And he was only there a short time. I think he ranks right there along with Remington; far better than Russell. There is a robustness in my father's western works that you can't deny. Even the early ones were wonderfully well composed. And of course his letters home about the whole visit are remarkable records, too. Even with these early images my father was moving out in new directions as far as illustration was concerned. He was producing big pictures, but ones with an economy of line. They had qualities quite different from Pyle's. And over the next fifteen years he received several important book commissions. Yet look at those books: he used a new style for almost every one. He was always groping for something new. He was experimenting in painting. But he began each book project in the same way— he read the story.

Pa's first and foremost interest was: Is it a well-written story? Is it a vital story? What he wanted to do was to bring air into those books that had been sitting in libraries for decades. Take *The Last of the Mohicans*, which to me is a boring book. My father's illustrations certainly added a luster to that leatherstocking tale. People often refer to the books Pa illustrated as "children's classics," but I don't think you can call *The Last of the Mohicans* a child's book. And certainly *The Mysterious Stranger* by Mark Twain is not a child's book. Pa felt that a good story could be understood by all ages, that an illustrator shouldn't get too complex. He was also very upset by illustrators doing cartoony illustra-

tions of the big, bad wolf or making caricatures such as the red-nosed reindeer. Taking a beautiful deer and making it a cartoon, he thought was deplorable. Since my father didn't talk down to children, he certainly wasn't going to paint down to them. It may be that he had this approach because of the way he was raised. He always believed that children were more mature than adults gave them credit for. When children wrote to him, they'd often comment about his illustrations. They'd ask, "Why did you put the bandage on so and so in one picture with the bloodstain on one side, but in the other picture put the bloodstain on the opposite side?" They also mentioned the coloring of the pictures. He was terribly sensitive to children, and I think that's one reason why his illustrations are so great.

After initially reading the story, especially if it was a good yarn, Pa would reread it very carefully and underline passages that he felt were the essence of the story. I remember him sometimes sitting on the porch reading manuscripts and galley proofs. Then he would turn his imagination loose. He always picked a scene that was not described very much. He once explained, "Why take a dramatic episode that is described in every detail and redo it? Instead I create something that will *add* to the story." Look at "Old Pew" (page 52). That scene isn't completely described by Stevenson. He says that Pew is tapping along, but makes no mention of the moonlight shining on Admiral Benbow Inn. Pa added the details and the mood and created an outstanding picture. To me it's an indelible image. The whole picture is a vignette of a keyhole: that shape of the cape; the shadow; the cane coming towards you. It's amazing! And then you see the inn in the moonlight. I think the whole image is very strong. A beautiful piece of work. You could say that it shows a slight influence of Pyle, but Pyle taking flight. Freedom.

"Train Robbery" (page 91) is another remarkable picture. He painted it in one morning. At that time he was doing pictures of adventure stories for Hearst publications and he could make up any subject he wanted as long as it had to do with the West and was something with a lot of drama. He was getting us kids breakfast early and got the idea of this train robbery, went up to the studio, and just painted it like mad. It was finished by noon.

My father used his subconscious mind heavily. It came from something within him, and all the author did was get my father's imagination working. He believed a person should be able to walk into the book store and just thumb through a book and get the idea of the story by the drama of the illustrations— very quickly.

Pa loosed his imagination against a local backdrop. His illustrations don't have the European flavor, even though the stories may be set in Europe. His skies are the skies of Chadds Ford. And they're distinctly unlike Howard Pyle's skies. Pyle was definitely an illustrator who was influenced by early illustrators of Europe. Pa built his pictures up with very little. He learned a lot about a subject, but he never overdid the image. He made his scene look perfectly normal, as if it could happen today. Look at his illustrations— they're amazingly simple. In *Westward Ho!* he shows just the glint on the guard of the sword to make you realize that it's Spanish. "The Treasure Cave!" (page 105) has all that gold and this figure counting it out. But look at the way those coins are painted; they're only suggested— very freely painted. That's a great quality of the best ones from *Treasure Island*, they have a marvelous abstract freedom and painterliness. Look at the parrot with Jim Hawkins and John Silver in the galley. The parrot is done with a few swipes. The frying pans and skillets on the wall give you the feeling of the ship's movement in the sea, but their back-and-forth sweep is suggested with very little detail. These are what make his illustrations so enduring and not particularly dated. Other illustrators spent a lot of time learning all the equipment and what was carried, but they never absorbed it into their bloodstreams. My father did. He made it become a part of everyday life. That's why kids can dress up as his characters with very simple things and feel they are really there. Pyle crowded his illustrations with detailed costumes and settings— everything is shown; my father suggested things. The simple idea is actually the most complex one in the world— to absorb all the knowledge and then put it down to look like you just went *swish* and there it is. He got to know it so well that he could put a buckle where he wanted to and know it was right.

Throughout his life Pa acquired the buckles, the costumes, the Indian blankets and chaps, and many other props. He had trunks of costumes,

but I never saw him use them on models. He may have done so in the beginning when John Weller, Pyle's former model, posed for him. Weller came out from Wilmington after Pyle's death and spent many weekends posing for Pa. But I don't think Pa ever *hired* models for any of his great illustrations. He did use us. All of us posed. We posed for hands and feet and for portraits. But even before he had his own children, in very early pictures such as "Mowing" (page 19), my father often painted children, and he seemed to have a great sympathy for the form of the child; in his early illustrations, children are very natural and real. Later on, I think, they became sort of a cliché of the blond-haired child, but in those early years when he was in his top form as an illustrator, the children looked like they could be urchins, not innocent. Pa also did quite a number of self-portraits and he did himself in a stocking cap, laughing. Then he did one of himself wearing the cape and stovepipe hat that had belonged to his great-great-grandfather, a divinity teacher at Harvard. He painted himself a good deal. Here was a perfect model, and he couldn't say, "Well, I've got to go home, you've got to stop painting, Mr. Wyeth."

When it came time to do an illustration, Pa had an amazing ability to do the image without a model. You can't put a model into the motion that he caught, like a man climbing over a stockade or a figure fighting in a doorway. Those things are momentary, imaginary. And yet he had an amazing accuracy in his drawing. "Captain Bones Routs Black Dog" (page 103) has very powerful and marvelous action. My father's feeling for action belies any photography. You couldn't possibly catch that in a photograph, or that whole point of view. You're looking down slightly on the scene. The strength of the hand that sweeps that cutlass and hits the Admiral Benbow sign, and then comes around and slashes into the frame of that doorway is marvelous. And "One More Step, Mr. Hands" (page 98) is fine. That's a very handsome composition. The way Pa has painted that bloody hand with the knife is remarkable. "The Siege of the Round-House" (page 26) is magnificent. That man looks like a cornered rat, and he's stabbing at these men through the door. Look at the expression and the cutlass and dirk in his hands; sense the feeling of these people pushing their way towards him— one's fallen and been sliced through with his cutlass. Look at those teeth, you just see the teeth of a rat. I know that was on my father's mind.

Some people have suggested my father didn't paint women as well as he painted men and children. My sister Henriette thinks he painted women very poorly. I love these women, but they don't have much passion in them. To put it very directly, I don't think you would want to go to bed with the women that he painted. His women were submissive types that were always there— the homemaker: wholesome, beautiful, but slightly removed. Now my mother posed for many of them, and she was a very lovely person, but I don't think he brought out her sexual quality in any of them.

In many of his paintings, the faces have a relaxed, almost deathlike quality that is extraordinary. I once asked about this. Pa said, "Andy, I'll tell you." And he drove his point right home to me: "When my mother died, I took the train right to Needham. I got there in the late afternoon and they had her laid in her bed upstairs. I went up and sat there with her, with that amazing face that looked like the mother of Europe. As the sun went down, studying that face lying there on that white pillow and that waxy skin" — he was almost whispering— "it made such a deep impression on me. Andy, if you ever have a chance to be with someone you have loved, don't hesitate to do it, because that's the most profound quality, a head in death. It changed everything for me."

Twenty years later my father was killed. I arrived from Maine the next afternoon. I didn't stop to say anything. I took the car up to Birmingham Meeting and I sat there in that meeting house where he and Newell, my brother Nat's son, lay. I will never forget that scene and the dry leaves blowing in late October. I remembered what my father said. He was so right. Their faces had become masks of eternity. I couldn't have taken the funeral the next day if I hadn't done that. For some reason that afternoon with them just raised my spirit so that I was sort of hovering above. It sounds a little melodramatic now, but my entire point of view was looking down on the whole thing.

"Death of Edwin" (1921; page 115), from *The Scottish Chiefs*, is one of Pa's magical illustrations of death. The composition has moonlight striking on the head and shoulders and breast of young Edwin, who has just been pierced by a shaft from the British archers, and as Sir William

Wallace bends, the light catches on his hand, a hand that is beautifully painted. The whole composition is very stunning. And I think this is the essence of what he learned sitting by his mother when she was dead.

"The Passing of Robin Hood" (page 114) has that same quality of death beautifully expressed in the head and the hands that clench that bow, as if death has already moved into him. That late afternoon sun hitting the wall seems slowly moving up as the sun goes down. Lovely simplicity in it. Pa used very few props; you only sense the heavy woods outside this monastery. With this pale figure clenching the bow and then those two stalwart friends in back of him, both weeping, it's quite a moving picture and very contemporary, strangely enough. The room is like the inside of my father's home.

Pa's memories of Needham and the house that he built in Chadds Ford provided settings — all kinds of elements and settings for his work. In "Ben Gunn" (page 24), from *Treasure Island*, the pine tree was in a section of woods right across from his home in Needham— a stand of enormous pines and uneven ferns. And that's really what was painted, although it was done from his memory. He was thinking all the time about Needham. And the Admiral Benbow Inn in "Old Pew" is his family home in Needham. King Arthur's tales are another example of Chadds Ford scenery. Look at that little landscape in the background of "It hung upon a thorn" (page 113). That could be back over the hills here in Chadds Ford, looking down a dirt road and out across the fields. "They fought with him . . . three hours" (page 31) is a marvelous piece of landscape painting and an unusual picture for Pa in terms of design. And of all the King Arthur pictures it made the greatest impression on me as a child. The only other pictures I'd seen of medieval knights were like Howard Pyle's with a castle in the distance and a romanticized land-scape. But this picture shows the landscape I knew as a boy— and men in armor are fighting on it! The picture is unusual in other respects, too. When I saw the original again recently, I was kind of shocked by it. The group of figures is very complex, and there is something terribly truthful about that picture to me. The feeling of dead walnut trees with bark coming off is fascinating. And the verticality of that picture is unique. It's a rare portrait landscape.

In "The children were playing at marriage-by-capture" (page 92), I'm also particularly struck by the feeling of the landscape. That could be a stream right here in Chadds Ford, but the reeds and brackish water are a rich piece of painting suggesting the salt marshes of the Massachusetts coast.

My father often talked of the sea in his early letters. It was in his back-ground and this crept into his paintings. "The Wreck of the 'Covenant' " (page 99) conveys the marvelous feeling of nighttime, a rolling sea and a beautifully expressed wetness. The light on those sails and that lamp on the stern of that ship are beautiful. "The Rescue of Captain Harding" (page 96), a handsome composition, has the feeling of a sand dune. Look at the light of the sand reflected up onto that stretcher, the tall grass that grows on dunes. I feel salt in the air in that picture. Another example is "On the Island of Earraid" (page 27), the boy in the fog among the rocks. Pa painted the sea so well in that picture, and years later, of course, he painted many sea pictures from life in Maine, but I don't think any of his later pictures compare to this feeling of rocks and sea. This painting seems to express it all. He seemed to know how to paint a subject before he went to study it.

Even Pa's animals are outstanding in his illustrations. He could do a horse on its back, flying through the air, or in any position you'd want. I asked him once, "How did you learn to do a horse in so many positions without a model and make it really alive?" He said, "Well, I'll tell you. On the roundup I had the chance to cut up a horse that had died. I'll never forget the anatomy of a horse."

"Fight on the Plains" ("A shower of arrows rained . . ."; page 15) for Buffalo Bill's autobiography has those dead mules. I've read that book and I can't find for the life of me anything described that has the slight-est association with the picture. This picture came out of something that happened in the meadow below the studio. There was a storm, and a bunch of mules under a tree were struck by lightning, or the tree was, and they were all electrocuted. My father heard about it when he went to get the mail the next day and walked over to where they were lying. He knew that they used mules a great deal on the plains and that Buffalo Bill

used them when he was hunting buffalo for the railroad. And this is where the composition came from. Notice the shafts of the Indian arrows, where they've actually driven into the bodies of the mules, where they've hit bones, and where they're broken off and snapped in two, some of them practically disappearing right up to the feathers; it's a brutal painting, and a stunning, dramatic one. You sense Indians because of the shafts. It's an extraordinary leap from a group of dead mules in a field to that concept. There's more to this story, though. My father gave that painting to a local man, and years later, after Pa's death, I was able to buy the picture back. The wife of the man said to me, "You know your father had this picture two years before he died. 'I want to clean it up,' he said. After he had it for about a week he called my husband and said, 'I would like you to trade this picture for a better one. I'd like to keep this because I feel that I'd like to give it to Buffalo Bill's son. Would you take another picture?' We refused because we loved the painting." That is very interesting because Buffalo Bill never had a son. I think my father realized how good this painting was and wanted to get it back.

The commercial illustrations Pa did provided a relatively steady income. All those done for *Treasure Island* and the other early books were sold outright to publishers and they kept them. Scribner's sold them or gave them away. For instance, the Barrymores bought three of the *Treasure Island* works. And Mr. Randall, who was in charge of the rare book department of Scribner's at one time, apparently sold pictures. Russell Colt bought the *Kidnapped* and *Last of the Mohicans* pictures. Imagine if Pa had done the *Treasure Island* pictures on royalties; instead, he got $5,000 for doing them. At that time, that was a lot of money, of course. He did a few books for royalties much later. *The Mysterious Stranger* was done on a royalty basis and didn't sell at all.

While my father was churning out illustrations and after leaving Pyle's studio, he kept in contact with Stanley Arthurs. He saw Frank Schoonover for a while. Clifford Ashley also came out, and Harvey Dunn came out a good bit with Gayle Hoskins. Dunn and my father were very close at one time, and I've always loved Dunn. He was such a handsome-looking man. He was born in South Dakota; he looked like an American Indian— robust. Dunn to me is an outstanding Pyle student.

Of the New Hope Group of impressionists, Edward Redfield, Daniel Garber, and William Lathrop, he liked Lathrop the best. He thought Lathrop was the most sensitive of them. During the teens, architect William Price became a strong influence on my father. I'm not saying a particularly good one either. Price loved art nouveau and was very much connected with Rose Valley, and Pa went up there a good deal. The Rose Valley group was an artificial influence on my father.

A lot of the very adroit people Pa knew were not good influences. My mother used to say that William Cahill, who had been a student of Pyle's with him, had a terrible influence. Cahill would come to Chadds Ford and they'd stay up all night. Their discussions would "leave Convers all stirred up." Art critic Christian Brinton, who lived nearby, was another one. Brinton even brought down a Russian artist, whom I have never heard of since, but his work was rather abstract, and this man said, "N.C., you've got too much illustration in your painting to make good painting, and too much good painting in your illustration to make good illustration." My father was also much influenced by the Spanish painter Sorolla; Brinton promoted him in this country and insisted that Pa look at his work very carefully. Brinton also showed my father reproductions of Repin's work. Brinton owned a lot of Chagalls, painted before the artist was messed up by going to Paris. He showed them to my father and later sold them.

There were also a number of other people whose work influenced my father, and some of these were good influences. "Winter" (page 21), the Indian on the cliff and the soaring birds, owes a lot to George de Forest Brush. But it also has a robustness that Brush never possessed. Brush was a beautiful painter, I mean a beautiful technician, clean like crystal. My father was a much more earthy painter.

Although Pa didn't think about his illustrations hanging apart from their publications, he went to exhibitions— and Pyle would have him go— to see Winslow Homer, to know Giovanni Segantini, the Alpine painter. He saw several Segantini originals in this country, one in Brooklyn and the one now out in San Francisco. Those men— he knew— were painting paintings that lived on their own, not tied to a book, complete

subjects, rich in subject matter and connotations, overtones and undertones of mood.

Segantini's method shows a little in my father's work — the way the impasto is laid on. You can see it very strongly in some of the illustrations for *The Mysterious Stranger*. "Newborn Calf" (1917; page 22) is very clearly influenced by a combination of people, certainly by J. Alden Weir, Childe Hassam, and Segantini. But it's even more impressionistic than Segantini; Segantini would have done long strokes and this is not quite that. This is more like Weir or Hassam. My father was a terrific technician. I can see no flaw in his impressionist technique, but I do think it was limiting for him to work in broken color that way. He had too vital a talent for that.

When Pa made obvious and dramatic changes, he was reacting to many specific artists. Late in his career Peter Hurd had a strong influence on him. Even I had an influence on him, and a not very good one. I know it was not good! But by that time my father had lost his excitement for painting. I think he had lost the vitality. He remained a terrific thinker. He was well read. Look at his letters. He had a lot of theories, and they show in his painting late in life, right up to the end. Midway through his career, around 1920, he took time off— I think it was two years— and really did no commercial work because he felt that he needed to paint just landscapes. But he had to get back to illustrating because he had five children; it had become purely a commercial matter. I think that's why he became rather jaundiced towards illustration, he recognized that he was manufacturing those things. One picture every few days to meet some tight schedule. The real charm of illustrating had disintegrated for him. He was more interested in painting. He did try, however, to bring modern styles into his illustrations, such as those he did for Homer's *Odyssey*. Years later there was just one book which he was very pleased to do: *Men of Concord*. He rejuvenated himself with it, although I don't think it's one of his great books. Because he loved Henry David Thoreau, he loved doing that book. He talked often about Thoreau to me.

Pa was also a master at still lifes. He would set up his still lifes right in his studio, and they usually were done rather quickly. I think he felt that

he *needed* to work from life, and I can understand that. If you work all the time from your imagination, as Pa did for his illustrations, every now and then you think, "I've got to go out and eat a good roast beef or something." You need to nourish yourself. Working completely from the imagination is a very draining experience. A lot of his illustrations have still lifes set off at one side. He loved those, loved them. Look at the marvelous painting of the astrologer in *The Mysterious Stranger* who pours the wine out of that big bowl (page 109). Now that's a bowl that my mother used as a mixing bowl. I don't think I've ever seen a still life better than that bowl with that little sediment line showing the level of the wine that has been poured out.

Pa very definitely rejuvenated himself by doing landscapes. But I have very grave doubts about them. Theoretically it sounds right for him to go and paint landscapes here in Chadds Ford and Maine to enrich his ideas for illustrations. But I don't think an artist works that way. Some artists get things right with almost no knowledge at all, much better than if they go out and search for it. Pa's best paintings were spontaneous ideas. A concept needs the juice, the essence of the thing, more than all the theory or more knowledge. This is a very sensitive thing. I think my father was born with an amazing capacity, like a sponge, to soak up all thoughts, ideas, and happenings— even moonlight nights as a child— and then when he finally was ready (that is to say, once Pyle had given him training), he squeezed it out— dry. When he painted a landscape or did a still life, those were things in his mind, wholly apart from illustration. I think he wanted to go to the truth. We have grave doubts sometimes about our imagination and we want to check it every now and then. And you know, we shouldn't. An imagination is a very sensitive thing. Pa's landscapes were a kind of checking up, and I don't think they ever lived up to his imagination; he never got the excitement out of a landscape that he got when he painted from his imagination. Now people will say, Andrew, you're discarding a great period, your father's landscape painting, and I'll grant you it is important, but to me his *illustrations* are a perfect portrait of N. C. Wyeth. *No one* else could have ever done them but him. His landscape paintings are not unique, although they're excellent paintings, and they're better than other people were doing at the time. But Pa had an ability to do illustrations

that no one else had. I mean I realized early: don't get into illustration, Andy, you can't compete with a man with his talents. You can't!

You don't think of anyone but N. C. Wyeth when you're looking at his illustrations. You're seeing a *complete* master of his emotion. Technically they are very important, but I don't think you can dislodge technique from mood, because then it becomes like a technical, how-to publication. I don't think it can be done that way.

My father really worked in a variety of media. He did watercolor. Some very early watercolors done when he was twelve years old are remarkable and show a lovely feeling for wash. He also did watercolors in his letters. Once in a while when we were kids he would come out and he would do a watercolor of a pirate head or something, always beautifully done. Pa was always excited by my interest in watercolor. But a lot of my early ones were trite drawings filled in with color; I was illustrating *Robin Hood* or *The Three Musketeers*, things like that. Then one fall day while I was out in the orchard doing an apple tree he asked, "Andy, why don't you really free yourself?" He sat down by me and did this watercolor, very free, of an apple tree. He didn't pursue watercolor himself because he felt that it wasn't his medium. He was crazy, of course. He was a master technician.

Pa rarely worked in pen and ink. I always liked his pen drawings for *Rip Van Winkle* and *The Mysterious Island*— they had great quality. But he dismissed them, saying, "No, Andy, they're pencil drawings rendered in ink. You have a feeling for pen and ink. I don't." That's why he got me to do all of those pen and ink drawings in *Men of Concord* and the *Hornblower* series for him. The publisher never knew.

His use of charcoal is fascinating. It comes through the oil. When he did his early illustrations, he quickly drew them right on the canvas in charcoal, marvelous drawings with rich blacks. Then he would start right in with his oil, with glazes, and you could see his thumb marks and other things building these up.

He used glazing a good deal, and, of course, in the little "Self-Portrait" (1913; page 88) it's very beautifully done. He probably learned glazing

from Pyle. He used it in many illustrations and some of those have a wonderful transparency.

All the illustrations were oil. He never did an illustration in egg tempera, though people think he did. I know, I was with him. In the thirties he was doing oil, but very, very thin oil. As the forties approached, I think of my father having a red sable brush and a little bit of egg tempera, having to mix it up and build up a cross-hatching for his landscapes. It was not Pa's quality. It was not like the man. In one of our last talks, Stanley Arthurs said, "Your father should never have left the oil medium. He was so much at home with oil. All we students in the Pyle class would just marvel at the way he could work with charcoal and with transparent oil mixed with turpentine glazes and how these illustrations would come out of these enormous canvases. For him to take up a medium like tempera was a great tragedy."

Now Pa understood the tempera medium very well. He often said that if you lift the surface of a tempera, it all would come off like a marvelous Oriental rug, all equally powerful in its texture and design, and no thin, open spaces. Tempera is not a medium for just cleverness. It can be done freely, but it has to be a studied process. If you look at Pa's "Island Funeral" (1939; page 28), that's very freely painted; however, it's not really a tempera, since there is oil there too. But, finally, he got into the method of building up pictures, such as in "Nightfall" (1945; page 28). He understood it, but there wasn't any technique that he didn't understand beautifully. Master technician, no doubt about it.

Because Pa understood technique, he could teach others, too. He had only a few students, John McCoy, Peter Hurd, my sisters Henriette and Carolyn, and me— but not many. I think he taught because they happened to be around. He wasn't seeking students. He taught Pete Hurd because he came here and Pa liked him, and, of course, Pete fell in love with his daughter. John McCoy came here, too. He was brought here early by his mother and father and showed Pa some things and said that he had gone to Fontainebleau and studied. I would never say that teaching was an important facet of Pa's life, although I think he was a great teacher. When it came to cast drawings, his other students never

did any. But we kids were something different. We did them. My sister Carolyn is the best charcoal artist that ever lived, no doubt about that. And he made me study in charcoal. I was never very good, but I did study a lot of it. He sent Henriette to the Museum School in Boston because he thought she was beyond him.

Pa was my only teacher. He taught me watercolors and oils. I remember one day when I was working in oil, doing a head of a man in strong light, and I started to get a lot of half-lights in the shadow side, reflected light. And he said, "You know, Andy, you've started out well, but you've lost your simplicity." He took his finger and he put it in some raw sienna and using his thumb just simplified that whole shadow. He made it sing. That's the painterliness that you find in pictures for *Treasure Island* and *Kidnapped* and in "Mowing" (page 19). Another time I was drawing an illustration. I guess I was about eighteen and the image was of this man leaping out of a tree onto a man below. It was to be the perspective of looking down on the figure who was looking up and being leapt on. My father said, "You'll have to get a model for this, but you want to get this feeling," and he quickly made a drawing of the figure looking up with his hands out, startled by this figure falling. It was a marvelous little drawing. Then I got a model and had him stand below me in that position as I got up in a tree. My father's drawing was absolutely accurate! But far better than that because it had an expression and expressiveness.

I always showed him my work, but not until it was finished. Once I started to work, I came as far as I could and then I'd have him come down and look at it. I showed him "Soaring" (page 42) in 1942, three years before his death. He thought it was terrible. "Andy, that doesn't work. That's not a painting." So I put it in the cellar. It was there for six years. My sons set up a train on the back of it. If you look at the picture now, turn it over; it has track marks on it. Lincoln Kirstein saved it: I was having a show in New York in 1950, and he asked, "Andy, have you showed me everything for this show? Have you forgotten anything?" I replied, "There's one in the cellar." So, we hauled it out, covered with dust. Lincoln said it was terrific. "Fix it up." I fixed it up. Maybe Pa was right. Maybe it doesn't work, but it's interesting. It doesn't have much

color. It's vacant. Pa didn't like that. He once said, "Andy, you've got to get color in your pictures." There's a lot of color, even in his winter paintings. Oh, did we have arguments over that, we really did. I tried to explain, "I don't see this country in the winter that way."

The 1920s and 1930s were a very social period. My father enjoyed it. We kids never knew who was coming, I mean, they were always driving in with these enormous cars. I remember Scott Fitzgerald in a touring car with all these big straw hats, and oh, we kids had a great time with that. The Great Gatsby, right here! But of course, the Fitzgeralds lived nearby for a time. Joseph Hergesheimer was another big drawing card here and a very good friend of my father's. He'd bring down his manuscripts and stay up all night reading them to Pa. Other visitors were Hugh Walpole, Lillian Gish, John Gilbert, who played in *The Big Parade*— oh, the list is long. Richard Barthelmess, Paul Horgan, Eric Knight, who wrote *This Above All* and *Lassie, Come Home*. Of course, both Paul and Eric were friends of Pete and Henriette. I would almost call them students of Pa's literary side. Oh, yes, and Max Perkins, the editor at Scribner's, was always asking Pa to write.

Doug Fairbanks, Sr., wanted my father to move the entire family to Hollywood when they filmed *The Black Pirate*, a silent movie. My father went to New York, met Fairbanks and Mary Pickford, and spent the day with them. He decided it would be the ruination of him and us to move there. So he got a friend of his, Dwight Franklin, who did amazing dioramas of pirate things, to do costumes for the film based on my father's concepts.

In the thirties, Pa's painting method had changed. He no longer sketched his idea on the canvas first. He would make a pencil drawing, a cartoon, and take it to a photographer by the name of Sanborn, who would make a lantern slide of it. Then my father would use the slide projector to blow it up on the canvas or panel and paint it in. So his illustrating was deteriorating. He wasn't that excited to go right at it anymore. By 1940 he was awfully tied up. I think he had given his whole body and soul to these vital pictures, and God knows he produced an enormous amount. I think he was exhausted. It's as simple as that. He didn't think what he

had done in illustration was worth a damn. One of our last talks occurred in Maine and lasted until three o'clock in the morning. I tried to make him see my point: "You know, if you had done nothing but the illustrations, the great illustrations, Pa, you've done it." He felt pretty good about the *Treasure Island* illustrations at the time he did them. But an artist forgets the early thing; we say, "Oh, I did that as a child." My wife Betsy never cared for the things that Pa did while she knew him in the 1940s here. She felt I was a much better painter; then she saw his great illustrations. After his death, we bought "Blind Pew" (page 102). We hung it right here in the studio. I remember the day it arrived at the Chadds Ford station. I brought it up and undid it. Oh, it was the most thundering thing to both of us. I don't think that if he had lived for another hundred years he would ever have done any more illustrations. I think he wanted to paint, not illustrate. He still had ideas and a few tricks still up his sleeve. He wanted to do the source of a brook. That was one of his ideas. That's a constant theme through the work. He loved the idea of the little brook and tracing its course. Oh, he loved brooks. The moving water going through a landscape and the way it wandered. He also loved the idea of a path. He thought a path could indicate the quality of the person, in how a person walked around a rock or up a little rise and down. He loved that idea.

He was still a keen observer of life. Just minutes before he died here in Chadds Ford Pa was overheard talking to Nat's son about bundling shocks of corn: "This is something you must remember because this is something that is passing." It's an incident that is very compelling. A year or so later, Betsy picked up the woman whom he had been watching with the corn that day and drove her to Kennett Square. She told Betsy all about how Pa stopped and brought the little boy over and showed him what she and her husband were doing and talked all about the corn. Finally he said good-bye and returned to the car. She went back to work. About three minutes went by. They heard the train and this terrible crash. It's so ironic he was killed so close to home. He had talked to me a year before as we walked down that railroad track and he showed me the spring where the Howard Pyle students would stop along the railroad and get water. It was still running. And a year later he was killed near that spot. It was October 19, the same date that he had first arrived here to study with Howard Pyle.

Edited by James H. Duff from tapes of his conversations with Andrew Wyeth in May 1986.

N. C. WYETH *"Self-Portrait"* *1913* (22)

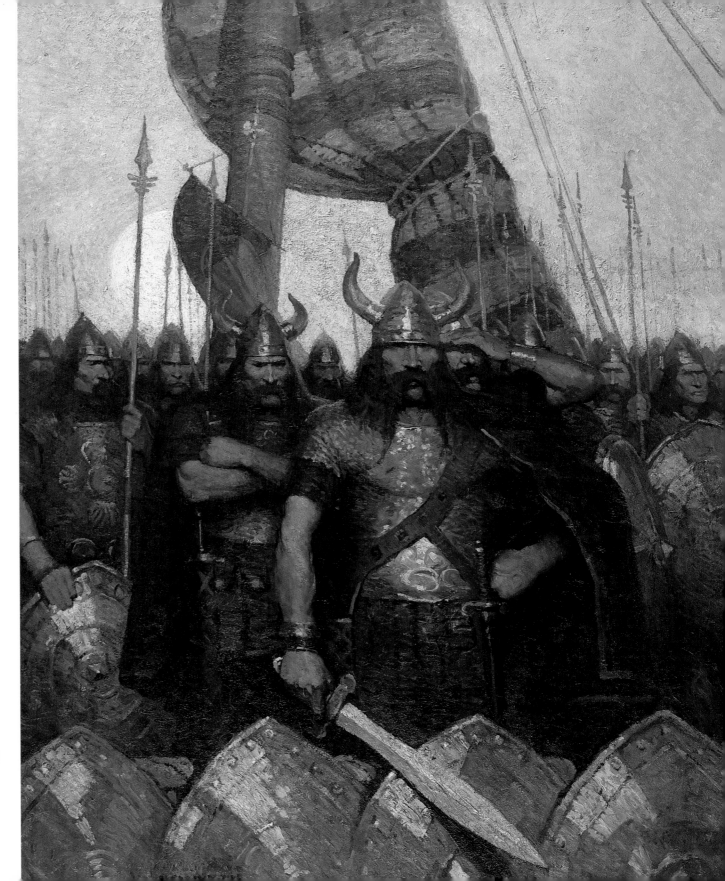

N. C. WYETH *"The First Cargo"* 1910 (7)

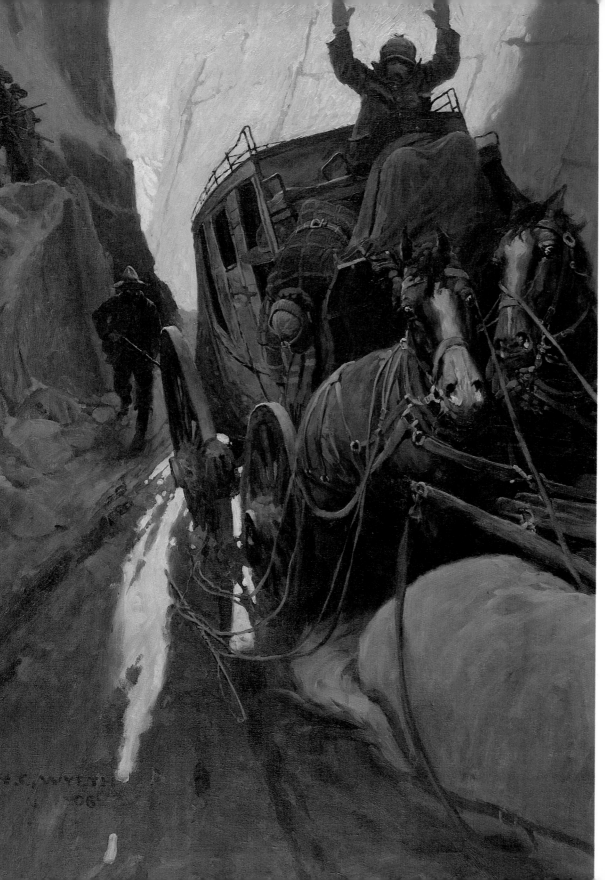

N. C. WYETH *"Hands up!"* (*"Hold Up in the Canyon"*) *1906* (2)

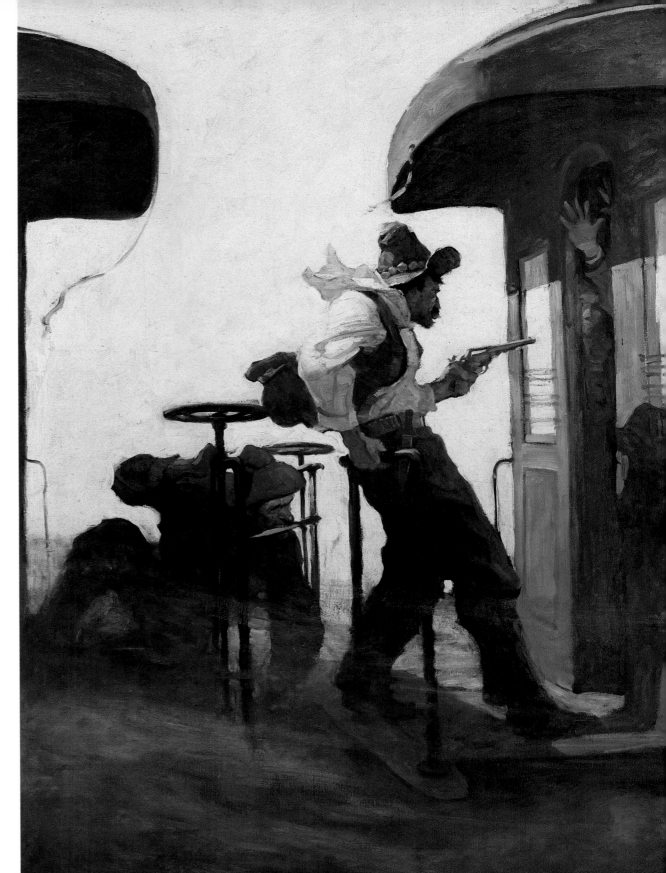

N. C. WYETH *"McKeon's Graft" ("Train Robbery") 1912 (19)*

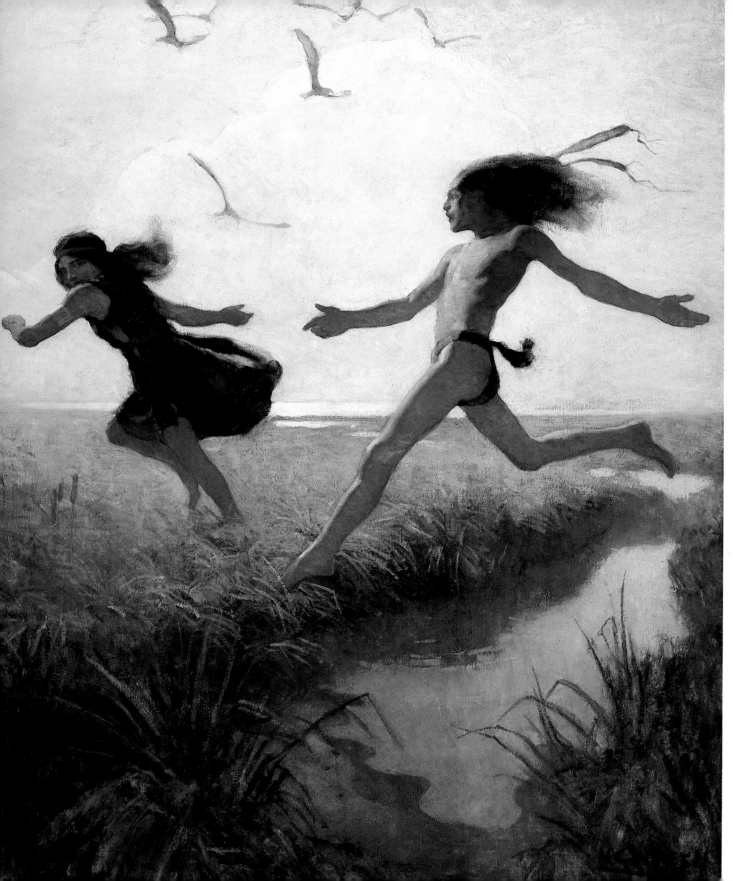

N. C. WYETH
*"The children were playing
at marriage-by-capture" 1911 (9)*

92

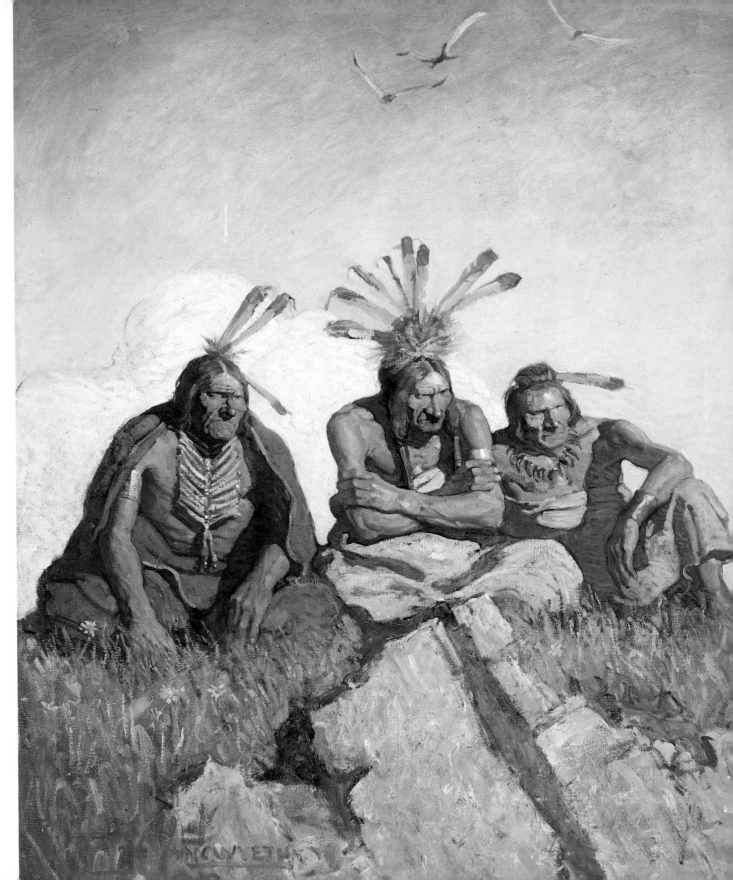

N. C. WYETH
"Nothing would escape . . ."
("The Guardians") 1911 (10)

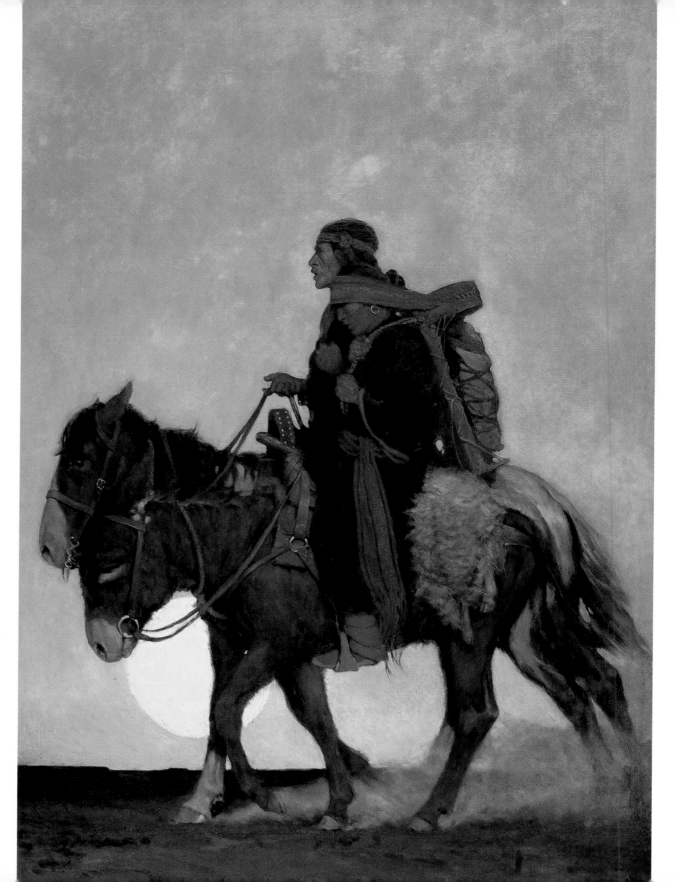

N. C. WYETH
"On the October Trail" ("A Navajo Family") 1908(5)

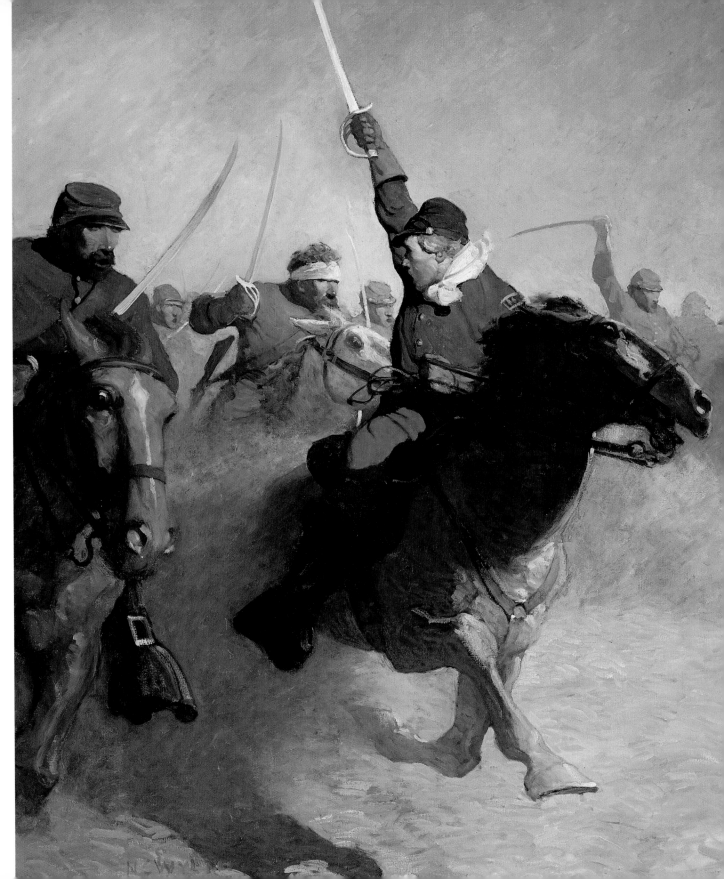

N.C. WYETH *"War" ("The Charge")* 1913 (28)

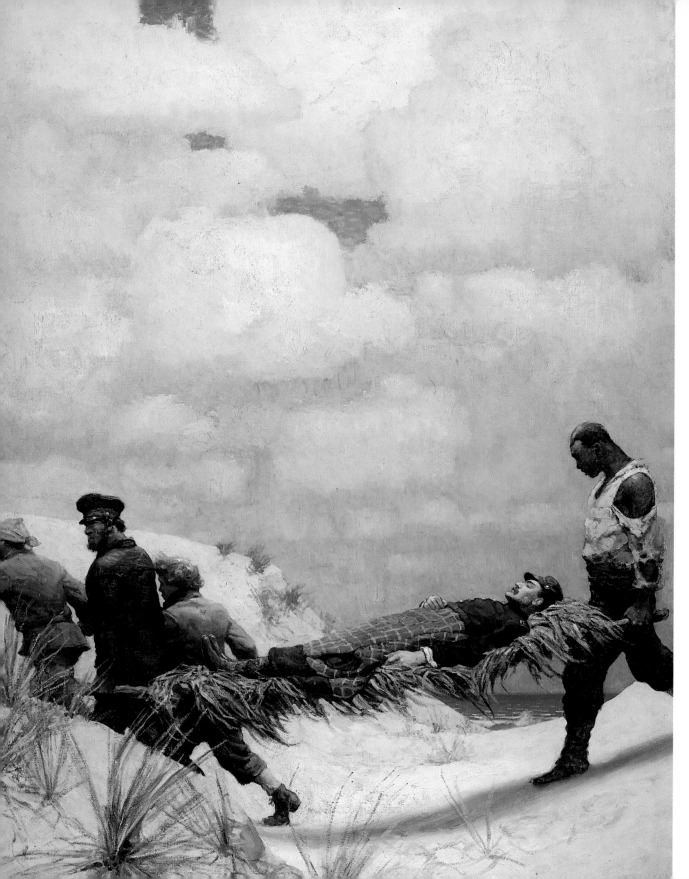

N. C. WYETH *"The Rescue of Captain Harding"* 1918 (38)

96

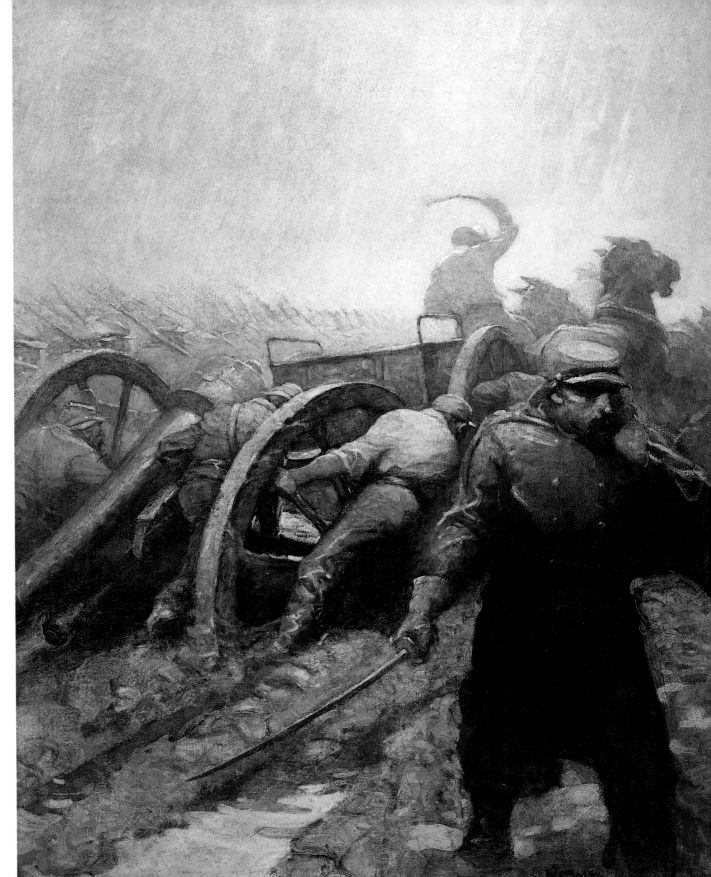

N. C. WYETH *"The Road to Vidalia"* 1912 (20)

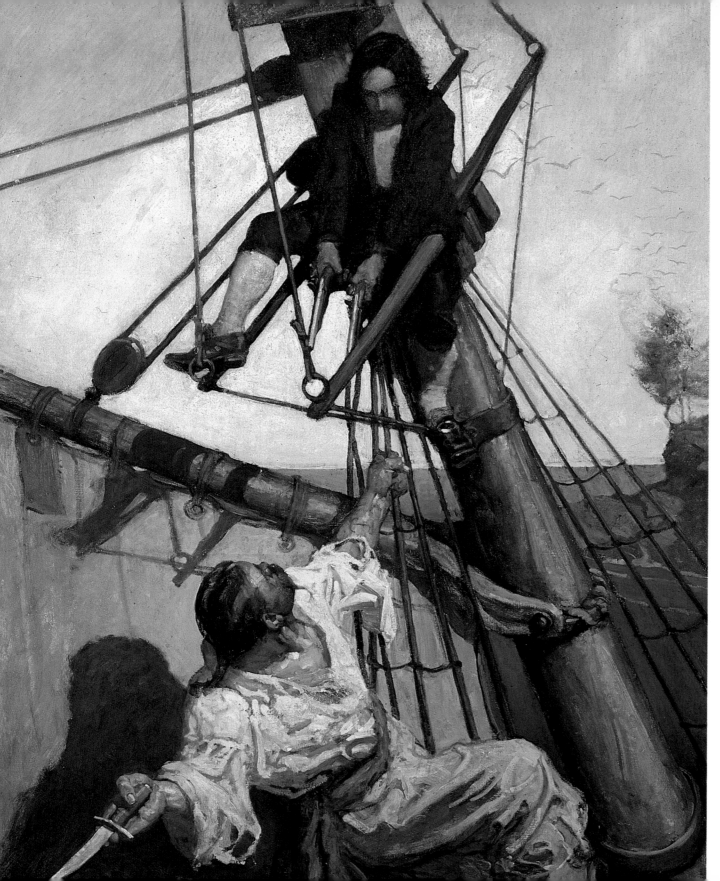

N. C. WYETH *"Israel Hands"* 1911 (14)

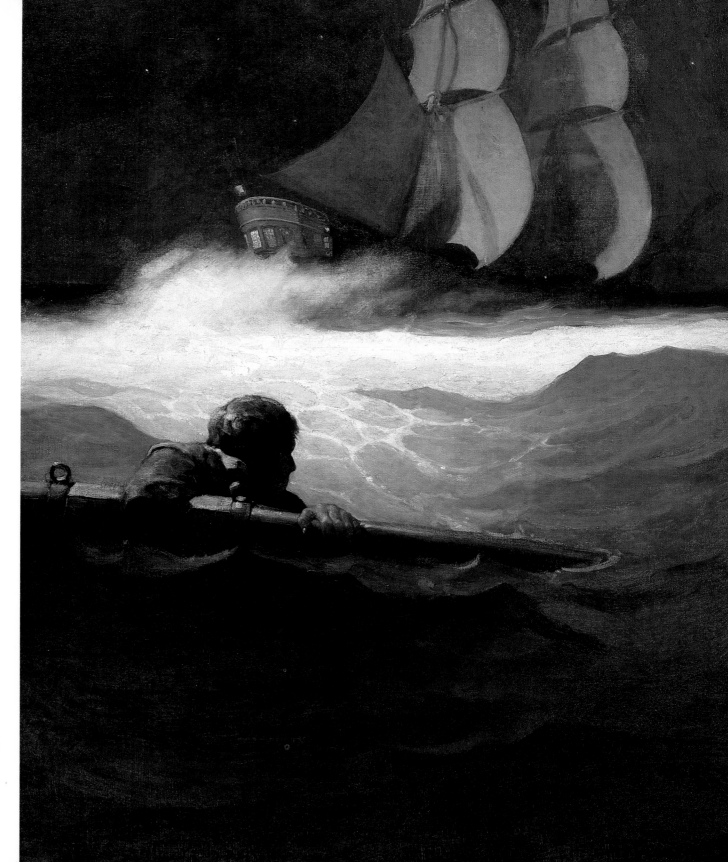

N. C. WYETH
"The Wreck of the 'Covenant'" 1913 (27)

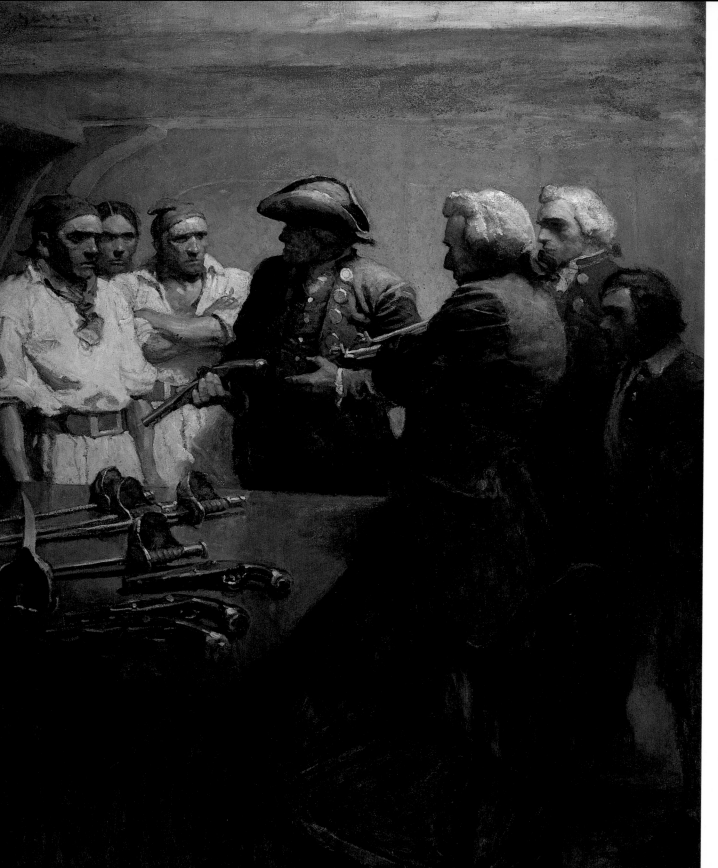

N. C. WYETH *"Preparing for the Mutiny"*
("Serving Out the Weapons") 1911 (16)

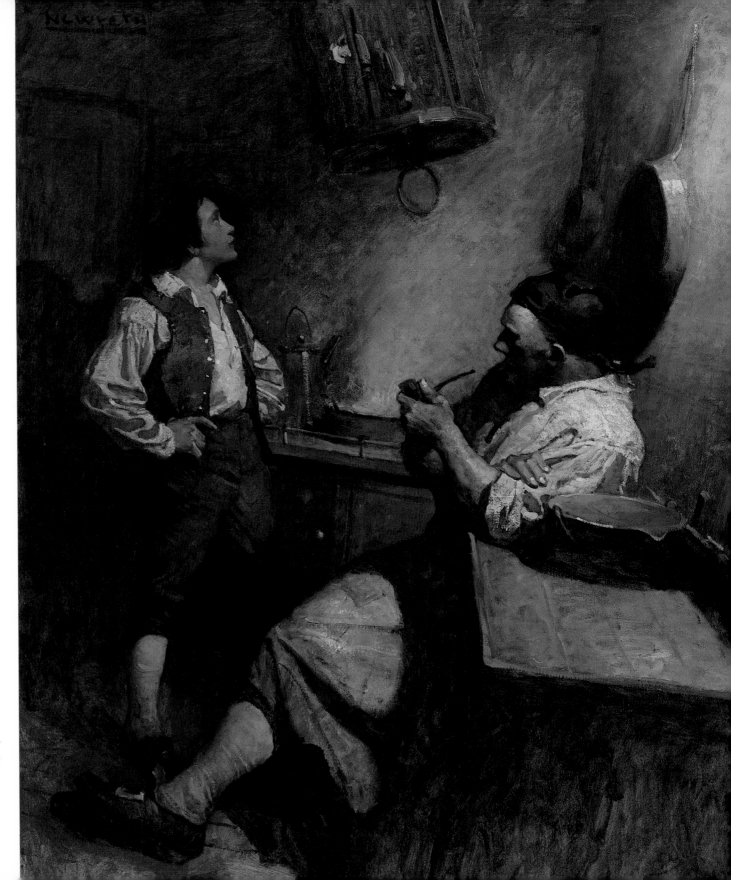

N. C. WYETH *"Long John Silver and Hawkins"*
("In the Galley with Long John Silver") 1911 (15)

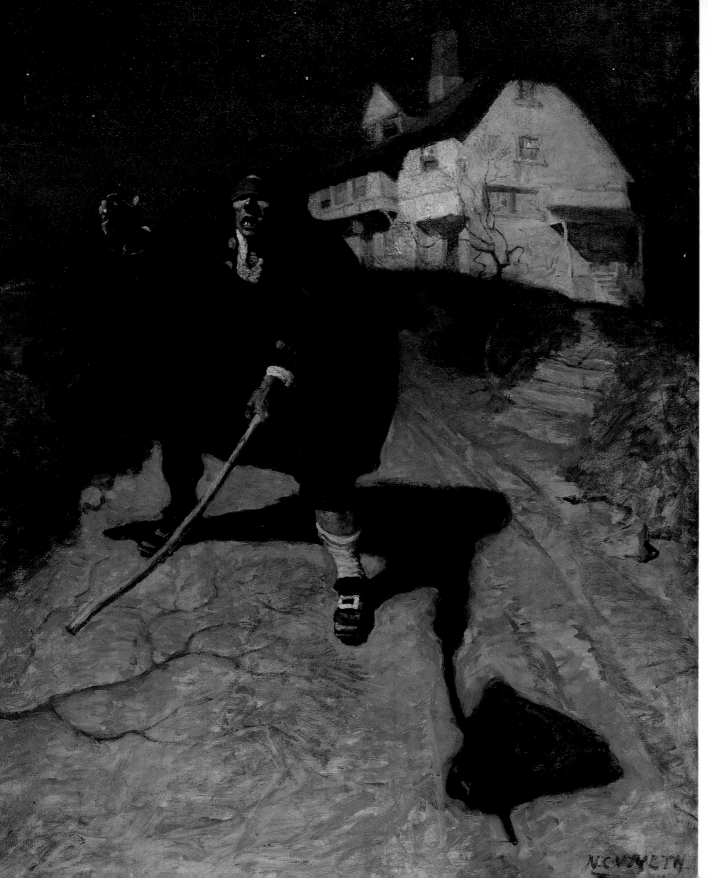

N. C. WYETH
"Old Pew" ("Blind Pew") 1911 (17)

102

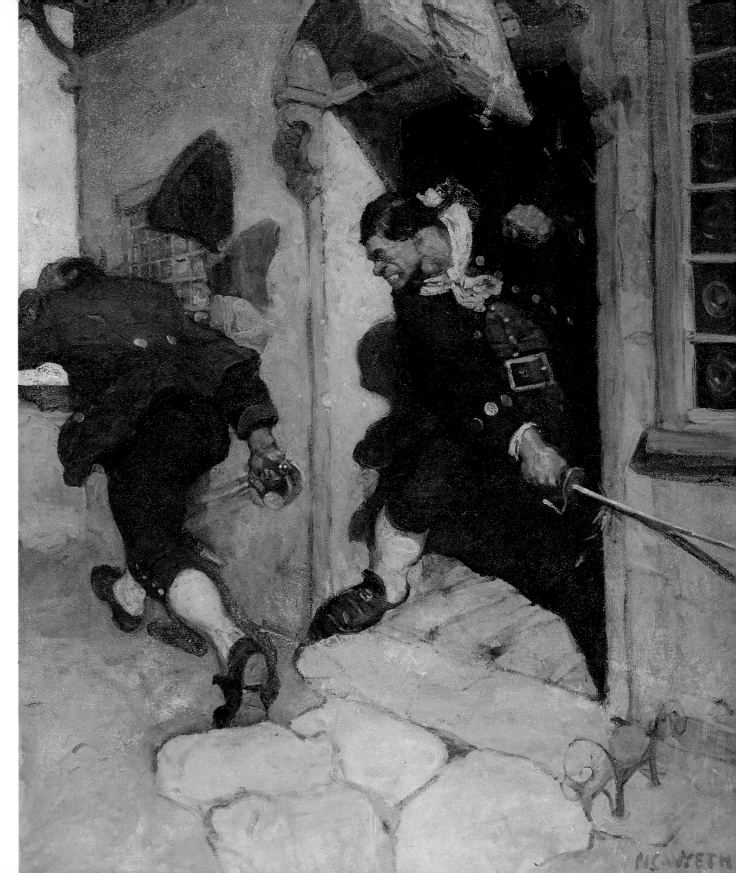

N. C. WYETH
"Captain Bones Routs Black Dog" *1911* (13)

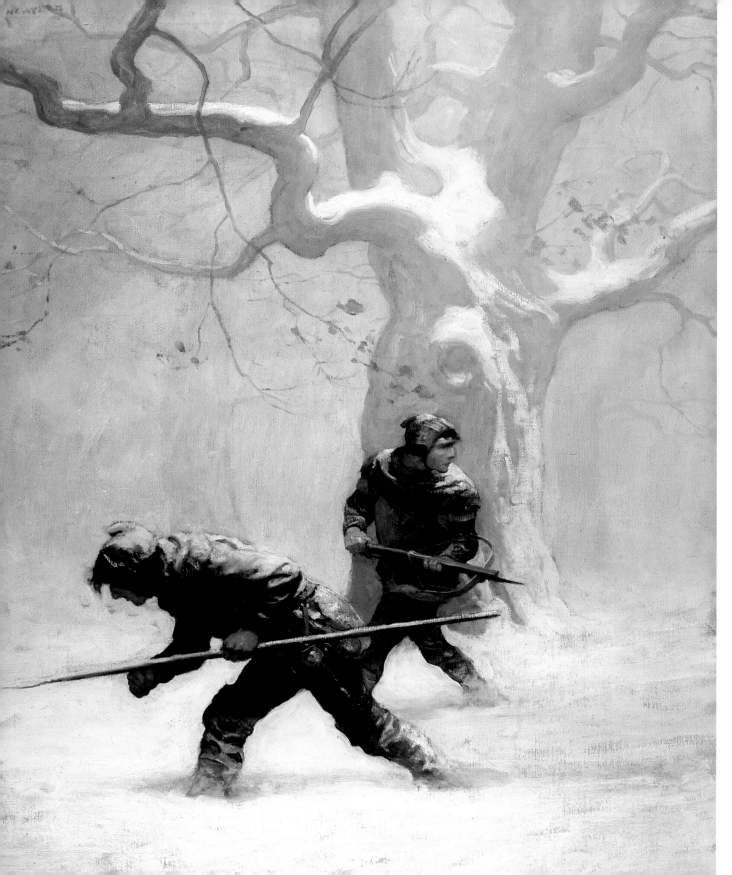

N. C. WYETH *"And Lawless, keeping half a step
in front of his companion . . ."* 1916 (29)

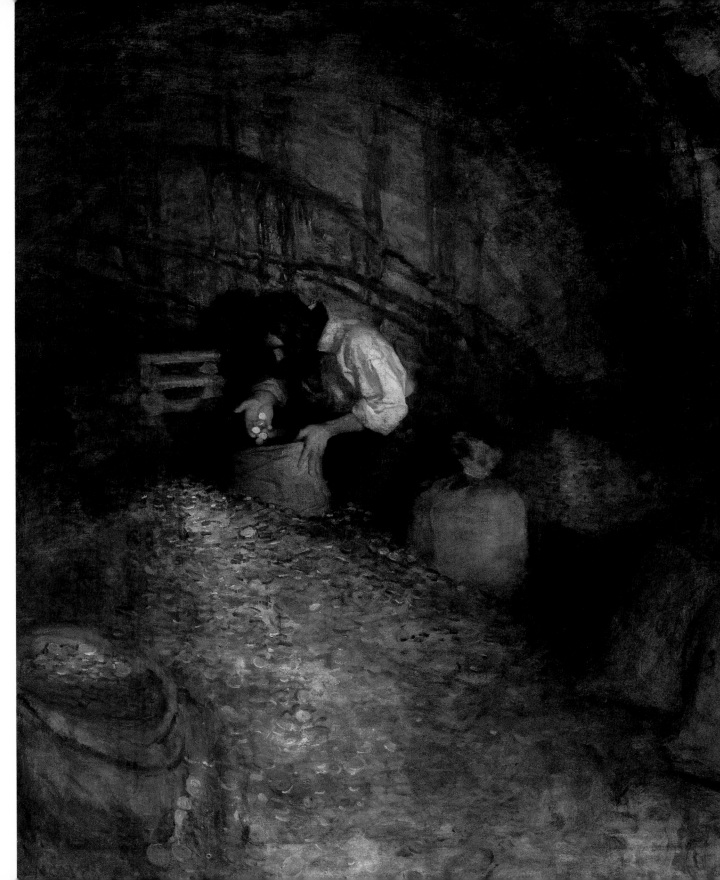

N. C. WYETH *"The Treasure Cave!"* *1911* (18)

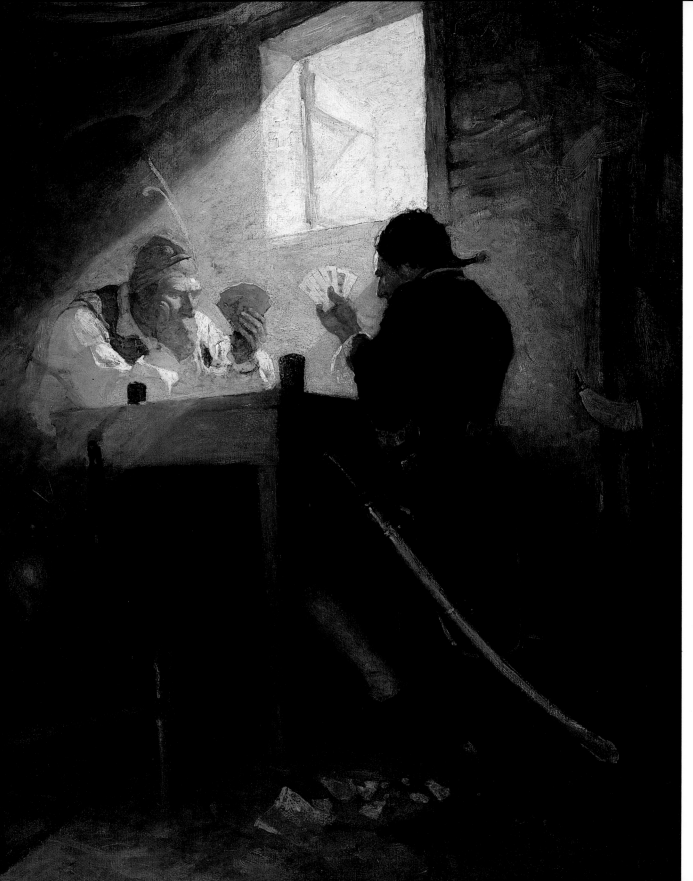

N. C. WYETH
"At the Cards in Cluny's Cage" 1913 (23)

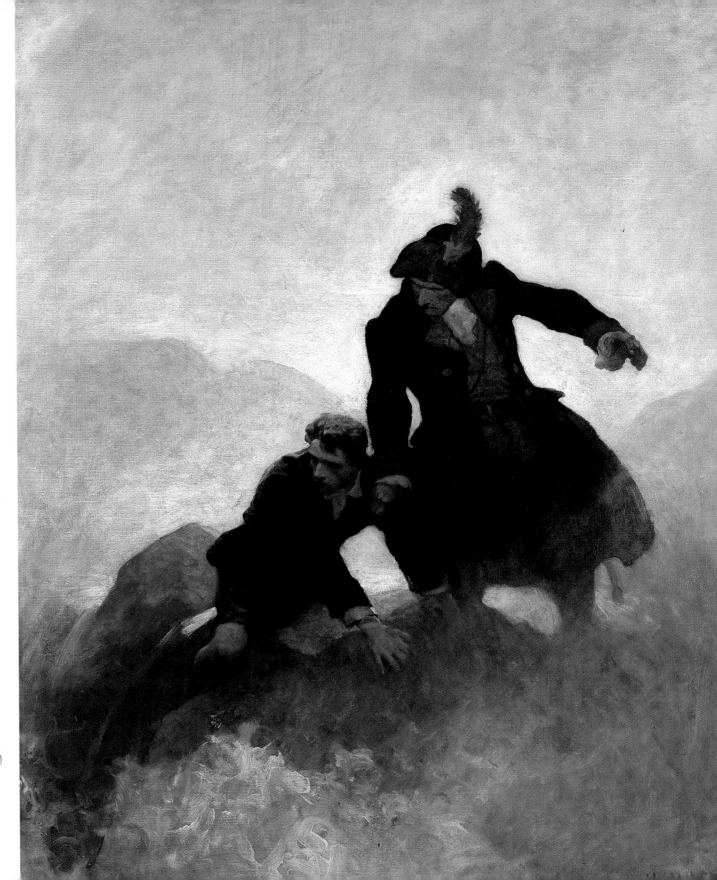

N. C. WYETH
"The Torrent in the Valley of Glencoe" 1913 (26)

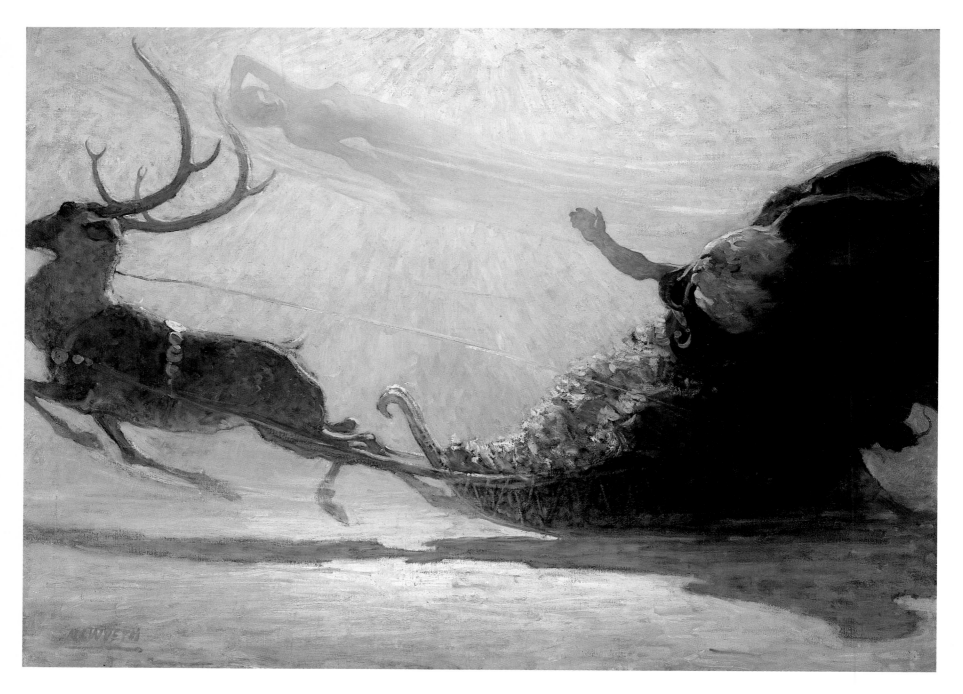

N. C. WYETH *"The Magician and the Maid of Beauty"* *1912* (21)

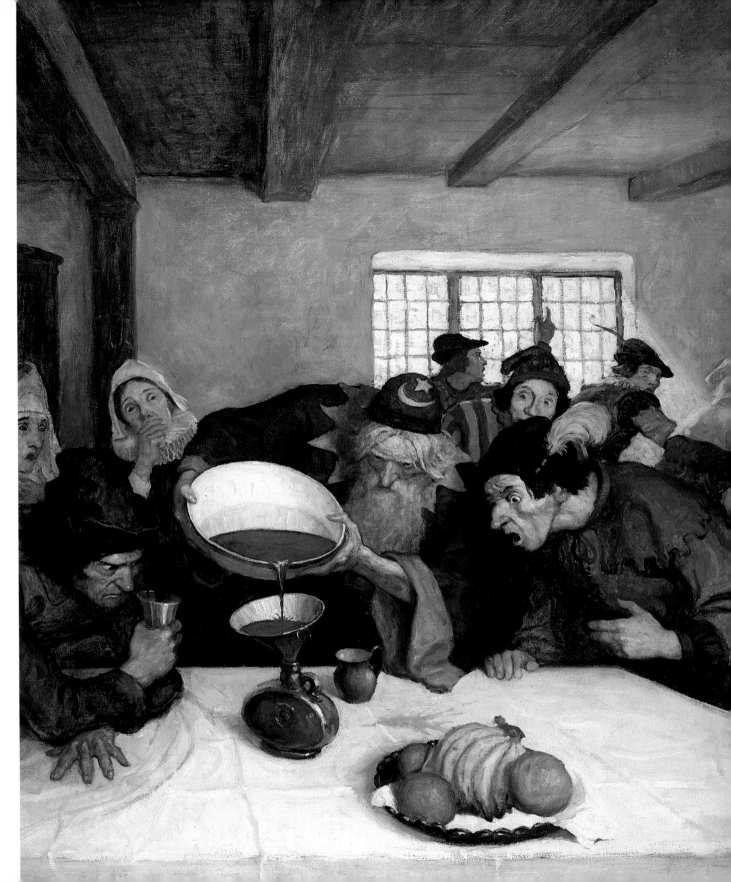

N.C. WYETH *"The Astrologer Emptied the Whole of the Bowl into the Bottle"* *1916* (32)

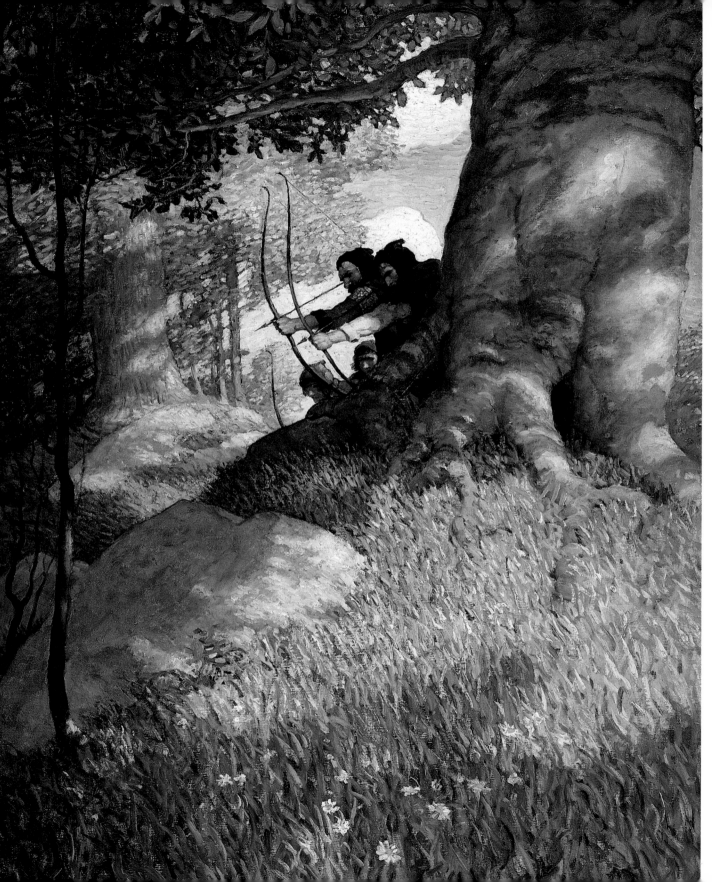

N. C. WYETH
"Robin Hood and His Companions
Lend Aid . . ." 1917 (37)

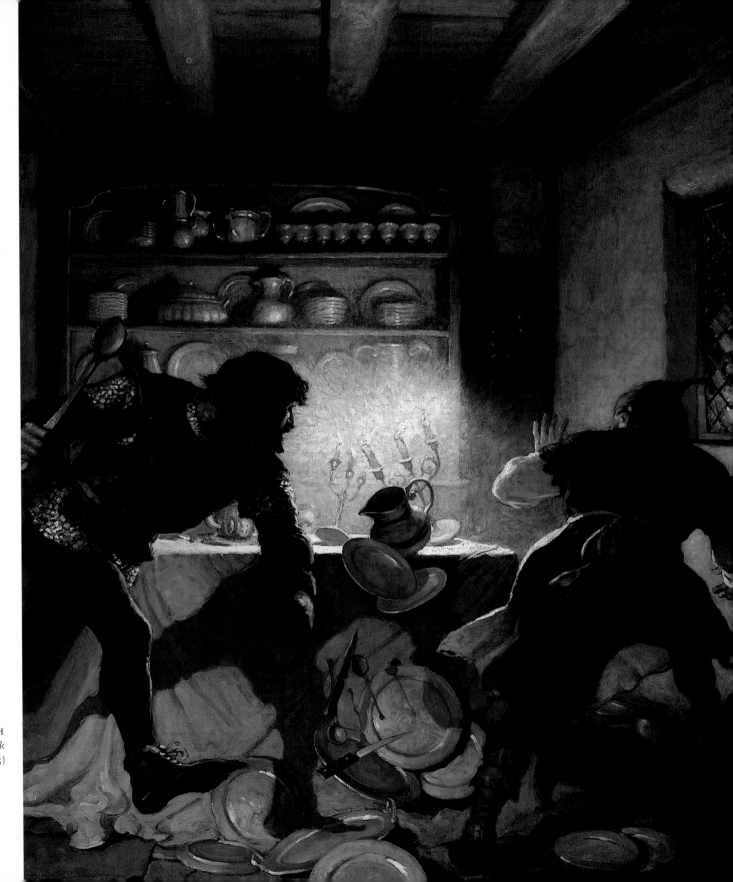

N. C. WYETH
"Little John Fights with the Cook
in the Sheriff's House" *1917* (35)

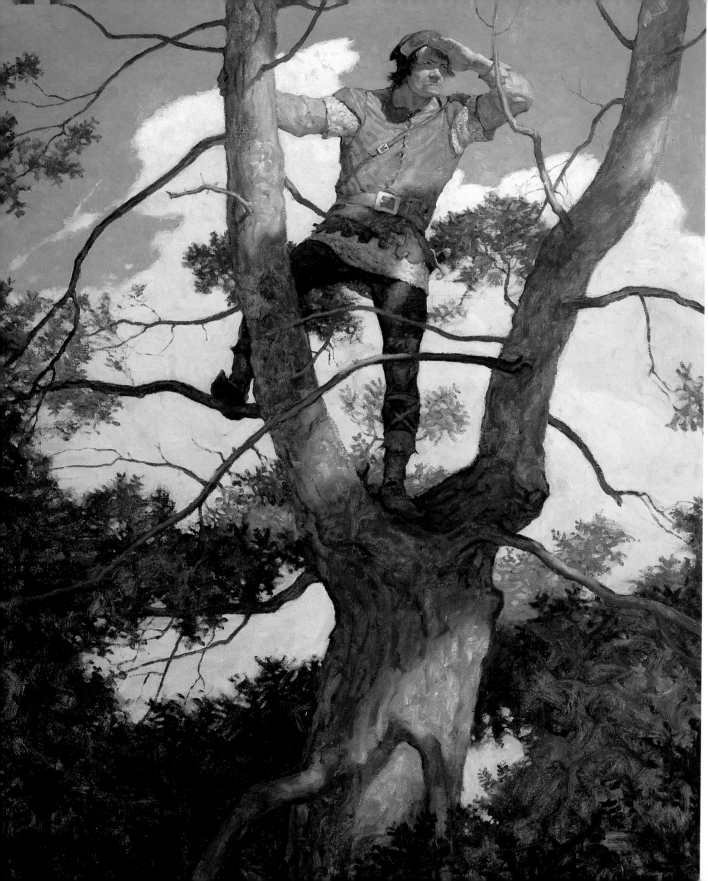

N. C. WYETH
"*In the fork, like a mastheaded seaman . . .*" *1916* (30)

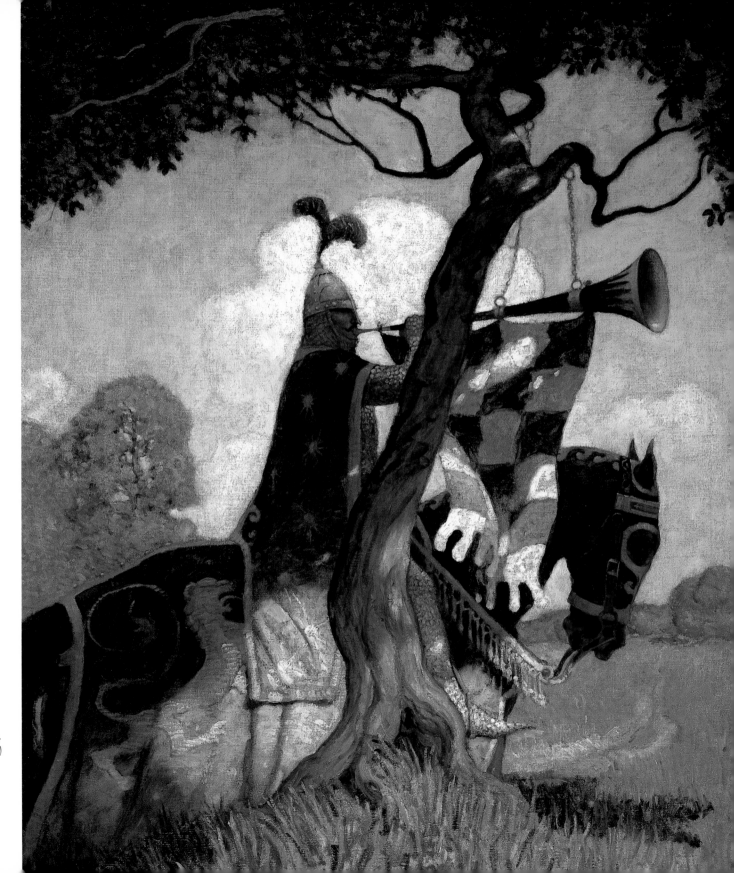

N. C. WYETH *"It hung upon a thorn,
and there he blew three deadly notes"* 1917 (33)

N. C. WYETH
"The Passing of Robin Hood" 1917 (36)

114

N. C. WYETH
"Death of Edwin" 1921 (39)

Overleaf: ANDREW WYETH
"Maidenhair" (detail) 1974 (59)

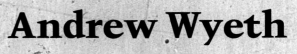

Andrew Wyeth

THOMAS HOVING

THOMAS HOVING

Andrew Wyeth

What are we to make of the work of Andrew Wyeth, that most puzzling and misjudged American painter of the second half of the twentieth century? The serious critics don't offer a clue. For the most part they either ignore him or reject him— usually for silly reasons or because they feel they are in some sort of aesthetic ideological warfare with him. Hilton Kramer tossed off the remark a few years ago that after seeing the Wyeth show at the Metropolitan, he was relieved to get into a Yellow Cab, so depressed he was at the painter's use of dung-brown colors in his depiction of the Kuerners' farm in Pennsylvania. And John Russell, the senior art critic of the *New York Times*, once stated in a letter to Wyeth that he felt uncomfortable even to be corresponding with the artist, being as he was "on the opposite side." It's not only Wyeth's severest critics who are in the dark about him. Many of his staunchest supporters are unaware of who Wyeth is and what he has achieved, believing him to be merely a devilishly clever technician or a painterly Knight Templar of the American Way.

Just where does Andrew Wyeth fit into the history of American painting anyway? If you sift through the myriad styles, trends, tendencies, and modes that have burst forth in the past forty or fifty years and get down to basics, it's fair to say that only two styles and three movements have been significant. The styles are abstraction and realism. The former has been powerful and assertive, and the latter for the most part old hat and febrile. The three major movements incorporating several schools of painting have been abstract expressionism, abstract impressionism, and observation. The masters are Jackson Pollock for action painting, Mark Rothko and Jasper Johns for poetic evocation, and Andrew Wyeth for the school of observation. Wyeth has been gravely misunderstood because

he has always worked in an unfashionable style within the school of realism, which generally deserves its shabby reputation. But if you care to put such considerations as fashion, schools, and movements aside, and study the artist totally on what he has accomplished, a different view emerges, one that inescapably defines Andrew Wyeth as one of America's most important and innovative painters in the second half of the twentieth century.

Wyeth is far more complex than many of his contemporaries who work almost exclusively in the abstract style. What appears, at first glance, to be an insistently naturalistic world actually exhibits many degrees of abstraction. What is little noted is that invariably his vividly recognizable images of the farms, landscapes, equipment, and people of Maine and Pennsylvania began as utter abstracts— a fluid, undisciplined, and romantic series of forms and shapes, black-and-white passages, or darting, energetic scribbles and lines offering only a hint about reality. To Wyeth, initiating a work is "quite literally an impulsive act, something sharp, like darting after something." A tempera, watercolor, or drybrush simply won't work out unless, right from the start, "the thrill of the romantic and the undisciplined is combined with the joy of the direct observation of the object and its reality."

For Wyeth, direct observation goes far beyond surface appearances. "I've never been after an image of something or an illusion," he says. "I search for the *realness*, the real feeling of a subject, all the texture around it. . . . I always want to see the third dimension of something, not a frozen image in front of me, not the way the nineteenth-century American trompe-l'oeil painter William Harnett would have done it. I want to

come alive with the object. I want the primitive effect you get when you bring abstraction and the real together." By *primitive* Wyeth means striving for that startling mixture of reality and the determined negation of the real that one sees in the works of such a northern Renaissance painter as Albrecht Dürer, whom he has always revered.

Despite impressions to the contrary, Wyeth has never been shackled to a recurring subject matter. Although he seems to dote upon his subjects, he is in reality uninterested in them. As he puts it, "I finally get beyond the subject; for it means many more things to me than just one image." Wyeth's works are born from chance and instinct. They succeed only if the artist becomes excited— almost agitated. "A picture has to come naturally, freely, organically, in a sense— through the back door. I have to be careful of getting too wrapped up in the meticulousness of my technique, or getting frozen or constipated. I try to do things deliberately sloppily at times." The words could easily have been spoken by an abstract expressionist.

But can we believe him? Is this chic, glib, theatrical chitchat? A passing scrutiny of his works gives the impression that he's obsessed with just rendering a factual image. He can look, but can he see, one wonders. Yes, he can see. More than almost anyone believes. A prolonged study of his works makes the perceptive observer realize that Wyeth is only in part a realist. He is also partly an action painter and a romantic— an artist constantly shifting, changing, and searching. It might come as a shock to learn that only recently has he started to mature fully.

Although he claims he's suspicious of technique and at times holds it in disdain, he reveres the materials of his art. They influence his work more deeply than they do any other contemporary painter. Each medium is a state of mind. To know this is to begin to know the artist.

"Drawing is a very emotional, very quick, very abrupt medium. I will work on a tone of a hill . . . and then all of a sudden I'm drawn into the thing penetratingly. I will perhaps put in a terrific black and press down on the pencil so strongly that the lead will break. . . . Any medium is abstract, but to me pencil is more abstract."

Watercolor is even freer and wilder. It is something never to be tamed. "The only virtue to it is to put down an idea about what you feel at the moment."

Drybrush is for more contemplative works, or when a work arrives at a profound emotional stage. "I use a smaller brush, dip it into color, splay out the bristles, squeeze out a good deal of the moisture and color with my fingers so that there's only a very small amount of paint left." Drybrush is layer upon layer— a definite "weaving process."

Tempera, which Wyeth learned from his brother-in-law the late Peter Hurd, is the pinnacle, combining aspects of drawing, watercolor, and drybrush into a highly serious state of mind. It is, as is well known, an exceedingly dry pigment mixed with distilled water and the yolk of egg. When he talks about the medium, the artist becomes rapt. "I think the real reason tempera fascinated me was that I loved the quality of the colors: the earth colors, the *terra verde*, the ochers, reds, the Indian reds, and the blue reds are superb." He adores the natural quality of tempera because it reminds him of the dry mud of the Brandywine River valley. "I've been blamed for the fact that my pictures are colorless, but the color I use is so much like the country I live in. Winter is that color here in Pennsylvania. If I see a blue bird or something spontaneous with a brilliant flash of color, I love it, but the natural colors are the best. I really like tempera because it has a cocoon-like feeling of dry lostness— almost a lonely feeling."

Wyeth paints his temperas very broadly at first, then "tightens down" on them. Tempera has to be painted in massive and slow layers, "the way the earth itself was built." But he doesn't try to gain motion by freedom of execution. "It's all in how you arrange the thing," he explains, "the careful balance of the design *is* the motion. It's a moment that I'm after, a fleeting moment, but not a frozen moment."

He confesses he has to watch himself with tempera so as not to become too perfect. When he finishes a tempera that seems to have technical perfection, he always discovers that, in time, he doesn't like it.

His materials also reflect degrees of mental and physical stamina. It is important to remember when one looks at his work that drawing is the quickest, most facile, and least exhausting. Watercolor is used after he is tired from months of laying down a tempera. When he begins to feel stronger and thirsts for greater character, he switches in mid-course and creates a drybrush from the untrammeled freedom of the watercolor, and then, after that— maybe— he will start the slow and difficult process of building up the many layers of the tempera.

One of the most carefully constructed, yet deliberately undisciplined, temperas Wyeth ever produced is "Distant Thunder" (1961; page 40), the joyful, poetic, and evocative study of his wife, Betsy, dozing in a meadow in Maine, a box of strikingly blue berries beside her and a pair of glistening black binoculars nearby. The marvelously painted spruce trees, stiff and alert, are like sentinels protecting her against the approaching storm. Classical, orderly, and abstract— as measured as any Mondrian— this work manages to combine a profound sense of humanity and spontaneity with a secure, yet almost hidden, sense of geometry. The freedom of the application of paint is a revelation. One has only to approach the grasses and ferns very closely with one's eye to realize the stunning vitality and near carelessness with which they have been rendered. The chiaroscuro of each blade has been meticulously attended to, but without formula or rigidity. It's Dürer's "Great Piece of Turf" set to modern music.

Perhaps the most striking characteristics of "Distant Thunder" are its pungent environment and captured movement. The spruce-and-salt-scented atmosphere, the temperature of the waning afternoon, the lingering warmth of the sun, and the incipient coolness of the shadows are unparalleled. And all movement has been stilled for that brief moment just before the approach of the thunderstorm. Combined, these flavors penetrate deeply into our consciousness.

Throughout his entire career, Wyeth has been deeply influenced by two localities and a handful of people. One locality is the famous farm in Chadds Ford, Pennsylvania, owned by the late Karl Kuerner, one of the people who particularly fascinated him. The other place is, of course, the

Olson property in Maine where he was inspired to create his most famous painting, "Christina's World" (page 46), the image of another human being who intrigued him in aesthetic and human terms. The Kuerners' farm appealed to him primarily because it possessed those cherished colors of the Brandywine River valley and the feeling of the "strength of the land," the enduring quality of it, and the "solidity of it." Maine, on the other hand, appealed for the opposite reason. Maine is "spidery, light in color, windy perhaps, sometimes foggy, giving the impression sometimes of crackling skeletons rattling in the attic."

One of the primary misconceptions about Wyeth's studies of the farmland at Chadds Ford is that the painter was caught up by the "poetry of farming" or the rugged individualism of the farmer. Not at all. "I didn't go to that farm because I was in any way interested in it or because it was in any way bucolic. . . . The abstract, almost military quality of that farm directly appealed to me. The farm is very utilitarian in its quality. To enter the Kuerner house with those heavy thick walls and have beer on draft or hard cider was an exciting thing. To see the hills capped with snow in the wintertime or to look at the tawniness of the fields in the fall all made me want to paint it. But here again, I backed into it. I didn't think it was a picturesque place. It just excited me, purely abstractly and purely emotionally."

Now that Karl Kuerner is dead and his wife, Anna, is slipping into the penumbra of advanced age, the Kuerner place has little interest for Wyeth. But in the 1960s and 1970s, one powerful image after another emanated from the place and each one meant far more than a portrait of a farmer or a farm.

Early in 1960 at the Kuerners' he painted one of the most impressive drybrush works of his career. It's entitled "Young Bull" (page 135) and demonstrates perfectly that process of "weaving and layering of paint" over countless series of washes deep beneath the surface. "Young Bull" is a very large work, measuring 20 by 41 inches, and seems to be larger. Monumental in scope, it encompasses a vast area of territory and an equally vast series of textures, from the matte whiteness of the walls of the Kuerner house to the tensile wire of the fence door to the matted and

irregular coat of the bull, which blends into one with the astonishing stone and plaster walls. That deceptively bare hill is the only element in the picture that appears to be pristine. But a close look reveals that it, too, is tangled, matted, and used. The house, the creature, the wall, the hill all possess an indomitable strength, made even more emphatic by the disquieting presence of the ugly wire gate and television antenna.

When Wyeth combines the firmness and patience of the drybrush technique with the frenzied haste of watercolor, the results are uncanny. "Garret Room" (page 142), painted in 1962 in Chadds Ford, is a superior example of this phenomenon. It is unsurpassed in American painting of this century. He started the work out as a slapdash watercolor, planning to get the washes down broadly, working rapidly around the white parts of the quilt, which he dexterously left as the bright, clear texture of the paper itself so that surrounded by rich color they would blaze with light. It was going well, but suddenly the painter became hypnotized— he doesn't recall why— by the pillow, actually an old sugar bag, under his model's head. "Damned if I was going to go home (after all, here he was sleeping) and grab my tempera colors and start working on it." So things really got serious, the drybrush "happened," and what had started as a free-flow exercise became the intense effort of pinning down the feeling of the room, the character of the man, the aura of silence, and the focused contrasts of colors and textures. The central elements of the picture— man, the pillow, and the amazing quilt— appear to be slightly magnified, more real than real, isolated as they are by what are almost tumultuous splashes of watercolor. The mixture is at once painterly and utterly abstract.

Although Wyeth's work in tempera created in the late 1940s and 1950s can hardly be called experimental, there are certain tight, tentative passages in it that are nowhere near as good as some of the more energetic drybrush and watercolor prestudies. Such is the case in the monumental depiction of the Kuerner farm, called "Brown Swiss," of 1957, prestudies of which are superior to the finished tempera. But by the mid-1960s, when Wyeth had mastered the delicate balance of those almost conflicting spirits of the medium— the permanent and the loose— his temperas reached a plateau of greatness that has never diminished.

"Spring Fed" (page 134) of 1967 is a case in point. This large tempera of the Kuerners' milk room, with the cattle milling around outside, the punctilious rectangles of the windows, the streak of snow on the hill in the distance, the silvery bucket looking like a Renaissance parade helmet, the stolid, everlasting water trough in the foreground, is one of the most powerful images of the Kuerner farm, brilliantly expressing that utilitarian sense of the place and something enduring, rock hard, and in constant, infinite movement. When he describes it, the painter becomes lyrical. His words mirror the depth of the picture itself. They seem to symbolize his overall aesthetics and philosophy of aesthetics.

I started "Spring Fed" because I was taken by the remarkable variety of sounds in the Kuerner farm. One day I became conscious of the sound of the running, trickling water all around the place. . . . I could hear the water running, nature itself running, pouring itself out. This picture has a lot of sound to it, everything is sound, the clang of the bucket, the sound of the hoofs, sound of the water. . . . It's not just a bucolic picture.

In his representations of the Kuerners' farm, Wyeth took countless liberties, changing the number of windows on the farmhouse, moving trees and stumps, removing Anna from the milk room because it suited his feeling for the composition. In Maine, he paid scrupulous attention to the facts: the complete feeling of the time of day, the exact temperature of the foggy evening, or the precise number of clapboards on the side of a house. In his almost frighteningly chaste "Weather Side" (page 37), the depiction of the Olson house from the windy flank, Wyeth claims to have "literally put the building together as if I were the builder." He actually counted and studied every one of the clapboards. One of the most moving passages of the painting is the section on the right-hand side, near the window where the cloth is stuffed into the broken pane. There one sees a couple of white pieces of wood. "Those are out of my house," Wyeth says with pride. He was intrigued not only with the monumentality of the Olsons' frail farmhouse, but with its disparate fragments— rather like Christina Olson herself.

I wanted "Weather Side" to be a true portrait of that house — not a picturesque portrait, but a portrait that I would be satisfied to carry around in my wallet to look at, because I knew the house couldn't last.

I had this deep feeling that it would not be long before this fragile, crackling-dry, bony house disappeared. I'm very conscious of the ephemeral nature of the world.

To many observers, "Weather Side" is almost too minimalist, a trick perhaps. Again, this is the result of looking too fleetingly at the painting. It is anything but simple. The bucket in the foreground is a sea unto itself. The second bucket near the end of the drain is an overture to a most complex Rube Goldberg construction, pinpointed, but not in the least dramatized, by the artist. The three flashes of color, when one finally perceives them, come as burning flares: the redness of the geranium, the pink-yellow of the faded curtain on the second-floor window, and the striking blue of the balled-up sheet. Grasses, metal, stone, wood, glass, fabric— the recurring leitmotives of Andrew Wyeth.

Christina Olson died in the winter of 1969, and instantly Wyeth took on as his principal Maine study a fourteen-year-old Finnish girl, Siri Erickson (page 139). It was a rebirth. "These pictures of the young Siri are continuations of Olsons, and at the same time they are sharp counteractions to the portraits of Christina, which symbolize the deterioration and dwindling of something. Then you get suddenly this change of such an invigorating, zestful, powerful phenomenon. Here was something bursting forth, like spring coming through the ground." The portrait of Siri entitled "Indian Summer" (page 48) is just such a burst of life unidealized, unromanticized, frank, and yet throbbing with a tense expectancy. The halo of darkness that encircles the young girl's head is, at one moment, real pine trees, and then at another, that hint of the ephemeral nature of life that so intrigues Wyeth. "Indian Summer" is romance, held at bay; theater, reined in.

When Wyeth lets himself go almost to the edge of theatricality, he can be at his very best. But he doesn't allow himself that fully free expression very often. As always, he has to come across a scene and a moment by pure chance, and then, if moved, he will proceed rapidly and unerringly. This is apparent in what is perhaps the best watercolor he ever created, "Wolf Moon" (page 53) of the winter of 1975. He was scouting around up there behind the Kuerner house at one o'clock one winter night. The moon was full and he was enchanted by the way it illuminated the melted patches of snow on the hill. Suddenly he heard a soft, regular sound from the woodshed. It was Anna Kuerner chopping kindling for the stove for breakfast. Wyeth listened, captivated. At length she stopped. The light in the woodshed went out as did the other lights, and finally there was only silence and the moon, the great expanse of the house, and the hill. "I made some pencil sketches to engrave the idea in my mind," he says, "and rushed back to the studio where I painted 'Wolf Moon' in pure watercolor in one go— in an hour or half an hour." He had to get it down in one blow, quickly, since he knew it would work or fail utterly. The next morning he saw that it had worked.

His original pencil drawing is quite different from the finished composition, being squat compared to the soaring rectangular composition of the watercolor. He virtually "shot" himself higher in the air so that he was almost taking off over the house. He emphasized the shape of the pond and an icy overflow that he had slipped on while returning. As he worked feverishly, he knew he was recording "past memory and the present and perhaps a bit of the future." He used a great deal of "luxurious black" with the whites of the pure paper. One of the striking things about this painting, which he says is "almost a caricature of the truth, something just this side of bravura," is that you can look at it every way, even upside down, and it works as a powerful abstract form.

There are some strange, anecdotal passages in "Wolf Moon," especially the jagged whites of the woodshed covered by corrugated tin. Those shapes reminded him of the fangs of the German shepherd who lived in the shed, so he emphasized them to evoke that private image. To Wyeth, the painting is like an Indian's painted face, "dark and then that glaring white." But "Wolf Moon" is also a portrait of that house, "a house full of strange qualities and in a real sense not painted from the outside looking in, but from the inside looking out and in at the same time."

On rare occasions Wyeth overreaches himself and attempts profound imagery that puzzles rather than mystifies, and cloys rather than creates a spiritual mood. Such is the case with the large tempera of 1978 called "Spring" (page 45) representing the frozen corpse of Karl Kuerner lying in a rotting patch of snow on his famous hill. Although parts of the painting are marvelously rendered— the almost mummified face of the old man and the poetic treatment of the dried winter grasses— the overall concept is trite. So much more effective, indeed, a world apart in its ability to capture one's attention and imagination, is the perverse, ambiguous, chilling statement about death in "Adrift" (page 44), a tempera painted in 1982. What is this? A suicide, a burial, or a Maine fisherman simply lying back in his dory in the afternoon sun? The painter refuses to resolve our questions, and in dismissing them, reaches our emotions in a compelling way. The painting demonstrates Wyeth at his highest degree of capability, blending his beloved abstract geometry with uncannily observed details. Perhaps by 1978 the desire to paint a portrait of Karl Kuerner had waned. Wyeth does admit that the house had begun to lose its magic as Karl began to deteriorate. And, besides, the painter had discovered a new model whom he depicted— mostly in the nude— often in one of the Kuerner farmhouse rooms. It was the Prussian woman Helga, whose dynamic and athletic figure brought about a rebirth of creativity, much as Siri Erickson had taken the place of Christina Olson.

Starting in 1972 and completing the series some fourteen years later, Wyeth recorded Helga Testorf in a remarkable chain of temperas, drybrushes, watercolors, and drawings, comprising 247 images in all (see, for example, pages 49, 140, 141). The effort is unique in the history of American art and demonstrates the artist at his mature best, investigating one human being in all states of mind and differing environments. The studies of Helga will doubtless become a landmark in contemporary painting— observation rendered in the purest way, yet with deep emotional involvement.

Today, at seventy years of age, Wyeth is still excited, surprised, and moved to create works that equal or surpass the vitality of his maturing years. But now a keener sense of order binds the spontaneity together. The enormous tempera called "Night Sleeper" (page 51) appears at first to be almost three disparate images forced into one picture plane. The artist tried too much, is one's first thought. Then, when the deftness of the classical continuity— laterally and horizontally— becomes more apparent, the observer recognizes the powerful cohesion of the composition and that it has a single subject. Wyeth has never captured the haunting glow of a miraculously clear night so well as in "Night Sleeper."

The artist is still searching. "If somehow I can, before I leave this earth, combine my absolutely mad freedom and excitement with truth, then I will have done something," he ruminated a decade ago. Of course, he's accomplished that goal a number of times, most recently in a tempera that sums up so much of his creative process and the reasons he is unique. The tempera is entitled "Ravens Grove" (page 52) and was completed in 1985. Here one sees the complete Andrew Wyeth as penetrating observer, romantic, and devotee of the abstractions in life. The powerful and menacing scrub pine is perhaps an allegory for the raven and other birds who have used the space beneath its spreading boughs to pick away at bits and pieces of shellfish they have cracked on the bleached rocks on the shore. Each shell is a moment in time, each color a mood. One hears many sounds through this painting: the wind rustling through the pine, the gentle washing of the air through the grasses— brilliantly brought into play to frame and pace the scene— and the far-off, lonely breaking of waves on the shoal. The whole picture has that distant, crackling ancientness that Wyeth so adores in Maine, which, he says, "is to me almost like going to the surface of the moon. I feel things are just hanging on the surface and that it's all going to blow away."

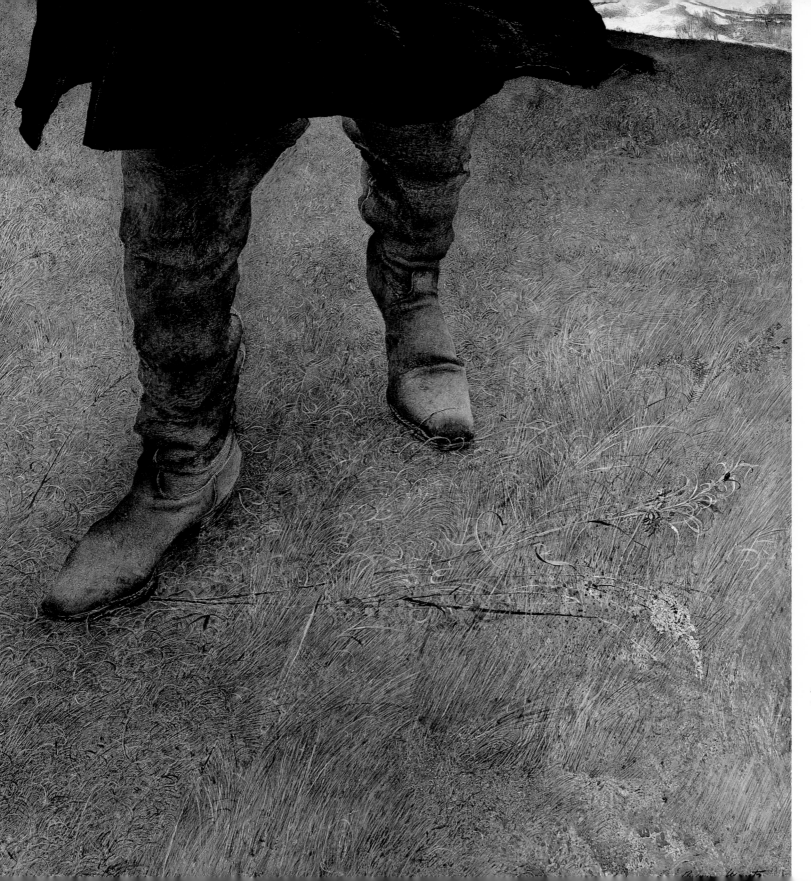

ANDREW WYETH
"Trodden Weed" 1951 (40)

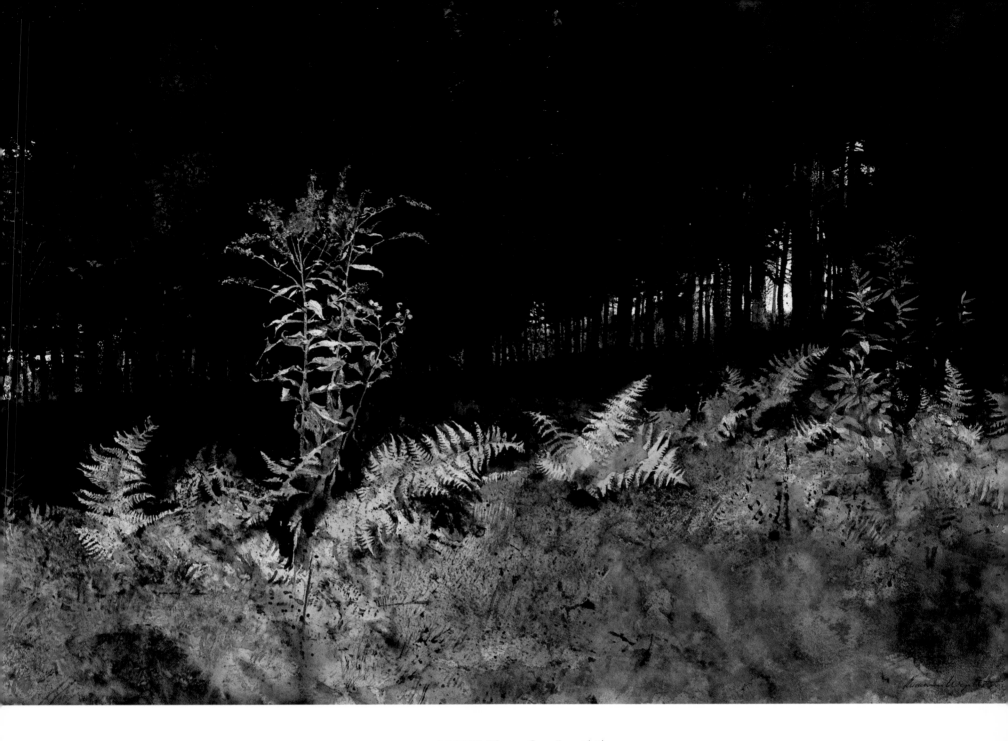

ANDREW WYETH *"Spruce Grove"* 1970 (57)

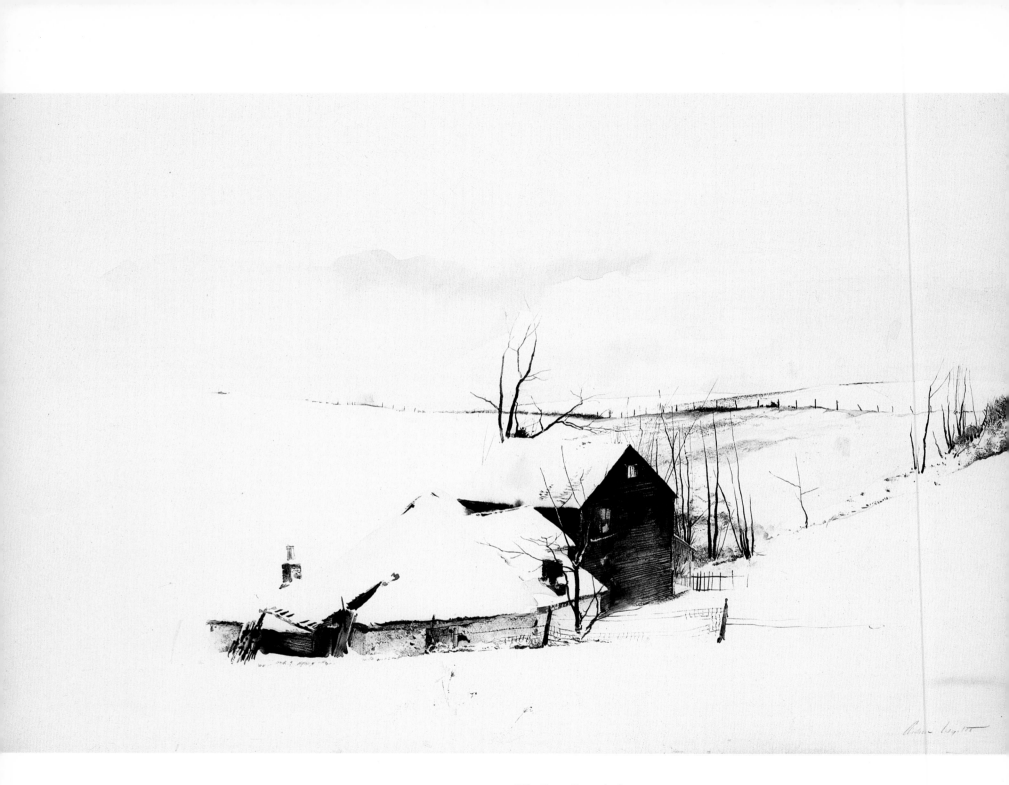

ANDREW WYETH *"The Corner"* 1953 (42)

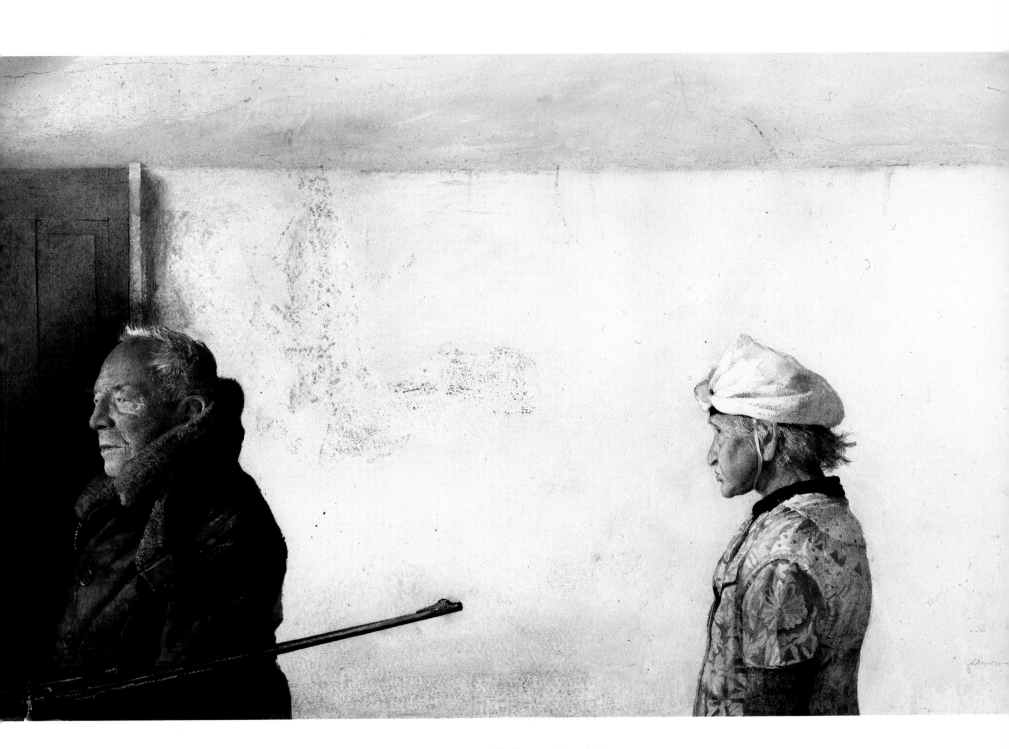

ANDREW WYETH *"The Kuerners"* *1971* (58)

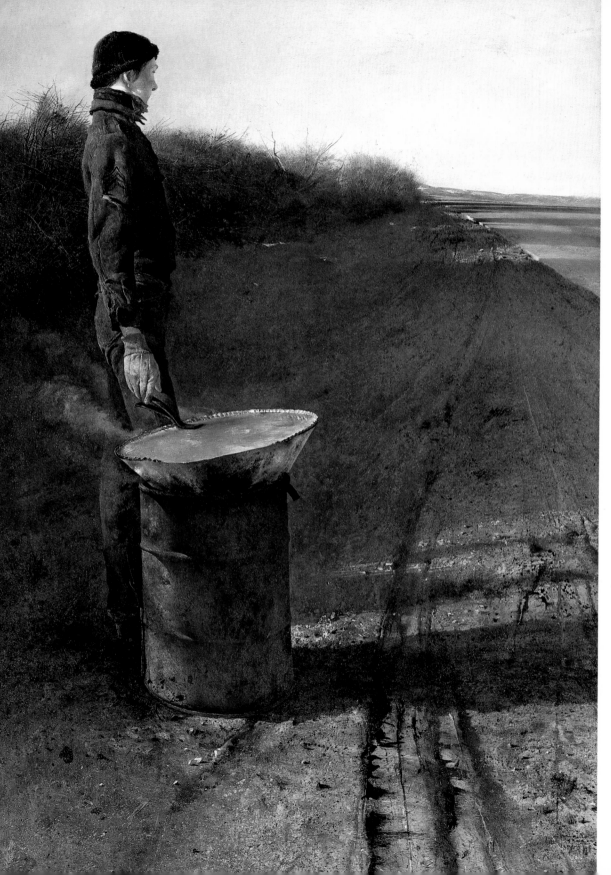

ANDREW WYETH *"Roasted Chestnuts"* 1956 (43)

128

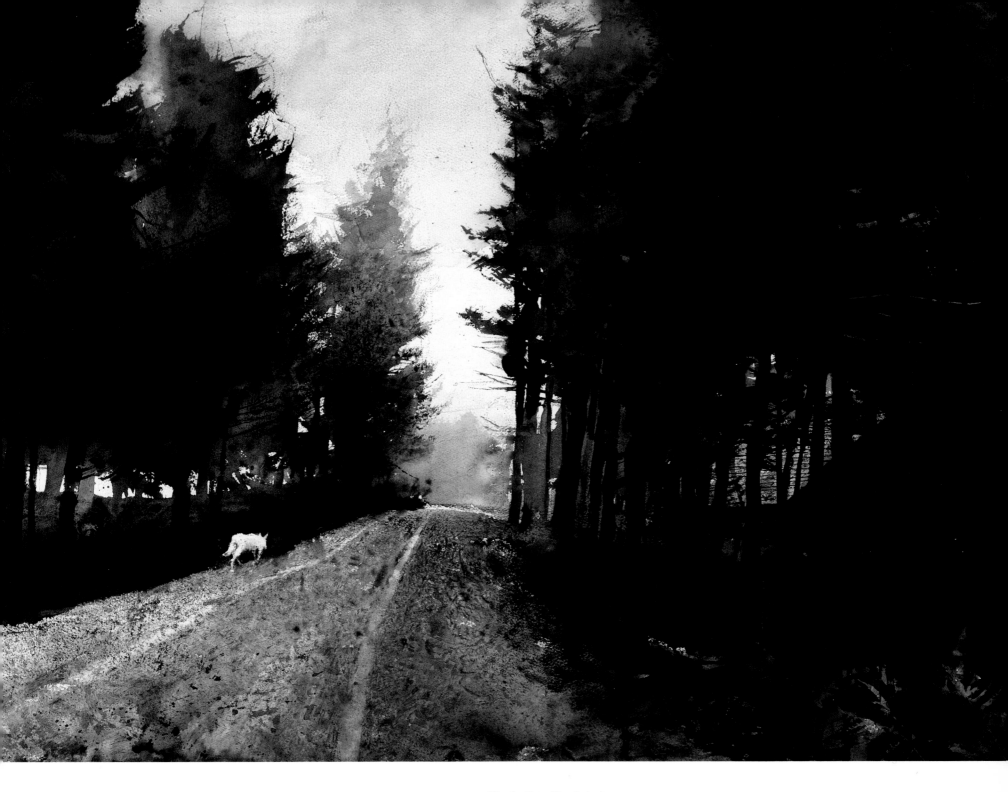

ANDREW WYETH *"Border Patrol"* 1984 (73)

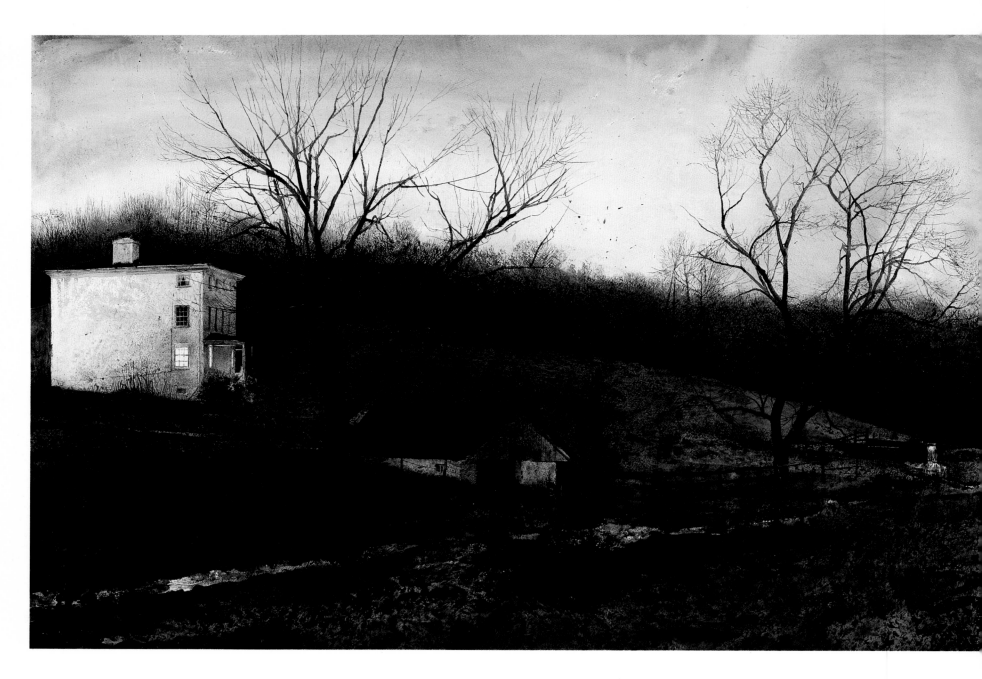

ANDREW WYETH *"Evening at Kuerners"* 1970 (54)

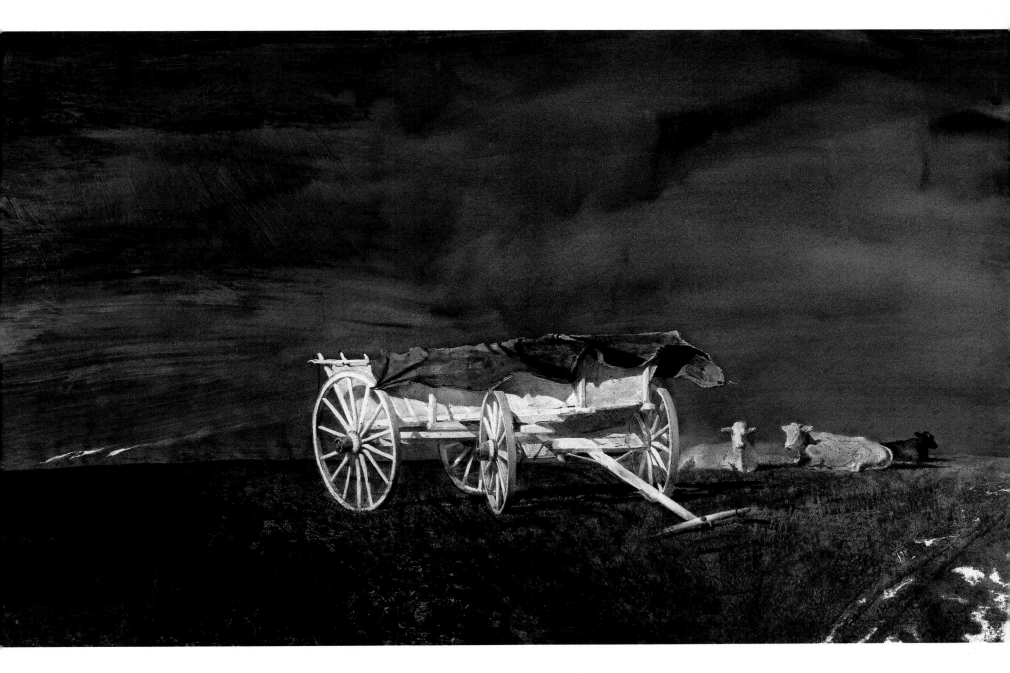

ANDREW WYETH *"Big Top"* 1981 (66)

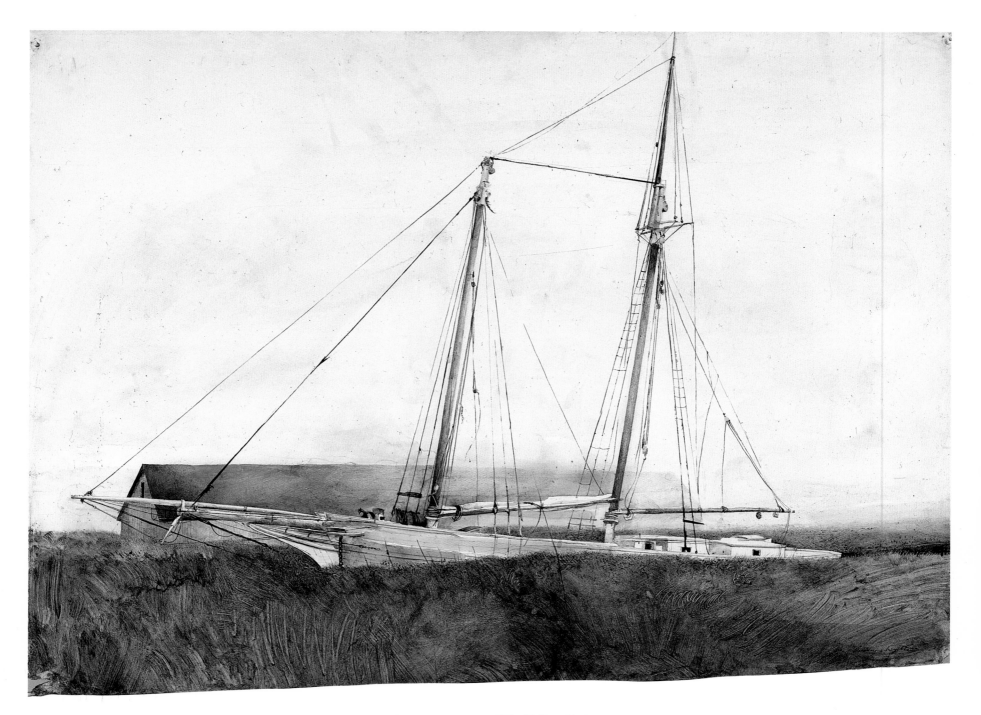

ANDREW WYETH *"The Slip"* 1958 (44)

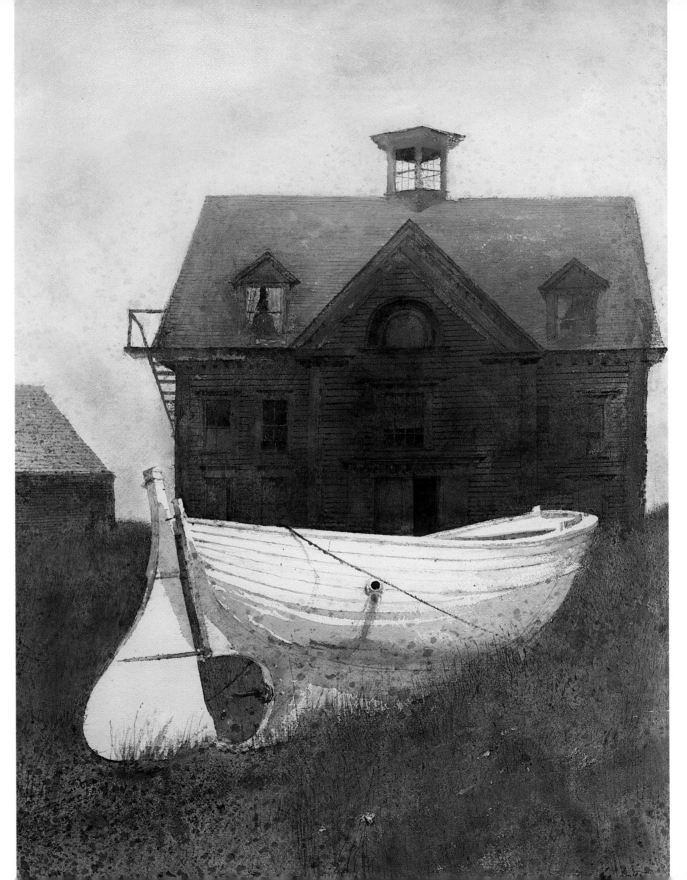

ANDREW WYETH *"Liberty Launch"* 1983 (70)

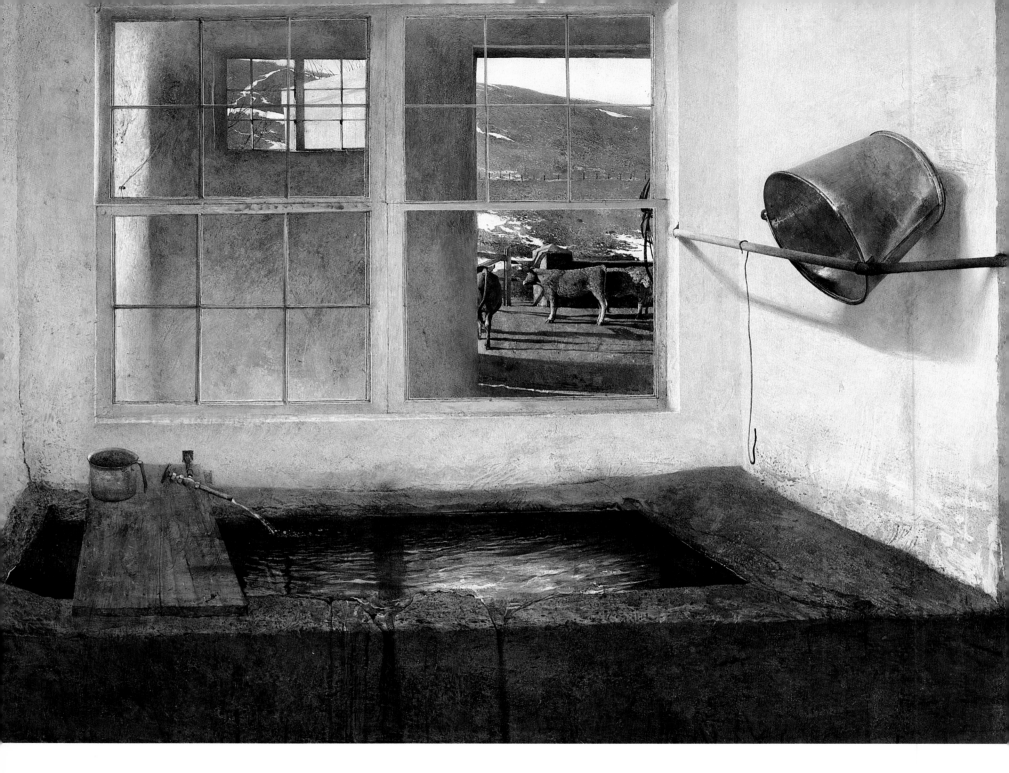

ANDREW WYETH *"Spring Fed"* 1967 (53)

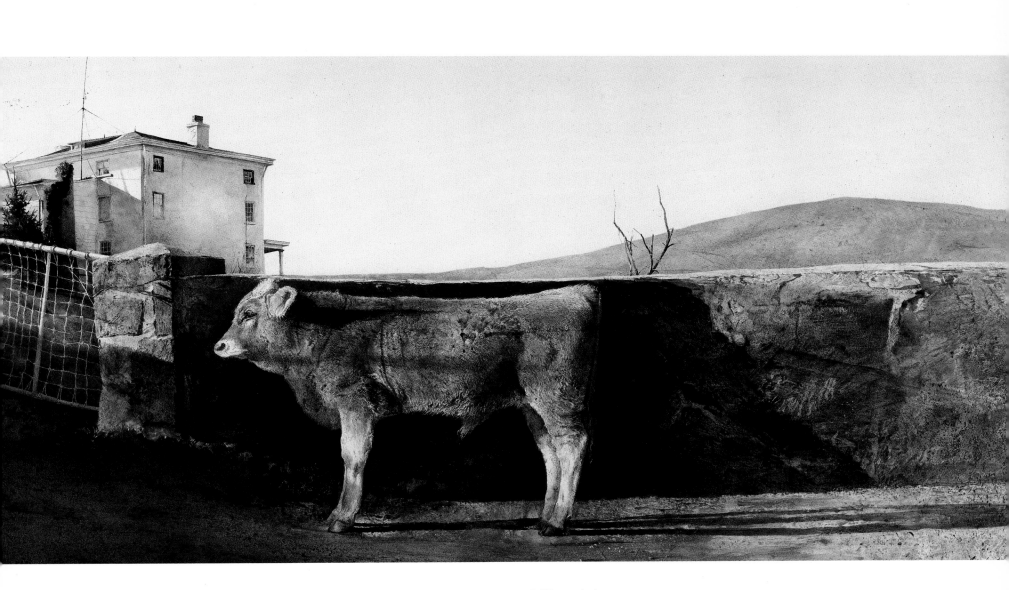

ANDREW WYETH *"Young Bull"* 1960 (47)

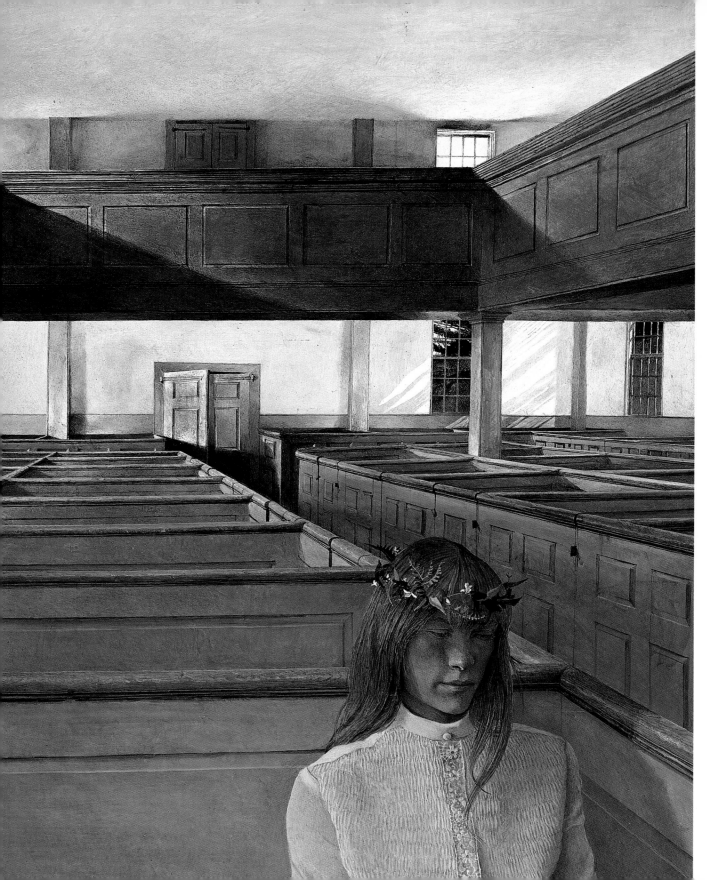

ANDREW WYETH *"Maidenhair"* 1974 (59)

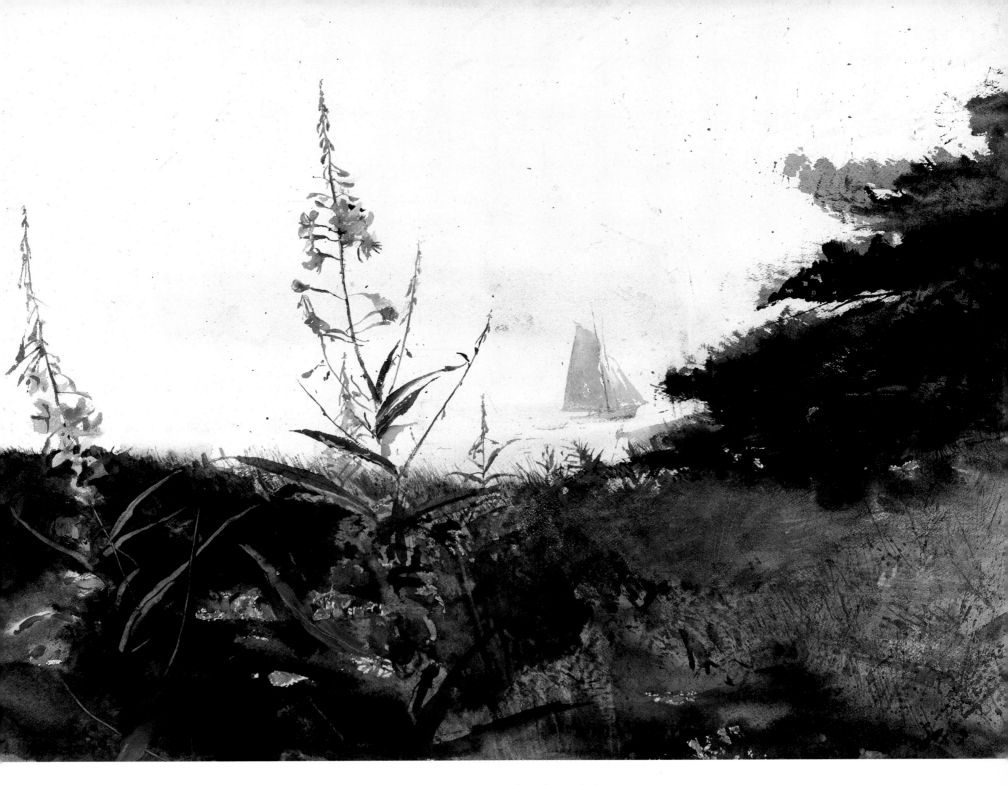

ANDREW WYETH *"Under Sail"* *1982* (69)

ANDREW WYETH *"Siri"* 1970 (56)

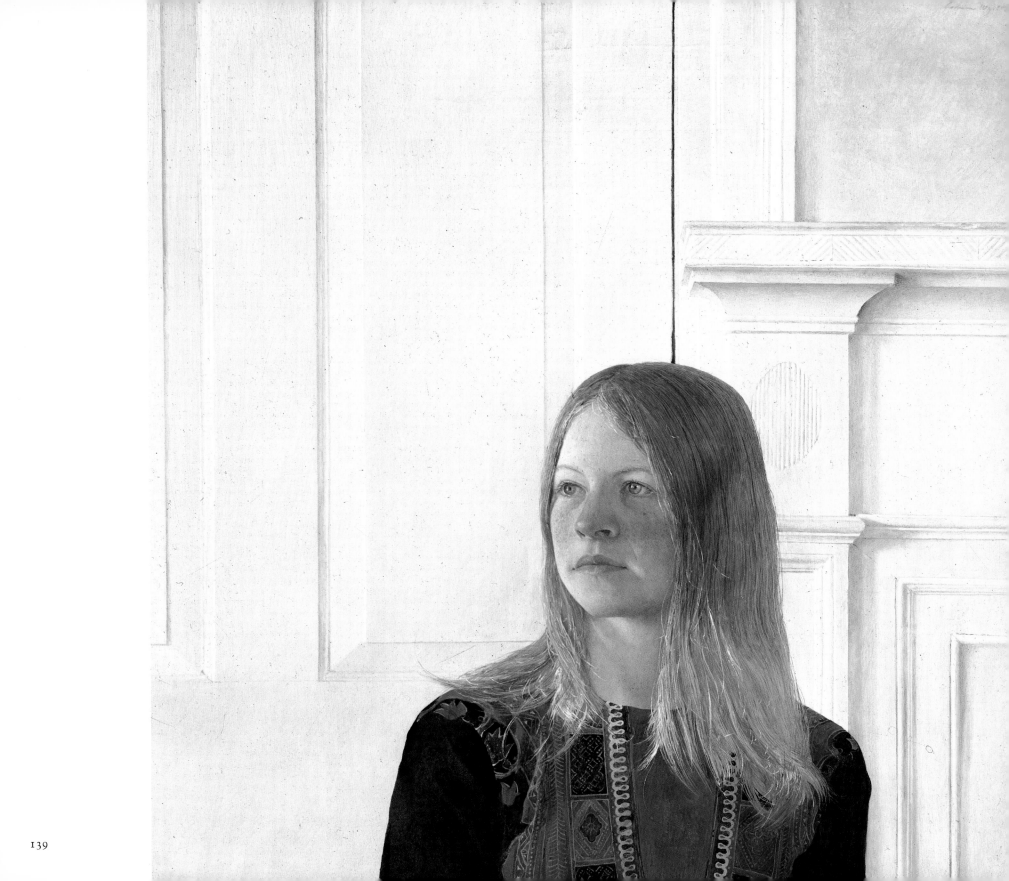

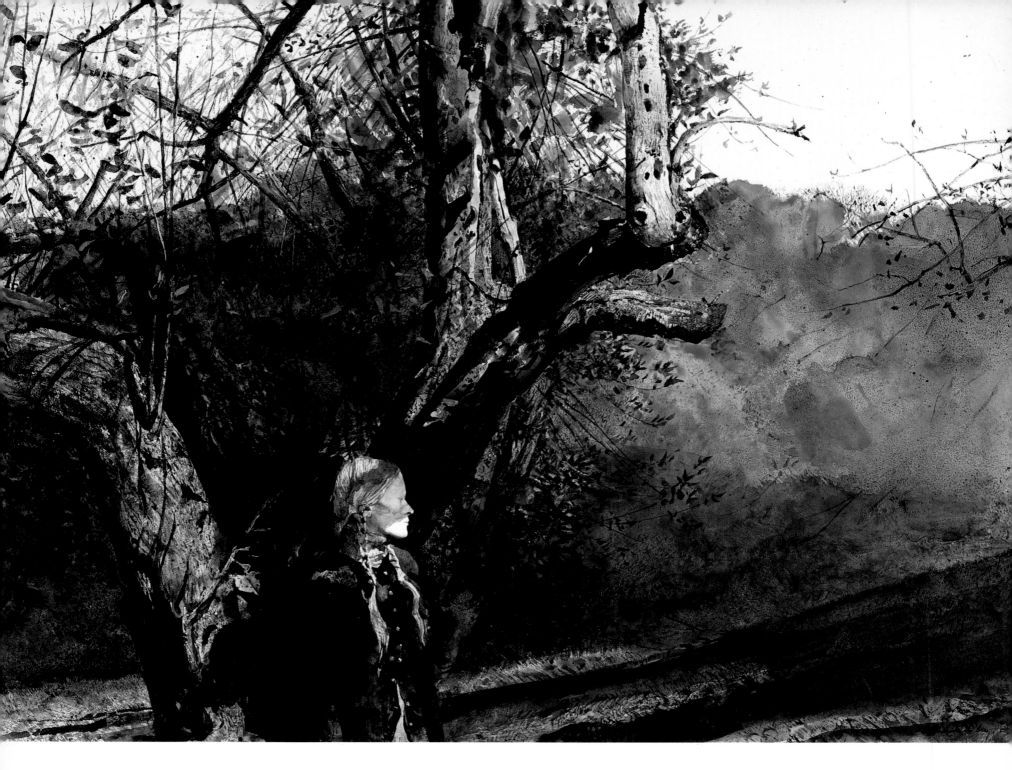

ANDREW WYETH *"Autumn"* 1984 (72)

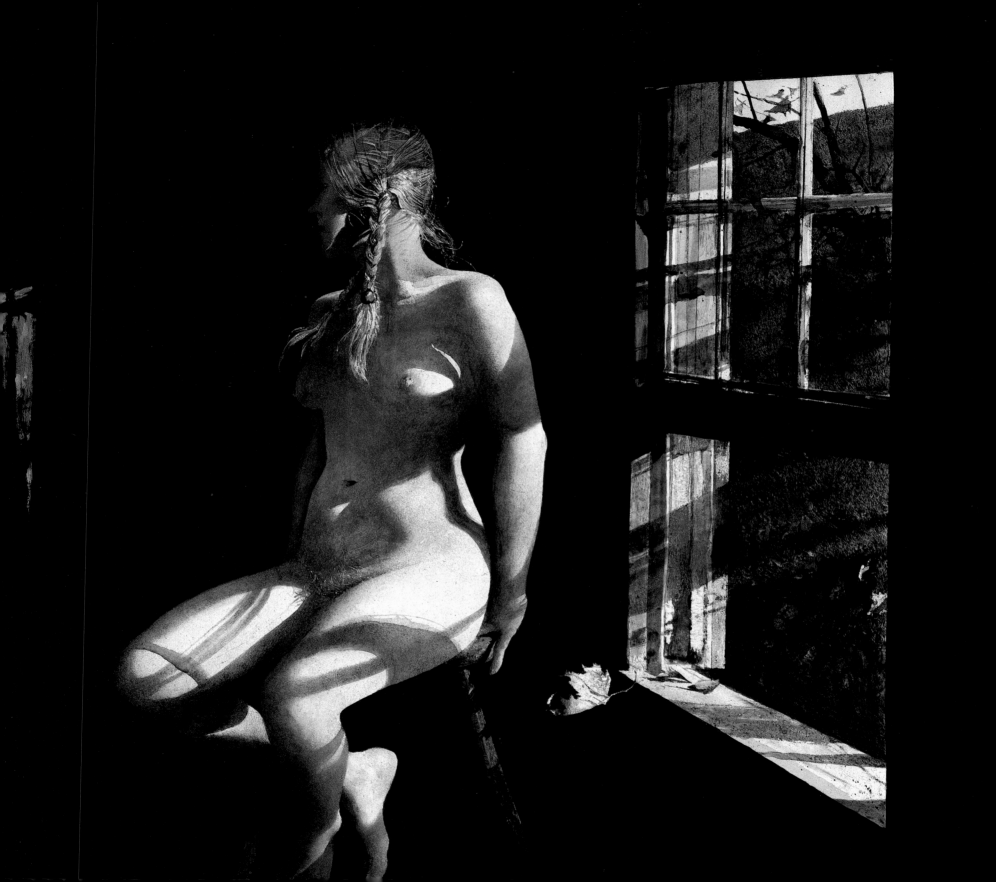

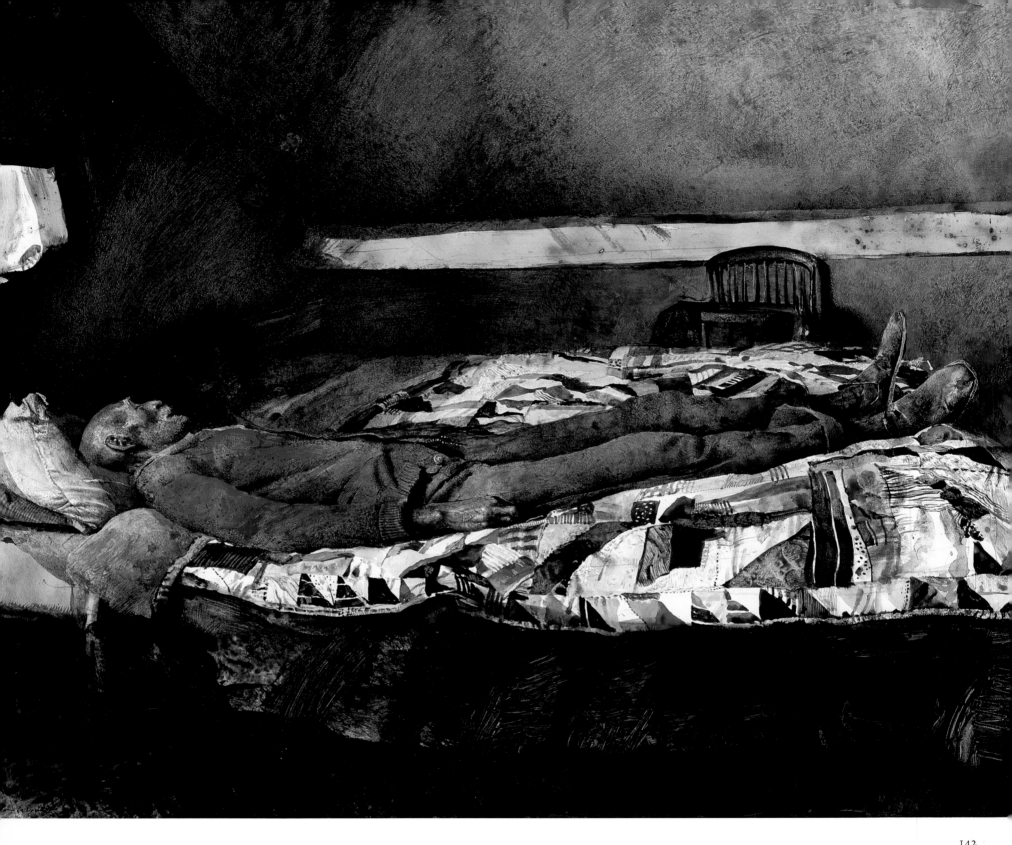

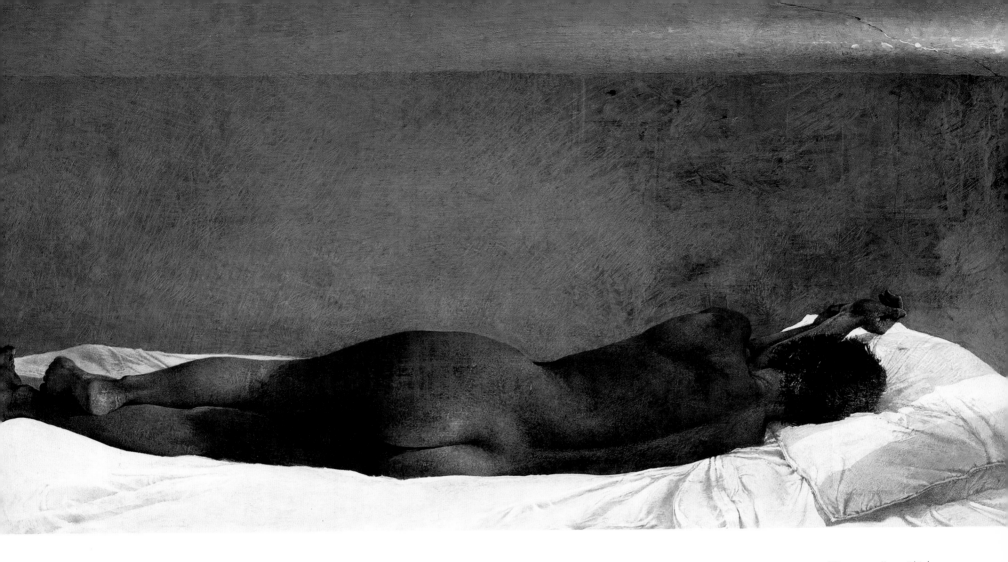

ANDREW WYETH *"Barracoon"* 1976 (61)

ANDREW WYETH *"Garret Room"* 1962 (49)

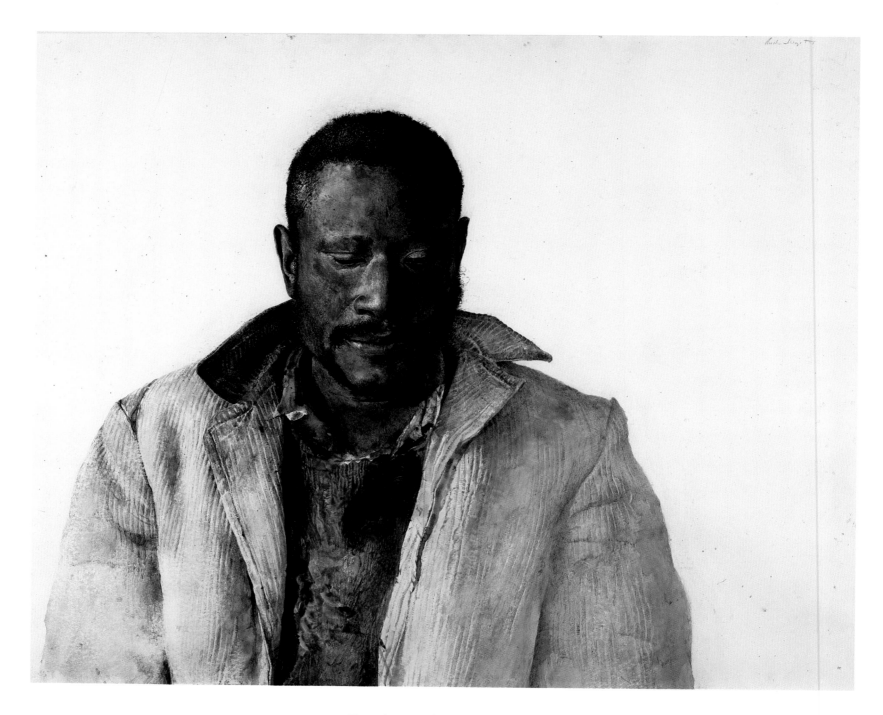

ANDREW WYETH *"The Drifter"* 1964 (50)

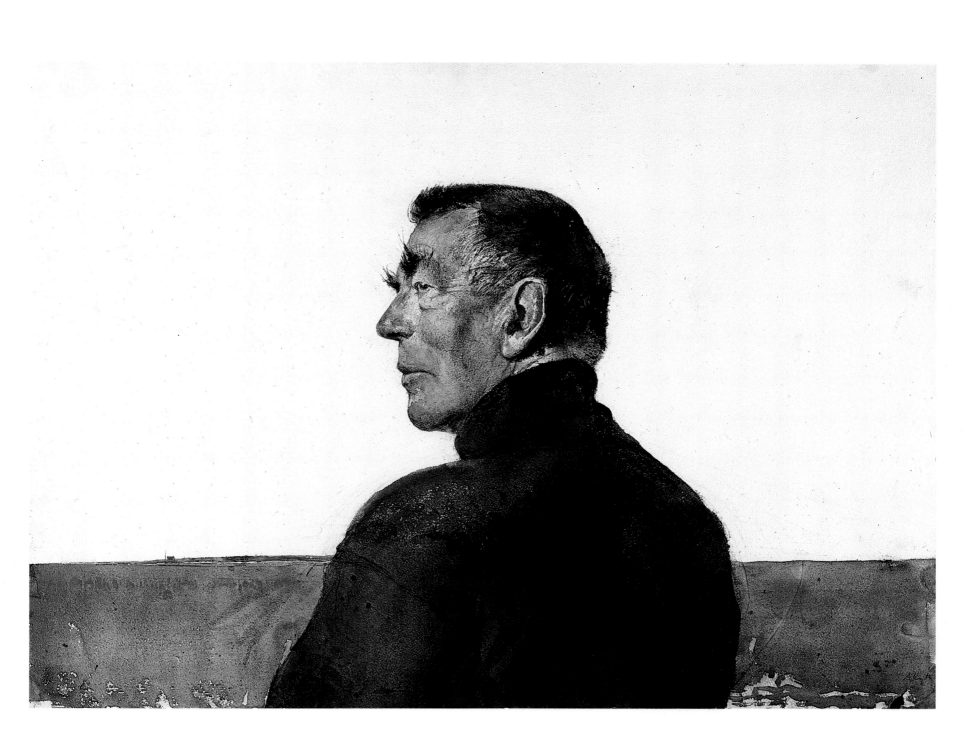

ANDREW WYETH *"Captain Cook"* 1986 (76)

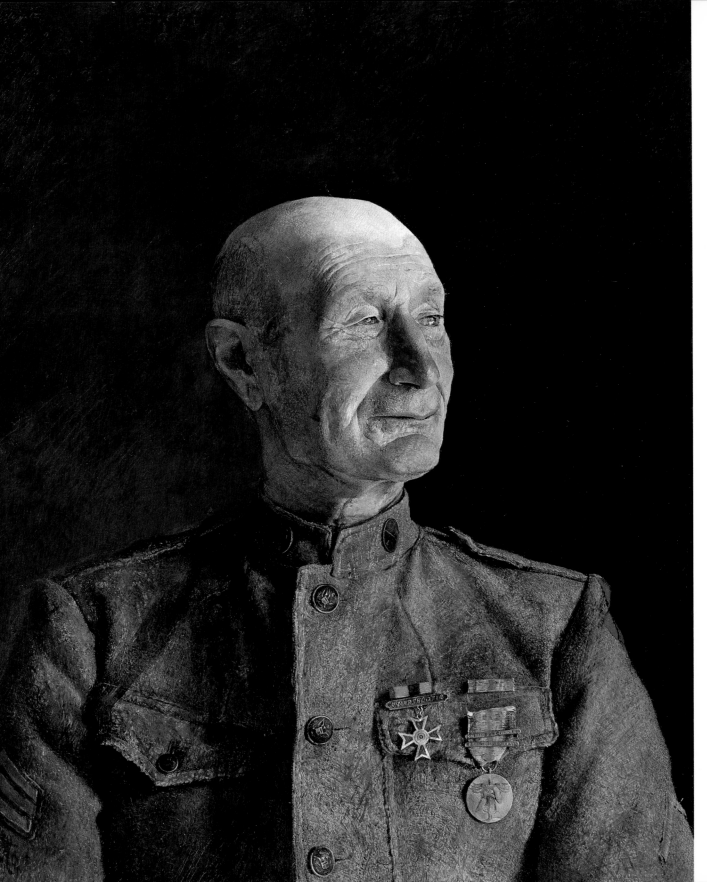

ANDREW WYETH
"The Patriot" 1964 (51)

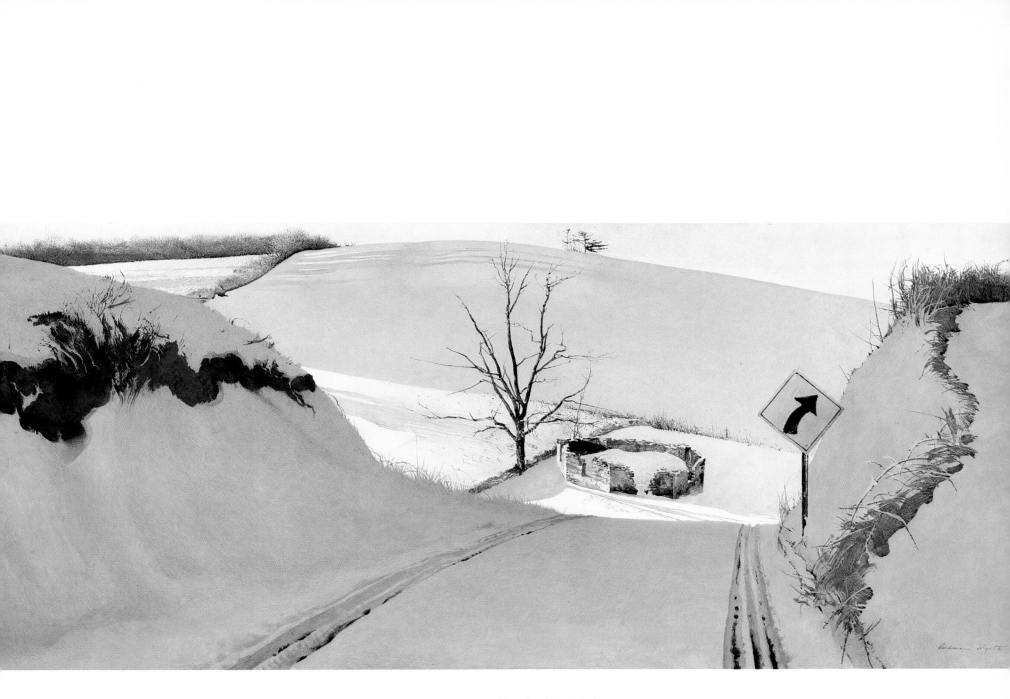

ANDREW WYETH *"Ring Road"* 1985 (75)

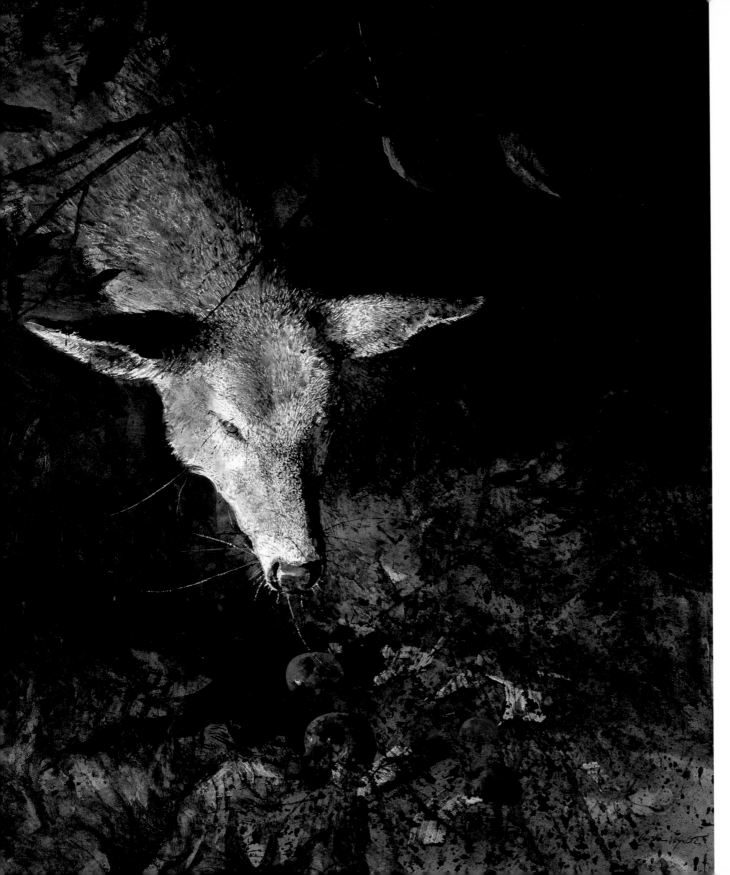

ANDREW WYETH *"Last Night"* 1980 (65)

148

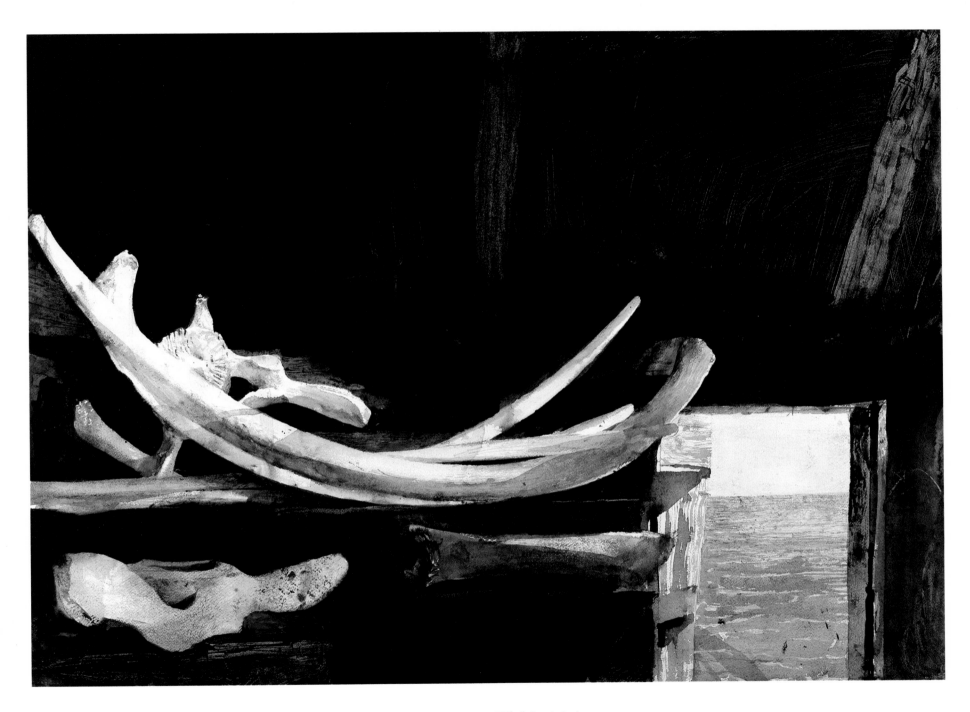

ANDREW WYETH *"Whale"* 1983 (71)

149

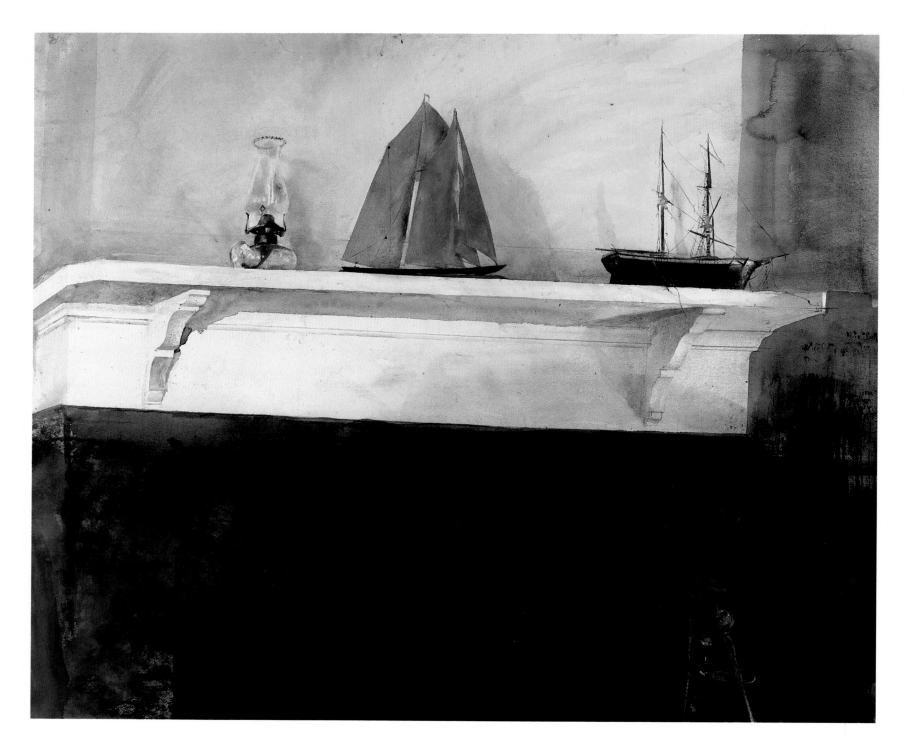

ANDREW WYETH *"Two Masters"* 1986 (78)

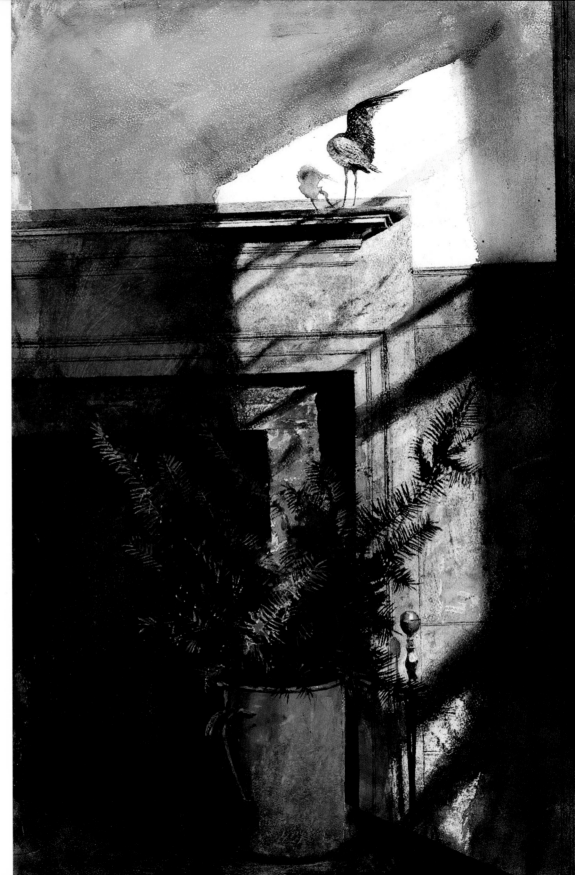

ANDREW WYETH *"Bird in the House"* *1979* (63)

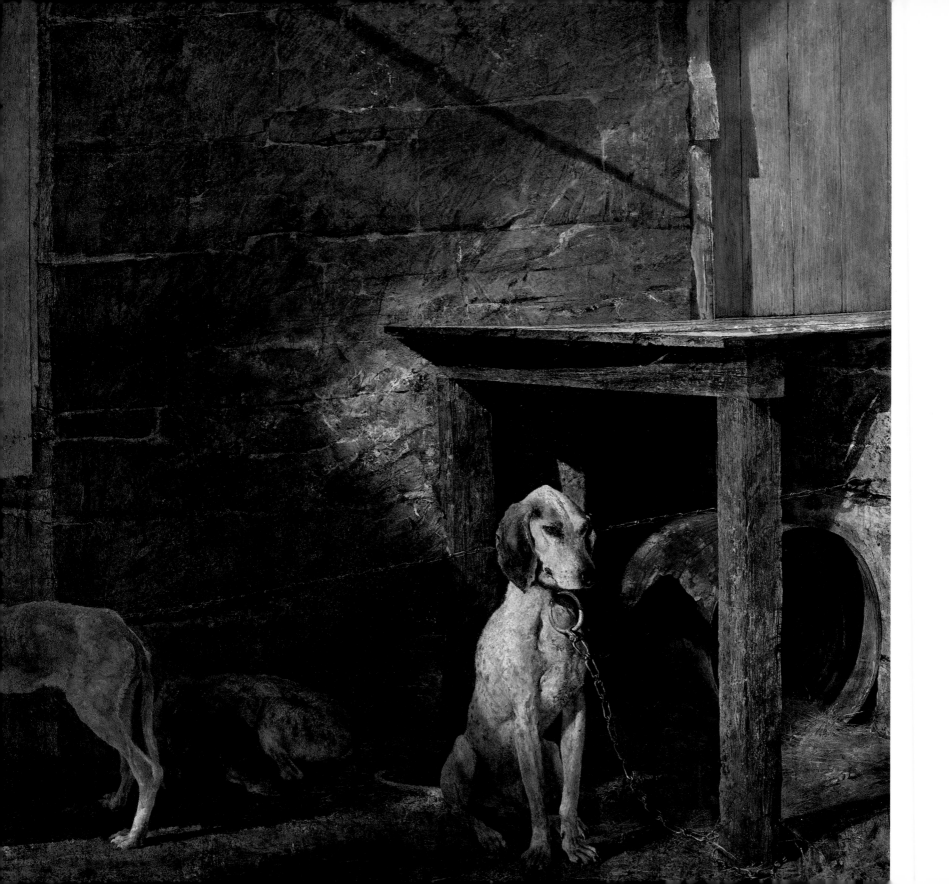

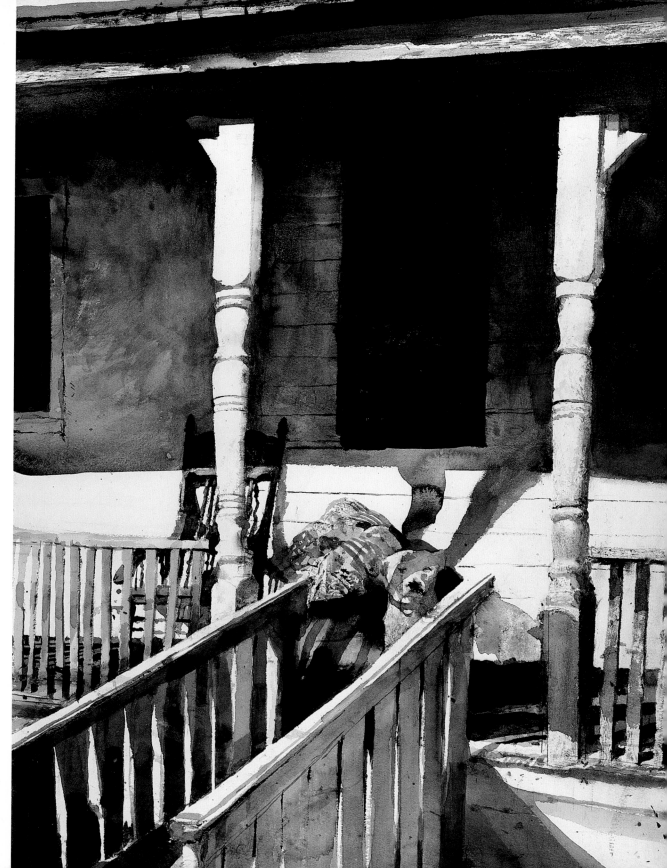

ANDREW WYETH *"Rag Bag" 1986* (77)

ANDREW WYETH *"Raccoon" 1958* (45)

Overleaf: JAMES WYETH
153 *"Sea of Storms" (detail) 1970* (88)

James Wyeth

LINCOLN KIRSTEIN

LINCOLN KIRSTEIN

James Wyeth

James Browning Wyeth was born July 6, 1946, at Chadds Ford, Pennsylvania. Grandfather was an illustrator and muralist of historical romance; father's portraits and landscapes affirmed a nostalgic Eden of preindustrial stoic innocence. Their heir was committed to painting before he'd grasped a brush. Early development of his talent, while following traditional method, led to a uniquely individual vision and style. One of his aunts, a professional artist, taught basics of rendering shades and shadows of three-dimensional form on a plane surface. Scrupulous study of cube, cone, and globe, after ancient academic custom, then the copying of plaster casts, gave James an almost premature efficiency in draftsmanship. Although aware of the expectations of his heritage, he was allowed perfect freedom in his own course. While his famous father never enforced his own attitudes, he provided constant suggestive direction through examples from others— Dürer's staghorn beetle, rabbit, and clump of grass, Rembrandt's pen and ink drawings, and Leonardo's work. From the start, James's preference differed from the conceptual forms and broken color of N. C. Wyeth, or the lean glazes in tempera of Andrew. In the maturity of accomplishment, his own textures would emerge as thick, rich, and juicy.

Prompt mastery was won at a cost. Not for this child's severe apprenticeship were fun and games of the ordinary high-school boy. Privately tutored, he was virtually isolated under the rigors of professional instruction. His closest companions were beasts and birds of the Brandywine's riverbanks and fields, a domain whose aspect had barely changed since before the eighteenth century. The swollen river running through the Wyeth land overflowed in spring freshets, so the ground floor of the miller's house his mother had restored was pierced with vents to let the water drain.

Grandfather Wyeth's illustrations had peopled a world of mythic and legendary archetypes. King Arthur's Round Table, the knights and squires of Camelot, seemed nearer than Philadelphia or New York. Robin Hood's Merry Men in Sherwood Forest, Robert Louis Stevenson's pirates and boy-adventurers furnished vibrant fantasies. And there was a dark strain of the old American macabre, the time warp of Washington Irving's Rip Van Winkle and the spectral headless horseman. Arthur Rackham's gnarled tree trunks, his spider-clawed, dragonfly-winged monsters, along with amiable badgers, rats, rabbits, executed with the cunning veracity of scientific documentation, were the charmed citizens of James's closed miniature continent, as well as E. H. Shepard's creatures for *The Wind in the Willows*.

Two hereditary dynasties governed the worldly and artistic ambience of James's purview. The du Pont family, pioneer munitions makers for the nation since colonial days, were the tribal seigneurs of Brandywine's domain. His mother bridled at the shut, self-exalted social fortress that gloried in the remnants of feudal sovereignty, and there would be some irony in the fact that James would choose a wife from this stock, though Phyllis by nature was quite apart. Parallel to such ancestral observance was a local apostolic descent of book illustrators, stemming directly from Howard Pyle, master of N. C. Wyeth, at one remove from William Morris and the Pre-Raphaelite medieval craft revival movement. In nearby Wilmington's museum hung excellent pictures by Rossetti, Burne-Jones, and their clan, vivid exemplars of a past made present.

While fantasy and folktale furnished his imagination, an immediate world far beyond the Brandywine impended, and James would come to grips with rumors of war in his own proximity. "Draft Age" (page 164), a portrait painted when James was nineteen, is the first in an extensive sequence notable for lodged impact, capturing a personage as the representative of a period. Its almost sinister allusiveness is made concrete against indeterminate darkness in which a fair youth slouches, armored in black leather, as if half in disdain, half at apprehensive ease. Carelessness is offset by the strict metal teeth of his zippered jacket, which might be a future soldier's battle dress. Plastic sunglasses mock the armored visors of chivalry in desuetude. In frayed months of peace, between battles against Hitler, in Korea, or in Vietnam, surly expectation menaces any fixed future. A young man, his health and present security taken for granted, is not unaware of what fate may promise. Doubt, a pervasive sense of personal apprehension, brands this personification as icon of its epoch.

From 1966 to 1971, James served in the U.S. Air Corps Reserve. After basic training in the Texas Panhandle, where temperatures ranged from freezing before dawn to blood heat at dusk, he managed to serve both the military and his own art. For a battalion ball he executed an enormous mural, 60 feet long, 18 high, of Adam and Eve evicted from Eden (page 64). A thundering bomber overhead causes Eve to drop the apple of discord. Painted on parachute silk, colors were ordinary government issue, while palettes were trash-can covers. Ironic caricatures for his unit's bulletin sported uniformed skeletons warning airmen in training of their imminent mortality. This attracted repudiation and censorship. An official portrait of Delaware's Governor Terry was commissioned. Its solid presentation recalled colonial magistrates by Copley and Stuart, minus their robes and periwigs.

Although James was scheduled for immediate transfer to Vietnam, the Tet Offensive canceled all flights for noncombatants. His national service assignments continued under other aspects. Granted a top-security clearance, he would witness and record several space launches with their attendant preparations and personnel; he became friends with the early astronauts. His assiduous documentation is now in the National Air and Space Museum in Washington. And he was approached privately to undertake a posthumous portrait of President John F. Kennedy (page 166). Before this, and after, he would seldom accept commissions. (His spiritual mentor, Thomas Eakins, was able to paint only those people who appealed to him; John Singer Sargent, on the other hand, after a long and trying career of portrait painting, abandoned face-painting in worldly disgust, for the unlicensed spontaneity of watercolor.) James had never seen Kennedy in the flesh and refused to accept guidelines from White House curatorial control. Nevertheless, he commenced by watching family and archival films for five hours a day for three weeks, becoming friendly with the assassinated president's widow, and accompanying his brothers on their campaign tours. A study of Robert Kennedy's head served as a first underpainting for an early full-length study, which, like a sculptured sketch, was abandoned.

John Fitzgerald Kennedy, grandson of "Honey Fitz," legendary boss of Boston's Irish political machine, inherited his vast gusto for the difficult game of manipulating men and power. James was the hereditary professional painter, Jack Kennedy the hereditary political virtuoso. The artist sensed the infinitely complex factors of hazard inherent in all crucial political decisions, plus the courage required to adopt an indeterminate yet single course. The Cuban Missile Crisis and the Bay of Pigs still hung in the air. Thus James's completed picture presented a man still young, but not untouched by grievous doubt, in a mute stasis of deliberate indecision, servant of a republic, bearing the burden of unimaginable risk. Mrs. Kennedy acknowledged the veracity of this view. But the attorney general, the late president's brother and closest friend, detested the entire depiction. Here was a confused weakling, biting his nails, and not a triumphant martyred hero. Such agonies had no place in Lincoln's sacred White House. After brief stays in our Paris embassy and at Trinity College, Dublin, the painting rests in the Kennedy Library in Boston. Through popular acceptance and reproduction, it has become the best-known image of a man who was chief executive in a moment of great crisis.

In 1974, James found himself an intimate observer of high political drama. The Supreme Court of the United States was the theater of

proceedings leading to the impeachment of a head of state, following the scandals of Watergate. No photographers were to be permitted in the courtroom, but Chief Justice Burger allowed Wyeth to sketch as he might. In sharp black pencil, dozens of minutely detailed drawings, some very highly finished, comprise documentation of graphic clarity. At a pretrial session, outside the court, as if seized from a newsreel, G. Gordon Liddy leaps to his feet to salute John Ehrlichman, his former White House superior, behaving as if the proceedings were a court-martial, rather than a civilian criminal case. Microscopically rendered, a tiny panorama profiles endless lines of civilians waiting to gain entrance to the spectacle within the marble, pillared temple. Rapid, precise, dispassionate, here is etched with breathless candor a pageant worthy of comparison with Daumier's ironic tribunals.

In total contrast to such plunges into the public arena is this artist's maintenance of a certain inviolable privacy, attached to the realms of observed nature. Against the foolish, heroic, wicked acts of men is the calibration of wind, weather, waves of birds and beasts in states of untrammeled earth, rock, and sea. For many years, James's summers into autumns have been based on Monhegan, a stony islet twenty miles off Cushing, halfway up the coast of Maine. This little port, backed by lush, grassy fields and thick forest, is sharply opposed to the naked, windswept promontory, connected to the mainland only by a small boat three times a week. James first sailed to Monhegan at age fifteen, staying alone at the sole inn, which reminded him of the Admiral Benbow Inn, where the search for Stevenson's *Treasure Island* began. There on Monhegan he would find riches past heaps of pirate gold for the next twenty years. Later, he would be able to own the big house where Rockwell Kent painted for much of his life. An excellent and personal landscapist, and a brilliant illustrator of James's grandfather's generation, Kent created fine black-and-white glosses on *Moby Dick* and *Candide* that had been favorites of the Wyeth family.

James came to paint Monhegan's gulls and sheep, its rocks and shingled houses, in weathers benign or menacing, with a concentration and completeness formerly accorded to his pictures of people. Manana, a tiny, treeless island off Monhegan, inhabited only by a single shepherd-hermit, prompted "Lady" (page 183), the haughty image of a formidable ewe with startling opal eyes. (James helped in the ewe's shearing, which took three hours, his fingers saturated with the lanolin oiling the thick, rich wool.) A flock of black-faced Hampshires abruptly faced the painter at the crest of a sunset hill, the sea flat beyond. "The Islander" (page 182) is also of a sheep, an electrifying profile of a wild ram intended as a memorial to the now-dead hermit. Its arrogant skull, wickedly horned, sniffs sun-drenched air, its gilt-bronze fleece spun of fierce wrinkled wire. This furious beast had tossed a huge Newfoundland dog into the sea.

In 1985, James painted one of his strongest evocations of nature's inherent artistry (page 176). He saw a young gull, a starfish clamped in its sharp beak, skittering across the beach. Tide was out. The shadow of the star shape is cast on the shore, yet the forms and coloration of feathers are indistinguishable from the ground of crushed tiny shell, bone, and pebble. Camouflage of gull against sea wrack, its sandy, sun-crisped strata eroded by retreating and oncoming waves, composes a puzzle picture of visual puns whose layered complexity can only be deciphered by steady viewing. It is splendidly framed in a rococo mosaic of tiny shells that, in their porcelain perfection, reflect the structure of the painted starfish.

Monhegan reversed Chadds Ford. Remoteness and alienation intensified its atmosphere, bared to the bone. James's neighbors, some sixty people, mainly women, here have their home. Their fisherman husbands are at sea three-quarters of the year. Half-deserted, disheartened, the island's inhabitants slowly diminish. The few visitors a week cross over for a couple of hours and depart with little gained or seen but a few souvenirs. The painting of "The Rookery" (1977; page 69) epitomizes the island's naked survival in ferocious opposition to time and weather. Upon a tumbled heap of jagged rocks split from ageless basalt, tossed onto a gaunt peak, one seagull crouches on its awkward perch, at unsteady rest for a moment, gathering strength to join a company already wheeling aloft, their extended wings breasting currents of oncoming storm.

Alone on Monhegan, yet still attached as an official artist to NASA,

James was suddenly summoned to observe preparations for the initial moon landing. Despite wildly tossing seas, he persuaded a fisherman to run him ashore to Cushing. There, a small plane flew him to Atlanta, where an Air Force jet met him and landed him at Cape Kennedy. Within six hours he'd been transported from a remote island without electric power or automobiles to observe and record the Apollo lift-off. Denial of gravity and pockets of energized air blanketing the earth were the gull's dominion; small bolts of feathered muscle had power enough to breast turbulence, a miniature parallel to this enormous bulk of fueled metal.

Dealing with the muscular mobility of animate creatures demands research in depth that few contemporary artists feel much need of. In older days, close information about bone and muscle was essential. Nowadays, not even drawing from the live model seems of general use. Photography's hasty data, rather than providing an added, though subsidiary, convenience, have come to replace time and skill in cautious study. A year before James's first one-man show at the Knoedler Galleries (1966), he felt impelled to investigate gross anatomy. His interest in dissection was in no way morbid, but a response to a steady curiosity about the human skeleton's structure and accoutrements. He had met a learned elder Russian anatomist then working in Manhattan. When James began this discipline, a Christmas wreath hung on the morgue's steel door, which was opened by a small bearded figure in a surgeon's white uniform. For a moment, the young painter was dismayed at the overwhelming display of trays brimming with severed arms and legs. The body of a beautiful young woman lay out on its shelf, quite as if asleep. A cheerful handyman moved cadavers from hook to hook. Surgeons scheduled to operate the next morning would come down to rehearse their delicate procedures. Compassion alone did not prompt them, but rather the satisfaction in the efficacious slice. James was mesmerized by the upholstery and articulation of cartilage and layered muscle, sheaths of tendons, the labyrinthine skeins powering man's movements. Under the resilient glove of skin, how lay the separate masses of flesh forming breasts and buttock? Absorbing evidence in the tradition of Galen and Vesalius, he could note the parallel components of pig and man. For six months the hinges of mortal engineering were

investigated in a lethal basement, where, in the mute company of 300 corpses, he cut and studied in silence. Results from the grasp of this and like attentions astonished the viewers of his first exhibition, which, apart from other aesthetic considerations, exposed the visual and digital virtuosity of a professional of twice his years.

As a youth, with small experience of horizons beyond Brandywine meadows and coastal Maine, he had found no need for travel, either for instruction or pleasure. However, once he'd become adult, great European towns and treasuries provided the satisfying corroboration of what had determined the crafts of his own hand and eye. In Ghent, he felt almost shocked by the complete candor of van Eyck's "Adam and Eve" on panels enclosing the stupendous altarpiece of "The Adoration of the Holy Lamb." There, he carried his semi-invalided wife up a long flight of stone steps to where the picture is enshrined. A sacristan took this intrusion by insistent pilgrims as some sort of pious or ritual fulfillment, as if to elicit a blessing. In Amsterdam there was Paulus Potter's huge heifer, no less noble than the calves and piglets of Chadds Ford. In Vienna, there was Lady Fame painted by Vermeer in his light-struck studio. But above all there was Botticelli's "Primavera" in Florence, and in Arezzo, Piero della Francesca's walls, where coins dropped in a tin box brought on a few minutes' electric light to view them. Rome's Colosseum at midnight was haunted by legions of abandoned cats. The Sistine Chapel, at seven in the morning, suddenly overcame him with a surfeit of seeing. (In any valid appreciation, much depends on the physical state of the observer in the sequence of what's just been seen.) When invited by the Union of Artists and Writers to Moscow, he was deeply impressed by the quality and variety of nineteenth-century Russian painting, the pageantry of Repin and Vereshchagin, the splendid portraits of Kiprensky, Fedotov, and Serov, and the extraordinary magic of Mikhail Vrubl.

Perhaps an experience that touched him closest occurred at Chatsworth. In the Duke of Devonshire's magnificent library, boxes were unlocked and the intimate preparatory drawings of the great Renaissance masters passed through his fingers until three o'clock in the morning. At his bedside lay Henry VIII's missal. Then came autumn in Sherwood Forest, a boyhood dream come alive. He pocketed acorns as Robin Hood's

bounty to Chadds Ford. But he found himself uncomfortable when not at work.

While painting remains primary, James has accumulated an impressive body of graphic work. For some two years he was manfully occupied in etching and lithography, worried from the start by dichotomies in the problem of "reproduction." Multiple copies issued in limited editions reverse the uniqueness of individual paintings as picture-making. He had an instinctive prejudice against signing sheets of identical pulls as if these were negotiable bank notes. Which, of what number, is an "original"? Also, there was need for a technician or printer who should rank as aide, or, indeed, partner. Yet, whatever the doubts, there was the magnetic challenge of Rembrandt and Goya.

A German professional with a drill-sergeant's manners supervised elementary groundwork and process. The physics and chemistry involved are complex; experience is not quickly bought. Acid can explode and crack glass plates. Copper plates can be overbitten into blackness. The expert commands perfection: *"Ein, zwei, drei!"* Just estimates of pressure on the pull were tricky. A relentless methodology in the craft permitted no intervening accident, which in paint might with luck be turned to correction or improvement. Too often he heard, *"Alles ist kaput!,"* one more epitaph on a spoiled proof. Hours were spent countering disaster, poor registry, smudged print, big empty spaces questioning their blankness or the need to fill with blackness. Nevertheless, a generous number of large compositions in black and white or color testify to loyal accomplishment, despite the recalcitrance of their manufacture.

James has received a share of negative criticism. Official patronage, as well as what amounts to popularity, hardly recommends one today to curators of the permanent advance guard. The art of our century is generally stamped by demands for insistent novelty, with easily recognizable idiosyncratic expression as the marketable ideal. The pride in the handling of paint that he professes admits little new about its application, and less as subjective or reductive comment, protest, charm, or praise. The capacity to assume the mask of a modern dandy for

social purposes, ease in passing in and out of several worlds, rob him of that glamour of nervous desperation that inflates so many memorable innovators.

He has been labeled as an anachronist, yet he can be seen not as against the current of his times, but rather, and without apology, contrary to the summary conclusions of prevailing taste. Off-shore islands, farm birds, and animals live in worlds without clocks. They are, were, and will be at home with biped mortals, in their own proud hierarchies of fur and feather. James avoids any mannerism to which a date may be assigned, and his visual inheritance is so clear that his personality seems more shared, or inherited, than gained as a signature. But this personality is certified by the separate discretion and quality of individual paintings, more often than not portraits with an almost hallucinatory impact and presence. In this, he avoids any immediately identifiable stylization by which evidence of the author's fingerprints is more important than a transference of the subject to canvas. Likeness in portraiture is the minimum that can be offered or expected; beyond that is the celebration of the moral or metaphysical residue in a given nature. In the fiercely attentive "Andy Warhol" (page 173), it is as if the flayed features of the enormously self-publicized victim accuses the hapless innocence of his dachshund, an alter-ego. Technique of which an amiable inadequacy is often today warped into a trademark has never been a bother. Yet every confrontation with plumage or pelt has been something of a battle-ground upon which the subject's mysterious and elusive essence is gained or lost, only skirted or captured in depth.

Animals sit sweetly, without malaise or nervousness. Here close intimacy is simple, the painter's patient probing into an *other* nature. Prize cockerels ask no flattery; pigs in their monumental pinkness are complacently happy in their fat. James shares his studio with their bristles and whiskers, sensing mute, stoic pathos in their utter dependence on the mercy of men, and the virtue in their animal essence. Portraits of people, as a profitable craft, must contend with a taint of constant compromise, cajolery, or vanity. Even the most memorable contain levels of praise, rather than diagnosis or earnest comment. James has been able, much of the time, to seduce such subjects who,

with objectivity, support their private selves, however eccentric, irregular, asymmetrical, or aging their facial maps. His best heads have been genuine collaborations, granting truth to life as the supreme flattery.

In 1986, he achieved a very large oil painting that, in many ways, puts a capstone to his career (page 71). The painting may be taken as the riveting picture of a personage, Kalounna, yet its physical scale and moral inference raise it above any common category of a fascinating face. Landscape, in which the dominating figure stands, full-front and three-quarter length, frames an individual's biography in the years and worlds he's so far been given.

Kalounna is an eleven-year-old Laotian refugee, one of the host of boat people, anonymous survivors whom our era attempts, one way or another, to assume or reject as a running responsibility. By agonizing steps and devious paths, through the merciful network of Roman Catholic charity, Kalounna's father, mother, sister, and brothers have found a home and sustaining work. First in Philadelphia, then four years in Wilmington, thence to Chadds Ford, the family is now permanently employed as caretakers for Phyllis and James Wyeth's farm, with its big herd of Black Angus cattle, its pigs and pets.

In the family's eagerness to become naturalized, Kalounna has become "Bruce"; mother Kongma, "Gladys"; papa Paoune, "Paul"; Desai, "Kim" or "Ike"; Noi, "Fred." Translocation has not been so easy. In Laos, the man is in charge. In America, a wife has found it simpler to command, and the ancient male principle is under strain. What such survivors saw and heard on the killing fields of Southeast Asia has seared its indelible scars. A surprise burst of Fourth of July fireworks sent children scurrying at reminders of long-past bombardment. Their farmhouse is still a Laotian outpost. The Wyeths came bearing a cake for Christmas Eve. The door opened, just a wary slit, to reveal the tribe feasting in secret on the floor, native food spread out on mats, and the door slammed, shut.

Bruce-Kalounna's first paid job was to pose for his portrait, after school, 3:30 to 5:30, every day for weeks. He is already head of his class, and his English is all but perfect. The background comes from Frogtown, a small community some miles from Chadds Ford, where James had noticed an enormous trailer-truck, parked empty in scarlet splendor, before an old farmhouse with identical red shutters. Its owner was asked if it might be painted. Came the answer: "But I like the color as it is."

The boy stands stock-still, ignoring the huge paramilitary dray now in disuse, but which in other sites or times could have carried riflemen and helicopters. Rigidity spells fear half-conquered. One fist is hard-clenched. Fingers of the other are tensely splayed. To us westerners, tea-colored skin, burning, coal-nugget, lidless eyes, a black silken cap of straight hair, a shut, high-cheekboned mask, project an almost feral creature from some other planet. His expression is clouded, but blatantly banal is his shirt, the uniform of an all-American boy, boasting the logo of the soap opera *Dallas*. The picture is the focused synthesis of a philosophical and historical crux, set in the cool specifics of immediacy. Here is an enigmatic appeal that yields, without sentimentality, a direct, irrefutable response.

Today, many of our more advertised younger painters opt for careers spasmodically lit by one-man exposures of pictures of broad dimensions suitable, they hope, for the walls of museum galleries, and seldom intended for private apartments. Aimed at corporate patronage, their quality is dictated by curatorial prestige or marketing taste, futures promulgated for high vulgarization. Picture-making as a service to representative significance or the historicity of moral order is considered unsuitable and distracting as decoration. The arresting portrait must compete with the passive comfort of chair and sofa. Yet over the last decade, change has come over the entire arena of popular interest. What has been taken for three-quarters of a century as retardative academicism is now, in a recent turnabout, found to contain elements of value for use. The random liberality of loose construction and summary brushwork exhausts its wearied success. The self-centered "originality" of the massively exposed and catalogued schools of Paris and New York, locked in their successive chapters, takes on the familiarity of brand labels.

In England, Spain, Germany, and the United States, a rising generation of picture-makers intend formal clarity, honoring the exhaustively observed object. The logic in traditional method has once more become welcome, not as a finished or finicky academy, but as repository of gained information, where trial and error provided the most comprehensive criteria available. Fragmentary, inconclusive, or sketchy handling, coarsely surfaced, allowed viewers the sophistical game of completing vacancy by themselves. The melodramatics of expressionism, the rapid collapse of cubism, the feverish simplicities of abstraction imposed their own nervous academy, no less rigid as to its succession than the old official formal schools. But under the surface of what have become familiar formulae exists a resurrected curiosity in careful and sober quietude.

James Wyeth is not to be considered as *chef d'école* of the proponents of this new attitude. Asserting the extreme possibilities of painting as something superior to decoration or confession, as an art that involves a definition of history and natural ordering, he has organized a large body of sharp observation in deeply revelatory images of current immediacy.

JAMES WYETH *"Portrait of Shorty"* *1963* (79)

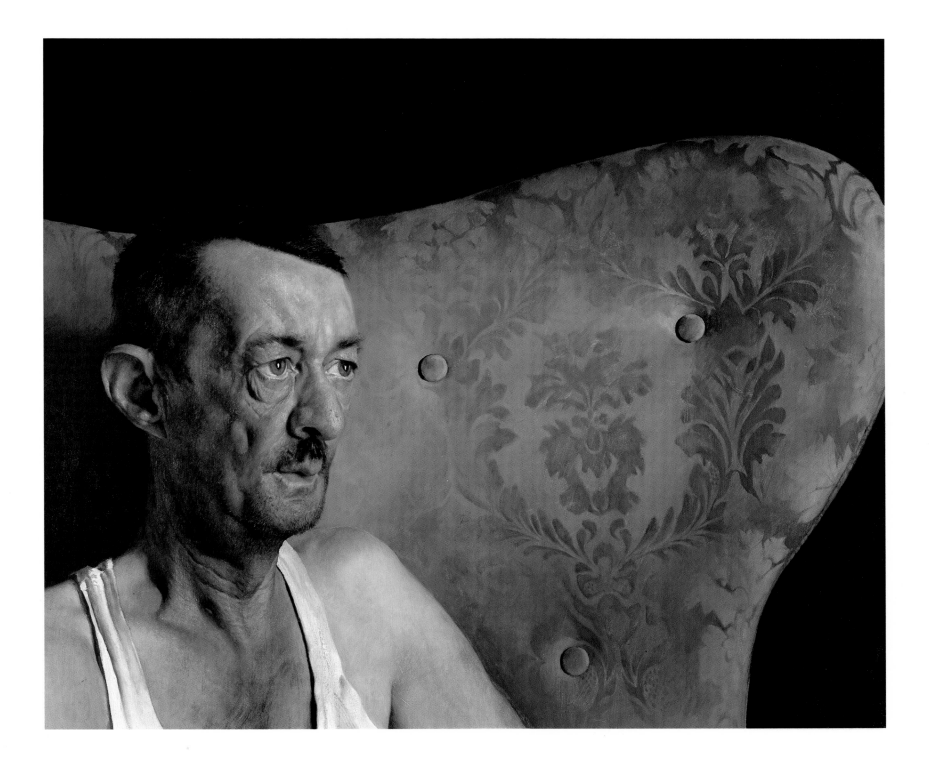

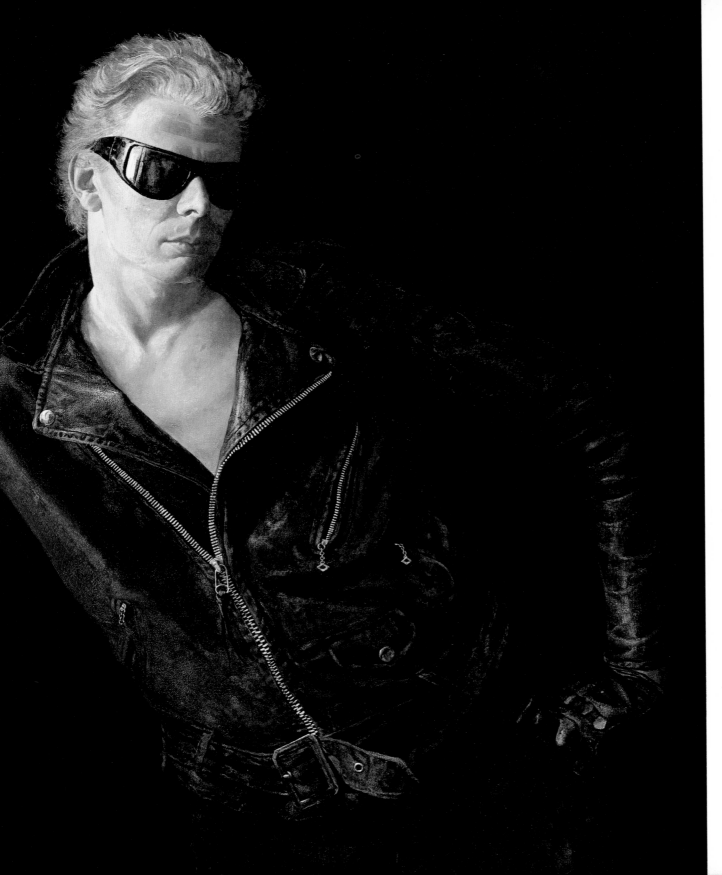

JAMES WYETH
"Draft Age" 1965 (80)

JAMES WYETH
"Portrait of Jeffrey" 1966 (81)

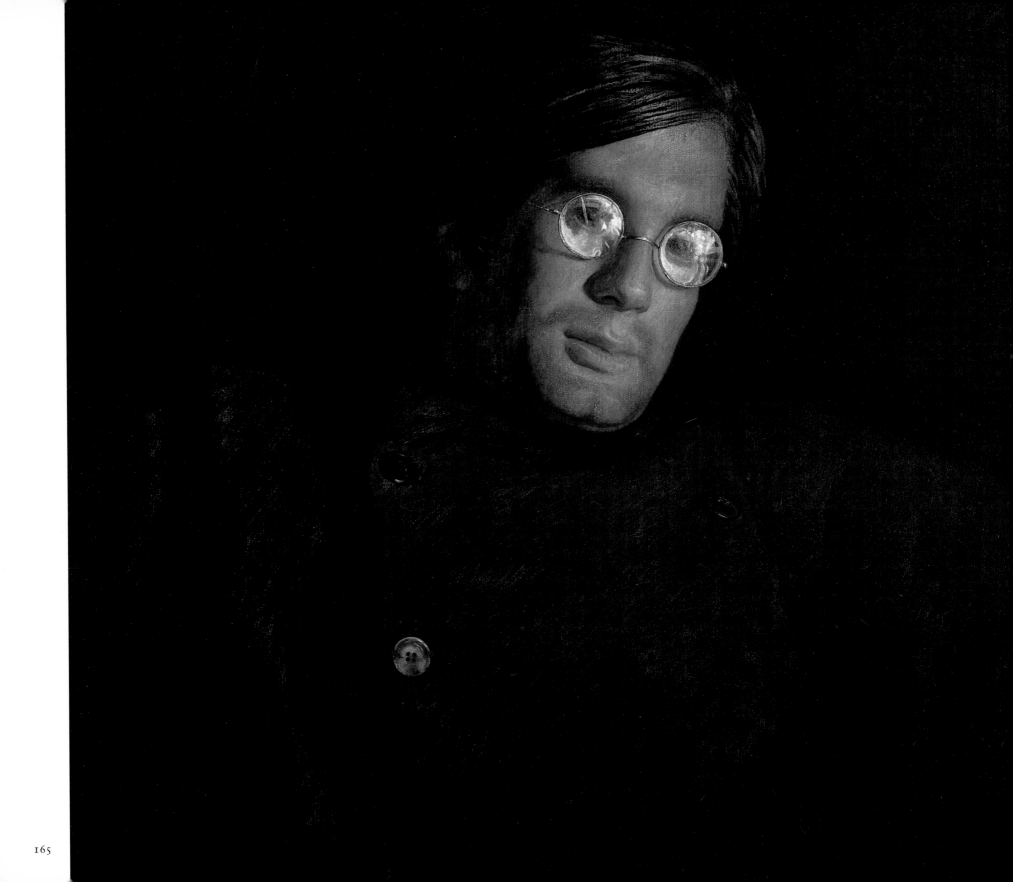

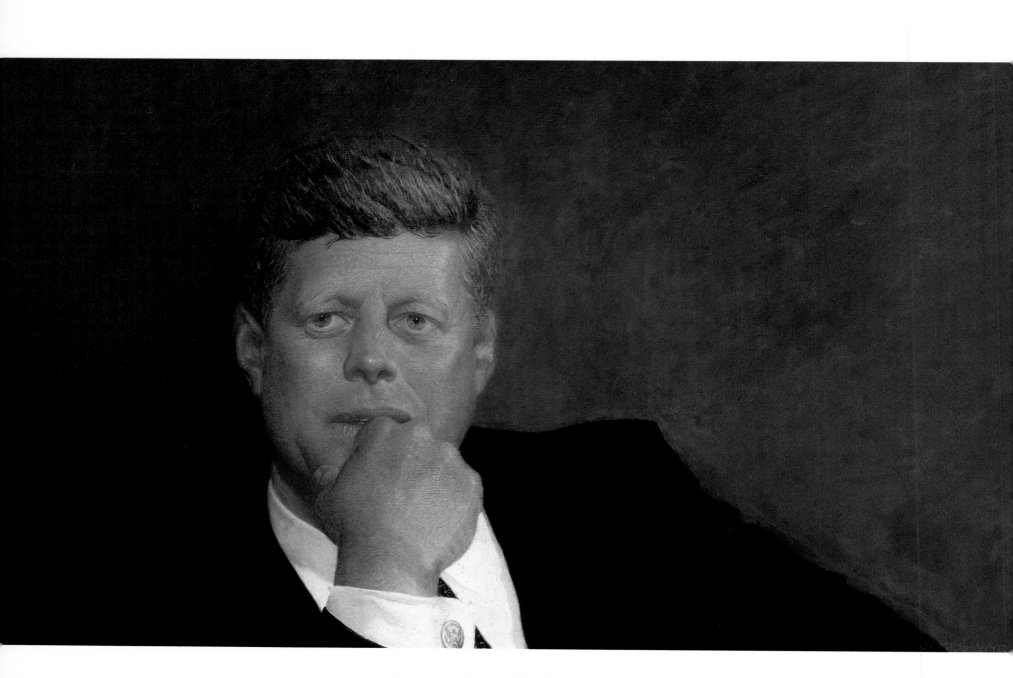

JAMES WYETH *"Portrait of John F. Kennedy"* 1967 (82)

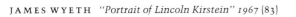

JAMES WYETH *"Portrait of Lincoln Kirstein"* *1967* (83)

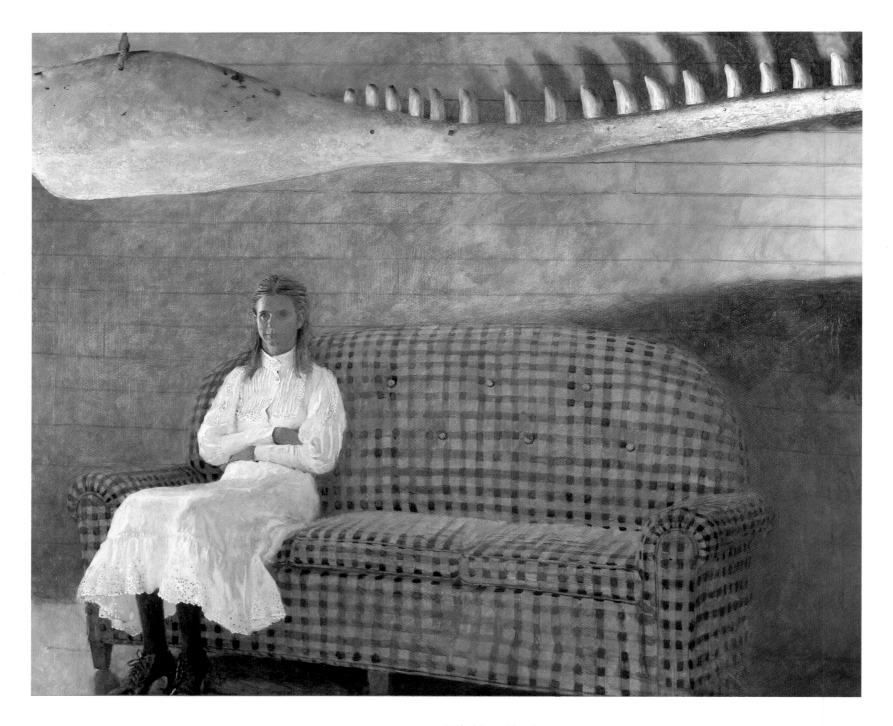

JAMES WYETH *"Whale"* 1978 (100)

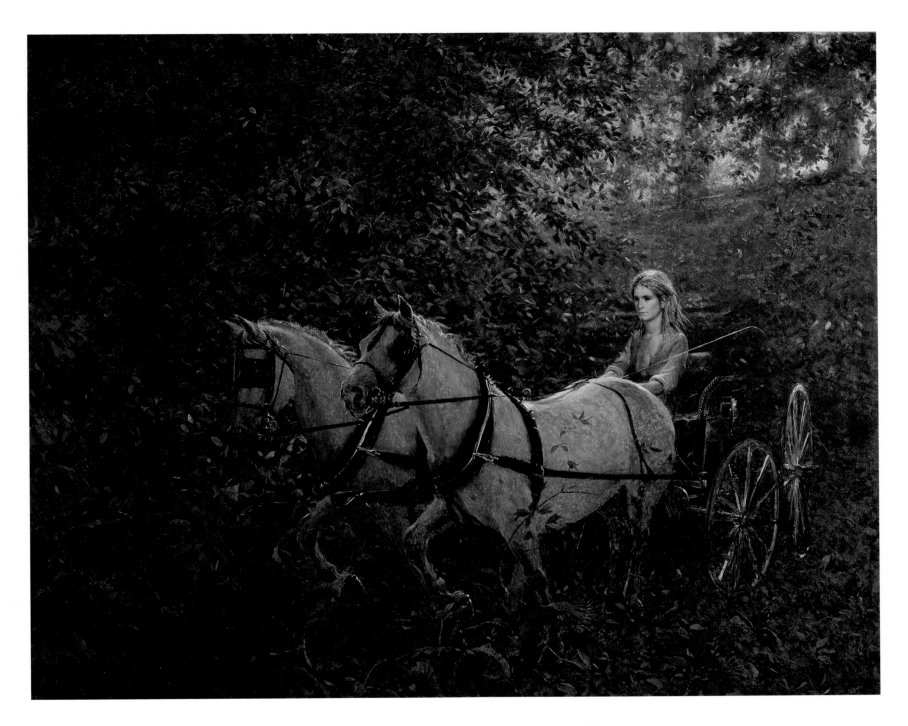

JAMES WYETH *"And Then into the Deep Gorge"* 1975 (94)

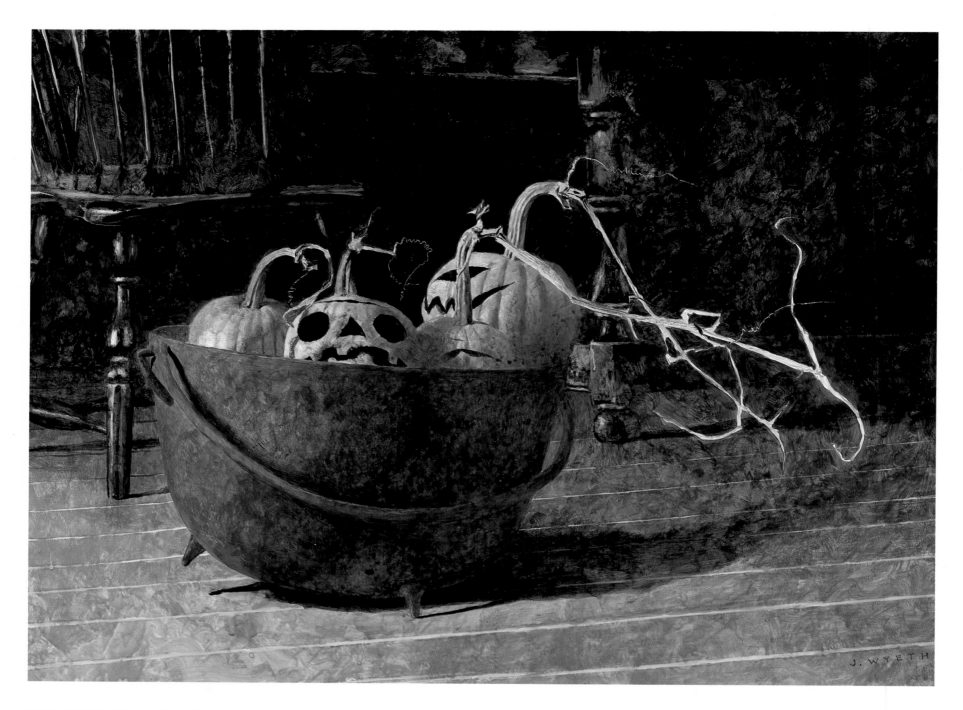

JAMES WYETH *"Runners"* 1984 (112)

JAMES WYETH *"Pumpkinhead–Self-Portrait"* 1972 (91)

JAMES WYETH "*Automaton*" 1979 (101)

172

JAMES WYETH *"Portrait of Andy Warhol"* 1976 (96)

173

JAMES WYETH *"Breakfast at Sea"* 1984 (110)

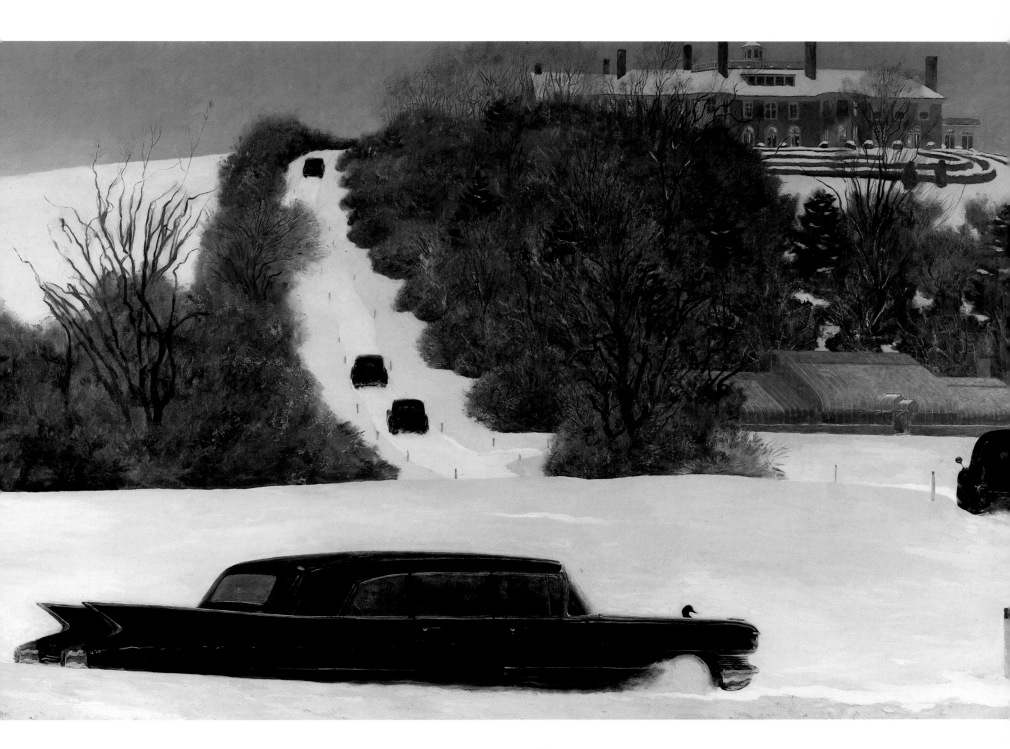

JAMES WYETH *"New Year's Calling"* 1985 (114)

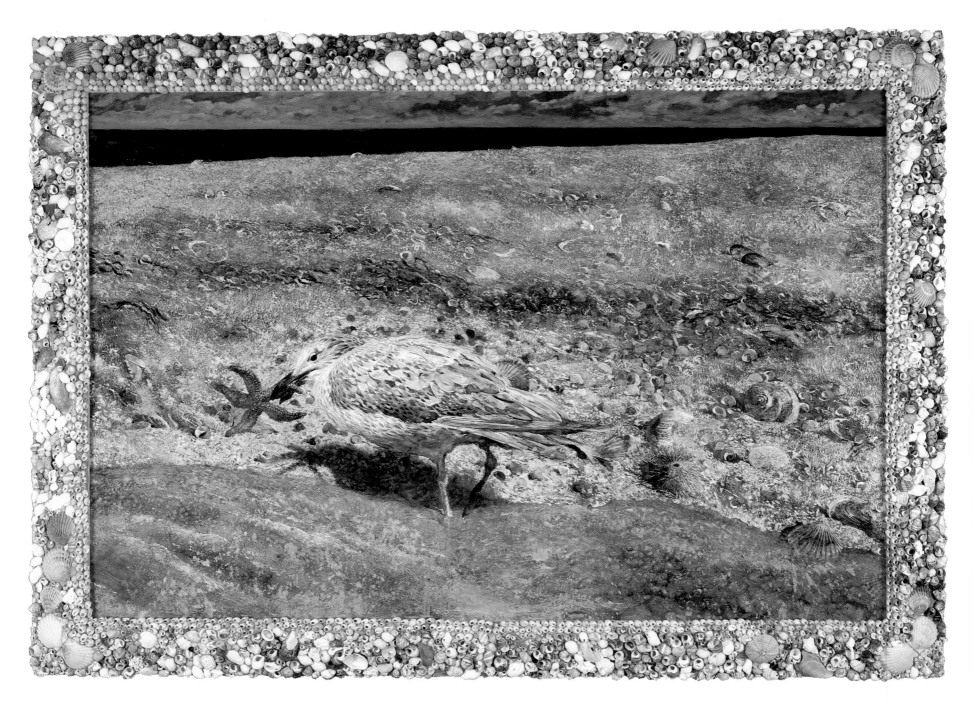

JAMES WYETH *"Sea Star"* *1985* (115)

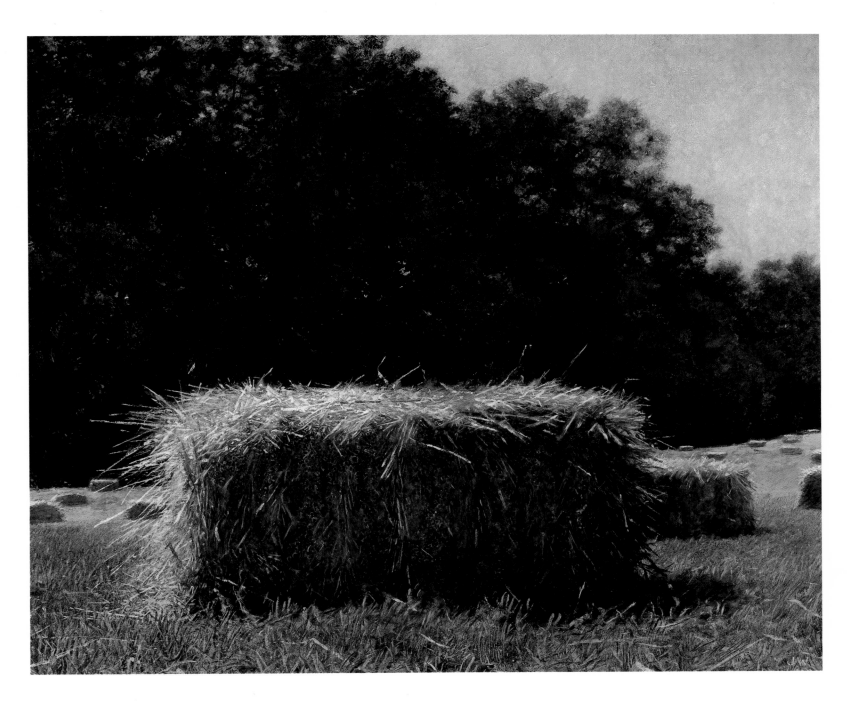

JAMES WYETH *"Bale"* 1972 (90)

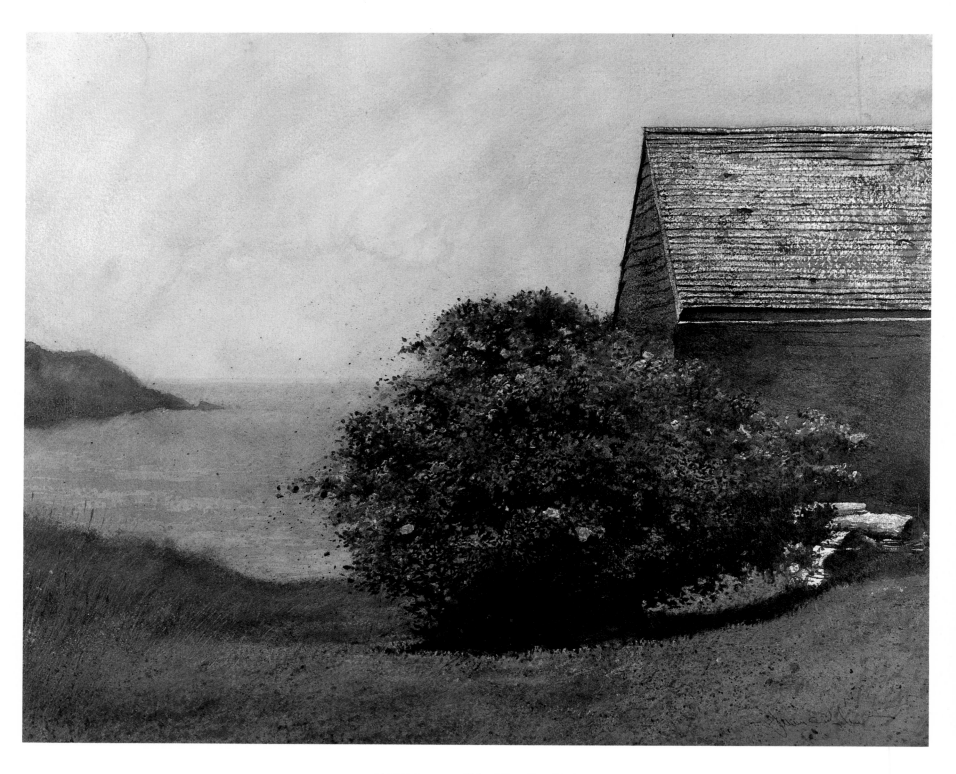

JAMES WYETH *"Island Roses"* 1968 (84)

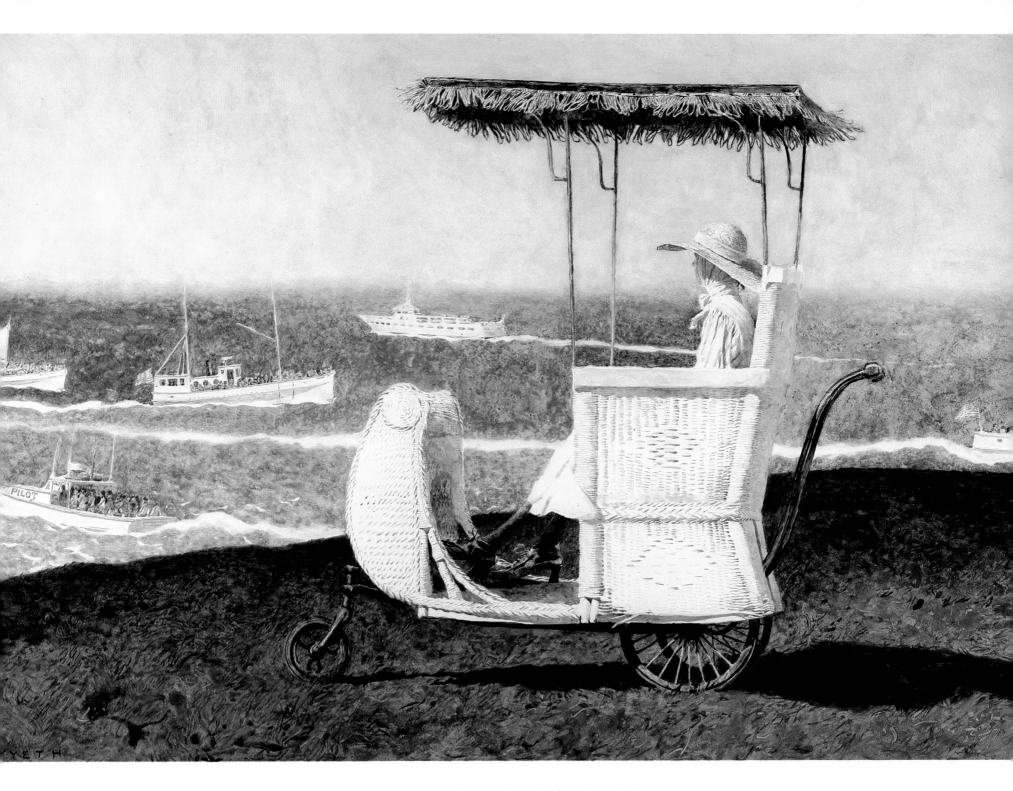

JAMES WYETH *"Excursion Boats, Monhegan" 1982* (106)

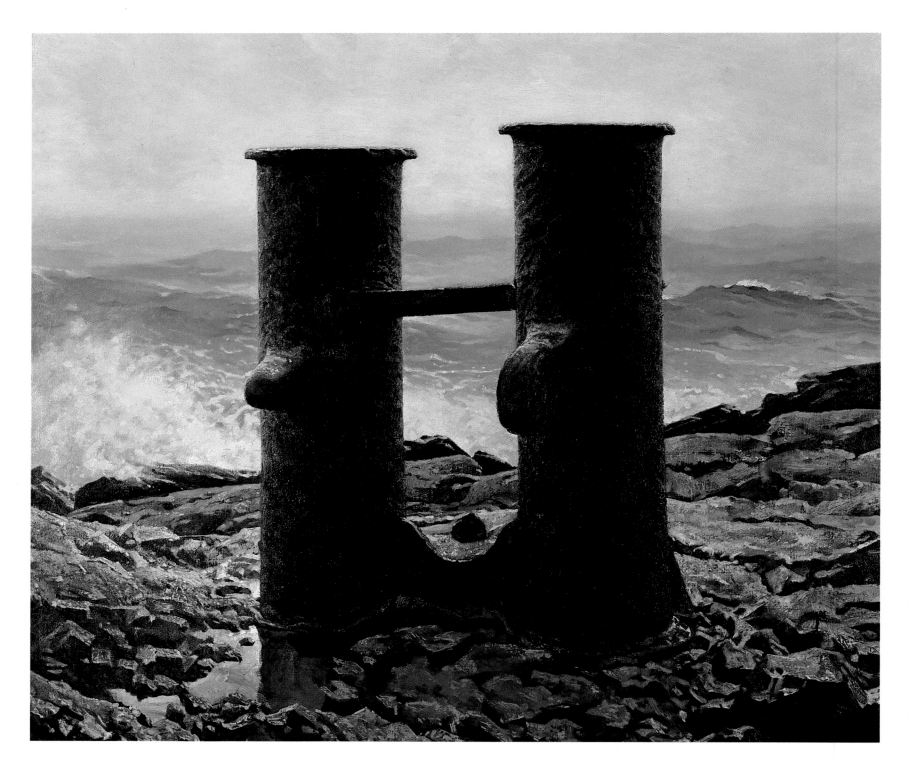

JAMES WYETH *"Sea of Storms"* 1970 (88)

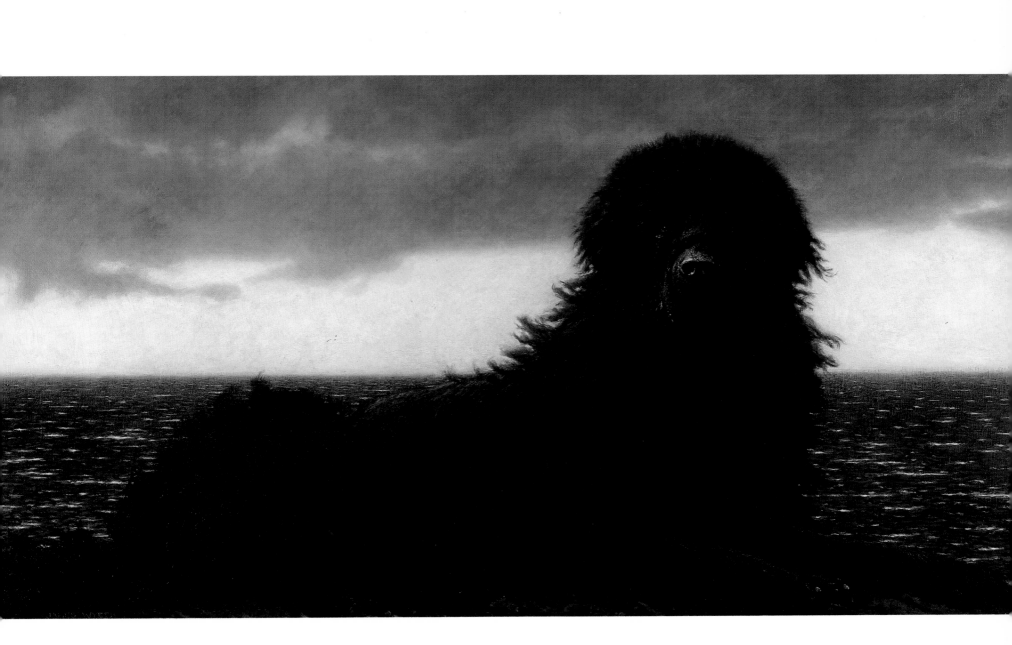

JAMES WYETH *"Newfoundland"* 1971 (89)

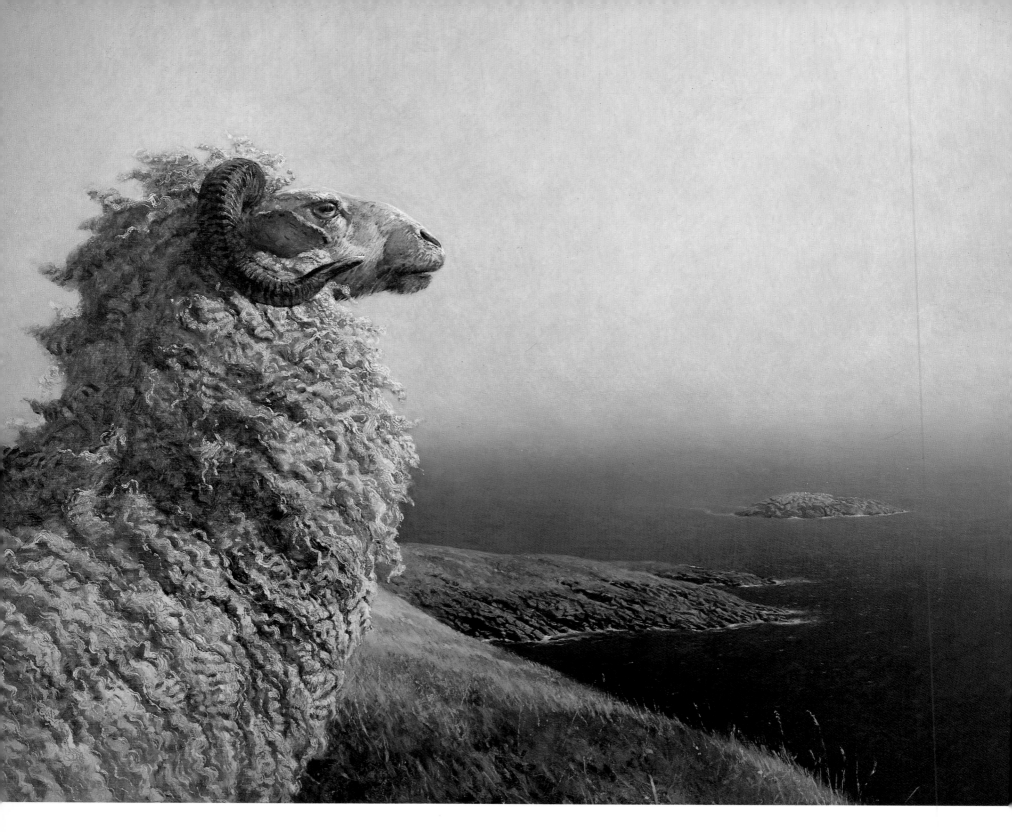

JAMES WYETH *"Islander"* 1975 (95)

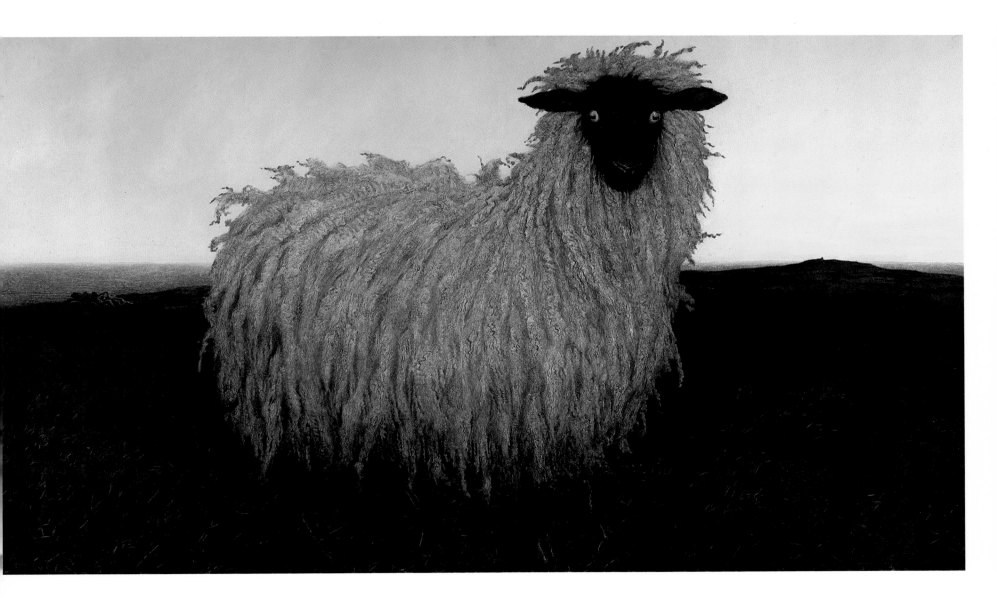

JAMES WYETH *"Portrait of Lady" 1968* (85)

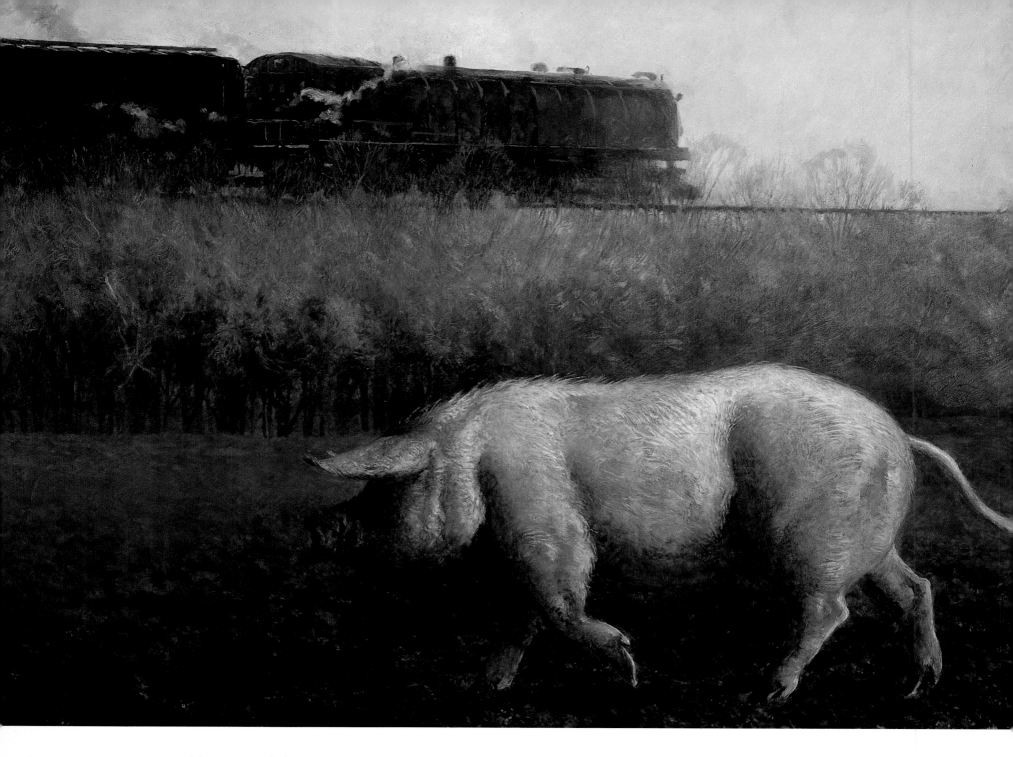

JAMES WYETH *"Pig and the Train"* *1977* (98)

JAMES WYETH *"Night Pigs"* *1979* (102)

184

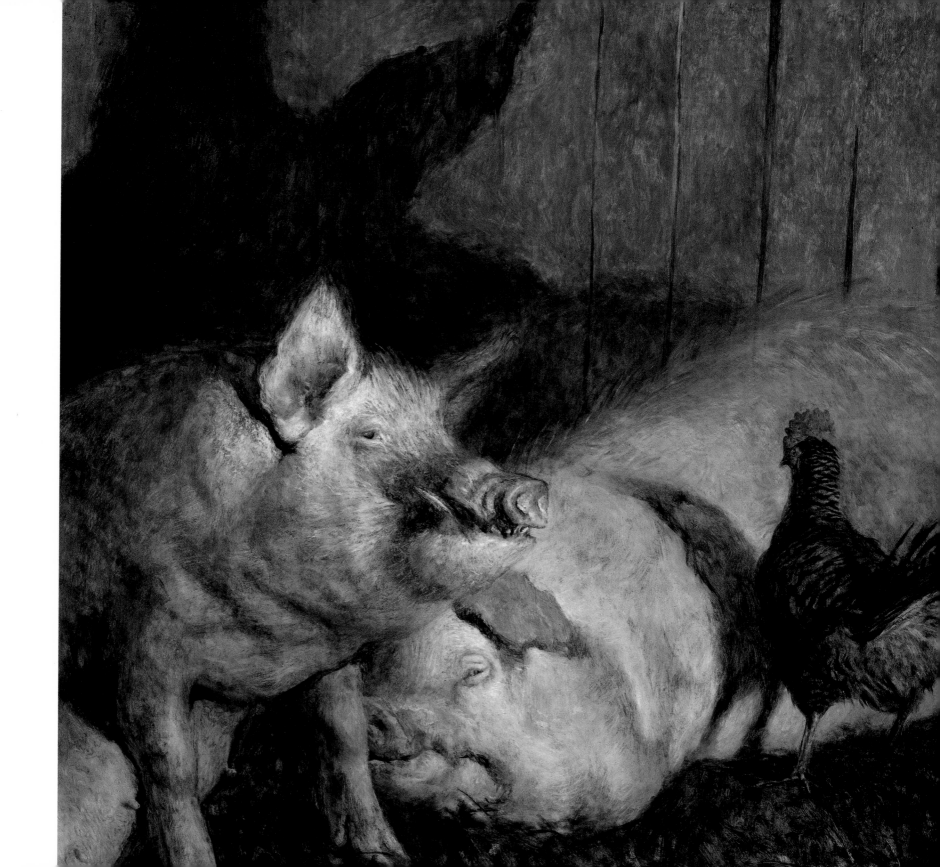

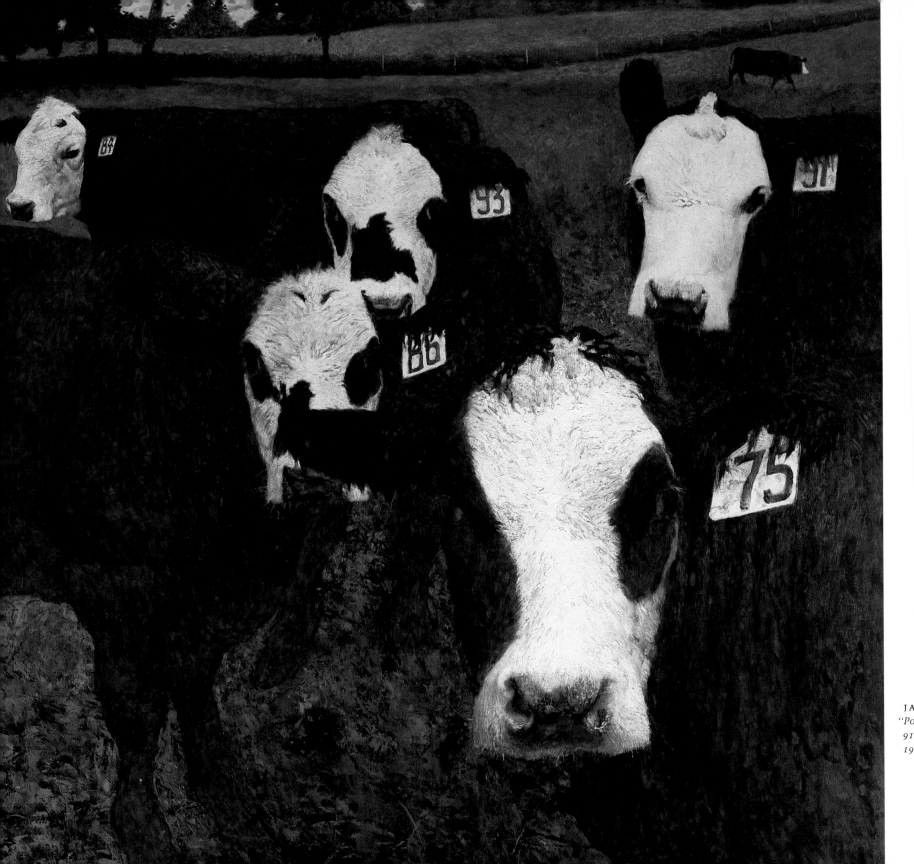

JAMES WYETH
"Portrait of 75, 86,
91, 93, 84"
1980 (104)

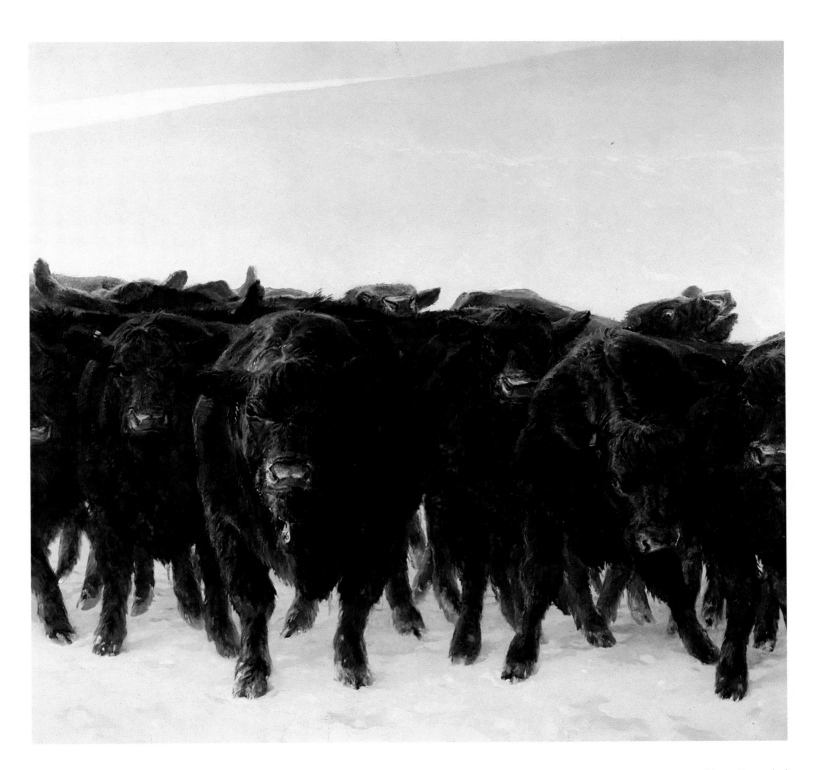

JAMES WYETH *"Angus"* 1974 (93)

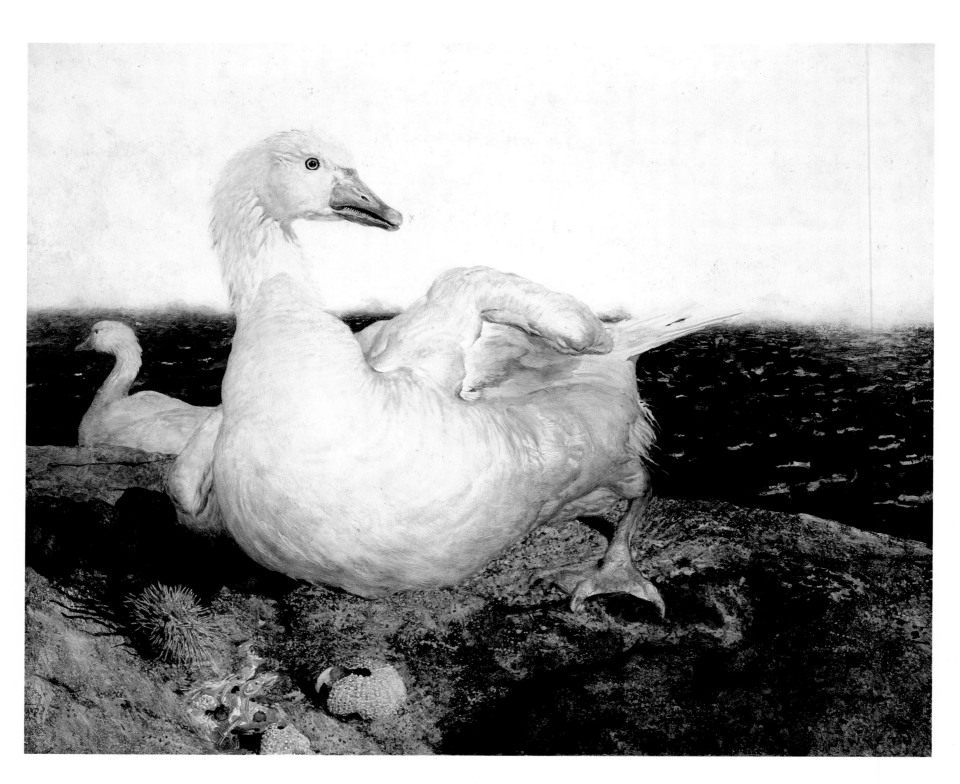

JAMES WYETH *"Island Geese"* 1982 (107)

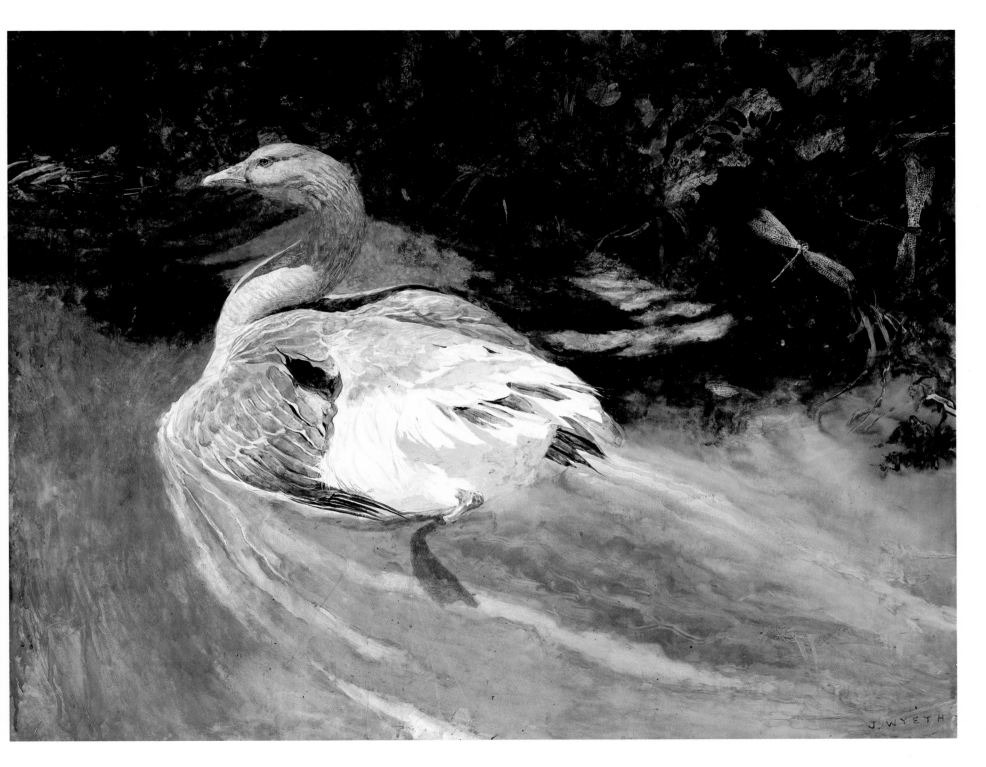

JAMES WYETH *"Dragonflies"* 1986 (116)

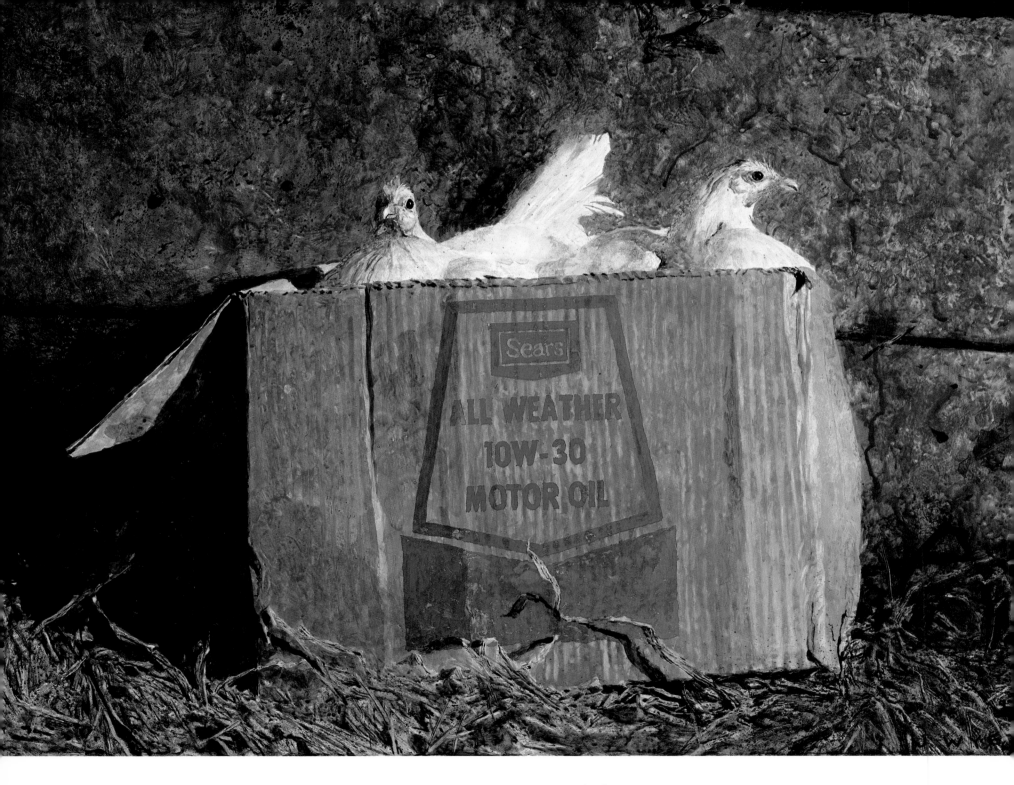

JAMES WYETH *"10W30" 1981* (105)

JAMES WYETH *"Night Chickens" 1983* (108)

Compiled by MARYLOU ASHOOH LAZOS

Bibliography

General

Brandywine River Museum, Chadds Ford, Pennsylvania. "The Brandywine Heritage." 1971. Introduction by Richard McLanathan. (Exhibition catalogue)

———. "Carolyn Wyeth, Artist." 1979. Introduction by Richard Meryman. (Exhibition catalogue)

———. "Henriette Wyeth." 1980. Essay by Paul Horgan. (Exhibition catalogue)

Dallas Museum of Fine Arts, Dallas, Texas. "Famous Families in American Art." 1960. Text by J. Bywaters. (Exhibition catalogue)

Delaware Art Museum, Wilmington, Delaware. "Brandywine Tradition Artists." 1971–72. New York: Great American Editions, 1971. Introduction by Rowland Elzea. (Exhibition catalogue)

———. "Howard Pyle: Diversity in Depth." 1973. Rowland Elzea, et al. (Exhibition catalogue)

———. "A Small School of Art: The Students of Howard Pyle." 1980. Edited by Rowland Elzea and Elizabeth H. Hawkes. (Exhibition catalogue)

Elzea, Rowland. *Howard Pyle.* New York: Bantam Books, 1975.

Memphis Brooks Museum of Art, Memphis, Tennessee. "Howard Pyle and the Wyeths: Four Generations of American Imagination." 1983. Catalogue text by Douglas K. S. Hyland. Essay by Howard P. Brokaw. (Exhibition catalogue)

Meyer, Susan E. "Three Generations of the Wyeth Family," *American Artist,* No. 39 (February 1975), pp. 35–75, 78–89.

Pitz, Henry C. *The Brandywine Tradition.* Boston: Houghton Mifflin Company, 1969.

———. *Howard Pyle.* New York: Clarkson N. Potter, 1975.

Wyeth, Betsy James. *The Stray,* with drawings by Jamie Wyeth. New York: Farrar, Straus and Giroux, 1979.

N. C. Wyeth

Allen, Douglas, and Allen, Douglas, Jr. *N. C. Wyeth.* New York: Crown, 1972.

Brandywine River Museum, Chadds Ford, Pennsylvania. "N. C. Wyeth." 1972. Introduction by Lincoln Kirstein. (Exhibition catalogue)

———. "Not for Publication: Landscapes, Still Lifes and Portraits by N. C. Wyeth." 1982. Essay by James H. Duff. (Exhibition catalogue)

Buffalo Bill Historical Center, Cody, Wyoming. "The Western World of N. C. Wyeth." 1980. Essay by James H. Duff. (Exhibition catalogue)

Meyer, Susan E. *America's Great Illustrators.* New York: Harry N. Abrams, 1978.

William A. Farnsworth Library and Art Museum, Rockland, Maine. "An Exhibition of Paintings from the World of N. C. Wyeth." 1966. (Exhibition catalogue)

———. "N. C. Wyeth in Maine/A Centenary Exhibition." 1982. Essay by Christine B. Podmaniczky. (Exhibition catalogue)

William Penn Memorial Museum, Harrisburg, Pennsylvania. "N. C. Wyeth and the Brandywine Tradition." 1965. (Exhibition catalogue)

Wyeth, Betsy James, editor. *The Wyeths: The Letters of N. C. Wyeth, 1901–1945.* Boston: Gambit, 1971.

Andrew Wyeth

Albright-Knox Art Gallery, Buffalo, New York. "Andrew Wyeth: Temperas, Water Colors and Drawings." 1962. Introduction by Joseph Verner Reed. (Exhibition catalogue)

Arizona University Art Gallery, Tucson, Arizona. "Andrew Wyeth: Impressions for a Portrait." 1963. Introduction by Paul Horgan. (Exhibition catalogue) Reprinted in *Ramparts,* Vol. II, No. 3 (November 1963), pp. 69–84.

Canton Art Institute, Canton, Ohio. "Andrew Wyeth." 1985. Foreword by John H. Surovek. Introduction by M. J. Albacete. (Exhibition catalogue)

The Currier Gallery of Art, Manchester, New Hampshire, and William A. Farnsworth Library and Art Museum, Rockland, Maine. "Paintings and Drawings by Andrew Wyeth." 1951. Introduction by Samuel M. Green. (Exhibition catalogue)

The Fine Arts Museum of San Francisco, San Francisco, California. "The Art of Andrew Wyeth." Greenwich, Connecticut: New York Graphic Society, 1973. Essay by Wanda Corn with contributions by Brian O'Doherty, Richard Meryman, and E. P. Richardson. (Exhibition catalogue)

Fogg Art Museum, Cambridge, Massachusetts. "Andrew Wyeth: Dry Brush and Pencil Drawings." 1963. Introduction by Agnes Mongan. (Exhibition catalogue)

Greenville County Museum of Art, Greenville, South Carolina. "Works by Andrew Wyeth from the Holly and Arthur Magill Collection." 1979. Essay by John Canaday. (Exhibition catalogue)

Hoving, Thomas. "The Prussian: Andrew Wyeth's Secret Paintings (1972–85)," *Connoisseur,* September 1986, pp. 84–87.

Institute of Contemporary Arts, London. "Symbolic Realism in American Painting, 1940–1950." 1950. Introduction by Lincoln Kirstein. (Exhibition catalogue)

Knoedler, M., & Co., New York. "Exhibition of Paintings by Andrew Wyeth." 1953. Introduction by Robert G. McIntyre. (Exhibition catalogue)

Los Angeles County Museum of Art, Los Angeles, California. "Eight American Masters of Watercolor." 1968. Introduction by Larry Curry. (Exhibition catalogue)

Meryman, Richard. *Andrew Wyeth.* Boston: Houghton Mifflin Company, 1968.

———. "Andrew Wyeth," *Life,* Vol. LVIII, No. 19 (May 14, 1965), pp. 92–106.

The Metropolitan Museum of Art, New York, New York. "Two Worlds of Andrew Wyeth: Kuerners and Olsons." 1976. Foreword and introduction by Thomas Hoving. (Exhibition catalogue)

Meyer, Susan E. "Editorial: Random Thoughts on the Most Famous Painter in America," *American Artist,* No. 41 (February 1977), pp. 6–7.

Mortenson, C. Walter. *The Illustrations of Andrew Wyeth: A Check List.* West Chester, Pennsylvania: Aralia Press, 1977.

Museum of Art, Fort Lauderdale, Florida. "Andrew Wyeth." 1983. Introduction by John H. Surovek. (Exhibition catalogue)

Museum of Fine Arts, Boston, Massachusetts. "Andrew Wyeth." 1970. Introduction by David McCord. (Exhibition catalogue)

The Museum of Modern Art, New York, New York. "American Realists and Magic Realists." 1943. Foreword by Dorothy C. Miller. Introduction by Lincoln Kirstein. (Exhibition catalogue)

O'Doherty, Brian. "Andrew Wyeth," *Show,* Vol. V, No. 4 (May 1965), pp. 46–55, 72–75.

———. "Wyeth and Emerson: Art as Analogy," *Art and Artists* (London), Vol. II, No. 1 (April 1967), pp. 12–15.

Oklahoma Museum of Art, Oklahoma City, Oklahoma. "The Wonder of Andrew Wyeth." 1967. (Exhibition catalogue)

Pennsylvania Academy of the Fine Arts, Philadelphia, Pennsylvania. "Andrew Wyeth." 1966. Text by E. P. Richardson. (Exhibition catalogue)

Richardson, E. P. "Andrew Wyeth," *Atlantic Monthly,* Vol. CCXIII, No. 6 (June 1964), pp. 62–71.

Royal Academy of Arts, London. "Andrew Wyeth." 1980. Essay by Marina Vaizey. (Exhibition catalogue)

Schaire, Jeffrey. "The Unknown Andrew Wyeth," *Art & Antiques,* September 1985, pp. 46–57.

———. "Andrew Wyeth's Secret Paintings," *Art & Antiques,* September 1986, pp. 68–79.

Wichita Art Museum, Wichita, Kansas. "Wyeth's World." 1967. (Exhibition catalogue)

Wyeth, Betsy James. *Christina's World: Paintings and Prestudies of Andrew Wyeth.* Boston: Houghton Mifflin Company, 1982.

———. *Wyeth at Kuerners.* Boston: Houghton Mifflin Company, 1976.

James Wyeth

Amaya, M. "Artist's Dialogue: A Conversation with Jamie Wyeth," *Architectural Digest,* No. 38 (May 1981), pp. 196+.

Boer, Westin. "Jamie Wyeth at 38," *North Shore Weekender,* August 2, 1984.

Coe Kerr Gallery, New York, New York. "James Wyeth Recent Paintings." 1974. Essay by Theodore E. Stebbins, Jr. (Exhibition catalogue)

———. "Jamie Wyeth/Recent Paintings." 1977. Introduction by Warren Adelson. (Exhibition catalogue)

———. "Jamie Wyeth/Recent Works." 1984. Introduction by R. Frederick Woolworth. (Exhibition catalogue)

Doherty, M. S. "Jamie Wyeth's Studio Retreat," *American Artist,* No. 45 (February 1981), pp. 56–61.

Giffin, Marianne. "Island to Island: An Interview with Jamie Wyeth," *The Inquirer and Mirror*, Nantucket, Massachusetts, August 2, 1984.

Holverson, John. "Jamie Wyeth: An American View," *Horizon*, July/August 1984. Reprinted in *Views*, January/February 1986, pp. 8–16.

Joslyn Art Museum, Omaha, Nebraska. "James Wyeth." 1976. Essay by Theodore E. Stebbins, Jr. (Exhibition catalogue)

Knight, Carleton, III. "Jamie Wyeth: The Artist in His Environment," *Historic Preservation*, Vol. XXIV, No. 1 (January–March 1972), pp. 8–12. Reprinted in "Brandywine River Museum Antiques Show," 1974, Chadds Ford, Pennsylvania, pp. 12–15. (Exhibition catalogue)

Ledger, Marshall. "Jamie's World," *Philadelphia Magazine*, September 1980, pp. 130–137 +.

Lewis, Maggie. "Jamie Wyeth: The Artist Is a Lonely Hunter," *The Christian Science Monitor*, November 3, 1981, pp. B2 +.

Meryman, Richard. Untitled, *People Weekly*, February 9, 1981, p. 116.

Meyer, S. E. "James Wyeth," *American Artist*, No. 39 (February 1975), pp. 84–89.

Montgomery Gallery, San Francisco, California. "Jamie Wyeth/Special Works." 1985. Introduction by Peter M. Fairbanks. (Exhibition catalogue)

Pennsylvania Academy of the Fine Arts, Philadelphia, Pennsylvania. "Jamie Wyeth." 1980. (Exhibition catalogue)

Portland Museum of Art, Portland, Maine. "Jamie Wyeth: An American View." 1984. Essay by Michael Preble. (Exhibition catalogue)

Roddy, Joseph. "Another Wyeth: The Portrait Artist Is a Young Man," *Look*, April 2, 1968, pp. 56–62.

Rollins, Thomas C. "Jamie Wyeth: An American View," *The Columbian Record*, September 13, 1984.

William A. Farnsworth Library and Art Museum, Rockland, Maine. "Jamie Wyeth/Oils, Watercolors, Drawings." 1969. (Exhibition catalogue)

Wyeth, James. *Jamie Wyeth*. Boston: Houghton Mifflin Company, 1980.

Lenders to the Exhibition

Adams Davidson Galleries

Ken and Joan Austin

Dr. and Mrs. Ronald Brady

Brandywine River Museum

Mr. D. P. Brown

Mr. and Mrs. George P. Caulkins, Jr.

Dr. and Mrs. Donald Counts

Dr. James E. Crane

Louise Philibosian Danelian

Dr. and Mrs. Milton C. David

Delaware Art Museum

Diamond M Museum of Fine Art

Mr. John J. Edwards

Fine Arts Center/Cheekwood

Mr. Frank E. Fowler

Gulf States Paper Corporation, The Warner Collection

John F. Kennedy Library and Museum

Mr. Lincoln Kirstein

Mr. and Mrs. Fred C. Larkin

Judith and Alexander Laughlin

Holly and Arthur Magill Collection

New Britain Museum of American Art

New York Public Library

Mr. and Mrs. Robert L. Noland

Mr. and Mrs. I. T. Schwartz

Seibu Pisa, Ltd.

Terra Museum of American Art

Mr. Jeffrey Theodore

Valley National Bank of Arizona

Estate of William E. Weiss

Mr. and Mrs. Walter J. Winther

Mrs. Norman B. Woolworth

Mr. and Mrs. Andrew Wyeth

Mr. and Mrs. James Wyeth

Mr. Nicholas Wyeth

Anonymous lenders

Checklist

N. C. Wyeth

1 "From an upper snow platform to which the hard blocks were thrown, a second man heaved them over the bank" ("Attack of the Snow Shovels"), 1906 (*page 14*)
Oil on canvas, 52 x 34 inches (132.1 x 86.4 cm)
Signed: "N. C. Wyeth/06," lower right

 Illustration for W. M. Raine's and W. H. Eader's "How They Opened the Snow Road," *The Outing Magazine*, January 1907, Vol. XLIX, No. 4.

 Private Collection

2 "Hands up!" ("Hold Up in the Canyon"), 1906 (*page 90*)
Oil on canvas, 43 x 30 inches (109.2 x 76.2 cm)
Signed: "N. C. Wyeth/'06," lower left

 Illustration for C. P. Connolly's "The Story of Montana," *McClure's Magazine*, August 1906.

 Lent by the Valley National Bank of Arizona

3 "In the Crystal Depths," 1906 (*page 17*)
Oil on canvas, 38 x 26 inches (96.5 x 66 cm)
Signed: "N. C. Wyeth/1906," upper left

 Illustration for "The Indian in His Solitude," *The Outing Magazine*, June 1907.

 Collection of the Brandywine River Museum

4 "Mowing," 1907 (*page 19*)
Oil on canvas, 37½ x 26¾ inches (95.5 x 67.9 cm)
Signed: "N. C. Wyeth, Chadds Ford, PA," lower right

 Unpublished illustration.

 Lent by Mr. Nicholas Wyeth

5 "On the October Trail" ("A Navajo Family"), 1908 (*page 94*)
Oil on canvas, 41¾ x 29¼ inches (106 x 74.3 cm)
Signed: "N. C. Wyeth," lower right

 Frontispiece illustration, *Scribner's Magazine*, October 1908, Vol. XLIV, No. 4.

 Collection of the Brandywine River Museum

6 "Winter," 1909 (*page 21*)
Oil on canvas, 33 x 29½ inches (83.8 x 74.9 cm)
Signed: "'N. C. Wyeth/1909," lower left

 Illustration for George T. Marsh's poem "The Moods," *Scribner's Magazine*, December 1909.

 Private Collection

7 "The First Cargo," 1910 (*page 89*)
Oil on canvas, 47 x 38 inches (119.4 x 96.5 cm)
Signed: "N. C. Wyeth," lower left

 Illustration for Arthur Conan Doyle's "Through the Mists II: The First Cargo," *Scribner's Magazine*, December 1910.

 Lent by the New York Public Library, Central Children's Room, Donnell Library Center

8 "The Vedette," 1910 (*page 20*)
Oil on canvas, 47 x 38 inches (119.4 x 96.5 cm)
Signed: "N. C. Wyeth/'10," lower right

 Illustration for Mary Johnston's *The Long Roll*. Boston: Houghton Mifflin Company, 1911.

 Private Collection

9 "The children were playing at marriage-by-capture," 1911 (*page 92*)
Oil on canvas, 46½ x 38 inches (118.1 x 96.5 cm)
Signed: "N. C. Wyeth," lower right

Illustration for Gouverneur Morris's "Growing Up," *Harper's Monthly Magazine*, November 1911.

Private Collection

10 "Nothing would escape their black, jewel-like, inscrutable eyes" ("The Guardians"), 1911 (*page 93*)
Oil on canvas, 46½ x 37½ inches (118.1 x 95.3 cm)
Signed: "N. C. Wyeth," lower left

Illustration for Gouverneur Morris's "Growing Up," *Harper's Monthly Magazine*, November 1911.

Lent by the Warner Collection of Gulf States Paper Corporation, Tuscaloosa, Alabama

11 "Ben Gunn," 1911 (*page 24*)
(Original caption: "I saw a figure leap with great rapidity behind the trunk of a pine")
Oil on canvas, 47 x 38 inches (119.4 x 95.5 cm)
Signed: "N. C. Wyeth," lower right

Illustration for Robert Louis Stevenson's *Treasure Island.* New York: Charles Scribner's Sons, 1911.

Private Collection

12 "The Black Spot," 1911 (*page 25*)
(Original caption: "About half way down the slope to the stockade, they were collected in a group")
Oil on canvas, 46 x 37½ inches (116.8 x 95.3 cm)
Signed: "N. C. Wyeth," lower left

Illustration for Robert Louis Stevenson's *Treasure Island.* New York: Charles Scribner's Sons, 1911.

Private Collection

13 "Captain Bones Routs Black Dog," 1911 (*page 103*)
(Original caption: "One last tremendous cut which would certainly have split him to the chin had it not been intercepted by our big signboard of Admiral Benbow")

Oil on canvas, 47 x 38 inches (119.4 x 96.5 cm)
Signed: "N. C. Wyeth," lower right

Illustration for Robert Louis Stevenson's *Treasure Island.* New York: Charles Scribner's Sons, 1911.

Private Collection

14 "Israel Hands," 1911 (*page 98*)
(Original caption: " 'One more step, Mr. Hands,' said I, 'and I'll blow your brains out' ")
Oil on canvas, 47¼ x 38½ inches (120 x 97 cm)
Signed: "N. C. Wyeth," lower right

Illustration for Robert Louis Stevenson's *Treasure Island.* New York: Charles Scribner's Sons, 1911.

Lent by the New Britain Museum of American Art. Harriet Russell Stanley Memorial Fund

15 "Long John Silver and Hawkins" ("In the Galley with Long John Silver"), 1911 (*page 101*)
(Original caption: "To me he was unweariedly kind; and always glad to see me in the galley")
Oil on canvas, 47 x 38 inches (119.4 x 96.5 cm)
Signed: "N. C. Wyeth," upper left

Illustration for Robert Louis Stevenson's *Treasure Island.* New York: Charles Scribner's Sons, 1911.

Private Collection

16 "Preparing for the Mutiny" ("Serving Out the Weapons"), 1911 (*page 100*)
(Original caption: "Loaded pistols were served out to all the sure men")
Oil on canvas, 47⅜ x 38⅜ inches (120.3 x 97.4 cm)
Signed: "N. C. Wyeth," upper left

Illustration for Robert Louis Stevenson's *Treasure Island.* New York: Charles Scribner's Sons, 1911.

Private Collection

17 "Old Pew" ("Blind Pew"), 1911 (*page 102*)
(Original caption: "Tapping up and down the road in a frenzy, and groping and calling for his comrades")
Oil on canvas, 47 x 38 inches (119.4 x 96.5 cm)
Signed: "N. C. Wyeth 1911," lower right

Illustration for Robert Louis Stevenson's *Treasure Island.* New York: Charles Scribner's Sons, 1911.

Private Collection

18 "The Treasure Cave!," 1911 (*page 105*)
(Original caption: "I was kept busy all day in the cave, packing the minted money into bread-bags")
Oil on canvas, 47⅜ x 38¼ inches (120.3 x 97.2 cm)
Signed: "N. C. Wyeth," lower left

Illustration for Robert Louis Stevenson's *Treasure Island.* New York: Charles Scribner's Sons, 1911.

Lent by the New York Public Library, Central Children's Room, Donnell Library Center

19 "McKeon's Graft" ("Train Robbery"), 1912 (*page 91*)
Oil on canvas, 44 x 33 inches (111.8 x 83.8 cm)
Unsigned

Illustration for Luke Thrice's "McKeon's Graft," *New Story Magazine*, October 1912.

Lent by Ken and Joan Austin

20 "The Road to Vidalia," 1912 (*page 97*)
Oil on canvas, 47 x 37 inches (119.4 x 93.4 cm)
Signed: "N. C. Wyeth," lower right

Illustration for Mary Johnston's *Cease Firing.* Boston: Houghton Mifflin Company, 1912.

Private Collection

21 "The Magician and the Maid of Beauty," 1912 (*page 108*)
(Original caption: "High in the sky he saw a rainbow, and on it the Maid of Beauty")
Oil on canvas, 33 x 46¼ inches (83.8 x 117.5 cm)
Signed: "N. C. Wyeth," lower left

Illustration for James Baldwin's *The Sampo.* New York: Charles Scribner's Sons, 1912.

Lent by Mr. James Wyeth

22 "Self-Portrait," 1913 (*page 88*)
Oil on canvas, 18¼ x 12¼ inches (46.4 x 31.1 cm)
Unsigned

Lent by Mr. Nicholas Wyeth

23 "At the Cards in Cluny's Cage," 1913 (page 106)
(Original caption: "But Alan and Cluny were most of the time at the cards")
Oil on canvas, 40 x 32 inches (101.6 x 81.3 cm)
Signed: "N. C. Wyeth," upper right

Illustration for Robert Louis Stevenson's *Kidnapped.* New York: Charles Scribner's Sons, 1913.

Collection of the Brandywine River Museum. Bequest of Mrs. Russell G. Colt

24 "On the Island of Earraid," 1913 (page 27)
(Original caption: "But the second day passed; and as long as the light lasted I kept a bright look-out for boats on the sound or men passing on the Ross")
Oil on canvas, 40 x 32 inches (101.6 x 81.3 cm)
Signed: "N. C. Wyeth," lower right

Illustration for Robert Louis Stevenson's *Kidnapped.* New York: Charles Scribner's Sons, 1913.

Private Collection

25 "The Siege of the Round-House," 1913 (page 26)
(Original caption: "It came all of a sudden when it did, with a rush of feet and a roar, and then a shout from Alan")
Oil on canvas, 40 x 32 inches (101.6 x 81.3 cm)
Signed: "N. C. Wyeth," lower right

Illustration for Robert Louis Stevenson's *Kidnapped.* New York: Charles Scribner's Sons, 1913.

Collection of the Brandywine River Museum. Bequest of Mrs. Russell G. Colt

26 "The Torrent in the Valley of Glencoe," 1913 (page 107)
(Original caption: "I had scarce time to measure the distance or to understand the peril before I had followed him, and he had caught and stopped me")
Oil on canvas, 40 x 32 inches (101.6 x 81.3 cm)
Signed: "N. C. Wyeth," lower right

Illustration for Robert Louis Stevenson's *Kidnapped.* New York: Charles Scribner's Sons, 1913.

Lent by the New York Public Library, Central Children's Room, Donnell Library Center

27 "The Wreck of the 'Covenant,' " 1913 (page 99)
(Original caption: "It was the spare yard I had got hold of, and I was amazed to see how far I had travelled from the brig")
Oil on canvas, 41¾ x 33¾ inches (106 x 85.7 cm)
Signed: "N. C. Wyeth," lower right

Illustration for Robert Louis Stevenson's *Kidnapped.* New York: Charles Scribner's Sons, 1913.

Collection of the Brandywine River Museum. Bequest of Mrs. Russell G. Colt

28 "War" ("The Charge"), 1913 (page 95)
Oil on canvas, 47½ x 38¼ inches (120 x 97.2 cm)
Signed: "N. C. Wyeth," lower left

Illustration for John Luther Long's *War; or, What Happens When One Loves One's Enemy.* Indianapolis: The Bobbs-Merrill Company, 1913.

Private Collection

29 "And Lawless, keeping half a step in front of his companion and holding his head forward like a hunting-dog upon the scent, . . . studied out their path," 1916 (page 104)
Oil on canvas, 40 x 32 inches (101.6 x 81.3 cm)
Signed: "N. C. Wyeth," upper left

Illustration for Robert Louis Stevenson's *The Black Arrow: A Tale of the Two Roses.* New York: Charles Scribner's Sons, 1916.

Private Collection

30 "In the fork, like a mastheaded seaman, there stood a man in a green tabard, spying far and wide," 1916 (page 112)
Oil on canvas, 40 x 32 inches (101.6 x 81.3 cm)
Signed: "N. C. Wyeth," lower right

Illustration for Robert Louis Stevenson's *The Black Arrow: A Tale of the Two Roses.* New York: Charles Scribner's Sons, 1916.

Private Collection

31 "A shower of arrows rained on our dead horses from the closing circle of redmen" ("Fight on the Plains"), 1916 (page 15)
Oil on canvas, 32 x 40 inches (81.3 x 101.6 cm)
Signed: "To Mr. And Mrs. Howard Pyle/from N. C. Wyeth," lower right

Illustration for Col. William F. Cody's "The Great West That Was," *Hearst's Magazine,* 1916.

Private Collection

32 "The Astrologer Emptied the Whole of the Bowl into the Bottle," 1916 (page 109)
Oil on canvas, 39⅞ x 31⅞ inches (101.3 x 80.9 cm)
Signed: "N. C. Wyeth," upper left

Illustration for Mark Twain's *The Mysterious Stranger.* New York: Harper & Brothers, 1916.

Lent by Dr. James E. Crane, Stamford, Connecticut

33 "It hung upon a thorn, and there he blew three deadly notes," 1917 (page 113)
Oil on canvas, 40 x 32 inches (101.6 x 81.3 cm)
Signed: "N. C. Wyeth," lower right

Illustration for *The Boy's King Arthur,* edited by Sidney Lanier. New York: Charles Scribner's Sons, 1917.

Private Collection

34 "They fought with him on foot more than three hours, both before him and behind him," 1917 (page 31)
Oil on canvas, 43¾ x 35½ inches (111.1 x 90.2 cm)
Signed: "N. C. Wyeth," lower right

Illustration for *The Boy's King Arthur,* edited by Sidney Lanier. New York: Charles Scribner's Sons, 1917.

Private Collection

35 "Little John Fights with the Cook in the Sheriff's House," 1917 (page 111)
(Original caption: "At last he made a dart upon Roger and the chase grew furious. Dishes, plates, covers, pots and pans— all that came in the way of them went flying")

Oil on canvas, 40 x 32 inches (101.6 x 81.3 cm)
Signed: "Wyeth," lower right

Illustration for Paul Creswick's *Robin Hood*. Philadelphia: David McKay, 1917.

Lent by the New York Public Library, Central Children's Room, Donnell Library Center

36 "The Passing of Robin Hood," 1917 (*page 114*)
(Original caption: "Leaning heavily against Little John's sobbing breast Robin Hood flew his last arrow out through the window, far away into the deep green of trees")
Oil on canvas, 40 x 32 inches (101.6 x 81.3 cm)
Signed: "Wyeth," lower right

Illustration for Paul Creswick's *Robin Hood*. Philadelphia: David McKay, 1917.

Lent by the New York Public Library, Central Children's Room, Donnell Library Center

37 "Robin Hood and His Companions Lend Aid to Will o' th' Green from Ambush," 1917 (*page 110*)
(Original caption: "Their arrows flew together, marvellous shots, each finding its prey")
Oil on canvas, 40 x 32 inches (101.6 x 81.3 cm)
Signed: "N. C. Wyeth," upper left

Illustration for Paul Creswick's *Robin Hood*. Philadelphia: David McKay, 1917.

Lent by the New York Public Library, Central Children's Room, Donnell Library Center

38 "The Rescue of Captain Harding," 1918 (*page 96*)
(Original caption: "However, after traveling for two hours, fatigue overcame him, and he slept")
Oil on canvas, 40 x 30 inches (101.6 x 76.2 cm)
Signed: "N. C. Wyeth," lower left

Illustration for Jules Verne's *The Mysterious Island*. New York: Charles Scribner's Sons, 1918.

Lent by the Diamond M Museum of Fine Art, Snyder, Texas

39 "Death of Edwin," 1921 (*page 115*)
(Original caption: "Edwin lay extended on the ground, with an arrow quivering in his breast; his closing eyes still looked upwards to his friend")
Oil on canvas, 40 x 32 inches (101.6 x 81.3 cm)
Signed: "N. C. Wyeth," lower left

Illustration for Jane Porter's *The Scottish Chiefs*. New York: Charles Scribner's Sons, 1921.

Collection of the Brandywine River Museum

Andrew Wyeth

40 "Trodden Weed," 1951 (*page 124*)
Tempera on panel, 20 x 18⅜ inches (50.8 x 46.7 cm)
Signed: "Andrew Wyeth," lower right
Private Collection

41 "Faraway," 1952 (*page 41*)
Drybrush watercolor on paper, 13¾ x 21½ inches (34.9 x 54.6 cm)
Signed: "Andrew Wyeth," lower right
Private Collection

42 "The Corner," 1953 (*page 126*)
Drybrush watercolor on paper, 13½ x 21½ inches (34.3 x 54.6 cm)
Signed: "Andrew Wyeth," lower right
Lent by the Delaware Art Museum. Gift of Mr. and Mrs. W. E. Phelps

43 "Roasted Chestnuts," 1956 (*page 128*)
Tempera on panel, 48 x 33 inches (121.9 x 83.8 cm)
Signed: "Andrew Wyeth," lower left
Collection of the Brandywine River Museum

44 "The Slip," 1958 (*page 132*)
Drybrush watercolor on paper, 21 x 29¼ inches (53.3 x 74.3 cm)
Signed: "Andrew Wyeth," lower right
Private Collection

45 "Raccoon," 1958 (*page 152*)
Tempera on panel, 48 x 48 inches (122 x 122 cm)
Signed: "Andrew Wyeth," lower left
Collection of the Brandywine River Museum. Given in memory of Nancy Hanks. Acquisition made possible by David Rockefeller, Laurance S. Rockefeller, the Pew Memorial Trust, and anonymous donors

46 "May Day," 1960 (*page 36*)
Watercolor on paper, 12¾ x 29 inches (32.4 x 73.7 cm)
Signed: "Andrew Wyeth," lower right
Private Collection

47 "Young Bull," 1960 (*page 135*)
Drybrush watercolor on paper, 19⅞ x 41⅜ inches (50.5 x 105.1 cm)
Signed: "Andrew Wyeth," lower right
Private Collection

48 "Distant Thunder," 1961 (*page 40*)
(To be seen in the USSR only)
Tempera on panel, 48 x 30½ inches (121.9 x 77.5 cm)
Signed: "Andrew Wyeth," lower right
Lent by Mrs. Norman B. Woolworth

49 "Garret Room," 1962 (*page 142*)
Drybrush watercolor on paper, 18 x 23 inches (45.72 x 58.42 cm)
Signed: "Andrew Wyeth," lower left
Private Collection

50 "The Drifter," 1964 (*page 144*)
Drybrush watercolor on paper, 23⅛ x 29 inches (58.7 x 73.66 cm)
Signed: "Andrew Wyeth," upper right
Private Collection

51 "The Patriot," 1964 (*page 146*)
Tempera on panel, 28 x 24 inches (71.1 x 61 cm)
Signed: "Andrew Wyeth," upper left
Private Collection

52 "Weather Side," 1965 (*page 37*)
Tempera on panel, 48 x 27¾ inches (121.9 x 70.5 cm)
Signed: "Andrew Wyeth," lower left
Lent by the Holly and Arthur Magill Collection

53 "Spring Fed," 1967 (*page 134*)
Tempera on panel, 27½ x 39½ inches (69.9 x 100.3 cm)
Signed: "Andrew Wyeth," lower right
Lent by the Estate of William E. Weiss

54 "Evening at Kuerners," 1970 (*page 130*)
Drybrush watercolor on paper, 25½ x 39¾ inches
(64.8 x 101 cm)
Signed: "Andrew Wyeth," lower right

Private Collection

55 "Indian Summer," 1970 (*page 48*)
Tempera on panel, 42 x 35 inches
(106.7 x 88.9 cm)
Signed: "Andrew Wyeth," upper left

Collection of the Brandywine River Museum

56 "Siri," 1970 (*page 139*)
Tempera on panel, 30 x 30½ inches
(76.2 x 77.5 cm)
Signed: "Andrew Wyeth," upper right

Collection of the Brandywine River Museum

57 "Spruce Grove," 1970 (*page 125*)
Watercolor on paper, 18½ x 27½ inches
(47 x 70 cm)
Signed: "Andrew Wyeth," lower right

Lent by Mr. and Mrs. Walter J. Winther

58 "The Kuerners," 1971 (*page 127*)
Drybrush watercolor on paper, 25 x 40 inches
(63.5 x 101.6 cm)
Signed: "A. Wyeth," lower right

Private Collection

59 "Maidenhair," 1974 (*page 136*)
(To be seen in Washington, D.C., Dallas, Chicago,
Tokyo, Milan, Cambridge, and Chadds Ford)
Tempera on panel, 29⅛ x 23 inches (74 x 58.4 cm)
Signed: "A.W.," center left

Private Collection

60 "Wolf Moon," 1975 (*page 53*)
Watercolor on paper, 40 x 28½ inches
(101.6 x 72.4 cm)
Signed: "Andrew Wyeth," lower left

Private Collection

61 "Barracoon," 1976 (*page 143*)
Tempera on panel, 17¼ x 33¾ inches
(43.8 x 85.7 cm)
Signed: "Andrew Wyeth," upper left

Private Collection

62 "Spring," 1978 (*page 45*)
Tempera on panel, 24 x 48 inches (61 x 121.9 cm)
Signed: "A.W.," lower right

Private Collection

63 "Bird in the House," 1979 (*page 151*)
Watercolor on paper, 29½ x 21½ inches
(74.9 x 54.6 cm)
Signed: "Andrew Wyeth," lower left

Private Collection

64 "Night Shadow," 1979 (*page 49*)
Drybrush watercolor on paper, 19⅝ x 25⅜ inches
(49.9 x 64.4 cm)
Signed: "Andrew Wyeth," lower left

Private Collection

65 "Last Night," 1980 (*page 148*)
Watercolor on paper, 19⅝ x 15⅝ inches
(49.9 x 39.7 cm)
Signed: "Andrew Wyeth," lower right

Private Collection

66 "Big Top," 1981 (*page 131*)
Drybrush watercolor on paper, 28¾ x 51 inches
(73 x 129.5 cm)
Signed: "Andrew Wyeth," lower left

Private Collection

67 "Lovers," 1981 (*page 141*)
Drybrush watercolor on paper, 22½ x 28½ inches
(57.2 x 72.4 cm)
Signed: "A. Wyeth," upper right

Private Collection

68 "Adrift," 1982 (*page 44*)
Tempera on panel, 27⅝ x 27⅝ inches
(70.2 x 70.2 cm)
Signed: "A. Wyeth," lower right

Private Collection

69 "Under Sail," 1982 (*page 137*)
Watercolor on paper, 21 x 29 inches
(53.3 x 73.7 cm)
Signed: "Andrew Wyeth," lower left

Lent by Mr. and Mrs. George P. Caulkins, Jr.

70 "Liberty Launch," 1983 (*page 133*)
Watercolor on paper, 30¾ x 22 ⅜ inches
(78.1 x 56.8 cm)
Signed: "Andrew Wyeth," lower right

Lent by Mr. and Mrs. I. T. Schwartz

71 "Whale," 1983 (*page 149*)
Watercolor on paper, 21 x 29 inches
(53.3 x 73.7 cm)
Signed: "Andrew Wyeth," lower right

Lent by Dr. and Mrs. Donald Counts

72 "Autumn," 1984 (*page 140*)
Watercolor on paper, 21 x 29½ inches
(53.3 x 74.9 cm)
Signed: "Andrew Wyeth," lower right

Private Collection

73 "Border Patrol," 1984 (*page 129*)
Watercolor on paper, 21¾ x 30 inches
(55.2 x 76.2 cm)
Unsigned

Private Collection

74 "Ravens Grove," 1985 (*page 52*)
Tempera on panel, 31 x 27¾ inches
(78.7 x 70.5 cm)
Signed: "Andrew Wyeth," lower left

Lent by Seibu Pisa, Ltd., Tokyo, Japan

75 "Ring Road," 1985 (*page 147*)
Tempera on panel, 16⅞ x 39¾ inches
(42.9 x 101 cm)
Signed: "Andrew Wyeth," lower right

Private Collection

76 "Captain Cook," 1986 (*page 145*)
Watercolor on paper, 21½ x 30⅛ inches
(53.7 x 76.5 cm)
Signed: "A. Wyeth," lower right

Private Collection

77 "Rag Bag," 1986 (*page 153*)
Watercolor on paper, 30 x 22⅜ inches
(76.2 x 56.8 cm)
Signed: "Andrew Wyeth," upper right
Lent by Mr. John J. Edwards

78 "Two Masters," 1986 (*page 150*)
Watercolor on paper, 29⅛ x 36 inches
(74 x 91.4 cm)
Signed: "Andrew Wyeth," upper right
Lent by Mr. D. P. Brown

James Wyeth

79 "Portrait of Shorty," 1963 (*page 163*)
Oil on canvas, 18 x 22 inches (45.7 x 55.8 cm)
Signed: "James Wyeth," lower right
Private Collection

80 "Draft Age," 1965 (*page 164*)
Oil on canvas, 36 x 30 inches (91.4 x 76.2 cm)
Signed: "James Wyeth," lower right
Lent by Mr. Jeffrey Theodore

81 "Portrait of Jeffrey," 1966 (*page 165*)
Oil on canvas, 19 x 22 inches (48.3 x 55.9 cm)
Signed: "James Wyeth," lower left
Lent by Mr. Jeffrey Theodore

82 "Portrait of John F. Kennedy," 1967 (*page 166*)
Oil on canvas, 16 x 29 inches (40.6 x 73.6 cm)
Signed: "James Wyeth," lower right
Lent by the John F. Kennedy Library and Museum

83 "Portrait of Lincoln Kirstein," 1967 (*page 167*)
Oil on canvas, 38½ x 29 inches (97.8 x 73.7 cm)
Signed: "James Wyeth," lower right
Lent by Mr. Lincoln Kirstein

84 "Island Roses," 1968 (*page 178*)
Watercolor on paper, 19 x 24 inches (48.3 x 61 cm)
Signed: "James Wyeth," lower right
Private Collection

85 "Portrait of Lady," 1968 (*page 183*)
(To be seen in the USSR and Washington, D.C.,
only)
Oil on canvas, 36 x 63½ inches (91.4 x 161.3 cm)
Signed: "James Wyeth," lower right
Lent by Judith and Alexander M. Laughlin

86 "Portrait of Andrew Wyeth," 1969 (*page 56*)
Oil on canvas, 24 x 32 inches (61 x 81.3 cm)
Signed: "James Wyeth," lower left
Private Collection

87 "Portrait of Pig," 1970 (*page 63*)
Oil on canvas, 48 x 84 inches (121.9 x 213.4 cm)
Signed: "James Wyeth," lower right
Collection of the Brandywine River Museum.
Gift of Mrs. Andrew Wyeth

88 "Sea of Storms," 1970 (*page 180*)
Oil on canvas, 38 x 45 inches (96.5 x 114.3 cm)
Signed: "James Wyeth," lower right
Lent by Dr. and Mrs. Donald Counts

89 "Newfoundland," 1971 (*page 181*)
Oil on canvas, 30 x 58 inches (76.2 x 147.3 cm)
Signed: "James Wyeth," lower left
Private Collection

90 "Bale," 1972 (*page 177*)
Oil on canvas, 28½ x 36 inches (72.4 x 91.4 cm)
Signed: "J.W.," lower right
Private Collection

91 "Pumpkinhead– Self-Portrait," 1972 (*page 171*)
Oil on canvas, 30 x 30 inches (76.2 x 76.2 cm)
Signed: "James Wyeth," lower left
Private Collection

92 "The Red House," 1972 (*page 58*)
Watercolor on paper, 19 x 29 inches
(48.3 x 73.7 cm)
Signed: "James Wyeth," lower left
Private Collection

93 "Angus," 1974 (*page 187*)
Oil on canvas, 52½ x 56½ inches
(133.4 x 143.5 cm)
Signed: "James Wyeth," lower right
Lent by Mr. and Mrs. Fred C. Larkin

94 "And Then into the Deep Gorge," 1975 (*page 169*)
Oil on canvas, 36 x 46 inches (91.4 x 116.8 cm)
Signed: "James Wyeth," lower right
Private Collection

95 "Islander," 1975 (*page 182*)
Oil on canvas, 34 x 44 inches (86.4 x 111.8 cm)
Signed: "James Wyeth," lower right
Private Collection

96 "Portrait of Andy Warhol," 1976 (*page 173*)
Oil on panel, 30 x 24 inches (76.2 x 61 cm)
Signed: "James Wyeth," lower right; also "Andy
Warhol," lower left
Lent by the Fine Arts Center/Cheekwood,
Nashville, Tennessee. Funds donated by Mr. and
Mrs. Rogers C. Buntin; Mr. and Mrs. Frank E.
Fowler; Martin Hayes & Co., Inc.; Mamie C.
Howell, In Memory of Corinne Craig Oliver; Mr.
and Mrs. Jack C. Massey; NLT Corporation; In
Memory of Mr. and Mrs. John Oman, Jr.; Mr. and
Mrs. Joe M. Rodgers; Mrs. Hugh Stallworth; An
Anonymous Donor

97 "Andy Warhol Facing Left," 1976 (*page 67*)
Mixed media on paper, 16 x 14 inches
(40.6 x 35.6 cm)
Signed: "J. Wyeth," lower right
Private Collection

98 "Pig and the Train," 1977 (*page 184*)
Oil on canvas, 24 x 34¼ inches (61 x 87 cm)
Signed: "J. Wyeth," lower left
Private Collection

99 "Rudolf Nureyev, Study #10," 1977 (*page 66*)
(To be seen in Washington, D.C., Dallas, Chicago,
Tokyo, Milan, Cambridge, and Chadds Ford)
Mixed media on paper, 16 x 20 inches
(40.6 x 50.8 cm)
Signed: "J. Wyeth," lower right
Private Collection

100 "Whale," 1978 (*page 168*)
Oil on canvas, 36 x 46 inches (91.4 x 116.8 cm)
Signed: "J. Wyeth," lower right

Lent by Louise Philibosian Danelian

101 "Automaton," 1979 (*page 172*)
Oil on board, 29¼ x 39½ inches (74.3 x 100.3 cm)
Signed: "J. Wyeth," lower right

Lent by Mr. Frank E. Fowler

102 "Night Pigs," 1979 (*page 185*)
Oil on board, 30 x 30 inches (76.2 x 76.2 cm)
Signed: "J. Wyeth," lower right

Lent by Dr. and Mrs. Milton C. David

103 "Wicker," 1979 (*page 59*)
Oil on canvas, 22 x 29 inches (55.8 x 73.6 cm)
Signed: "J. Wyeth," lower right

Private Collection

104 "Portrait of 75, 86, 91, 93, 84," 1980 (*page 186*)
Oil on canvas, 40 x 40 inches (101.6 x 101.6 cm)
Signed: "Wyeth," lower left

Private Collection

105 "10W30," 1981 (*page 190*)
Mixed media on paper, 23 x 31 inches
(58.4 x 78.7 cm)
Signed: "J. Wyeth," lower right

Private Collection

106 "Excursion Boats, Monhegan," 1982 (*page 179*)
Mixed media on paper, 25¼ x 36⅝ inches
(64.1 x 93 cm)
Signed: "J. Wyeth," lower left

Private Collection

107 "Island Geese," 1982 (*page 188*)
Mixed media on paper, 23¼ x 29 inches
(58.1 x 73.7 cm)
Signed: "J. Wyeth," lower right

Lent by the Daniel J. Terra Collection. Terra
Museum of American Art, Chicago, Illinois

108 "Night Chickens," 1983 (*page 191*)
Mixed media on canvas, 23 x 29 inches
(58.4 x 73.7 cm)
Signed: "J. Wyeth," lower left

Lent by Mr. and Mrs. Robert L. Noland

109 "Night Wind," 1983 (*page 70*)
Oil on canvas, 29½ x 36 ⅜ inches (74.9 x 92.4 cm)
Signed: "J. Wyeth," lower right

Lent by Dr. and Mrs. Ronald Brady

110 "Breakfast at Sea," 1984 (*page 174*)
Oil on canvas, 36 x 46 inches (91.4 x 116.8 cm)
Signed: "J. Wyeth," lower right

Private Collection. Washington, D.C. Courtesy
Adams Davidson Galleries

111 "Kleberg," 1984 (*page 62*)
Oil on canvas, 30½ x 42½ inches (77.5 x 108 cm)
Signed: "J. Wyeth," lower left

Lent by the Daniel J. Terra Collection. Terra
Museum of American Art, Chicago, Illinois

112 "Runners," 1984 (*page 170*)
Mixed media on paper, 36 x 30 inches
(91.4 x 76.2 cm)
Signed: "J. Wyeth," lower right

Private Collection

113 "Wolfbane," 1984 (*page 61*)
Mixed media on paper, 28¼ x 22 inches
(71.8 x 55.9 cm)
Signed: "J. Wyeth," lower left

Collection of the Brandywine River Museum

114 "New Year's Calling," 1985 (*page 175*)
Oil on canvas, 35¾ x 56 inches (90.8 x 142.2 cm)
Signed: "J. Wyeth," lower left

Private Collection

115 "Sea Star," 1985 (*page 176*)
Oil on panel with integral shell frame,
31 x 46 inches (78.7 x 116.8 cm)
Signed: "J. Wyeth," lower right

Lent by the Daniel J. Terra Collection. Terra
Museum of American Art, Chicago, Illinois

116 "Dragonflies," 1986 (*page 189*)
Mixed media on paper, 30 x 40 inches
(76.2 x 101.6 cm)
Signed: "J. Wyeth," lower right

Private Collection

117 "Kalounna in Frog Town," 1986 (*page 71*)
Oil on panel, 36 x 50 inches (91.4 x 127 cm)
Signed: "Kalounna — J. Wyeth," lower left

Lent by the Daniel J. Terra Collection. Terra
Museum of American Art, Chicago, Illinois

Index

Page numbers in italics indicate illustrations.

Titles of works by the Wyeths are followed by their initials.

Designed by Greer Allen
Copyedited by Peggy Freudenthal
Production coordination by Amanda Freymann
Most transparencies by Peter Ralston
Composition in Trump Medieval by American-Stratford Graphic Services, Inc.
Printed by BCK Graphic Arts S.A., Geneva, Switzerland